THIRTY-SIX VIEWS

The Kangxi Emperor's Mountain Estate in Poetry and Prints

避暑山莊三十六景詩圖

EX HORTO

DUMBARTON OAKS TEXTS IN GARDEN AND LANDSCAPE STUDIES

Creating a garden is like composing a poem or writing prose. Its twists and turns must follow artistic principles; what initially appears and what follows later should resonate with each other. By all means avoid excess and artificiality as well as dazzling complexity. Then, it will be acknowledged for its excellent design. When a garden is finally completed, it is necessary that the owner himself match it and that everything is fittingly installed and arranged. Ordinary types and vulgar sorts should not be allowed to sojourn within it. Then, it will be considered a notable garden.

造園如作詩文, 必使曲折有法, 前后呼應, 最忌堆砌, 最忌錯雜, 方稱佳構. 園既成矣, 而又要主人之相配, 位置之得宜, 不可使庸夫俗子駐足其中, 方稱名園.

—QIAN YONG 錢泳 (1759–1844),
Chats by Lüyuan, the "Garden Rambler" (Lüyuan conghua 履園叢話, 1825).

THIRTY-SIX

The Kangxi Emperor's
Mountain Estate
in Poetry and Prints

避暑山莊三十六景詩圖

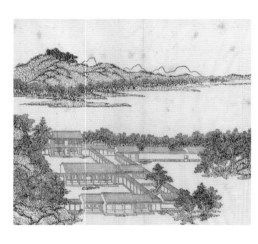
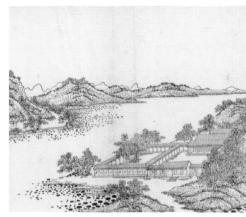

VIEWS

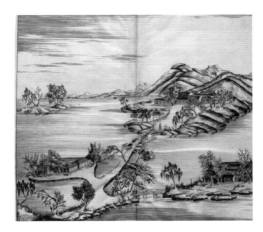
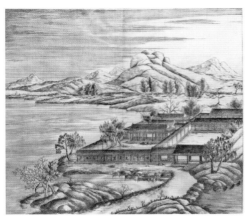
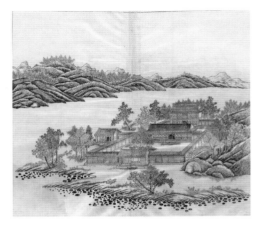

Poems by the Kangxi Emperor

with illustrations by
Shen Yu *and* Matteo Ripa

Translated by
Richard E. Strassberg

with introductions by
Richard E. Strassberg
and Stephen H. Whiteman

DUMBARTON OAKS RESEARCH LIBRARY AND COLLECTION | WASHINGTON, D.C.

Printed in China by Everbest Printing Company.

LIBRARY OF CONGRESS CATALOGING-IN-PUBLICATION DATA

Kangxi, Emperor of China, 1654–1722.

 [Poems. Selections. English]

 Thirty-six views : the Kangxi emperor's mountain estate in poetry and prints /
poems by the Kangxi Emperor with illustrations by Shen Yu and Matteo Ripa;
translated by Richard E. Strassberg, with introductions by Richard E. Strassberg
and Stephen H. Whiteman.

 pages cm.— (ex horto: Dumbarton Oaks texts in garden and landscape studies)

 Includes bibliographical references and index.

 ISBN 978-0-88402-409-5 (hardcover : alk. paper)

I. Shen, Yu, active 17th century–18th century, illustrator.

II. Ripa, Matteo, illustrator.

III. Strassberg, Richard E., translator. IV. Title.

 PL2715.a52a2 2016

 895.11′4—dc23

 2015011219

COVER ILLUSTRATIONS: (*front cover*) View 2, "A *Lingzhi* Path on an Embankment to the Clouds" (Zhijing yundi 芝逕雲隄), Chinese Collection, Harvard-Yenching Library, © President and Fellows of Harvard College; (*back cover*) View 11, "Morning Mist by the Western Ridge" (Xiling chenxia 西嶺晨霞), Dumbarton Oaks Research Library and Collection, Washington, D.C.

The woodblock illustrations of the Thirty-Six Views are courtesy of the Chinese Collection, Harvard-Yenching Library, © President and Fellows of Harvard College. The engravings are courtesy of Dumbarton Oaks Research Library and Collection, Washington, D.C.

Book and cover design and type composition: Melissa Tandysh

www.doaks.org/publications

CONTENTS

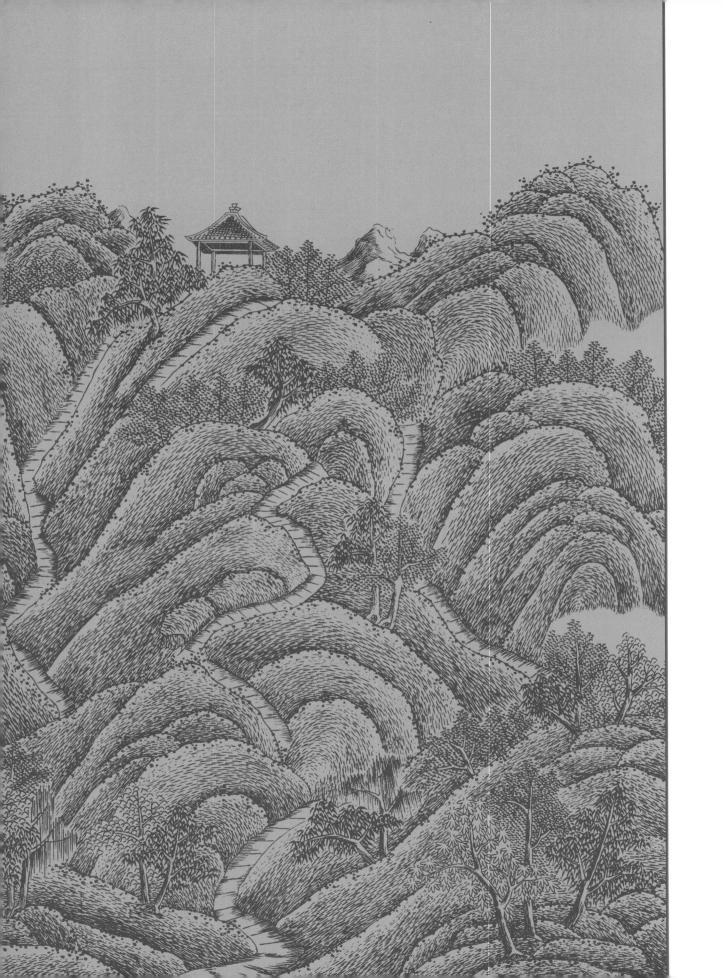

FOREWORD

In 2013, Dumbarton Oaks launched *ex horto*, a new series of significant texts in the histories of garden design and landscape architecture. To reach a large audience of both general readers and scholars, the series makes available in English works that have never before been translated, along with previously unpublished manuscripts and books that have long been out of print. Its volumes will cover a broad geographical and temporal range and will eventually constitute a library of historical sources that have defined the core of the field. By making these works approachable, the series provides unprecedented access to the foundational literature of garden and landscape studies.

This book is the third title in the new series. It is a translation of and a scholarly commentary on the *Imperial Poems on the Mountain Estate for Escaping the Heat* (1712), composed by China's Kangxi emperor, who ruled from 1661–1722. He published this unprecedented book as a summary self-portrait of his life in his favorite garden as he approached the age of sixty. The setting of these poems is one of the oldest and best preserved of the Qing dynasty imperial parks, Bishu shanzhuang, which played a significant role in the history of the Manchu court for more than a century and a half. Located beyond the Great Wall, about 110 miles northeast of Beijing, it was the principal summer residence of three emperors, where they often lived for nearly half the year. Now a UNESCO World Heritage Site that covers some 1,400 acres, it rivals any other designed landscape in China in terms of significance, but it is considerably less well known than either the imperial gardens of Beijing or the literati gardens of Suzhou.

Originally written in Chinese and then translated into Manchu, Kangxi's poems were accompanied by woodblock prints, which were created by court artists to illustrate the Thirty-Six Views. Subsequently, the emperor commissioned Matteo Ripa (1682–1746), an Italian priest then serving at the imperial court, to create a set of copperplate engravings of the views. Ripa's prints became the first eyewitness images of Chinese gardens to reach Europe, where they had a pronounced effect on the development of continental landscape tastes and "informal" gardening styles. Relatively few copies of the original book survive today. Harvard University is fortunate to possess not only fine examples of the Chinese and Manchu editions with the woodblock illustrations but also a rare bound copy of the engravings, which is in the Dumbarton Oaks Library.

Thirty-Six Views: The Kangxi Emperor's Mountain Estate in Poetry and Prints is a collaborative effort between Richard E. Strassberg (Professor of Chinese, University of California, Los Angeles) and Stephen H. Whiteman (Lecturer in Asian Art, University of Sydney), who are specialists, respectively, in classical Chinese literature and Chinese art and garden history. This book makes available to the public important but hitherto unpublished textual

and visual resources. It is the first translation into a Western language of the text of Kangxi's book, with complete reproductions of both the woodblock and copperplate illustrations, published together here for the first time. We hope it will appeal to a wide audience interested in Chinese gardens and landscape studies, bringing new light to fundamental yet under-studied aspects of Chinese culture, especially the close relationship between gardens and the literary and visual arts. At the same time, we believe it will open new perspectives for the English-speaking world on Qing history, literature, and art as well as on East-West cultural interaction and exchange. Kangxi's poems and prints are remarkable instances of transla-tion—of landscape into words, of words into images, and of images from one medium to another, which were then transmitted from China to the West. Dumbarton Oaks is pleased to take yet another step in this process of cultural translation and to make these words and images available to new generations of readers in lands far distant from their place of origin.

JOHN BEARDSLEY
Director, Garden and Landscape Studies
Dumbarton Oaks

ACKNOWLEDGMENTS

RICHARD E. STRASSBERG

I would like to thank the following colleagues for their generous assistance: Profs. Jack W. Chen, Paola Demattè, Mark Elliot, David E. Mungello, Bianca Maria Rinaldi, Yang Ye, and Elena Suet-ying Zhao. Su Chen, Head Librarian, Richard C. Rudolph East Asian Library, University of California, Los Angeles, and Chen Hongyan, Director and Research Librarian, Rare Books and Special Collections Library, National Library of China, generously provided the image from the original edition of the *Imperial Poems*. Prof. Lida Viganoni, Rector of the University of Naples "L'Orientale," kindly granted permission to reproduce the portrait of Matteo Ripa. Special thanks go to Emeritus Prof. Michele Fatica of the University of Naples "L'Orientale," presently President of the Study Center on Matteo Ripa and the Chinese College of Naples, for his guidance over the course of several years regarding a number of historical and textual questions about Matteo Ripa and his writings.

STEPHEN H. WHITEMAN

The process of writing this book in many ways fundamentally changed how I think about pictures, which is perhaps the most any scholar can hope to say about a project. This did not happen in a vacuum, however, and I owe my thanks to a great many for their contributions to, and support of, my research. During the period in which I worked on this project, I was the A. W. Mellon Postdoctoral Fellow at the Center for Advanced Study in the Visual Arts at the National Gallery of Art in Washington, D.C., in which position I benefitted inestimably from the support of my cohorts of fellows and the gallery staff. My thanks to the staffs of the Philadelphia Museum of Art, The Morgan Library, the New York Public Library, Dumbarton Oaks Research Library and Collection, the British Museum, the British Library, the Muban Foundation, the Harvard Yen-ching Library, the Gest East Asian Library, the Johns Hopkins University Library, and the Library of Congress for making original copies of the woodblock and copperplate prints discussed in this volume available for study, and especially to Robert Batchelor, Christer von der Berg, John Finlay, and Frances Wood for photographs and bibliographic advice from afar. I spent many enjoyable and productive hours in conversation while looking at the Views, for which I must thank especially Jonathan Bober, Julie Nelson Davis, Shelley Langdale, Stuart Lingo, Bianca Rinaldi, Larry Silver, Richard Strassberg, Anatole Tchikine, Christer von der Berg, and James Wehn. For their thoughtful reading of, and insightful comments upon, various versions of this text, I owe a deep debt of gratitude to Meredith Gamer and Edward Vazquez. While I could not have completed the project without the support of these many scholars and friends, any remaining errors

or misjudgments are of course my own. Finally, my greatest thanks go to John Beardsley, for his constant support of this project and my work, and to Tanya Rose, for her constant support of me.

Both of us would like to express our gratitude to Jan Ziolkowski and John Beardsley at Dumbarton Oaks for their unfailing support for this project. We also appreciate the helpful comments of the outside readers as well as the assistance of Anatole Tchikine in assembling the final manuscript. Sara Taylor has expertly edited the text, and Melissa Tandysh is responsible for the elegant design.

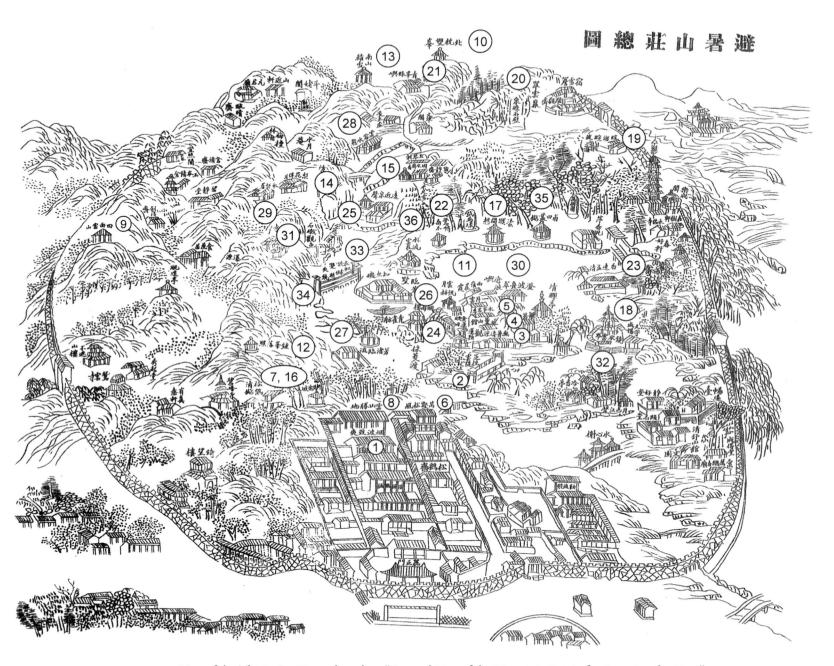

Map of the Thirty-Six Views, based on "General Map of the Mountain Estate for Escaping the Heat" (*Bishu shanzhuang zongtu* 避暑山莊總圖), in the *Imperially Sponsored Gazetteer of Rehe* (*Qinding Rehe zhi* 欽定熱河志, 1781). Map prepared by Richard E. Strassberg.

MAP OF THE THIRTY-SIX VIEWS

Based on "General Map of the Mountain Estate for Escaping the Heat" (*Bishu shanzhuang zongtu* 避暑山莊總圖), in the *Imperially Sponsored Gazetteer of Rehe* (*Qinding Rehe zhi* 欽定熱河志, 1781).

1. Misty Ripples Bringing Brisk Air (Yanbo zhishuang 烟波致爽)

2. A *Lingzhi* Path on an Embankment to the Clouds (Zhijing yundi 芝逕雲隄)

3. Un-Summerly Clear and Cool (Wushu qingliang 無暑清涼)

4. Inviting the Breeze Lodge (Yanxun shanguan 延薰山館)

5. Fragrant Waters and Beautiful Cliffs (Shuifang yanxiu 水芳巖秀)

6. Pine Winds through Myriad Vales (Wanhe songfeng 萬壑松風)

7. Sonorous Pines and Cranes (Songhe qingyue 松鶴清越)

8. Scenes of Clouds and Mountains (Yunshan shengdi 雲山勝地)

9. Clouds and Peaks on All Sides (Simian yunshan 四面雲山)

10. Nestled in the North between a Pair of Peaks (Beizhen shuangfeng 北枕雙峰)

11. Morning Mist by the Western Ridge (Xiling chenxia 西嶺晨霞)

12. Sunset at Hammer Peak (Chuifeng luozhao 錘峰落照)

13. Southern Mountains Piled with Snow (Nanshan jixue 南山積雪)

14. Pear Blossoms Accompanied by the Moon (Lihua banyue 梨花伴月)

15. The Scent of Lotuses by a Winding Stream (Qushui hexiang 曲水荷香)

16. Clear Sounds of a Spring in the Breeze (Fengquan qingting 風泉清聽)

17. Untrammeled Thoughts by the Hao and Pu Rivers (Hao Pu jianxiang 濠濮間想)

18. The Entire Sky Is Exuberant (Tianyu xianchang 天宇咸暢)

19. Warm Currents and Balmy Ripples (Nuanliu xuanbo 暖溜暄波)

20. A Fountainhead in a Cliff (Quanyuan shibi 泉源石壁)

21. Verdant Isle of Green Maples (Qingfeng lüyu 青楓綠嶼)

22. Orioles Warbling in the Tall Trees (Yingzhuan qiaomu 鶯囀喬木)

23. Fragrance Grows Purer in the Distance (Xiangyuan yiqing 香遠益清)

24. Golden Lotuses Reflecting the Sun (Jinlian yingri 金蓮映日)

25. Sounds of a Spring Near and Far (Yuanjin quansheng 遠近泉聲)

26. Moon Boat with Cloud Sails (Yunfan yuefang 雲帆月舫)

27. A Fragrant Islet by Flowing Waters (Fangzhu linliu 芳渚臨流)

28. Shapes of Clouds and Figures in the Water (Yunrong shuitai 雲容水態)

29. A Clear Spring Circling the Rocks (Chengquan raoshi 澄泉遶石)

30. Clear Ripples with Layers of Greenery (Chengbo diecui 澄波疊翠)

31. Observing the Fish from a Waterside Rock (Shiji guanyu 石磯觀魚)

32. Clouds and Peaks in the Mirroring Water (Jingshui yuncen 鏡水雲岑)

33. A Pair of Lakes Like Flanking Mirrors (Shuanghu jiajing 雙湖夾鏡)

34. A Long Rainbow Sipping White Silk (Changhong yinlian 長虹飲練)

35. An Immense Field with Shady Groves (Futian congyue 甫田叢樾)

36. Clouds Remain as Water Flows On (Shuiliu yunzai 水流雲在)

REDESIGNING SOVEREIGNTY

The Kangxi Emperor,
the Mountain Estate for Escaping the Heat,
and the *Imperial Poems*

Richard E. Strassberg

The Imperial Villa of Gehol [Jehol, Rehe] is situated in Tartary, and it is located about 150 Italian miles from Peking by winding routes on a plain completely surrounded by mountains from the base of which runs a river that one can usually cross on foot. But, during rainy weather or when the ice and snow melt, it overflows so much that it is frightening to look at. From this hill gently emerges a high and spacious hill at the base of which were constructed houses for the emperor's entourage as well as for the others coming from various provinces of China to sell their merchandise. This hill ends in a plateau where a wall begins that surrounds the Villa. From this plateau one descends to another, situated in a valley of the hill from which emerges a mountain crowned with various lovely hills with an abundance of water that gushes forth in the same place. Aided by art, this water circulates around the hills like rivers and then forms a beautiful, large lake very rich with good fish. . . . Now this plateau with the mountain and hills is the one that the Emperor Canghi [Kangxi] enclosed for himself, and it takes more than one hour on horseback to go around it. And, here he built in various distinct locations at a distance from one another various dwellings or compounds of houses that are more or less large according to the use decided by this emperor.[1]

1 Matteo Ripa, "Description of the Villa" (translated by Bianca Maria Rinaldi). For the complete text, see Appendix 2.

S o wrote Matteo Ripa 馬國賢 (1682–1746) about the Mountain Estate for Escaping the Heat (Bishu shanzhuang 避暑山莊), the summer residence of the Kangxi emperor 康熙 (r. 1661–1722) (Figures 1–2). A missionary from Naples who served the Qing dynasty (1644–1911) court as a painter for thirteen years, Ripa was one of the few who were privileged not only to visit but also to dwell here.[2] In a unique collaboration, this Manchu emperor and Italian artist joined together to produce a rare book of poems and illustrations of thirty-six of its most beautiful views, the *Imperial Poems on the Mountain Estate for Escaping the Heat* (*Yuzhi Bishu shanzhuang shi* 御製避暑山莊詩, postscript 1712).

In Kangxi's original conception, the Mountain Estate was intended to be a private, rustic retreat, though constructed on a grand scale.[3] It embraced the sophisticated charm of a Han Chinese literati garden within an expansive landscape that extended to the Manchu homeland. Located in the modern city of Chengde 承德, about 110 miles northeast of Beijing, it is one of the few such places that have survived into the present. In the early Qing dynasty, this area was originally called Rehe 熱河 in Chinese, literally "Hot River," based on several hot springs in the vicinity, while foreigners, such as Ripa, often referred to it as Jehol.[4] As early as 1681, Kangxi began to briefly stop here, as it was one of a string of camp sites and simple lodges along the route from the capital to the annual autumn hunt at the Mulan 木蘭 hunting grounds, some one hundred miles further north.[5] As the emperor later noted, the site occupies an advantageous geomantic position and its scenic beauty includes

2 Ripa's experiences at the Qing court were principally expressed in his journal, which he edited in his final years. See chapter two, "An Intercultural Artist," 42n1.

3 Most existing scholarship on the Mountain Estate has investigated it as it existed under his grandson, the Qianlong emperor 乾隆 (r. 1735–1795), who altered it in a number of ways. See Chen Baosen 陈宝森, *Chengde Bishu shanzhuang Waibamiao* 承德避暑山庄外八庙 [The Mountain Estate for Escaping the Summer Heat and the Outer Eight Temples in Chengde] (Beijing: Zhongguo jianzhu gongye chubanshe, 1995); Philippe Forêt, *Mapping Chengde: The Qing Landscape Enterprise* (Honolulu: University of Hawai'i Press, 2000); Cary Liu, "Archive of Power: The Qing Dynasty Imperial Garden-Palace at Rehe," *Meishu shi yanjiu jikan* 美術史研究集刊 28 (2010): 43–66; James Millward et al., eds., *New Qing Imperial History: The Making of Inner Asian Empire at Qing Chengde* (London: Routledge, 2004); and Zhou Weiquan 周维权, *Zhongguo gudian yuanlin shi* 中国古典园林史 [A History of the Classical Chinese Garden] (Beijing: Qinghua daxue chubanshe, 1999). For a study of the Mountain Estate as it originally existed under Kangxi, see Stephen H. Whiteman, "Creating the Kangxi Landscape: Bishu Shanzhuang and the Mediation of Qing Imperial Identity" (PhD diss., Stanford University, 2011).

4 On the complicated nomenclature for this area, see Chen, *Chengde Bishu shanzhuang Waibamiao*, 2–4; Forêt, *Mapping Chengde*, xiii–xiv, 16; and Mark C. Elliott and Ning Chia, "The Qing Hunt at Mulan," in *New Qing Imperial History: The Making of Inner Asian Empire at Qing Chengde*, ed. James Millward et al. (London: Routledge, 2004), 71. "Rehe" 熱河 was a Chinese translation of the original Mongol name. The Manchus pronounced it "Žeho," and the Europeans Romanized it as "Jehol" with variant spellings, such as Ripa's "Ge-hol." "Rehe" was also used to refer to a region, a city, a river, various imperial residences, a hot spring, as well as hunting grounds in this area. The city was renamed "Chengde" 承德 in 1733.

5 For a map and description of the Mulan 木蘭 hunting grounds, see *Qinding Rehe zhi* 欽定熱河志 [Imperially Sponsored Gazetteer of Rehe], ed. Heshen 和珅 (Hešen) et al. (1781; repr., Dalian: Youwenge / Liaohai shushe, 1934), 45:5a; and Elliott and Chia, "The Qing Hunt at Mulan," 71.

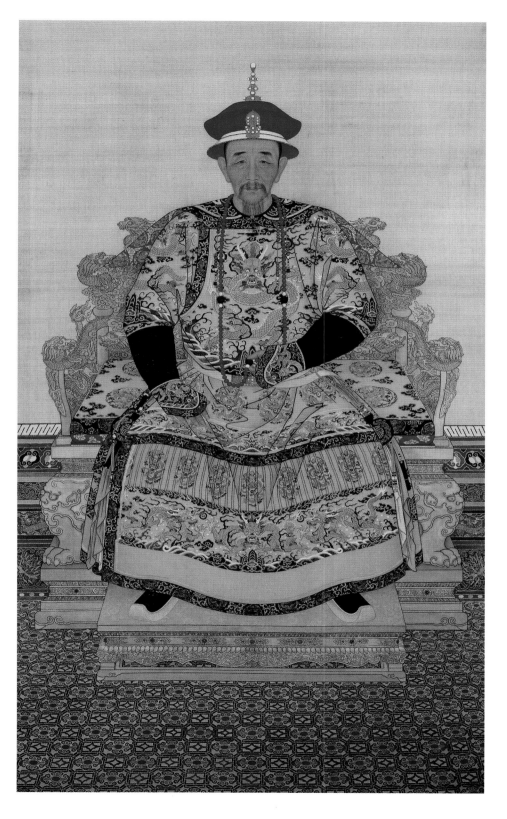

figure 1
Anonymous, *Portrait of the Kangxi Emperor* 康熙 (r. 1661–1722). Kangxi is depicted around the age of sixty wearing formal court robes. The National Palace Museum, Beijing.

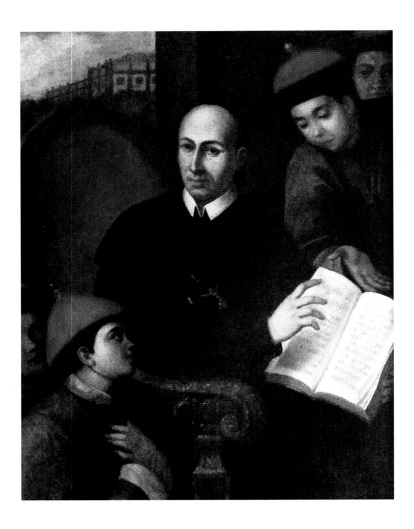

figure 2

Giovanni Scognamiglio, *Father Matteo Ripa and His Four Chinese Pupils in Naples, ca. 1725,* 1818. Ripa is shown reading the Gospel to the four students that he brought back to Naples from China. They were later ordained at the Collegio dei Cinesi, which he founded in 1732. The painting was executed in 1818, after the Bourbons were restored to the throne in Naples. They were important patrons of the Collegio and their palace is shown in the upper left. Courtesy of the rector of the Università degli Studi di Napoli "L'Orientale," Naples.

some outstanding rock formations.[6] Construction began on a permanent imperial residence at the site in 1703, and was essentially completed seven years later. After a period of neglect under Kangxi's son, the Yongzheng emperor 雍正 (r. 1722–1735), his grandson, the Qianlong emperor 乾隆 (r. 1735–1795), restored and greatly expanded the residence from 1741 to 1792. Subsequently, several other Qing rulers also spent seasonal sojourns—sometimes extending from May through early November—here. They, too, sought to avoid the summer heat and the pressures of imperial life in the capital while continuing to rule the wealthiest and most populous empire in the world. Today, the Mountain Estate covers more than fourteen

6 See his preface, "Imperial Record of the Mountain Estate for Escaping the Heat," 122–23, as well as various poems that refer to such positive influences as geomantic "dragon veins" (*longmai* 龍脈), extraordinary mountain formations, warm springs, balmy air, etc. Physical descriptions of the area are also presented in Forêt, *Mapping Chengde,* 35–43; and Millward, *New Qing Imperial History,* 4–8.

RICHARD E. STRASSBERG

hundred acres. Despite having suffered periods of neglect and partial destruction, it has been substantially restored and was placed on the UNESCO World Heritage List in 1994.[7]

More than any other place, the Mountain Estate embodied Kangxi's lifelong goal of combining his Manchu heritage with the best elements of the elite culture of his Han Chinese subjects. It became his favorite residence, where he enjoyed a less formal and more active outdoor life in the invigorating atmosphere of the northern mountains beyond the Great Wall. He also pursued his many intellectual and aesthetic pastimes here—just like a Han literatus dwelling at leisure in one of the famous gardens of the Jiangnan area in the lower Yangtze region. When the residence was substantially completed in 1711, the emperor was approaching the milestone age of sixty by Chinese reckoning and had brought peace and prosperity to the empire during his long reign. It was an appropriate moment for commemoration. In addition to the poems in Chinese that he had selected, Kangxi added descriptive prefaces and had his official translators produce a Manchu version of the text (Figure 3).

He commanded his court artists to illustrate these scenes in Chinese woodblock prints and further ordered Matteo Ripa to interpret these images in a European style through copperplate engravings—a medium that had not yet been practiced in China. Throughout the production process, the emperor closely supervised the officials and artisans in the Imperial Printing Office down to the smallest details. Originally issued in a limited, fine-art edition of about four hundred copies, the book presented an intimate self-portrait of Kangxi through vignettes of his life at the Mountain Estate. It was intended for a select circle of readers centered on his extended family and other leading members of the Eight Banners establishment.[8]

But, as Matteo Ripa discovered during his thirteen years of service, the picturesque vistas and delightful pavilions in the Mountain Estate disguised the tense atmosphere at the Qing court over the struggles for the succession to the throne that surfaced at this time. As Kangxi began the first of his annual sojourns here in 1708, a series of intrigues within the imperial family erupted that resembled some of the melodramatic operas that the emperor enjoyed in his private theaters. Unexpectedly, the aging emperor at the height of his glory found himself faced with the frightening prospect that the future of the Qing dynasty (and even his life) might be in jeopardy. It was against the backdrop of these fears that the *Imperial Poems* was written and published. Despite its manifest purpose of commemorating the completion of the Mountain Estate, the book also enabled the emperor to reassert his patriarchal authority for his readers in order to assure the continuity of the empire. The self-portrait of Kangxi that emerges in the *Imperial Poems*, therefore, simultaneously reiterated his lifelong project of redesigning an enduring form of imperial sovereignty.

7 On the UNESCO designation, see Forêt, *Mapping Chengde,* 6–8.

8 For a study of the Eight Banners, the primary social and military organization of the Manchus and their allies, see Mark C. Elliott, *The Manchu Way: The Eight Banners and Ethnic Identity in Late Imperial China* (Stanford: Stanford University Press, 2001). See also Pamela Kyle Crossley, *The Manchus* (Oxford: Blackwell, 1997); Pamela Kyle Crossley, *A Translucent Mirror: History and Identity in Qing Imperial Ideology* (Berkeley: University of California Press, 1999); Evelyn S. Rawski, *The Last Emperors: A Social History of Qing Imperial Institutions* (Berkeley: University of California Press, 1998); and Jonathan D. Spence, *Ts'ao Yin and the K'anghsi Emperor, Bondservant and Master* (New Haven: Yale University Press, 1966).

figure 3

Pages from *Imperial Poems on the Mountain Estate for Escaping the Heat* (*Yuzhi Bishu shanzhuang shi* 御製避暑山莊詩), postscript 1712. The first lines of Kangxi's poem on View 1, "Misty Ripples Bringing Brisk Air" (*Yanbo zhishuang* 烟波致爽), are printed in large characters, reading from right to left. Between the lines in two columns of smaller characters is the commentary appended by the editors. Every word or phrase is glossed by citations from a wide range of classical literature based on the dictionary—*A Treasury of Rhymes for Ornamenting Literature* (*Peiwen yunfu* 佩文韻府, 1711)—sponsored by Kangxi. Collection of the National Library of China.

RICHARD E. STRASSBERG

In what sense can Kangxi's visionary poems about scenes in his garden be regarded as essentially autobiographical in intent? As a genre, narrative autobiography never achieved the status in traditional China that it enjoyed in Western literature; it was assumed that the story of a life with historical judgments could and should only be written afterward by others. Thus, the impulse to represent the self was usually expressed by recording impressionistic moments, especially in short forms such as lyric poetry.[9] There is a long tradition of Chinese poetry and expressive prose where the author constructs a persona who envisions a *jing* 景, or view.[10] This special sense of a view as a fusion of emotion and scene also underlies the conception of the literati garden of later Imperial China. Its design, which often sought to replicate the picturesque qualities of landscape painting, can be understood as a spatial arrangement of various environments that are meant to be experienced sequentially while casually wandering along a circuitous path. A Chinese poem about a view, therefore, is more than an aesthetic description of a place.

Such a view only comes into being through the constructive acts of the poet, who imaginatively patterns his perceptions using a largely traditional lexicon of symbolic objects selected from a landscape. Over the centuries, this literary practice evolved into a discourse composed of conventionalized imagery and themes. These elements were syntactically assembled according to formal rules of prosody in various genres that usually employed highly allusive diction. The result maps a coherent, textualized sense of place within a vast hypertext of other, similarly constructed locations. Through this extended process of naming, the poet's self is perpetuated as he inscribes a persona that is simultaneously emplaced in as well as expressed through a view. Traditional Chinese readers typically sought to enter into a deeply empathetic relationship with the author. In poems on views, they reimagined the poet's original experience by becoming a virtual traveler themselves as they retraced his steps.[11] Such a reader willingly adjusted his gaze to accord with the perspective in the

9 See Stephen Owen, "The Self's Perfect Mirror: Poetry as Autobiography," in *The Vitality of the Lyric Voice: Shih Poetry from the Late Han to the T'ang*, ed. Shuen-fu Lin and Stephen Owen (Princeton, N.J.: Princeton University Press, 1986), 71–102, for the use of poetry as autobiography. For a discussion of autobiography in early Chinese literature in comparison with Western genres, see Matthew V. Wells, *To Die and Not Decay: Autobiography and the Pursuit of Immortality in Early China* (Ann Arbor: Association for Asian Studies, 2009), 1–54; and for Confucian autobiography in later imperial China, see Pei-yi Wu, *The Confucian's Progress: Autobiographical Writings in Traditional China* (Princeton, N.J.: Princeton University Press, 1980).

10 The concept of *jing* 景 in Chinese gardens is explored in Hui Zou, *A Jesuit Garden in Beijing and Early Modern Chinese Culture* (West Lafayette, Ind.: Purdue University Press, 2011), 51–75. A prose genre that often combined autobiographical and lyrical impulses based on representing such views was the travel account (*youji* 遊記). For an anthology of this literature, see Richard E. Strassberg, *Inscribed Landscapes: Travel Writing from Imperial China* (Berkeley: University of California Press, 1994).

11 Among strong readers who are themselves poets, such readings can yield new poems in response, creating a chain of dialogical texts over time that further map a place in the literary culture. The Qianlong emperor followed this practice by later adding two sets of thirty-six poems of his own in 1741 and 1752 in response to Kangxi's original set. See *Qinding Rehe zhi* 26:2a–29:13b; and Fan Shuyuan 樊淑媛 and Duan Zhongrong 段钟嵘, eds., *Bishu shanzhuang yuzhi fengjingshi jianshang* 避暑山庄御制风景诗鉴赏 [An Appreciation of Imperial Landscape Poems on the Mountain Estate for Escaping the Heat] (Hailaer: Neimenggu wenhua chubanshe, 2000).

text, and the shared view emerged as an emotional, spatialized vision that encoded the singular identity of the poet along with its reception by the reader. In this way, the intention of a Chinese poem about a view may be understood as fulfilling a recent definition of autobiography as a text where the author, narrator, and subject are all claimed to be the same person.[12]

The *Imperial Poems* constitutes a remarkably intimate self-portrait by Kangxi as he entered the final decade of his life. The author assembles an eclectic variety of personae out of the great tradition of Chinese literature and visual art as he takes his readers on a virtual tour of his Mountain Estate. Although he often clothes himself in the guise of a Han literatus reclusively dwelling at leisure in his garden, Kangxi employs these poetic views to present a kaleidoscopic image of a Manchu dynastic patriarch ruling a multicultural empire. Today, this image may appear aspirational, in light of what is known about his complex personality and his emotional state at this time.[13] Nevertheless, it represents how one of the most confessional among the nearly two hundred rulers of China wished to be known.

Only a small number of copies of the *Imperial Poems* have survived. Now considered rare treasures, they present the Mountain Estate as it appeared when it was first completed in 1711. Their illustrations—in addition to their art-historical value—document architectural details that have proven invaluable to modern restorers of the imperial residence. Furthermore, the emperor's Chinese and Manchu texts marked an intracultural act within the ethnically diverse Qing Empire. Matteo Ripa's engravings, and their transmission to the West, were similarly significant as intercultural events in an earlier phase of globalization.[14] When Ripa's engravings reached Europe, they did not contain Kangxi's text, which few people were capable of reading anyway. Nor have they been considered in their original literary context by modern scholars.[15] Now, for the first time, Kangxi's poems have been translated into English; they appear together with the original woodblock illustrations in the Harvard University Library and the set of Ripa's copperplate engravings in the Dumbarton Oaks Library. The resultant study not only offers readers an opportunity to appreciate the multiple dimensions of the *Imperial Poems* but provides an example of how Kangxi, arguably one of the greatest emperors in Chinese history, presented visions of his garden as a means of defining an enduring form of imperial identity at a time of personal and political crisis.

12 Philippe Lejune, *On Autobiography* (Minneapolis: University of Minnesota Press, 1989), 12; and Wells, *To Die and Not Decay*, 19.

13 For a comprehensive, psychologized study of Kangxi and the succession struggle among his sons and their factions, see Silas H. L. Wu, *Passage to Power: K'ang-hsi and His Heir Apparent* (1661–1722) (Cambridge, Mass.: Harvard University Press, 1979).

14 See Richard E. Strassberg, "Transmitting a Qing Imperial Garden" 一座清代御苑之传播, *Landscape* 风景园林 83 (June 2009): 93–103.

15 A relatively small number of Ripa's engravings were transmitted to the West as soon as they were completed in 1714. They have been preserved in private collections and, more recently, in museums. But their connection to Ripa was often unknown or forgotten because they lacked signatures. Scholars began to study these engravings in the twentieth century—beginning with Paul Pelliot (1878–1945) in 1926—but even the most recent studies have ignored their relationship to Kangxi's poems.

RICHARD E. STRASSBERG

Kangxi has often been compared to his contemporaries Louis XIV of France (r. 1643–1715) and Peter the Great of Russia (r. 1682–1725) as epitomizing the traditional autocrat who signifi-cantly altered the course of human history.[16] Like them, he overcame early challenges to his authority, consolidated an empire, and patronized culture extensively. The future emperor was born on May 4, 1654, in the Forbidden City to the sixteen-year-old Shunzhi emperor 順治 (Fulin 福臨, r. 1643–1661) and a fourteen-year-old imperial consort from the Tong 佟 family. Later known as Empress Dowager Xiaokang 孝康 (1640–1663), she was from a fam-ily that was originally classified as Han Chinese by the Manchus and that belonged to the Han Plain Blue Banner.[17] His paternal grandmother, posthumously titled Grand Empress Dowager Xiaozhuang 孝莊 (Bumbutai, 1613–1688), was a Korchen Mongol from the dis-tinguished Borjigit 博爾濟吉特 clan.[18] Thus, Kangxi's background actually included Han and Mongolian ethnicities, though he always sought to personify an ideal Manchu ruler. Since his father was still young (and was expected to produce many more sons) and his mother was not from an important Manchu or Mongolian clan, Kangxi was not regarded as a possible heir to the throne as a young child. Following Manchu custom, the boy was raised outside the palace by a substantial bannerman family and was mostly in the care of

16 Jonathan D. Spence, "The K'ang-hsi Reign," in *The Cambridge History of China,* vol. 9, pt. 1, *The Ch'ing Empire to 1800,* ed. Willard J. Peterson (Cambridge: Cambridge University Press, 2002), 120. In addition to this survey of Kangxi's reign, see Fang Chao-ying, "Hsüan-yeh," in *Eminent Chinese of the Ch'ing Period,* ed. Arthur W. Hummel (Washington D.C.: Government Printing Office, 1943), 327–331; and Jonathan D. Spence, *Emperor of China: Self-Portrait of K'ang-Hsi* (New York: Alfred A. Knopf, 1974), for further biograph-ical information. Kangxi also shared with Louis XIV the commissioning of numerous portraits as well as a love of the theater. Under Kangxi, the Qing developed new levels of diplomatic, cultural, and economic relations with France and Russia, and the emperor was interested in learning as much as he could about their monarchs.

17 The Tongs 佟 were a prominent Han bannermen (*hanjun* 漢軍) family from Fushun, Liaodong, in the region where the Qing Empire arose. They began to serve the Manchu rulers with distinction two generations before their conquest of China. Long after Xiaokang died, the Tongs were finally honored with a Manchu surname, Tungyiya. But only her branch was allowed to transfer into a Manchu ban-ner following a petition to Kangxi in 1688 by her influential brother, "Imperial Uncle" Tong Kuogang 佟國綱 (d. 1690); the petition claimed that the family was originally ethnically Jurchen, ancestors of the Manchus. Despite having given birth to a son, Xiaokang did not become an influential figure in the palace, and her personal name is unknown. She remained an imperial consort until Kangxi ascended the throne, whereupon she was officially promoted to empress dowager. Xiaokang died, some say under sus-picious circumstances, at the age of twenty-three, when Kangxi was only nine. Kangxi later recalled that he had had very little contact with her. For biographies of several important members of the Tong family, see Arthur W. Hummel, ed., *Eminent Chinese of the Ch'ing Period* (Washington D.C.: Government Printing Office, 1943), 792ff. Their ethnicity is discussed in Crossley, *A Translucent Mirror,* 55–56; and Elliott, *The Manchu Way,* 87.

18 Xiaozhuang was a formidable force during the reigns of Shunzhi and Kangxi whose power extended well beyond the women's palace. Despite her conflicts with her son Shunzhi, she has been generally regarded as a wise and stabilizing influence at court. Xiaozhuang used her influence with senior banner-men and Mongol tribes at critical points to enable the young Kangxi to consolidate his authority. For a biography, see Hummel, *Eminent Chinese of the Ch'ing Period,* 300–301.

wetnurses and servants.[19] Little was recorded about these first years, but toward the end of his life, Kangxi recalled with regret that he had very little contact with his parents.[20] An event that would prove critical to his future destiny, however, was his surviving a bout with smallpox. It left his face pockmarked but provided him with immunity to the disease, which was endemic in China and particularly fatal to Manchus and Mongolians. A few years later, it would unexpectedly strike down his father at the age of twenty-two.

While Kangxi was growing up in relative obscurity, Shunzhi's brief reign was plagued by controversies over his attempts to consolidate and expand imperial authority.[21] These were often manifestations of fundamental conflicts between the Eight Banners system, which had been established relatively recently by the Manchus, and the native Han political system that had governed China for centuries. The banner system was a feudal form of social and military organization based on ethnic, tribal, family, and personal loyalties. Promoting the martial virtues characteristic of Northern and Inner Asian cultures, elite bannermen dominated by the Manchus formed the core of the ruling class of the Qing. Considerable power was concentrated in the hands of the top commanders of each banner, who, in turn, swore fealty to one among them as a khan. The native Han system, on the other hand, was administered by a largely meritocratic, civilian bureaucracy through an extensive network of institutions where conformity to ritual and precedent helped to sustain the status quo. Its officials, who trained in the traditions of classical literature, were mostly selected from the landed gentry through the examination system and owed their loyalty to an emperor based on Confucian ideology. Thus, the Qing system that the young Kangxi would inherit was highly dualistic, enabling the vastly outnumbered members of the Eight Banners to govern the Han population.[22]

The Eight Banners establishment was mindful of the failures of the preceding Ming dynasty (1368–1644) and fearful of the effects of assimilation. The dominant military leaders who ruled as regents during Shunzhi's minority sought to maintain hegemony by promoting traditional Manchu martial virtues and by limiting Han Chinese cultural and political

19 Among Kangxi's wetnurses were Mistresses Gulwalgiya 瓜爾佳 and Sun 孫, who were posthumously raised by him to the rank of dame-consort. Mistress Sun was later married to the Han bannerman and bondservant Cao Xi 曹璽 (d. 1684); she bore Cao Yin 曹寅 (1658–1712), who became a trusted official under Kangxi. For a study of the relationship between Kangxi and Cao Yin, see Spence, *Ts'ao Yin and the K'ang-hsi Emperor*.

20 *Veritable Records of Emperor Shengzu [Kangxi]* (*Shengzu shilu* 聖祖實錄), 290:8b–9a, in *Qing shilu* 清實錄 [Veritable Records of the Qing Dynasty] (Beijing: Zhonghua shuju, 1985), 6:822–823. See also Bai Xinliang 白新良, ed., *Kangxi zhuan* 康熙传 [Biography of Kangxi] (Beijing: Xueyuan chubanshe, 1994), 2.

21 For surveys of the Shunzhi reign, see Jerry Dennerline, "The Shun-chih Reign," in *The Cambridge History of China*, vol. 9, pt. 1, *The Ch'ing Empire to 1800*, ed. Willard J. Peterson (Cambridge: Cambridge University Press, 2002), 73–119. See also Fang Chao-ying, "Fu-lin," in *Eminent Chinese of the Ch'ing Period*, ed. Arthur W. Hummel (Washington D.C.: Government Printing Office, 1943), 255–259; Robert B. Oxnam, *Ruling from Horseback: Manchu Politics During the Oboi Regency, 1661–1669* (Chicago: University of Chicago Press, 1975); and Frederic E. Wakeman Jr., *The Great Enterprise: The Manchu Reconstruction of Imperial Order in Seventeenth-Century China* (Berkeley: University of California Press, 1985), 2:894–987.

22 Aspects of the Manchu occupation of China are discussed in Elliott, *The Manchu Way*, 89–132.

influence within the Qing system, especially at the imperial court. Nevertheless, Shunzhi developed a strong interest in Han culture, especially those elements that would enable him to assert a more powerful imperial role. After assuming direct rule in 1651, the inexperienced and hot-tempered youth struggled to establish his personal authority through Han institutions (such as the Hanlin Academy, the examination system for recruiting officials, and the Thirteen Offices of palace eunuchs) and through the patronization of Chinese learning, arts, and religion. His program of increased Sinification met stiff resistance from leading bannermen, who resented any shift in the power balance between the khan/emperor and their own prerogatives as feudal barons. Shunzhi also clashed with his mother, Empress Dowager Xiaozhuang, over his marriages. The emotional stress from these conflicts precipitated what today would be called a nervous breakdown, which was soon followed by the onset of smallpox on February 2, 1661.

When it suddenly became apparent that Shunzhi would die, an heir had to be quickly chosen from among his six surviving sons. The seven-year-old Kangxi was selected over the others by leading bannermen with the support of the formidable Xiaozhuang. It is generally maintained that his acquired immunity to smallpox was an important factor in his favor.[23] On February 4, the day before his father died, Kangxi was named the heir apparent and formally given a Chinese name, Xuanye 玄燁. Xiaozhuang immediately took him to live with her in the Forbidden City, where she carefully raised him with the aid of her grandniece, who was one of Shunzhi's widows, the posthumously styled Empress Dowager Xiaohui 孝惠 (1641–1718).[24] He regarded both women as his parents and he maintained a lifelong devotion to them. Later, he stated that he owed everything to Xiaozhuang, whose political support and guidance at critical points may have instilled in him a tendency toward moderation and stability. After her death in 1688, his filial feelings focused on Xiaohui, who became more influential in her own right. She accompanied Kangxi to the Mountain Estate every summer until her death and is reverently celebrated in the seventh of the Thirty-Six Views.

Both women were the objects of Kangxi's sincere and effusive demonstrations of filial piety, a primary Confucian virtue that he promoted and one that he especially sought to instill in his sons through personal example. In addition to being consulted both here and in the next world, these empresses also appeared to him in dreams at moments of crisis. Unlike

23 Kangxi's original name in Manchu has not been recorded. The Manchu for Xuanye is Hiowan yei. It has been said that Johann Adam Schall von Bell (Tang Ruowang 湯若望, 1592–1666), a German Jesuit missionary serving in the Directorate of Astronomy who earned the confidence of both Shunzhi and Xiaozhuang, convincingly argued that Kangxi's immunity to smallpox made him the superior choice for emperor. Kangxi's elder brother by one year, Fuquan (Fuciowan) 福全 (1653–1703), was blind in one eye, which was considered inauspicious, and his mother's clan had fallen into disfavor at the time. The other brothers were all younger, and their mothers, though Manchu, came from less influential clans than the Tongs. See Bai, *Kangxi zhuan*, 5; and Spence, "The K'ang-hsi Reign," 127–128.

24 Empress Dowager Xiaohui was the grandniece of Xiaozhuang and the second (but virtually ignored) wife of Shunzhi. She remained childless, but she was protected by her great aunt and was raised to the status of empress dowager along with Kangxi's biological mother, Xiaokang, after his accession. For a poem expressing his feelings of filial piety for Xiaohui, see View 7. Opinions vary about her political influence and popularity at the court. See Wu, *Passage to Power*, 35–36.

Shunzhi, Kangxi dutifully married the women who Xiaozhuang helped select for his wives. At age eleven, he took the first of the more than sixty wives whom he would accumulate in the course of his life, and, at age thirteen, he begin to sire the more than twenty sons who survived to adulthood. In addition, he produced eleven surviving daughters and lived to enjoy more than one hundred grandchildren. No other Qing ruler, and few Chinese emperors before or after him, produced such an extensive family.[25]

Because Shunzhi failed to bequeath an effective model of imperial sovereignty before his untimely death, Kangxi was forced from his early years to confront similar political problems.[26] Until Kangxi assumed sole authority at the age of fifteen, the Qing Empire was again ruled by regents—in this case, a group of four senior Manchu bannermen later known as the Oboi Regency after its dominant member.[27] Sometimes acting in conjunction with Xiaozhuang and other times virtually ignoring the palace, the regents reversed many of Shunzhi's policies, especially those regarded as too favorable toward Han Chinese. In a court atmosphere that promoted traditional Manchu virtues, Kangxi was brought up with a strong sense of Manchu superiority. Despite his growing admiration for aspects of Han literati culture, he would remain suspicious of the loyalty of some of his Han subjects, especially those in the south, many of whom continued to harbor deep resentments about the Manchu conquest. Kangxi was not a robust youth. But he strove to strengthen himself physically as he learned to become an expert archer, horseman, and huntsman, thereby developing a deep love of the outdoors as well as the military skills that would enable him to personally command an army one day.

Kangxi was taught to read and write the Manchu language by Lady Sumala 蘇麻喇 (d. 1702), a palace woman attached to his grandmother. Zhang 張 and Lin 林, two older eunuchs who had served in the palace since the last reigns of the Ming dynasty, secretly tutored him in the basic elements of literary Chinese, including the Neo-Confucian *Four Books* (*Sishu* 四書).[28] As he was probably able to communicate in Mongolian as well, he was thus multilingual from childhood. But he did not receive any formal education in literary

25 Kangxi sired some thirty-five sons, twenty of whom are said to have survived beyond the age of ten, and twenty-one daughters, eleven of whom similarly grew to adulthood. In contrast, Shunzhi had nineteen wives. He sired seven sons, four of whom survived beyond childhood, and nine daughters, four of whom survived to adulthood. These figures are based on Bai, *Kangxi zhuan*, 445–451, and include the lower ranks of palace women as imperial wives; still, at least forty of these in Kangxi's case are listed as holding the rank of worthy lady or above. Other sources vary slightly concerning these numbers.

26 Shunzhi's posthumous reputation was damaged by his last testament, which is generally believed to have been forged by his exasperated mother, Empress Dowager Xiaozhuang, and the powerful Manchu bannermen who he had offended. Among the fourteen failures that he supposedly confessed to on his deathbed were: the adoption of Han Chinese customs and the excessive employment of Han officials; the failure to follow the protocols of earlier Manchu rulers; the poor treatment of important bannermen; the neglect of government duties; the wasteful expenditure on constructing palaces; the provocation of discord among his wives; and the display of unfilial behavior towards his mother. See Hummel, *Eminent Chinese of the Ch'ing Period*, 258; Oxnam, *Ruling from Horseback,* 51–63, 205–207; and Spence, "The K'ang-hsi Reign," 125–127.

27 For a study of the Oboi Regency, see Oxnam, *Ruling from Horseback*.

28 Bai, *Kangxi zhuan*, 3, 346.

RICHARD E. STRASSBERG

Chinese. The program of regular lectures and tutorials in the Confucian classics established under Shunzhi had been abolished by the Oboi Regency, and requests by Han officials to formally commence Kangxi's Chinese education were rejected. His officials later stated that he had begun to write compositions in Chinese at age thirteen but that he had to study secretly; he was even forced to suspend his reading at times because Xiaozhuang disapproved.[29] Under these circumstances, whatever knowledge of the Chinese literary tradition that he managed to acquire during these critical formative years fell short of the rigorous preparation that was standard for children of the Han elite, who were being prepared to compete in the official examinations.[30]

Nevertheless, like his father, Kangxi developed a passion for Chinese learning and literati culture. He also recognized that the stability of the Qing dynasty depended on successfully enlisting the cooperation of the Han elite in order to rule over the far more numerous Han population of 130–150 million.[31] But only after 1669—when he finally overthrew the dominant regent Oboi 鰲拜 (d. 1669) and assumed sole power—was he able to freely pursue these subjects. He not only revived the Hanlin Academy, the traditional institution at court for talented scholars, but also gathered more than thirty experts in his private Southern Study in the palace.[32] Members of this select group would serve as his tutors, personal secretaries, confidants, and political and artistic advisors. Talented literati, such as Gao Shiqi 高士奇 (1645–1703), taught him about the finer points of poetry and prose style, the techniques of

29 *Kangxi qijuzhu* 康熙起居注 [Court Diary of the Kangxi Reign], ed. Zhongguo diyi lishi dang'anguan (Beijing: Zhonghua shuju, 1984), 2:1254. She repeatedly argued that he did not need to study Chinese so intensely because he was the emperor and not a candidate for the official examinations. It was also said that Xiaozhuang disliked the Chinese language and tried to prevent younger members of her family from learning it. See Bai, *Kangxi zhuan*, 346. Despite this discouragement, Kangxi managed to read through the basic *Four Books* of Confucianism while young.

30 On Kangxi's early education, see Bai, *Kangxi zhuan*, 34–44, 346–353. He reversed this policy with his own children, who were given a thorough grounding in Chinese language and literature, as were all Qing imperial princes thereafter.

31 The Han Chinese outnumbered the Manchus by about 350 to 1. The generally accepted figures for the population of China proper are 130 million in 1650 and 150 million by 1700. See William Lavely and R. Bin Wong, "Revising the Malthusian Narrative: The Comparative Study of Population Dynamics in Late Imperial China," *The Journal of Asian Studies* 57.3 (August 1998): 719. For statistics on the Manchu and other bannerman population, see Elliott, *The Manchu Way*, 3:363–364. Roughly speaking, at the time of the conquest in 1644, the total Manchu population was 206,000–390,000, and the total bannerman population including Mongols, Han Chinese, and bondservants was 1,300,000–2,450,000. This approximately doubled by the end of the Kangxi reign.

32 The Hanlin Academy began in the Tang dynasty (618–907) as an elite group of scholar-officials who served outside the formal government structure as consultants and personal secretaries to the emperor. By the Ming dynasty, it had become a prestigious government institution with various functions, including the production of official documents, historical records, and other publications. They also provided imperial education through lectures and tutorials, conducted the official examinations, and carried out ad hoc commissions. Kangxi restored the Hanlin Academy's independent status after 1670 and appointed permanent advisors and secretaries from there to his Southern Study after 1677. Some of these individuals, including the seven editors of the *Imperial Poems*, were also advanced to high positions in the government bureaucracy. For a study of the Hanlin Academy during the Qing dynasty, see Adam Yuen-chung Lui, *The Han-lin Academy: Training Ground for the Ambitious, 1644–1850* (Hamden, Conn.: Archon Books, 1981).

calligraphy, and the connoisseurship of painting.[33] The group of seven editors he later assembled to annotate his *Imperial Poems* all served in the Hanlin Academy or the Southern Study at one point or another. Beginning in 1671, when he was seventeen, Kangxi also revived Shunzhi's practice of twice-yearly imperial seminars on the classics well as daily lectures, which were essentially tutorials designed to systematically remedy the gaps in his previous education. The lectures, mostly by scholars from the Southern Study, extended for more than fifteen years, while the seminars continued for the remainder of his life. In addition to requiring similar arrangements for the education of his sons, he maintained a rigorous habit of self-study.

Throughout the course of his long reign, Kangxi was an enthusiastic patron of the arts who diligently practiced calligraphy; composed more than a thousand extant poems, along with numerous prose works; collected rare books, paintings, and other art objects; and patronized the theatre. He did not merely wish to demonstrate how he—a Manchu—possessed the level of competence in Han culture expected of a Chinese emperor. In the process of creating an even more authoritarian form of monarchy, he also sought to configure himself as the supreme arbiter of culture, even representing himself as more accomplished than he actually was.[34] An essential part of his construction of a distinctive Qing imperial identity was his active involvement in promoting intellectual and aesthetic orthodoxy by sponsoring the encyclopedic collection, standardization, and canonization of texts and other sources of information. An ambitious program of imperial publication was carried out that far surpassed in quantity and quality what previous emperors had attempted. Kangxi was intimately involved in many of these projects, which covered a wide range of subjects, including the dissemination of his own prose, poems, and calligraphy. Not only did he personally initiate most of these works, but, in many cases, he also served as the editor, contributing

33 For a biography of Gao Shiqi, see Hummel, *Eminent Chinese of the Ch'ing Period*, 413–415. Gao also served as one of the editors of the imperial anthology, *Poems of Emperor Shengzu [Kangxi] of the Qing (Qing Shengzu yuzhi shi* 清聖祖御製詩, 1703–1716). On Kangxi's calligraphy, see Jonathan Hay, "The Kangxi Emperor's Brush-Traces: Calligraphy, Writing, and the Art of Imperial Authority," in *Body and Face in Chinese Visual Culture*, ed. Wu Hung and Katherine Tsiang Miao (Cambridge, Mass.: Harvard University Press, 2004), 311–334.

34 Many Qing documents, as well as some foreigners, extolled Kangxi as an extraordinary talent while he himself often claimed to have achieved a superior mastery of Chinese literature and art. This has led to an overestimation by some of his actual level of cultural accomplishment. Although his self-creation as an imperial version of a Han literatus represented a considerable achievement and his cultural patronage helped revive a nation still suffering from the disruptive effects of civil war and conquest, his actual intellectual and artistic attainments were more modest. Despite Kangxi's openness to Western culture and his innovations in government, his tastes in matters concerning traditional Chinese culture were largely conservative, and his artistic and scholarly abilities were those of an enthusiastic amateur. Ripa considered him "che quell'uomo di gran mente" (really a man of enlarged understanding), even though he found the emperor's pride in his knowledge of Western mathematics and music to be unjustified. See Matteo Ripa, *Memoirs of Father Ripa, during Thirteen Years Residence at the Court of Peking in the Service of the Emperor of China,* trans. Fortunato Prandi (1844; repr., New York: Wiley and Putnam, 1846), 75–76; and Matteo Ripa, *Giornale (1705–1724)*, ed. Michele Fatica (Naples: Istituto Universitario Orientale, 1996), 2:25. See also Joachim Bouvet, *Histoire de l'Empereur de la Chine (Cang-Hy)* (The Hague: M. Uytwerf, 1699). For an assessment of Kangxi's writings, see Bai, *Kangxi zhuan*, 355–367.

prefaces and even overseeing details of the production process. Many of the reference works that he ordered his expert scholars to compile are still useful today. In some cases, they were probably commissioned to fulfill the needs of his personal program of studies. Compared to most other Chinese emperors, Kangxi's cultural accomplishments and influence were indeed exceptional, especially for a non-Han ruler.[35]

Kangxi's sixty-one-year reign was also the longest in Chinese history. By the time he began the construction of the Mountain Estate, he had established the foundations for an era of peace and prosperity that would endure for more than a century.[36] A key to Kangxi's success as a ruler was his consolidation and extension of imperial power, which enabled him to exercise greater authority over the Eight Banners as well as the other major constituents of the Qing Empire. This also required a more hybridized image of the imperial self that combined the martial virtues of a Manchu khan with the ideological and bureaucratic control of a Han emperor. A principal means by which Kangxi extended his autocracy was through the Imperial Household Department (Neiwufu 內務府), which he expanded into a more direct, personal form of government staffed with loyal bannermen, most of whom were also classified as bondservants (baoyi 包衣; Manchu: booi).[37] Included among the department's many bureaus was the Imperial Printing Office (Xiushuchu 修書處), located in the Hall of Military Glory (Wuyingdian 武英殿) in the Forbidden City. Other bureaus supervised the court artists and the European missionary-experts. Together, members of these groups helped to produce the Imperial Poems. The Imperial Household Department also included the Imperial Parks Administration (Fengchenyuan 奉宸苑), which was charged with the construction and maintenance of residences such as the Mountain Estate.[38]

35 Kangxi's role in imperial publications is discussed in Bai, *Kangxi zhuan*, 249–257, 355–369. For a catalogue and study of these and other Qing imperial publications, see Weng Lianxi 翁连溪, *Qingdai neifu keshu tulu* 清代内府刻书图录 [Illustrated Catalog of Qing Dynasty Imperial Printing] (Beijing: Beijing chubanshe, 2004).

36 The chaos of the transition from Ming to Qing dynasties is discussed in the essays in Jonathan D. Spence and John E. Wills Jr., eds., *From Ming to Ch'ing: Conquest, Region, and Continuity in Seventeenth-Century China* (New Haven: Yale University Press, 1979). For a study of Han resistance to Manchu conquest and rule, see Lynn A. Struve, *Voices from the Ming-Qing Cataclysm: China in Tigers' Jaws* (New Haven: Yale University Press, 1993). The multiple challenges that Kangxi and others in the early Qing Empire faced in reviving China are explored in Lawrence D. Kessler, *K'ang-hsi and the Consolidation of Ch'ing Rule, 1661–1684* (Chicago: University of Chicago Press, 1976); Tobie S. Meyer-Fong, *Building Culture in Early Qing Yangzhou* (Stanford: Stanford University Press, 2003); and Wakeman, *The Great Enterprise*. Only Qianlong held power for a longer period, from 1735 until his death in 1799. However, in 1795, Qianlong formally abdicated after sixty years on the throne in favor of his heir, the Jiaqing emperor 嘉慶 (r. 1796–1820), stating that he did not wish to reign longer than his grandfather.

37 The bondservants were a class of bannermen who were considered the property of powerful Manchu families. More than simply household slaves, some individuals belonging to the imperial family were entrusted with important government positions and exercised significant power. They were considered particularly loyal to their masters and they carried out many functions that had previously been held by eunuchs in the Han Chinese system. The complexities of their status are discussed in Elliott, *The Manchu Way*, 81–84; and Spence, *Ts'ao Yin and the K'ang-hsi Emperor*.

38 For a study of the Imperial Household Department, see Preston M. Torbert, *The Ch'ing Imperial Household Department: A Study of Its Organization and Principal Functions, 1662–1796* (Cambridge, Mass.: Council on

A number of reasons behind Kangxi's decision to build the Mountain Estate have been suggested, but he himself often acknowledged the importance of two sets of events. One was his decisive defeat of the Western Mongol leader Galdan 噶爾丹 (Dga'-ldan, r. 1671–1697) in 1696–1697, and the other was his tours of inspection to the south beginning in 1684.[39] The former consolidated Qing control over the north and northwest and quieted these borders for a generation. Kangxi personally commanded an army for the first time in the final battle against Galdan. His victory was psychologically gratifying, as it allowed him to demonstrate an achievement as a Manchu warrior. Along with the annual joint exercises at the hunting grounds, a permanent imperial residence in Rehe would have enabled the emperor to continue to maintain control over his Mongol allies by allowing him to diplomatically host visiting tribal leaders and to make short tours of inspection throughout the area. Establishing a residence and town midway between Beijing and Mulan also alleviated the logistical problem of gathering and moving huge supplies along with the thousands of people who participated in the annual hunt.

The imperial tours of inspection in the south, on the other hand, were grand public relations spectacles that brought the emperor into contact with the most beautiful areas of China and the finest manifestations of Han culture. The first two tours, in 1684 and 1689, marked the end of effective Han resistance to the Manchu conquest and showcased the success of Kangxi's Sinification policies. Portions of each trip were concerned with such practical matters as inspecting river control projects, agricultural development, and administrative practices as well as interviewing provincial officials and receiving representatives of local society. In addition, he carried out traditional Han imperial rituals, such as making pilgrimages to Mount Tai, the sacred mountain of the east, and paying his respects at the shrine that marked the home of Confucius.[40] There were also ample occasions to visit the many famous landscapes, cities, gardens, and temples of the Jiangnan region. These had long been immortalized as earthly paradises in Han culture, and Kangxi had hitherto only known

East Asian Studies, Harvard University, 1977). The department was established under the regent Dorgon 多爾衮 (1612–1650) in the early years of the Shunzhi reign, but it was abolished in 1654, when Shunzhi assumed control and transferred many of its powers to palace eunuchs in the Thirteen Offices (Shisan yamen 十三衙門). Reestablished under the Oboi Regency to curb the power of the eunuchs, its core group of officials, mostly trusted bondservants, grew under Kangxi from 402 to 939. By the end of his reign, it had accumulated a substantial treasury of some eight million ounces of silver.

39 On Kangxi's southern tours, see Michael G. Chang, *A Court on Horseback: Imperial Touring and the Construction of Qing Rule, 1680–1785* (Cambridge, Mass.: Harvard University Asia Center, 2007); and Joseph Spence, *Observations, Anecdotes, and Characters of Books and Men Collected from Conversation* (Oxford: Clarendon Press, 1966), 124–165. On the campaign against Galdan, see Hummel, *Eminent Chinese of the Ch'ing Period*, 265–268; Millward et al., *New Qing Imperial History*, 99–100; Peter Perdue, *China Marches West: The Qing Conquest of Central Eurasia* (Cambridge, Mass.: Harvard University Press, 2005); and Spence, *Emperor of China*, 17–23.

40 Kangxi made six southern tours, in 1684, 1689, 1699, 1702–1703, 1705, and 1707. For a study of the paintings commemorating Kangxi's 1689 southern tour, see Maxwell K. Hearn, "The Kangxi Southern Tour: A Narrative Program by Wang Hui" (PhD diss., Princeton University, 1990). On Kangxi's pilgrimages to Mount Tai, see Brian R. Dott, *Identity Reflections: Pilgrimages to Mt. Tai in Late Imperial China* (Cambridge, Mass.: Harvard University Press, 2004), 151–180.

RICHARD E. STRASSBERG

of them from literature and paintings or from descriptions by the scholars and officials in his entourage. On these occasions, he enjoyed demonstrating his command of Han literati culture by publicly writing inscriptions; meeting writers, artists, and connoisseurs; viewing operas; and accepting numerous gifts of valuable paintings, rare books, and antiques. The profound influence that these experiences exercised upon his imagination intensified his devotion to the aesthetic aspects of the Han literati lifestyle. Each time, he brought back to Beijing a hoard of treasures, and he subsequently summoned southern architects, garden designers, cooks, painters, actors, and scholars to the capital in order to create a Jiangnan in the north.

The first manifestation of this desire was his construction of the one-hundred-and-fifty-acre Garden of Joyful Spring (Changchunyuan 暢春園, 1687–1860), which became his primary residence in the capital. Begun in 1687, its innovative design prefigured that of the more extensive Mountain Estate and exemplified the innovations of the Qing imperial garden. These changes reflected the Manchu distaste for the ritualized formality of the palaces that they had taken over from the Ming emperors, especially the Forbidden City, which they found particularly oppressive, confining, and unhealthful. Located in a suburb northwest of Beijing where the air and the abundant water were of better quality, Kangxi's new residence transformed a garden formerly owned by a Ming aristocrat that already possessed Jiangnan-style features. With the help of his southern designers, Kangxi created a more private world that evoked the picturesque landscapes he had seen on his southern tours. To demonstrate the frugality that he often took pride in affirming, the architecture deliberately avoided the usual forms of imperial ornamentation. A more open plan asymmetrically situated some thirty villa complexes and pavilions among artificial hills and lakes linked by a network of canals. It dissolved the bifurcated arrangement of a dominant front palace and a rear garden characteristic of many Han Chinese palaces, which were designed to clearly demarcate public and private activities.

This traditional Han design, which had been classically articulated in a set of poems by Emperor Taizong of the Tang 唐太宗 (r. 627–649), enshrined the Confucian moral ideal of the imperial self as a ruler dutifully presiding from the center of the palace over a perfectly ritu-alized government.[41] The Garden of Joyful Spring, on the other hand, embodied a more fluid, hybridized plan that blended the traditional palace and garden areas. This reflected Kangxi's personal desire to dwell in natural surroundings while conducting the dualistic form of government of the Qing. For the more formal audiences required by Chinese protocol, a file of four modest reception halls and flanking offices was located in front. The remainder of the area was flexibly employed for both official and private purposes. Kangxi mainly resided in a

41 See Emperor Taizong's "Imperial Capital Poems" (Dijing pian 帝京篇, ca. 637–ca. 648). For a transla-tion and examination of how these poems formed part of Taizong's construction of his imperial identity, see Jack W. Chen, *The Poetics of Sovereignty: On Emperor Taizong of the Tang Dynasty* (Cambridge, Mass.: Harvard University Asia Center, 2010), 352–376. In a number of respects, Taizong was an important impe-rial model for Kangxi. See one of his earliest poems, "On Reading the *Protocols of the Zhenguan Era*" (Lan *Zhenguan zhengyao* 覽貞觀政要, 1678), in Kangxi emperor, *Kangxi shixuan* 康熙詩選 [Selected Poems of Kangxi], ed. Bu Weiyi 卜維義 and Sun Piren 孫丕任 (Shenyang: Chunfeng wenyi chubanshe, 1984), 1–3.

complex in the rear of the main garden and freely moved among all these scenic spaces like a traveler in a painting, shifting the center of power at will to wherever he located his person. Here, he could meet more informally with the bannermen and Han officials who constituted his personal government, pursue his intellectual studies, and enjoy his art and book collections and the theater. He could also engage in various outdoor activities, such as archery contests. In addition, his residence also contained studios where his court artists—including some of the European missionary-experts, such as Matteo Ripa—worked.[42] Thus, the Garden of Joyful Spring combined a Manchu love of outdoor mobility with the literati vision of a Jiangnan paradise while also including places for more formal imperial functions.[43]

The desire of Manchu rulers to build an estate in Rehe dates to at least 1650, when the regent Dorgon 多爾袞 (1612–1650) announced his intention to construct a small "city in the mountains" (*shancheng* 山城) where he could "escape the heat" (*bishu* 避暑). Expressing his distaste for the unhealthful environment of Beijing, he stated that he wished to emulate earlier non-Han dynasties that had established an Upper Capital (Shangdu 上都) beyond the Great Wall.[44] Dorgon's intention was purely personal: he wished to retire there in comfort and to enjoy private pleasures while delegating the day-to-day affairs of the government to his subordinates back in Beijing.[45] Such a motivation should not be discounted as a primary reason why Kangxi decided to build the Mountain Estate. He offered several justifications in his *Imperial Poems*, but none asserted the necessity of building such an extensive estate for the conduct of government. At the same time, he also sought to preempt the traditional criticism that imperial estates were extravagant indulgences.[46] His poems emphasize that the Mountain Estate was the place above all others where he truly wished to dwell for its natural

42 See Ripa's description of the Garden of Joyful Spring on p. 47. A fifty-acre garden adjacent on the west to Kangxi's garden became the residence of the crown prince Yinreng 胤礽 (1674–1725) and other sons of Kangxi for a while.

43 The Garden of Joyful Spring became the residence of Yongzheng's mother after Kangxi's death and, later, of Qianlong's mother. Yongzheng and his successors resided in the Garden of Perfect Clarity (Yuanmingyuan 圓明園, 1709–1860) just to the north. Both gardens were destroyed by the Anglo-French forces in 1860. For a description and plan of the Garden of Joyful Spring, see Zhou, *Zhongguo gudian yuanlin shi*, 280–284.

44 The Upper Capital (Shangdu 上都) of Kublai Khan (1215–1294), later Emperor Shizu of the Yuan 元世祖 (r. 1279–1294), was known to Europeans since the description of Marco Polo (1254–1324); this Shangdu was later the basis for the "Xanadu" celebrated by Samuel Taylor Coleridge (1772–1834) in his poem "Kubla Khan" (1797).

45 For Dorgon's official announcement dated August 4, 1650, see Wang Xianqian 王先謙, *Donghualu* 東華錄 [Records from the Eastern Flower Gate] (Shanghai: Guangbaisongzhai, 1884), "Shunzhi 7": 3:27ab; and Hummel, *Eminent Chinese of the Ch'ing Period*, 217. The estimated cost was about 2,500,000 ounces of silver, to be obtained from nine Chinese provincial governments. Private donations were also encouraged. But Dorgon died before the project could begin. Manchus and Mongols had many reservations about living in Beijing, especially during the summer, the principal one being their constant fear of contracting smallpox.

46 For a discussion of the literary discourse criticizing palaces beginning in the Zhou dynasty (ca. 1045–221 BCE), see Chen, *Poetics of Sovereignty*, 275–310. Wasting money on the construction of ornate palaces was also the sixth of the fourteen failures that Shunzhi supposedly confessed to in his last testament. See Bai, *Kangxi zhuan*, 7.

beauty and for the invigorating atmosphere that enabled him to nurture his health as he engaged in Confucian self-cultivation.

Beginning in 1677, Kangxi is recorded as traveling to the Rehe area to sacrifice at the imperial tombs, to hold diplomatic rituals with Mongol nobles, and to engage in hunting. In 1681, he reinvented the Qing hunting tradition in the Mulan area, which was presented to him by his Mongol allies at his request. Thereafter, Kangxi regularly journeyed from Beijing to Mulan to attend the autumn hunt. The entourage of thousands included family members, court officials, leading bannermen, Mongol nobles, and various soldiers, guards, and servants. This small army would briefly stop at various imperial camps and lodges along the way.[47] In August 1702, together with the Empress Dowager Xiaohui and seven of his sons, Kangxi toured the future site of the Mountain Estate, which then formed part of what was called the Upper Camp at Rehe (Rehe shangying 熱河上營). Impressed by its scenic location, he issued the order to build the estate, and construction began in October 1703.

When the first phase of construction ended around 1708, most of the basic features of the Mountain Estate had been completed and Kangxi formally bestowed this name on the residence, echoing Dorgon's earlier intention.[48] It was a walled estate, within which two-thirds of the area to the west and north was occupied by low hills, ravines, and creeks. Poetically imagined as mountains, these features sloped down to a broad plateau that had been considerably reshaped by the designers into a Jiangnan-style landscape. Water was diverted from the Rehe (Wulie) River,[49] which ran parallel outside the walls to the east, in order to create connecting lakes on which the emperor could move about in small boats. Most of the villa complexes and pavilions were situated in this lake area in picturesque arrangements beside or near the water. They alluded to, rather than reproduced exactly, some of the famous scenes in the Jiangnan region that Kangxi had observed on his southern tours. The Han Chinese architecture was, likewise, a translation of the southern idiom into a more stolid, rustic style suitable for the northern climate. As he did with the Garden of Joyful Spring outside Beijing, Kangxi emphasized with pride the deliberate avoidance of ornate,

47 Kangxi had a lifelong passion for the hunt; he died after falling ill while hunting in the winter in the Southern Park (Nanyuan 南苑) south of Beijing. It is estimated that Kangxi killed 135 tigers, 20 bears, 25 leopards, 96 wolves, and several hundred deer during his reign; see Elliott and Ning, "The Qing Hunt at Mulan," 69–70, 72.

48 The *Imperially Sponsored Gazetteer of Rehe* (*Qinding Rehe zhi* 欽定熱河志, 1781), later compiled under Qianlong, records that Kangxi first stayed at the Lower Camp at Rehe (Rehe xiaying 熱河下營) in 1702 and that he began staying briefly every year at the Upper Camp at Rehe, which included the area of the modern city of Chengde, after 1703. This continued until 1708, when the name "Rehe Traveling Palace" (Rehe xinggong 熱河行宮), first appears in official documents. This would indicate that the first phase of construction had been completed and that he began to reside at the Mountain Estate after 1708. Despite Kangxi's changing of the name in 1711, many official documents continued to formally refer to the Mountain Estate as the Rehe Traveling Palace. *Qinding Rehe zhi* 13:5b–14:14a. See also Stephen H. Whiteman, "From Upper Camp to Mountain Estate: Recovering Historical Narratives in Qing Imperial Landscapes," *Studies in the History of Gardens and Designed Landscapes* 33.4 (December 2013): 249–279.

49 The Wulie River (Wuliehe), which had a tendency to flood, was originally written as 武列水. The characters were changed to 武烈河 beginning in the nineteenth century. See Chen, *Chengde Bishu shanzhuang Waibamiao*, 2n2.

palace-style decoration at the Mountain Estate. In fact, the cost of constructing and maintaining such a vast estate was by no means negligible, even though he asserted that the funds did not come out of the regular government treasury.[50]

It is common today to divide the Mountain Estate into several distinct zones that suggest an original intention to specifically represent the key regions of the Qing Empire in miniature. But Kangxi did not refer to his estate in precisely these terms.[51] Rather, in describing it to others, he focused on the significance of the primary residential area illustrated in View 2, "A *Lingzhi* Path on an Embankment to the Clouds" (Zhijing yundi 芝逕雲隄). This was a manmade peninsula extending out into the lake that was composed of three separate landforms with villas linked by a narrow path built on top of an embankment. The emperor said that the shape resembled a *lingzhi* 靈芝, a divine fungus with magical medicinal properties, and a *ruyi* 如意, an auspicious, wish-fulfilling wand based on this motif. He further described the three landforms as resembling clouds, which were another way that *lingzhi* leaves were represented on *ruyi* wands. Sometimes, Kangxi referred to the area as Wish-Fulfilling Island (Ruyizhou 如意洲). The predominantly Daoist connotations of this imagery signified one of the major themes expressed in the *Imperial Poems*—that is, the emperor's enhancement of his health and longevity (*yangsheng* 養生) by dwelling in a natural paradise.[52]

Beginning in 1708, Kangxi began to reside at the Mountain Estate every year until his death at the end of 1722. He typically spent between five or six months there, from May through October, while making a few side trips through the Rehe area. The season culminated in the month-long autumn hunt at Mulan in August and sometimes concluded with a celebration of the Mid-Autumn festival in early October at the Mountain Estate before he returned to the Garden of Joyful Spring. Each time, he was accompanied by five to eleven of his sons, together with the Empress Dowager Xiaohui and his favorites from among his many wives. The entire entourage—including servants, civil officials, and soldiers—was estimated to be well over thirty thousand by Matteo Ripa. However, the great majority of the travelers were lodged in the town outside the walls of the Mountain Estate, since the residence was

50 While documentation has not yet come to light that would indicate the cost or financing of the Mountain Estate, it is quite likely that its construction in two phases depended on the amount of resources available to Kangxi at the time. The last major expenditure involved enhancing the surrounding wall in 1713, which occurred after Kangxi confiscated the property of a corrupt official.

51 Both modern Chinese and Western scholars, as well as contemporary tourist literature, often speak of four zones: 1) mountain (representing the Manchu heartland); 2) plains (Mongolia); 3) lake (China proper, especially Jiangnan); and 4) palace (Beijing). While Kangxi referred to parts of the lake area as evoking Jiangnan, he noticeably did not mention the formal audience halls that he later constructed as the "palace" area. Moreover, in his day, what is now called the plains area was used for several purposes, including two small farm patches. See View 35. Qianlong eliminated the farm and redesigned the area. It was renamed the "Garden of Myriad Trees" (Wanshuyuan 萬樹園), and it was used for diplomatic and other political rituals that were held in Mongol yurts. Inner Asian and European delegations—including that of the British envoy Lord George Macartney (1737–1806) in September 1793—were later hosted here.

52 See the preface and illustration to View 2. The villa complexes in Views 2 through 5 are all situated on this peninsula. Kangxi referred to the area as Wish-Fulfilling Island in his preface to the poem in View 30.

RICHARD E. STRASSBERG

generally restricted to members of the imperial family, palace eunuchs, and, sometimes, a few of the European missionary-experts.[53]

Ripa also observed that, while in residence at the Mountain Estate, Kangxi received very few people outside of his inner circle compared to his life in Beijing and that he seemed to spend most of his time relaxing with his family.[54] According to the court diary, on many days there were no official appointments listed. Most government affairs were handled simply with the aid of a few secretaries through palace memorials that were forwarded from Beijing, which was only two or three days away by couriers on horseback. On some days, it is recorded that he just spent the afternoon practicing archery with his sons. Occasionally, a Mongol noble paid a courtesy visit, groups of select officials were hosted for a banquet and short tour of the estate, and holidays were celebrated with guests.[55] The emperor would demonstrate Confucian filial piety by regularly calling on the Empress Dowager Xiaohui at her villa. A considerable amount of time was spent in the company of his favorite wives. Together, they would make excursions by boat to various pavilions, where they might enjoy a picnic or offer sacrifices at one of the many small shrines to various deities. There were small vegetable and melon patches where he could observe farming as well as places where he could fish, engage in equestrian activities, and hunt small animals. Kangxi could also pursue his intellectual hobbies, such as studying, practicing calligraphy, editing imperial publications, and writing poems and prose. He could hike among the hills, view the scenery, and experience reclusive moments of quiet introspection. This last group of activities constituted the ideal life of leisure and self-cultivation enjoyed by Han literati in their gardens and, thus, they are the main focus of the *Imperial Poems*.

From time to time, small groups of selected high officials were invited to visit the estate as a reward. These privileged guests were briefly admitted according to rigid protocols and were usually treated to a banquet with entertainment and a short tour through selected areas of the estate at mid-day before being escorted back outside. A unique account of two such occasions—on July 28 and August 14, 1708—was composed by Zhang Yushu 張玉書 (1642–1711), a talented Hanlin Academy scholar who rose to the position of grand secretary and was one of Kangxi's most trusted Han officials. Zhang described the itinerary followed by his group, which divided into high-ranking bannermen and Han officials. He also listed sixteen views that Kangxi had named by that time.[56] This would suggest that the additional

53 Matteo Ripa, *Memoirs of Father Ripa* (1846), 78; and Matteo Ripa, *Giornale (1705–1724)*, ed. Michele Fatica (Naples: Istituto Universitario Orientale, 1996), 2:31. Ripa noted that the escort of soldiers alone numbered thirty thousand when he and four other European missionaries serving at the court were ordered to accompany the emperor to the Mountain Estate in 1711.

54 See Appendix 2.

55 For a sample of Kangxi's official activities at the Mountain Estate, see the entries in the court diary for the fifty-third year of the Kangxi reign (1714), from the beginning of the fifth lunar month (mid-June) to the middle of the ninth month (late October) in *Kangxi qijuzhu*, 3:2088–2116; also *Qinding Rehe zhi* 14:10b–11a.

56 Zhang was one of the initial chief editors of the *History of the Ming Dynasty* (*Mingshi* 明史, 1679–1777), *Imperial Prose by Emperor Shengzu [Kangxi] of the Qing* (*Qing Shengzu yuzhi wen* 清聖祖御製文, 1711–1732), *A Treasury of Rhymes for Ornamenting Literature* (*Peiwen yunfu* 佩文韻府, 1711), and the *Kangxi Dictionary* (*Kangxi zidian* 康熙字典, 1716). The Chinese text of his account of his visit was reprinted in Zhang Yushu

sites that comprise the Thirty-Six Views of the *Imperial Poems* were named by 1711, when the second phase of construction was completed. By that year, Kangxi had added a file of reception halls and offices in the front section of the garden to the south. This arrangement was similar to that of the Garden of Joyful Spring, as it likewise created a separate space for more formal, official functions. Today, this space is often referred to as the palace area, even though Kangxi neither referred to it as such nor included the halls in his Thirty-Six Views.[57]

In 1711, preparations were already underway to celebrate Kangxi's sixtieth birthday in 1713.[58] The completion of a sixty-year cycle normally marked a significant milestone in a person's life, a time of joyful acknowledgement of one's accomplishments as well as a recognition of entering one's senior years. After some fifty years on the throne, Kangxi had every reason to feel confident that he had resolved the major challenges that had faced the Qing dynasty. And with the completion of the Mountain Estate, he had realized his most monumental artistic project. In commissioning the *Imperial Poems*, his primary motivation was no doubt commemorative, for it offered him the opportunity to articulate a vision of his estate as a grand projection of his style of imperial sovereignty. Yet, ironically, at what would seem to have been the appropriate moment for celebrating success and expressing satisfaction, the crisis over the succession to the throne had already erupted within his family and spread far beyond the court.

張玉書, "Hucong ciyou ji" 扈從賜遊記 [Record of Touring the Rehe Rear Garden at Imperial Invitation], in *Dongbei shizhi: 1* 东北史志 [Historical Records of the Northeast: 1], in *Zhongguo bianjiang shizhi jicheng* 中國邊疆史志集成 [A Collection of Historical Records of China's Frontier Regions] (Beijing: Quanguo tushuguan wenxian suowei fuzhi zhongxin, 2004), and is translated here in Appendix 3. For a biography, see Hummel, *Eminent Chinese of the Ch'ing Period*, 65–66.

57 The reception hall and offices were built directly in front of the villa complexes Misty Ripples Bringing Brisk Air (Yanbo zhishuang 烟波致爽) (View 1) and Scenes of Clouds and Mountains (Yunshan shengdi 雲山勝地) [View 8]. See Chen, *Chengde Bishu shanzhuang Waibamiao*, 24, for a plan. Now called the "palace" area, these buildings were originally more modest and rustic in design in keeping with Kangxi's aesthetic. Under Qianlong, they were rebuilt in 1754, and the main reception hall, Tranquil and Dispassionate, Reverent and Sincere (Danbo jingcheng 澹泊敬誠), was renovated into a more impressive edifice with rare *nanmu* 楠木 wood for the pillars. In addition, Qianlong built the Studio of Pines and Cranes (Songhezhai 松鶴齋) in a similar style next door, in front of Pine Winds through Myriad Vales (Wanhe songfeng 萬壑松風) (View 6), for his mother and wives in 1749. He also erected another impressive complex further east, the East Palace (Donggong 東宮), which contained a three-story theater. The area was thus transformed into something far grander, prompting a modern scholar's observation that Qianlong's Mountain Estate conformed more to the traditional Han Chinese plan of a "front palace and rear garden" (*qiangong houyuan* 前宮後苑). See Zhou, *Zhongguo gudian yuanlin shi*, 394. This somewhat obscures how Kangxi designed the "rear garden" as a multifunctional space for both official and private activities and reduced the scale of his formal reception halls relative to the other villa complexes. A more appropriate characterization of the basic design of this and other Qing imperial gardens as a "unification of palace and garden" (*gongyuan heyi* 宮苑合一) appears in Meng Zhaozhen 孟兆祯, *Bishu shanzhuang yuanlin yishu* 避暑山庄园林艺术 [The Garden Artistry of the Mountain Estate for Escaping the Heat] (Beijing: Zijincheng chubanshe, 1985), 14.

58 His birthday was formally celebrated in Beijing on April 12, 1713. The handscroll *The Birthday Celebration of the Kangxi Emperor* (Wanshou shengdian tu 萬壽盛典圖), which depicted the elaborate procession from the Forbidden City to the Garden of Joyful Spring, was produced under the direction of the court painter Wang Yuanqi 王原祁 (1642–1715) and published as a series of 148 woodblock plates in 1715–1717. See Weng, *Qingdai neifu keshu tulu*, 197.

RICHARD E. STRASSBERG

Kangxi had sought to avoid the problems that he and his father experienced when they assumed power.[59] To consolidate authority and reduce the influence of senior Manchu bannermen, Kangxi, at the age of twenty-one, established as crown prince his eighteen-month-old second son Yinreng 胤礽 (1674–1725) on January 27, 1676, in accordance with Han protocol. Another reason for this decision may well have been the deep love he felt for the boy's mother, Empress Xiaocheng 孝誠 (1654–1674), who had died while giving birth to him.[60] It was also a timely moment for Kangxi to accelerate his broader program of Sinification. The Qing Empire was then under serious military threat from the rebellion of the Three Feudatories and other uprisings, and trusted officials advised naming a crown prince as one of the ways to muster support among the Han population.

Despite playing an active role in the education of Yinreng and his other sons, Kangxi was unable to prevent the formation of a corrupting faction that surrounded the young crown prince. As Yinreng grew to adulthood and was increasingly given government responsibilities, it became apparent that he commanded an entrenched group of supporters who abused their authority. Yinreng himself was widely regarded as cruel, erratic, and dissolute. Kangxi had, in fact, directly enabled the growth of the crown prince's authority over a period of several decades, as he had originally intended to retire, like Emperor Gaozong of the Southern Song 宋高宗 (r. 1127–1162), and to turn over the government to his heir. For many years, Kangxi ignored the negative reports that were brought to his attention by loyal informants—even though Yinreng's personality and notorious activities clearly indicated that he was unfit to rule. Even after ordering his own secret investigations of various allegations, Kangxi delayed taking action when the worst was confirmed. Years later, the emperor recalled with regret that he had let sentiment for his son and his deceased empress override his judgment and that he had placed too much hope in his attempts to reform Yinreng's character.

59 The accessions of each of Kangxi's three predecessors had not followed a consistent protocol, thus revealing the unresolved differences between traditional Manchu and Han practices. Primogeniture was not a practice in either culture. Nurhaci 努爾哈赤 (r. 1616–1626) achieved dominance as khan over the other Manchu chieftains through military means but died without naming an heir. His eighth son, Hong Taiji 洪太極 (aka Abahai, r. 1626–1643), defeated his rival brothers and later proclaimed himself first emperor of the Qing. He, too, died without designating an heir, so his ninth son Fulin was enthroned at age five as the Shunzhi emperor by a state council. Han protocol, however, stipulated that the emperor establish a crown prince, who could only be the son of an empress. Although Shunzhi named Kangxi his heir on his deathbed, the latter's accession was unexpected and primarily arranged by a group of senior bannermen and the Empress Dowager Xiaokang. The rise of Nurhaci and Hong Taiji is discussed in Crossley, *A Translucent Mirror,* 135–215.

60 Wu, *Passage to Power,* 31. The marriage of Kangxi and the eleven-year-old Empress Xiaocheng 孝誠 in 1665 represented a victory for Empress Dowager Xiaozhuang and the supporters of the palace against the dominant regent Oboi. Xiaocheng was the granddaughter of one the more independent regents, Sonin 索尼 (1601–1667), and was chosen over Oboi's candidate. Her father was chamberlain of the Imperial Bodyguards, and her uncle Songgotu 索額圖 (1636–1703), another son of Sonin, later aided Kangxi in the overthrow of Oboi. Kangxi was genuinely in love with her and felt her loss deeply. He subsequently raised two other wives to the rank of empress but both died soon afterwards. Thereafter, he refused to create any other empresses, no doubt fearing that this might give an advantage to any of their sons in any rivalry for the succession.

Opposition to the crown prince eventually grew so intense that Kangxi could no longer afford to ignore it, and, by 1697, he had changed his mind about abdicating. As Kangxi's suspicions grew, the relations between him and the crown prince deteriorated. Songgotu 索額圖 (1636–1703), Yinreng's grand-uncle and an influential supporter, was discovered to be plotting a coup d'état to force Kangxi into abdicating, and he was purged in 1703.[61] Sensing the vulnerability of the crown prince's position, several of his ambitious brothers—with the help of their own supporters—began to conspire against him, thus exposing deepening rifts within the imperial family. As Yinreng grew increasingly frustrated, resentful, ill-tempered, and fearful, he began to spy on Kangxi at night, causing the emperor to fear assassination. A number of other disturbing events combined to convince Kangxi that the time had come to act decisively to preserve the Qing dynasty. Things came to a climax at the end of the first summer spent at the Mountain Estate. On October 15, 1708, on the way back to the capital, Kangxi assembled his entourage and, in a violently emotional scene, suddenly deposed Yinreng as crown prince, ordering Yinreng chained and later placed under house arrest.

Kangxi was torn by guilt and remorse as soon as he removed Yinreng. He began to observe all kinds of evil omens. The spirit of Empress Dowager Xiaozhuang appeared to him in a dream aggrieved by his treatment of Yinreng. The emperor fell seriously ill from the stress and his health began an irrevocable decline. The seismic shift at court now sent shock waves to the other centers of power throughout the country, as many were obliged to recalculate their allegiances. Yinreng's supporters tried to convince Kangxi to restore him, and several of Kangxi's more ambitious sons, who had been secretly positioning themselves, now publicly emerged as alternative heirs. The eldest son Yinti 胤禔 (1672–1734) suggested to Kangxi that Yinreng could easily be done away with; he was exposed by the third prince Yinzhi 胤祉 (1677–1732) for hiring lamas to place a curse on the former crown prince. The eighth prince Yinsi 胤禩 (1681–1726) began to actively promote himself with the help of Kangxi's eldest son and a clique of influential courtiers who pressured the emperor into appointing him. But he was soon discovered to be in collusion with a fortune-telling physiognomist to murder Yinreng. Both Yinti and Yinsi were imprisoned and some of their supporters were punished. Other sons who were suspected of sympathizing with them were also arrested, and the physiognomist and lamas were summarily executed.

Whether Kangxi succumbed to genuine remorse or realized that he had precipitated an even worse situation than had existed previously, he soon relented and reinstated Yinreng on April 19, 1709, announcing that the crown prince had been rendered temporarily insane but had now completely recovered. Kangxi kept the restored crown prince under close scrutiny in the vain hope that he could restrain him from his previous excesses and improve his character. But Yinreng chafed under this new regime, and he and his reconstituted faction returned to their former ways. Once again, the emperor began to receive negative reports from his informants, but he turned a blind eye for several years, alternately appeasing Yinjeng and occasionally purging some of his more flagrant supporters. When another

61 After Kangxi's investigation, Songgotu and his followers were removed. He was imprisoned in 1703 and died soon after. See Wu, *Passage to Power*, 77–80.

plot to dethrone him by Yinreng's faction was uncovered, Kangxi was at last forced to acknowledge the complete failure of his plans for the succession. It was in the midst of these events that Matteo Ripa arrived in Beijing on February 5, 1711, to begin his career as an artist at the Qing court. On October 29, 1712, Yinreng was deposed for the second and final time in an angry scene that took place in the Garden of Joyful Spring, after Kangxi and his entourage returned from the Mountain Estate. This scene was witnessed by Ripa, among others. Thereafter, Kangxi abandoned his attempts to follow Han protocol, thus refusing to name a successor until a few hours before his death ten years later.[62]

This dramatic crisis over the succession played out during the period when the Mountain Estate was being completed and the poems were being compiled and published. Kangxi fell seriously ill on several occasions, especially after removing Yinreng for the second time. No doubt, this was also brought on by the humiliation of having to twice acknowledge to the court, the imperial ancestors, and the entire nation that he had failed as a Confucian father to govern his own family. Despite his weakening health, the emperor felt compelled to continue actively ruling in order to restrain the continuing rivalries among his more ambitious sons and their factions. It is possible, therefore, to see a deeper sense of urgency underlying the creation of the *Imperial Poems*, especially since this book was primarily intended for his extended family and inner circles. Despite its overall presentation of a contented, successful sovereign pursuing an ideal life of leisure, such themes as his need to sustain his vitality, his concern over aging and mortality, his demonstrative expressions of filial piety, and his continuing commitment to ruling take on added significance. With the growing divisions within his family and a more partisan atmosphere spreading throughout his court, issuing a literary self-portrait that reasserted his patriarchal authority was a timely act.

In the winter of 1708, when the struggles over the succession began to erupt and Kangxi fell gravely ill, he feared he might die and began drafting his own last testament. The emperor had always been skeptical of official historical accounts of past rulers, and he was well aware of how last testaments were usually issued by others at court for their own political purposes as an emperor lay dying. Over a period of a decade, he continued to revise this statement, which contained autobiographical reflections as well as his guidelines for ruling. It was finally issued on December 23, 1717, when he again fell seriously ill and summoned a large

62 These events are narrated in detail in Wu, *Passage to Power*. For biographies of Yinreng and the other important princes, see Hummel, *Eminent Chinese of the Ch'ing Period*, 915ff. Ripa's recollection of the scene when the crown prince was removed for the second time was recorded in Ripa, *Memoirs of Father Ripa*, 96; and Ripa, *Giornale (1705–1724)*, 2:90–91. The political consequences of the power struggles among Kangxi's sons persisted during the final decade of Kangxi's life and continued well into the Yongzheng and Qianlong reigns. Under Yongzheng, several of the brothers were severely punished and died after being arrested, and widespread purges over the years sought to root out their remaining supporters. Even Kuixu 揆叙 (ca. 1674–1717), the chief editor of the *Imperial Poems*, was posthumously deprived of his titles in 1724 because he had attended a meeting in 1708 that sought to pressure Kangxi into appointing the eighth prince Yinsi as heir apparent. See Hummel, *Eminent Chinese of the Ch'ing Period*, 430. Some of Kangxi's own reflections on Yinreng and his other sons are translated in Spence, *Emperor of China*, 115–139.

group—including his sons and leading officials—to the Forbidden City to hear it read.[63] No other emperor before him had sought to exercise such a degree of control in creating an image for posterity or had employed such a wide range of media for doing so throughout his reign. Ultimately, he was successful in transmitting the throne to the fourth prince, Yinzhen 胤禛 (1678–1735), who reigned as the Yongzheng emperor. But it was his grandson Qianlong who firmly established the image of Kangxi as the primary dynastic patriarch in the course of asserting his legitimacy and defining his own style of authority. Kangxi's preeminent role in the Qing imperial lineage was further confirmed a century and a half after his death, when the influential statesman Zeng Guofan 曾國藩 (1811–1872) wrote that it was Kangxi who had consolidated the Qing dynasty's foundation resulting in a direct line of six emperors up to that point. Zeng only regarded the heroic King Wen of the Zhou 周文王 (r. ca. 1099/1056–1050 BCE) as comparable in China's long history.[64]

The *Imperial Poems on the Mountain Estate for Escaping the Heat* seems to have begun to take shape sometime during 1711. By then, Kangxi had selected some of his many poems to comprise thirty-six views. The court artist Shen Yu 沈喻 (1649–after 1728) probably began his work on the illustrations along with the chief engravers Zhu Gui 朱圭 and Mei Yufeng 梅裕鳳 (both fl. 1696–ca. 1713). In August of that year, Kangxi composed the "Imperial Record of the Mountain Estate for Escaping the Heat" (Yuzhi Bishu shanzhuang ji 御製避暑山莊記), a commemorative account similar to one he had written earlier after building the Garden of Joyful Spring.[65] It is not until a year later, however, that the book begins to be mentioned in the Manchu memorials exchanged between Kangxi and General Work Supervisor Hesu 和素 (1652–1718) who, along with several others in the Imperial Printing Office, supervised the production process.[66] These documents reveal some of the technical complexities involved in imperial publications as well as Kangxi's close involvement in even the smallest details.[67]

63　Meng Zhaoxin 孟昭信, *Kangxi dadi quanzhuan* 康熙大帝全傳 [A Complete Biography of the Great Emperor Kangxi] (Changchun: Jilin wenshi chubanshe, 1987), 584–587. For an English translation, see Spence, *Emperor of China*, 142–151.

64　Meng, *Kangxi dadi quanzhuan*, 588. Ten emperors, beginning with Shunzhi, ruled in direct succession after the Qing conquered China. The last two Qing emperors, Guangxu 光緒 (r. 1875–1908) and Xuantong 宣統 (r. 1908–1911), were also descendants of Kangxi.

65　Kangxi's "Imperial Record of the Garden of Joyful Spring" (Yuzhi Changchunyuan ji 御製暢春園記) was reprinted by Qianlong in the imperially sponsored *Historical Information about the Capital with Additional Research* (Rixia jiuwen kao 日下舊聞考, 1785–1787). For the text, see Yu Minzhong 于敏中 et al., eds., *Rixia jiuwen kao* 日下舊聞考 [Historical Information about the Capital with Additional Research] (Beijing: Beijing guji chubanshe, 1981), 2:1268–1270.

66　For a biography of Hesu, see Hummel, *Eminent Chinese of the Ch'ing Period*, 281. He was considered one of the most talented Manchu translators of his time and held various high posts. In addition to tutoring some of Kangxi's sons in Manchu and Chinese and authoring several important bilingual imperial publications, he was in charge of the Manchu-Chinese Translation Office in the Hall of the Military Glory. In 1712, he was also made Grand Secretariat Academician Reader-in-Waiting. In the postscript to the *Imperial Poems*, he is listed first among the four officials in the Hall of Military Glory in charge of the production process.

67　The production of the *Imperial Poems* is recorded in some twenty-three Manchu memorials, part of a large number that have been translated into Chinese in Guan Xiaolian 关孝廉 and Qu Liusheng 屈六生,

　RICHARD E. STRASSBERG

They also show that the final form of the *Imperial Poems* evolved considerably during the process. The memorial—dated August 23, 1712—reported that the first samples of the Chinese text would be ready for the emperor's approval in a week and suggested that fifty engravers be employed for the task. After inspecting the samples, Kangxi had five wrong characters corrected and ordered that two hundred copies be printed. Engraving the woodblock illustrations, however, proved more troublesome. It was reported to the emperor on September 7 that there were not enough dry woodblocks available and that Zhu Gui and Mei Yufeng would each require twenty days to engrave a single image. It was then recommended that extra engravers be added to speed up the project.

The *Imperial Poems* was originally written in Chinese. It seems that the decision to produce a Manchu version and to include the "Imperial Record of the Mountain Estate for Escaping the Heat" as a preface occurred later. Not until on July 14, 1713, did Kangxi order the Chinese text of the poems, along with the "Imperial Record," to be translated into Manchu by his official translators in the Hall of Military Glory. As it is clear that he proofread their results, the final Manchu text can be considered a collaborative effort. Two days after ordering the Manchu translation, Kangxi also forwarded the Chinese text of the "Imperial Record" and ordered that it be quickly engraved and included at the beginning of the book. Meanwhile, it also appears that a later part of the Chinese text was only sent to the Imperial Printing Office on July 19.

The Manchu version was ready to be engraved by August 16, when General Work Supervisor Bashi 巴實 (fl. early eighteenth century) requested permission to proceed. Kangxi agreed and ordered that two hundred copies of the Manchu version be printed, the same number as the Chinese version. The memorials further indicate that the *Imperial Poems* was printed and bound in various formats using different kinds of paper, including a variety imported from Europe. The books were issued from time to time in small numbers, ranging from just one to as many as thirty. Kangxi indicated both his impatience to receive the copies as well as his praise for the results. Yet another interesting aspect of the memorials is the humble request by Hesu that his name and those of the other principal work supervisors be added at the end of the postscript, an indication of the prestige associated with participating in this project.[68] The last mention of the *Imperial Poems* in these memorials is on October 21, 1713, when thirty copies of the Manchu version were reported printed and bound. Still, the entire project cannot be considered to have been completed until the following year. On April 24, 1714, Matteo Ripa recorded in his journal that he finished printing and binding the copperplate engravings. Seventy volumes of these were presented to Kangxi, who praised them as "treasures."[69]

eds., *Kangxi chao manwen zhupi zouzhe quanyi* 康熙朝滿文朱批奏折全译 [Complete Translations of the Manchu Memorials with Imperial Comments during the Kangxi Reign] (Beijing: Zhongguo shehui kexue chubanshe, 1996). These are found between no. 1993 and no. 2284 and date from July 23, 1712, through October 3, 1713. However, the process may have begun earlier and did not end until Ripa's copperplate engravings were completed on April 24, 1714.

68 See Appendix 1, note 2. In addition to the editors and work supervisors, Shen Yu, Zhu Gui, and Mei Yufeng were also given credit in the publication in a cartouche within the illustration to View 36.

69 Ripa, *Giornale (1705–1724)*, 2:136.

Like the design of the Mountain Estate, the *Imperial Poems* is an innovative, encyclopedic assemblage of elements. The book's conception is fundamentally indebted to a long tradition of Chinese garden literature and painting, especially poems and prose accounts by owners who presented their gardens as self-portraits.[70] From the late Ming period (ca. 1570–1644) onward, lengthier works (including some with illustrations) as well as theoretical treatises and aesthetic criticisms of gardens increasingly appeared.[71] It is quite possible that Kangxi was also inspired by engraved views of royal palaces in some of the European books in his collection. But the exact models for Kangxi's book remain unknown. Certainly, there was no precedent for such a work among previous imperial publications. The *Imperial Poems* brings together the "Imperial Record," which is an imperial version of a garden account (*yuanji* 園記), together with the thirty-six short poetic prefaces (*xu* 序) written in ancient-style prose (*guwen* 古文) that contain the kind of comments found in the travel account (*youji* 遊記), art and literary criticism, and miscellaneous writings (*biji* 筆記). The poems themselves are written in ten different genres that manifest Kangxi's extraordinary creative ambition, which was well beyond what even great poets attempted.[72] The abundant interlinear annotations (*zhu* 注) and the postscript (*ba* 跋) added by the editors along with the two sets of illustrations (*tu* 圖) further render this book unique in Chinese literary history.

As a summary self-portrait, Kangxi's text can be seen as an aggregate of various literary personae framed by a "master persona." This master persona is the author's most formal and imperial self. It is enunciated in the "Imperial Record" at the beginning of the book, reiterated within many of the individual poems, and effusively praised in the final "Postscript" by the editors. The "Imperial Record" itself is written in a euphuistic, courtly style of parallel prose (*pianwen* 駢文) that descends from the ancient rhapsody (*fu* 賦) of the Han dynasty

70 For anthologies of garden literature, see Chen Zhi 陈植 and Zhang Gongchi 张公弛, eds., *Zhongguo lidai mingyuan ji xuanzhu* 中国历代名园集选注 [Annotated Anthology of Records of Famous Historical Gardens in China] (Hefei: Anhui kexue jishu chubanshe, 1983); and Zhao Houjun 赵厚均 and Yang Jiansheng 杨鉴生, eds., *Zhongguo lidai yuanlin tuwen jingxuan* 中国历代园林图文精选 [Selected Literature and Images of Historical Gardens in China] (Shanghai: Tongji daxue chubanshe, 2005).

71 For an example by the late Ming literatus Qi Biaojia 祁彪佳 (1602–1645) about his garden, Allegory Mountain (Yushan 寓山), see Duncan Campbell, "Qi Biaojia's 'Footnotes to Allegory Mountain': Introduction and a Translation," *Studies in the History of Gardens and Designed Landscapes* 19, nos. 3–4 (July–December 1999): 243–275. Autobiographical garden literature became so fashionable after the mid-fifteenth century that some literati who could not afford to possess a garden nevertheless produced similar writings about imaginary gardens of their own as vehicles for exploring their selves. See Ellen Widmer, "Between Worlds: Huang Zhouxing's Imaginary Garden," in *Trauma and Transcendence in Early Qing Literature*, ed. Wilt Idema et al. (Cambridge, Mass: Harvard University Press, 2006), 249–281; and Wai-yee Li, "Gardens and Illusions from Late Ming to Early Qing," *Harvard Journal of Asiatic Studies* 72, no. 2 (2012): 295–336.

72 The ten poetic genres and corresponding poems are: 1) pentasyllabic extended regulated verse (*wuyan pailü* 五言排律) (Views 1 and 9); 2) heptasyllabic ancient-style verse (*qiyan gushi* 七言古詩) (View 2); 3) heptasyllabic regulated verse (*qiyan lüshi* 七言律詩) (View 3); 4) heptasyllabic quatrain (*qiyan juejü* 七言絕句) (Views 4, 6, 8, 10, 11, 12, 13, 15, 16, 19, 22, 27, 31, 33, and 34); 5) pentasyllabic ancient-style verse (*wuyan gushi* 五言古詩) (View 5); 6) pentasyllabic quatrain (*wuyan juejü* 五言絕句) (Views 7, 17, 24, 25, 30, 35, and 36); 7) aria (*qu* 曲) (Views 18, 23, and 26); 8) six-syllable quatrain (*liuyan juejü* 六言絕句) (View 28); 9) pentasyllabic regulated verse (*wuyan lüshi* 五言律詩) (Views 14, 20, 21, and 29); and 10) six-syllable regulated verse (*liuyan lüshi* 六言律詩) (View 32).

(206 BCE–220 CE).[73] The emperor begins by locating the Mountain Estate within a space that is geomantically perfect and cosmically balanced. A nurturing, terrestial artery connects the site with Gold Mountain (*Jinshan* 金山), a powerful point in the Manchu heartland to the north. This representative of "mountains" (*shan* 山) is complemented by its bipolar opposite, "water" (*shui* 水), in the form of the Wulie River with its hot springs. Together, they form an ideal *shanshui* 山水, or "landscape," conjoining heaven and earth where the forces of yin and yang are in harmony.[74]

Kangxi emphasizes the pristine naturalness of the location as the basis of his choice to reside here, describing the site as encompassing all the elements of creation in a state of vitalistic animation. He points out that his construction of the estate maintained this purity by following an aesthetic of rustic simplicity that accords with the inherent disposition of the landscape; he also notes that the site was originally unpopulated. These last statements seek to preempt the traditional criticism leveled against emperors for building extravagant palaces that weakened the state and brought economic hardship to the common people.[75]

In his effort to legitimize his construction of the Mountain Estate and to justify spending half the year away from the capital, Kangxi conceals his desire to dwell peacefully in a private sphere in the "Imperial Record." A Confucian ethical discourse predominates as he notes that the estate is located close to the capital and that he is always mindful of the essential concerns of government while residing here. This culminates in the assertion that his engagement with nature is only for the purpose of moral self-cultivation—that is, he claims that he does not respond to the flowers, trees, or waters in order to experience lyrical emotions, or to find inspiration for artistic creativity, or even to nurture his vitality. Rather, he only reads these things as symbols of the virtues of a sagely ruler in accordance with the practice of ancient worthies. As a representation of Kangxi's most public image, the "Imperial Record" functions in the design of the book like the front palace halls of the Mountain Estate. It enunciates a ritualistic emplacement of his master persona as the ascetic, public-minded Son of Heaven who sincerely strives to maintain a stable cosmic order. This overarching identity stands in contrast to the shifting personae in the individual poems, where more personal, even reclusive emotions are expressed.

The thirty-six poems and prefaces shift the focus to a sequence of individual vignettes of the landscape that serve to mirror aspects of the self. Kangxi mostly appears in these as a solitary, wandering poet who guides the reader on a visionary journey through the Mountain

73 Some of the canonical examples in this genre celebrated vast imperial hunting parks by descriptively cataloging their abundant contents, representing the emperor's supremacy through his collection of a multitude of things within a microcosm. See, for example, "Rhapsody on the Shanglin Park" (Shanglin fu 上林賦) by Sima Xiangru 司馬相如 (ca. 179–ca. 118 BCE). Translated in Xiao Tong, ed., *Wen xuan, or, Selections of Refined Literature* (Princeton, N.J.: Princeton University Press, 1986–1992), 2:73–114.

74 For a discussion of the location of Gold Mountain, see Stephen H. Whiteman, "Kangxi's Auspicious Empire: Rhetorics of Geographic Integration in the Early Qing," in *Chinese History in Geographical Perspective*, ed. Du Yongtao and Jeffrey Kyong-McClain (Lanham, Md.: Lexington Books, 2013), 34–54.

75 On the discourse and ideological issues surrounding the emperor's construction of palaces, see Chen, *The Poetics of Sovereignty*, 267–310. Wasting money on palaces was one of the fourteen failures that Kangxi's father, Shunzhi, supposedly confessed to in his last testament.

Estate, now represented as a Han literati garden. He traces a purely imaginary itinerary that no visitor would have actually followed from beginning to end, for following it would require unnecessary backtracking over a wide area.[76] Nevertheless, the sequence of views reveals a definite aesthetic pattern similar to the narrative structure of a Chinese landscape handscroll. There is an entry into the estate (Views 1–5) that privileged guests, such as Zhang Yushu, would have used when they began their brief official visits. Then, there is a section of views that present various themes, personae, and moods that form an alternating rhythm of yin and yang (Views 6–17). The climax occurs in the middle of the sequence at View 18, when Kangxi climbs to the top of a pagoda dedicated to the Supreme God (Shangdi 上帝). Here, near the boundary of heaven, he gains a panoramic, "grand view" (*daguan* 大觀) of the entire Mountain Estate and observes with satisfaction that the world is in a perfect state of animation. Following this peak experience, he returns to more terrestrial levels in a subsequent section (Views 19–35) that complements the previous sequence (Views 6–17) with additional alternating scenes. Kangxi's literary tour through his garden finally concludes with a fade-out at View 36. Alone in a small pavilion by a lake, he ponders his advancing age in a somber mood that solicits empathy—in contrast to the triumphal master persona of the "Imperial Record." These multiple personae, disclosed through the sequence of poetic views, invite the reader to observe aspects of Kangxi's imperial identity as it unfolds diachronically. When considered together, these two complimentary self-portraits are designed to form a kaleidoscopic, yet coherent figure of the self.

Kangxi's artistic strategy of simultaneously presenting both his public and private sides rewrote the canonical Han Chinese representation of imperial sovereignty articulated by Emperor Taizong of the Tang in his "Imperial Capital Poems" (Dijing pian 帝京篇, ca. 637–ca. 648).[77] In this cycle of ten pieces (including a preface), Taizong recorded a circuit that he followed in his Brilliant Palace (Daminggong 大明宮) in the course of a single day. The preface avows his dedication to governing and moral self-cultivation, expresses disapproval of extravagant palaces, and rejects leisure. The poems then trace his departure from the palace halls in front and describe how he proceeds to roam among various pavilions in the rear garden. These scenes incrementally invoke an atmosphere of wandering among the seductive southern landscapes of the Jiangnan region, as the emperor increasingly strays from his public persona. When he returns to the palace, his surrender to sensual pleasure reaches an apogee as he feasts and enjoys women. Then, in the final poem, he abruptly renounces these activities and reaffirms a singular dedication to ruling. In Taizong's formulation, imperial identity is bifurcated into exclusive aspects. In accordance with the archetypal mechanics of

76 The *Imperial Poems* has sometimes been misunderstood by later readers as a practical guidebook, but it is unlike the one that Louis XIV composed for visitors to Versailles. As Zhang Yushu's account indicates, the privileged visitors to the Mountain Estate were not free to wander around but, following a reception, were taken on short tours that included just a few of these places before being escorted back outside. Only those who dwelled at the Mountain Estate or worked on various projects there would have been able to see all thirty-six Views.

77 For a discussion and translation of the "Imperial Capital Poems," see Chen, *The Poetics of Sovereignty*, 352–376.

yin and yang, when either of these forces reaches its ultimate, it suddenly reverses momentum and proceeds back towards its opposite. Thus, Taizong must return from his wandering and reject all private desires in order to effect a poetic closure as the exemplar of public virtue. This set of poems defines an image of imperial sovereignty that conforms to the Confucian ideal of moral correctness (*zheng* 正), which prescribes that the emperor's person maintain a ritualized centrality in the front palace.

Kangxi was no doubt familiar with Taizong's poems as he sought to legitimize his residence in a more private sphere where he was free to roam in a garden while also conforming to Han Chinese protocols.[78] Just as Kangxi reduced the role of the front palace structures in the design and functioning of the Mountain Estate, his poems avoided the configuration of the Thirty-Six Views as morally exclusive spaces. His sequence neither begins at nor returns to the formal receptions halls in front; in fact, he does not even mention them. Nor does any single View serve as the ultimate emplacement of the imperial person. Rather, most of the Views are spaces for the simultaneous performance of both public and private personae in time. This requires the poet to avoid representing extreme actions, such as indulging in food and sex or expressing a religious desire to transcend the human world entirely. The more moderate lifestyle that Kangxi presents in his poems could also be read as an imperial form of literati reclusion in the garden.[79] Instead of the bifurcated self in Taizong's model, Kangxi's form of imperial identity enfolds Confucian correctness within more diverse and complex images of the Qing emperor as the embodiment of an encyclopedic totality (*quan* 全).

There are primarily two ways by which Kangxi's poems effect this conflation of public and private selves. One technique employs a turning within a narrative sequence of events. An example is View 26, "Moon Boat with Cloud Sails" (Yunfan yuefang 雲帆月舫). Kangxi is enjoying musical entertainment in a boat-shaped pavilion, a common structure in Chinese gardens that evokes the pleasure barges of the south where banqueting with courtesans often occurred. The poetic genre he chooses is, appropriately, a *ci* 詞 lyric, which is a less restrictive form based on popular song patterns, many of which have romantic associations. Kangxi begins by imagining himself on an ecstatic journey among the mythical isles of the Daoist Transcendents (*xian* 仙). Seeking to encounter spirits, though a common theme in literati imagination, was condemned by Confucian moralism as inappropriate for an emperor, as Confucius himself refused to discuss such matters. Even Taizong's poetic cycle rejected such a desire, which was associated with some of the most notorious monarchs in the past.

78 See Kangxi's reference to these poems in View 3, "Un-Summerly Clear and Cool" (Wushu qingliang 無暑清涼), where he states: "When I can no longer hold to the Valley Spirit, I'll go back to Venerating Governance." The Valley Spirit (*gushen* 谷神) alludes to a Daoist concept that Kangxi employs to indicate the act of nurturing his health in nature, while Venerating Governance (*chongzheng* 崇政) is the name of a hall in Taizong's palace where the Tang emperor conducted government affairs. It is the subject of the second of Taizong's "Imperial Capital Poems."

79 For essays and paintings on the theme of reclusion (*yin* 隱) in China, see Peter Sturman and Susan Tai, *The Artful Recluse: Painting, Poetry, and Politics in Seventeenth-Century China* (Santa Barbara: Santa Barbara Museum of Art, 2012). In Kangxi's case, his imperial form of reclusion at the Mountain Estate could be seen as both a desire to retire from active governing in old age as well as a means of distancing himself from factional politics, including the struggle over the succession to the throne.

Kangxi the poet may allow himself to briefly indulge in such escapist fantasies, but he quickly exercises restraint. Midway through this poem, Kangxi lies down, and the enchanting music now sounds to him like the morally correct court music of the ancient thearchs. These pieces signify perfect government, and, by the time they are over, his thoughts turn toward concern for the common people and understanding of the meaning of the Confucian classics.

The other technique is more allegorical, where the poem can be read on two or more thematic levels. In View 31, "Observing the Fish from a Waterside Rock" (Shiji guanyu 石磯觀魚), Kangxi engages in fishing, one of his favorite activities. This conventional moment of leisure invokes the private experience of empathizing with the joy of fish mentioned in the Daoist classic *Master Zhuang* (*Zhuangzi* 莊子, ca. fourth century BCE). The poem evokes a reclusive atmosphere, where sounds of fishermen are heard in the evening, and celebrates the pleasure of obtaining a fat fish to eat. But it is also clear from a literary allusion to a famous remark by a Han dynasty Confucian scholar that the emperor's act of fishing can simultaneously be understood as a trope for recruiting virtuous men to become government officials. In this fashion, the emperor represents his private self as simultaneously coexisting with his public role.

Although the preponderance of poems invoke Kangxi's master persona in some way, about one-third of the Views express more purely aesthetic experiences that are largely devoid of moralistic concerns. Utilizing the traditions of Chinese landscape poetry, these poems present the emperor experiencing scenes of natural beauty. The spectrum of his emotional responses ranges from joy to melancholy, as he describes moments of pleasure and tranquility as well as moments when he attains a more profound understanding of himself and things. These Views often emphasize the solitude of the lyric poet alone with his thoughts. Such poems are the least didactic in intent, and the implied reader seems to be an ideal literary friend who can truly understand the author. Such intimate disclosures stand in contrast to the assertion in the "Imperial Record" that the emperor only looks at nature for its didactic effect of symbolizing moral values.

Like many Chinese aesthetes, Kangxi expresses delight at perceiving the conflation of art and life in his garden. In his role as a connoisseur, he asserts in several Views that their design not only achieves a resemblance to famous Chinese paintings but that his appreciation of art has recursively conditioned his vision of nature.[80] A View may produce a similar experience when it evokes lines from his favorite literary pieces or inspires him to write a new poem. He even demonstrates his taste in a few places by expressing critical opinions about some famous poets of the past. Transforming the landscape so that it resembles a painted scene or well-known poetic image reflects the Chinese ideal of the picturesque. In fact, most

80 Kangxi surrounded himself with art in all of his residences and he published *Selected Texts on Calligraphy and Painting from the Studio for Ornamenting Literature* (*Peiwenzhai shuhuapu* 佩文齋書畫譜, 1708). Although his father, Shunzhi, was also interested in Chinese painting, it was Kangxi who actively began the Qing palace collection that was greatly expanded by Qianlong and that later formed the core of the modern Palace Museum collections in Beijing and Taipei.

RICHARD E. STRASSBERG

of the famous garden designers recorded by literati were originally trained as painters.[81] Certain views in the Mountain Estate were also designed to invoke actual landscapes in southern China, such as West Lake (Xihu 西湖) in Hangzhou. Kangxi claimed that they even surpassed their models. In these visions of overwhelming beauty, Kangxi proudly celebrates his having achieved the Chinese garden owner's ideal of creating a three-dimensional painting that he can dwell in.

An example of Kangxi as connoisseur is the poem in View 12, "Sunset at Hammer Peak" (Chuifeng luozhao 錘峰落照), which focuses on an extraordinary rock that rises some one hundred and twenty-five feet just beyond the eastern wall of the Mountain Estate. The poet locates himself in a world apart as he observes it from a small open pavilion atop a hill. Although the scene describes the unique beauty of this landscape, its temporal and spatial dimensions are overlaid with visions of paintings and literature. The preface notes the entrancing sunset colors on the rock and compares the experience to viewing a painting by the Yuan dynasty master Huang Gongwang 黃公望 (1269–1354). It also employs syntax that clearly alludes to "The Pavilion of the Old Drunkard" (Zuiwengting ji 醉翁亭記, 1046), a famous piece written by the influential Northern Song official and literatus Ouyang Xiu 歐陽修 (1007–1072) when he was in exile. Later canonized as one of the Eight Masters of Tang and Song Prose, Ouyang similarly pointed out an outstanding mountain when he made an excursion to this pavilion and experienced bittersweet emotions of pleasure and sadness. The four lines of Kangxi's compact poem are structured by juxtaposing such oppositions. He begins by praising the endurance of this landscape, noting that it was recorded in texts as early as a thousand years ago. He then describes the autumnal atmosphere, which mirrors his advancing age and impending mortality. The final two lines, likewise, are based on juxtaposition. He first observes a panorama where most of the cliffs are busily competing with each other in beauty; he then concludes by focusing on Hammer Peak, which stands by itself in the distance. Empathizing with this solitary figure, he praises its unique quality and detachment, which he simply denotes by the word *you* 幽. Its range of meanings includes remoteness, seclusion, purity, and tranquility—core ideals in the discourse of literati reclusion.

Throughout the *Imperial Poems*, Kangxi's aestheticism is also manifested by his penchant for employing variant forms of Chinese graphs. He writes the graph 窗 as 窻, 從 as 従, and 解 as 觧—to give but a few examples—and no palace engraver would have dared to alter them.[82] Some of these variants are based on archaic or popular forms, while others were used in more expressive styles of calligraphy. Especially from the late Ming period onward, the

<hr />

[81] The concept of the picturesque (*ruhua* 如畫, also *huayi* 畫意) in Chinese painting is discussed in Wai-kam Ho, "The Literary Concepts of 'Picture-Like' (*ju-hua*) and 'Picture-Idea' (*hua-i*) in the Relationship between Poetry and Painting," in *Words and Images: Chinese Poetry, Calligraphy, and Painting,* ed. Alfreda Murck and Wen Fong (New York: The Metropolitan Museum of Art, 1991), 359–404. For a translation of *The Craft of Gardens* (*Yuanye* 園冶, 1634), a rare treatise by Ji Cheng 計成 (1582–after 1631), a late Ming garden designer who was also a painter and a poet, see Ji Cheng, *The Craft of Gardens*, trans. Alison Hardie (New Haven: Yale University Press, 1988). The connection between landscape painting and garden design is also discussed in Li, "Gardens and Illusions from Late Ming to Early Qing," 317–320.

[82] In the Chinese texts appended to the translations here, Kangxi's variant characters have been preserved when possible. But most have been changed to standard forms.

choice and even the invention of variant graphs was often a stylistic gesture by literati who wished to display their erudition or to assert their individualistic taste. As the forms of graphs became increasingly standardized through dictionaries and the spread of print culture, these variations were not typically employed in elite publications unless the book was reproducing someone's calligraphy. Kangxi's deliberate use of variants—including some rather idiosyncratic forms—gives the elegant, Song dynasty-style engraving of his text a distinctly personal tone. It not only underscores his ambition to create a uniquely attractive work that connoisseurs would appreciate but also reflects his lifelong desire to be recognized as having achieved a sophisticated command of Chinese letters.[83]

One of the most unusual features of the *Imperial Poems* is the extensive interlinear annotations compiled by a committee of seven eminent court scholars. Every word or phrase is shown to derive from one or more texts that extend over virtually the entire range of classical Chinese literature. Such an apparatus was hitherto found only in reference works such as encyclopedias and dictionaries. There was no precedent for a Chinese poet to include these annotations in an anthology of his own poems, and Kangxi did not employ this form in earlier imperial anthologies that he published of his writings. The better-educated readers of Chinese literature would not have required such information and might have even looked down on its inclusion.[84] But the *Imperial Poems* was primarily intended for his own family and other bannermen rather than for a wider Han readership. One motivation for the annotations may be a didactic intent on Kangxi's part to raise the level of literary competence among his intended readers.[85] Nevertheless, the breadth of the references in the annotations is impressive and serves to present Kangxi as an exemplary literatus by demonstrating his command over the textual tradition. Many of the individual allusions also serve to restrict the wide range of possible meanings in order to illuminate his authorial intentions.

An example can be seen in the glosses on the phrase *bishu* 避暑 (escape the heat) when it appears in the first line of the poem on View 1: "I often come to the Mountain Estate to escape the heat" 山莊頻避暑. This is glossed by citations of lines from three classical pieces where the same phrase appears. The first is from "Inscription on the Sweet Spring at the

83 Kangxi's personal use of variant graphs is at odds with his promotion of the standardization of graphs for the educated class through other imperial publications. Beginning around 1711, he sponsored the compilation of the *Kangxi Dictionary* (*Kangxi zidian* 康熙字典, 1716), which became the greatest reference work of its kind before the modern period, with about 47,000 standard graphs and almost 2,000 variant forms.

84 A caustic opinion of the inclusion of annotations as well as of Kangxi's poems was expressed by Pak Jiwŏn 朴趾源 (1737–1805) in his *Rehe Diary* (*Yŏrha ilgi*). Pak was a Korean literatus who was a member of the official delegation that visited the Mountain Estate in July–August 1780 to congratulate the Qianlong emperor on his eightieth birthday. See Pak Jiwŏn 朴趾源, *Yŏrha ilgi* 熱河日記 [Rehe Diary], trans. into modern Korean by Yi Sangho, in *Kyŏrae kojŏn munhak sŏnchap* [Anthology of Pre-Modern Korean Literature] (Kyŏnggi-do: Pori, 2004), 3:551–552.

85 The Manchu version does not include these annotations, as they would not have helped to explain the Manchu words. The Manchu translation thus conveys the semantic meaning of the Chinese original but without its pervasive allusiveness. It does include a few interlinear comments in Manchu, but these are short prosaic explanations providing various other kinds of information. As an indication of the literary competence of a substantial portion of the intended readership, the Manchu version may have been meant for those who would not have been able to fully comprehend the original Chinese.

RICHARD E. STRASSBERG

Nine-Story Palace" (Jiuchenggong liquan ming 九成宮醴泉銘, 632) by Wei Zheng 魏徵 (580–643): "The emperor escaped the heat at the Nine-Story Palace." This associates Kangxi with Emperor Taizong of the Tang, who had similarly built a rustic summer palace. The second is a line from the poem "Cooling Off" (Na liang 納涼) by Emperor Jianwen of the Liang 梁簡文 (r. 550–551): "I escape the heat beside a tall *wutong* tree, where light breezes often blow through my clothes." Jianwen, though an ill-fated emperor, was a talented writer who greatly influenced literary taste, especially in poetry. The third citation is from the poem "Dwelling in Reclusion in Wei Village" (Weicun tuiju 渭村退居) by the Tang poet Bo Juyi 白居易 (772–846): "I felt warmed when gazing at the view of spring flowers, and cooled off by escaping the heat among bamboo breezes."[86] Among Bo's achievements was his promotion of the garden as a private sphere while maintaining a Confucian commitment to serving as an official.[87] Together, these citations reveal how Kangxi's poetic use of the phrase "escape the heat" can invoke both public and private discourses about dwelling in gardens as they connect him to three outstanding figures in literary history.

Such copious annotations would probably not have been feasible without the completion of an important imperial publication at this time, *A Treasury of Rhymes for Ornamenting Literature* (*Peiwen yunfu* 佩文韻府, 1711). This encyclopedic compendium of two character expressions for use in literary composition was begun in 1704 under the chief editorship of Zhang Yushu. Gathered under each entry were multiple citations from a wide range of classical Chinese texts indicating how these expressions were used by writers in the past. A comparison of the citations for *bishu* with the annotation in the *Imperial Poems* reveals that the lines from the poems by Emperor Jianwen and Bo Juyi are among the six glosses listed in *A Treasury of Rhymes*; moreover, they are cited in the identical format.[88] With the exception of the chief editor Kuixu 揆叙 (ca. 1674–1717), all of the other editors of the *Imperial Poems* had also served as editors of *A Treasury of Rhymes*.[89] Clearly, they utilized *A Treasury of Rhymes* as

86 The Chinese text for these annotations is as follows: [魏徵九成宮醴泉銘] 皇帝避暑乎九成之宮. [梁簡文帝納涼詩] 避暑高梧側. 清風時入襟. [白居易詩] 望春花景暖. 避暑竹風涼. Kangxi emperor 康熙, *Yuzhi Bishu shanzhuang shi* 御製避暑山莊詩 [Imperial Poems on the Mountain Estate for Escaping the Heat], ed. Kuixu 揆叙 et al., with illustrations by Shen Yu 沈喻 (Beijing: Neiwufu Wuyingdian, postscript 1712), 1:1b.

87 For a study of Bo Juyi's role in defining the garden as a private sphere, see Yang Xiaoshan, *Metamorphosis of the Private Sphere: Gardens and Objects in Tang-Song Poetry* (Cambridge, Mass.: Harvard University Asia Center, 2003).

88 *Peiwen yunfu* 佩文韻府 [A Treasury of Rhymes for Ornamenting Literature], ed. Zhang Yushu 張玉書 et al. (Beijing: Neiwufu Wuyingdian, 1711; repr., Shanghai: Shanghai shudian, 1983), 2:1631c.

89 These editors were Li Tingyi 勵廷儀 (1669–1732), Jiang Tingxi 蔣廷錫 (1669–1732), Zhang Tingyu 張廷玉 (1672–1755), Chen Bangyan 陳邦彥 (1603–1647), Zhao Xiongzhao 趙熊詔 (principal graduate, 1709), and Wang Tubing 王圖炳 (metropolitan graduate, 1712). General Work Supervisor Hesu in the Hall of Military Glory was also involved in both publications. Zhang Tingyu would also serve as an editor of Qianlong's reissue of the *Imperial Poems* in 1741, which similarly annotated Qianlong's poetic responses. This form of annotation was used one more time, in 1745, in Qianlong's *Imperial Poems on the Forty Views of the Garden of Perfect Clarity* (*Yuzhi Yuanmingyuan sishijing shi* 御製圓明園四十景詩, 1745), which imitated the form of Kangxi's *Imperial Poems*. Zhang Tingyu again served on this committee of editors. Thereafter, such annotations of imperial poems was abandoned.

the primary source for their annotations, but they did so selectively, in accordance with the range of Kangxi's meanings for *bishu* in this context. The inclusion of these annotations transforms the *Imperial Poems* into a reference work as well. They demonstrate Kangxi's choice of poetic diction and indicate his preference for Tang dynasty poets. The annotations also suggest his approach to poetic composition—in other words, the fact that every word can be traced to other works of literature reveals that his poems are essentially verbal pastiches. Having memorized a vast vocabulary from other writings, Kangxi seems to have composed his own poems by stringing together words from various sources and possibly by filling in gaps by consulting *A Treasury of Rhymes*. This is certainly one way of composing a poem, particularly in later Imperial China, when various courts and schools of poetry promoted revivals of earlier styles. Though not very conducive to original or spontaneous creativity, Kangxi's method relies on considerable erudition while also demonstrating for readers a practical technique for assembling an acceptable poem. It is yet another example of his promotion of an aesthetic of encyclopedic assemblage to define Qing court taste.

Since its initial publication, the *Imperial Poems* has enjoyed a long afterlife and has remained in print down to the present day. It began to reach a wider audience four years after Kangxi's death, when a monumental encyclopedia that reproduced important illustrated books was completed under Yongzheng. The *Imperially Sponsored Encyclopedia of Books and Illustrations, Past and Present* (*Qinding gujin tushu jicheng* 欽定古今圖書集成, 1726–1728) reprinted the Chinese version of the *Imperial Poems* without the annotations, together with less skillful illustrations based on the original woodblock images.[90] This project was printed using moveable copper type and issued in at least sixty-four sets, thus granting a wider reading public access to Kangxi's book.

In 1742, Qianlong reissued an expanded edition of the *Imperial Poems* that included thirty-six of his own poems added in response to those of his grandfather. This edition followed the same design as the original book and reused the original woodblocks for the illustrations. Qianlong's poems employed the same genres and rhymes as well as included annotations added by an editorial committee consisting of his important literary officials.[91] He also composed an

90 See *Qinding gujin tushu jicheng*: "Yuanyou bu" 欽定古今圖書集成: 苑囿部 [Imperially Sponsored Encyclopedia of Books and Illustrations, Past and Present: "Gardens and Parks"] (Beijing: Neiwufu Wuyingdian, 1726–1728; repr., Shanghai: Zhonghua shuju, 1934): 785:25–34. The title of the book was changed to *Imperial Poems on Thirty-Six Views in Rehe* (*Yuzhi Rehe sanshiliujing shi* 御製熱河三十六景詩) without including Kangxi's name. The project began in 1701 under Chen Menglei 陳夢雷 (1651–after 1723) with the patronage of the third prince, Yinzhi 胤祉 (1677–1732). At some point, Kangxi assumed sponsorship and it became an imperial publication project. Just after Yongzheng assumed the throne in 1723, the new emperor began to persecute Yinzhi and exiled Chen, removing all mention of their names and appointing Jiang Tingxi as the editor. Jiang had also been one of the editors of the *Imperial Poems*, so it is possible that the *Imperial Poems* was included in the encyclopedia around this time. The largest of the imperial encyclopedias—with 6,109 chapters and 10,000 subsections—it was printed using moveable copper type and later reprinted in 1884, 1894, and 1934, in addition to now being available in an online version. See Hummel, *Eminent Chinese of the Ch'ing Period*, 94; Endymion Wilkinson, *Chinese History: A Manual, Revised and Enlarged* (Cambridge, Mass.: Harvard University Asia Center, 2000), 605–607.

91 Qianlong's book, *Imperially Composed Poems and Poems Written in Response on the Mountain Estate for Escaping the Heat with Illustrations* (*Yuzhi gonghe Bishu shanzhuang tuyong* 御製恭和避暑山莊圖詠, 1742),

"Imperial Record" of his own, in which he pointed out that he had been born in the same year as the Mountain Estate's completion.[92] Moreover, he fondly recalled that in 1722, Kangxi, then in the last year of his life, invited him to spend the summer at the estate to observe him conducting official affairs. This was clearly meant to prove that Kangxi had chosen Yongzheng as his successor and that he also regarded the eleven year-old prince as a future emperor.

Reissuing the *Imperial Poems* was part of Qianlong's revival of the Mountain Estate and the tradition of the Mulan hunt after a hiatus during the reign of Yongzheng. In the early years of Qianlong's reign, the estate had suffered damage from fires.[93] As he restored and expanded it, Qianlong preserved Kangxi's basic design and also perpetuated his grandfather's memory by renaming sites to commemorate their relationship and inscribing poems by both of them on two prominent rocks.[94] The enshrinement of Kangxi reached its apotheosis in the Temple of Eternal Protection (Yongyousi 永佑寺) built in 1751, where Kangxi was deified as an incarnation of Amitābha, the Buddha of Infinite Longevity (Wuliangshoufo 無量壽佛). The following year, Qianlong also had a stele erected with the story of his relationship with his grandfather. Kangxi was praised for building the Mountain Estate, defining its moral functions for the ruler, and constructing the original Thirty-Six Views, which were now seen as an eternal monument to him.[95] It is not known how many copies of Qianlong's book were printed. He did not commission a Manchu edition, perhaps because literary competence in Chinese among bannermen had grown considerably by his generation. In addition, Qianlong's book was probably intended for wider circles of readers than that of Kangxi.

included a preface of his own dated in the winter of the year *xinyou* (1742). It has also been reprinted in *Qingdai gongting banhua* 清代宮廷版畫 [Court Printed Illustrations of the Qing Dynasty], ed. Yang Renkai 楊仁愷 et al. (Hefei: Anhui meishu chubanshe, 2002), 6:1–513.

92 Qianlong's reflections on the Mountain Estate are recorded in several prefaces and postscripts in *Qinding Rehe zhi* 25:2b–6a. He remembered that he had seen all thirty-six Views when he spent the summer there in 1722, and he later recalled these Views when he read Kangxi's *Imperial Poems* as a young prince in 1729.

93 Wang Juyuan 汪菊渊, "Bishu shanzhuang fazhanshi ji qi yuanlin yishu" 避暑山庄发展史及其园林艺术 [A History of the Development of the Mountain Estate for Escaping the Heat and Its Garden Artistry], in *Bishu shanzhuang luncong* 避暑山庄论丛 [Collected Essays on the Mountain Estate for Escaping the Heat], ed. Bishu shanzhuang yanjiu hui (Beijing: Zijincheng chubanshe, 1986), 483.

94 In 1754, Qianlong added another thirty-six Views to Kangxi's original set, creating a total of seventy-two Views. But only ten of these were entirely new; the other twenty-six had already been created by his grandfather. See Chen, *Chengde Bishu shanzhuang Waibamiao*, 16. For a statement that he faithfully remained within Kangxi's original design when he added his additional thirty-six Views, see *Qinding Rehe zhi* 25:4ab. Qianlong also identified the number seventy-two as referring to the blessed lands (*fudi* 福地) of Daoism, which were believed to be located at sacred mountains where Transcendents dwelled. Kangxi's original number of thirty-six was, thus, said to refer to the thirty-six cavern-heavens (*dongtian* 洞天) of Daoism. In addition to the thirty-six poems in response and another set on the additional thirty-six Views, Qianlong wrote many other poems about Views in the Mountain Estate. For translations of five such poems, see Scott Lowe, trans., "Five Poems by the Qianlong Emperor," in *New Qing Imperial History: The Making of Inner Asian Empire at Qing Chengde*, ed. James Millward et al. (London: Routledge, 2004), 199–201.

95 The text of this stele is translated in Peter Zarrow, trans., "The Imperial Word in Stone," in *New Qing Imperial History: The Making of Inner Asian Empire at Qing Chengde*, ed. James Millward et al. (London: Routledge, 2004), 146–163. Qianlong also renamed the chamber where he stayed when he accompanied Kangxi in 1722 as the Hall Commemorating Benevolence (Jientang 紀恩堂).

The next dissemination of the *Imperial Poems* occurred through the publication of the *Imperially Sponsored Gazetteer of Rehe* (*Qinding Rehe zhi* 欽定熱河志) in 1781. This volume reproduced not only Kangxi's poems on the Thirty-Six Views but also a number of his other poems and inscriptions about the Mountain Estate as well as an abundance of additional writings by Qianlong.[96] Like the *Encyclopedia of Books and Illustrations*, it included another set of inferior woodblock illustrations, though it added the first printed map of the entire estate (see Map of the Thirty-Six Views). The *Gazetteer of Rehe* version was also reprinted in the *Imperially Sponsored Complete Collection of the Four Libraries* (*Qinding siku quanshu* 欽定四庫全書, 1773–1781).[97] Here, the illustrations were redrawn, slightly improving on the ones in the *Gazetteer of Rehe*. Through these imperial publications, the *Imperial Poems* was disseminated among a reading public far wider than Kangxi's original intention, before commercial reprints began to appear in the twentieth century.

In 1921, during the Republican period, a modern facsimile reprint of Qianlong's book was issued by the sometime official, banker, and bibliophile Tao Xiang 陶湘 (1871–1940), and in 1923, a reprint of the version in the *Encyclopedia of Books and Illustrations* was issued in Japan.[98] During the 1930s, interest in the Mountain Estate revived when it and the surrounding area were incorporated into the Japanese-sponsored state of Manchukuo. One of Kangxi's descendants, Puyi 溥儀 (1906–1967), who had briefly reigned as the last Qing ruler Xuantong 宣統 (r. 1908–1911), was installed as the Kangde emperor 康德 (r. 1934–1945), and attempts were made to establish continuity with Qing dynasty imperial culture. The *Gazetteer of Rehe* was reprinted in 1934 by an official Manchukuo publisher in Shenyang (Mukden), an earlier capital of the Manchus established before they conquered China. This was followed by an elegant facsimile edition of the original *Imperial Poems* printed in Japan in 1935 by the Japanese-Manchukuo Cultural Association (Nichiman bunka kyōkai 日滿文化協會). The previous year, the art historians Tadashi Sekino 関野貞 (1868–1935) and Takuichi Takeshima 竹島卓一 (1901–after 1973) produced four volumes of photographs of

96 See *Qinding Rehe zhi*, 25–29 for a reprint of the *Imperial Poems* along with additional poems and writings by Qianlong and a new set of woodblock illustrations. The *Gazetteer of Rehe* was compiled between 1756 and 1781; it was finally published under the editorship of Qianlong's favored official Heshen 和珅 (Hešen, 1750–1799).

97 See *Qinding siku quanshu* 欽定四庫全書 [Imperially Sponsored Complete Collection of the Four Libraries], ed. Ji Yun 紀昀 et al. (1772–1781; repr., Taipei: Shangwu yinshuguan, 1983–1986), 495:382–462. There were seven original sets of this monumental anthology, which collected and recopied more than 3,500 books. Four were placed in palace libraries in the north, primarily for the emperor's use. This included a copy stored in the specially built Hall of the Ford of Literature (Wenjin'ge 文津閣) at the Mountain Estate. Three were placed in the Jiangnan area, and Qianlong ordered that members of the educated class be granted access to them. A number of reprints of the four surviving editions have appeared during the past century, and it is now available online. For a study of the Four Libraries project, see R. Kent Guy, *The Emperor's Four Treasuries: Scholars and the State in the Late Ch'ien-lung Era* (Cambridge, Mass.: Harvard University Press, 1987).

98 The reprint of the Qianlong version was issued under the imprimatur of Mr. Tao's Sheyuan Garden in Wujin [mod. Changzhou, Jiangsu] (Wujin Taoshi Sheyuan 武進陶氏涉園). A reprint of Kangxi's book edited by Ōmura Seigai 大村西崖 (1871–1940) based on the *Encyclopedia of Books and Illustrations* version was published in Japan in 1923 by the Tosho sōkankai 圖書叢刊會.

the Mountain Estate that showed it to be in a state of disrepair after more than seventy-five years of neglect, as it had ceased to serve as an imperial residence after the Xianfeng emperor 咸豐 (r. 1850–1861) died there.[99] It was to suffer further damage during World War II and the civil war that followed.

After the establishment of the People's Republic in 1949, the Mountain Estate was placed under government protection as an important cultural asset in 1961. Since 1976, it has undergone several phases of restoration, which continue today. Its development as a popular tourist site and its use as a set for movie and television productions has helped stimulate a renewed interest in Qing dynasty culture and in Kangxi himself. In addition to a number of biographies and studies, several recent Chinese editions of his poems on the Mountain Estate, with modern annotations and commentaries, have appeared. In more recent years, there have also been a number of facsimile reprints of the 1921 reprint of Qianlong's edition of the *Imperial Poems* as well as of a rare handwritten album probably meant for Kangxi himself with Matteo Ripa's engraved illustrations.[100] Some of these are in elegant, imperial-style bindings, which may reflect the current interest in contemporary Chinese culture to reconnect with a glorious, imperial past.

What accounts for this enduring interest in Kangxi's poems on the Mountain Estate? No one would rank him among the great Chinese poets in imagination, technique, or influence. Nevertheless, with the aid of his literary editors, he acquitted himself well enough when placed in the company of other imperial poets. One attraction is the privileged access these poems provide to an extraordinary emperor's private thoughts and emotions as well as the momentary glimpses of his domestic life. Another may be the power of these poems to transport readers on a virtual journey through the original Mountain Estate viewed through the eyes of its creator. Without the poems, the scenes in the illustrations lack human presence, and without the images, the readers could not fully comprehend the places that inspired the poet. Together, text and image collaborate to enable us to continually reconstitute and animate the Thirty-Six Views. Ultimately, it remains for readers to decide whether Kangxi and the Mountain Estate successfully matched each other, as the critic Qian Yong 錢泳 (1759–1844) recommended.[101]

99 See Tadashi Sekino 関野貞 and Takuichi Takeshima 竹島卓一, *Jehol: The Most Glorious and Monumental Relics in Manchoukuo* (Tokyo: The Zauho Press, 1934). Xianfeng died at the Mountain Estate on August 22, 1861, where he had fled after the Anglo-French Expedition had occupied Beijing. For a discussion of these and other historical events at the Mountain Estate, see Xiaopeng 小朋, *Lengyan kan shanzhuang* 冷眼看山莊 [An Unbiased View of the Mountain Estate] (Harbin: Heilongjiang meishu chubanshe, 2000).

100 See Kangxi emperor, *Tongban Yuzhi Bishu shanzhuang sanshiliu jing shitu* 銅板御製避暑山莊三十六景詩圖 [Engraved Copperplate Edition of *Imperial Poems on Thirty-Six Views of the Mountain Estate for Escaping the Heat with Illustrations*] (1714; repr., Beijing: Xueyuan chubanshe, 2002). This version bound as a single album in imperial yellow silk contains Kangxi's Chinese text written out by the court calligrapher Wang Cengqi 王曾期 (fl. early eighteenth century), but without the annotations.

101 See the quotation in the frontispiece and Qian Yong 錢泳, *Lüyuan conghua* 履園叢話 [Chats by Lüyuan] (1825; repr., Beijing: Zhonghua shuju, 1979) 2:545.

AN INTERCULTURAL ARTIST

Matteo Ripa, His Engravings,
and Their Transmission to the West

Richard E. Strassberg

While the project to publish the *Imperial Poems on the Mountain Estate for Escaping the Heat* was underway, Kangxi decided to have the original Chinese woodblock illustrations translated into the medium of European copperplate engraving, which he was familiar with from the many Western books he had collected. Matteo Ripa (1682–1746), who had recently arrived at the Qing court to serve the emperor as an artist, was entrusted with the task. Completed in April 1714, it marks the introduction of the Western technique of copperplate engraving to China. Soon after, Ripa began to send sets of his engravings back to Europe. These were the first depictions of an actual Chinese garden by an eyewitness that Europeans were able to see, and they were created at a time when the aesthetics of Chinese garden design was becoming a topic of increased interest among the cultured classes. Both accomplishments are all the more remarkable because Ripa did not possess any formal training in art. Nor did he expect that when he became a secular priest in Italy, he would spend thirteen years at the Chinese court, where he was in personal contact with Kangxi on many occasions.

Ripa's extraordinary adventure took place as China and the West were growing closer as a result of increasing commercial trade and the expansion of European colonization and religious proselytizing in Asia. Throughout the eighteenth century and well into the nineteenth century, there was a great desire in the West for more information about China, but relatively few firsthand, reliable reports were transmitted. Ripa's experience provided him with a rare perspective that few foreigners at the time could hope to obtain. He primarily recorded his observations in a copious journal, which he later revised from 1743–1746, after he had returned to Naples. These include descriptions of the Mountain Estate, the Qing court, and Kangxi himself that are not to be found in Chinese sources. They not only form the basic

source for understanding his early life and career as an artist-missionary but also detail his process of engraving the Thirty-Six Views.[1]

Matteo Ripa, who was later given the Chinese name Ma Guoxian 馬國賢, was born on May 29, 1682, into a bourgeois family in Eboli, just south of Naples. In his youth, he had a great fondness for painting but could only secretly indulge it, as his father, a physician, opposed his artistic inclinations for fear that they would divert him from his studies.[2] Thus, although he never received any formal training, he developed an amateur skill in drawing and painting, especially in portraiture, by copying other images. At the age of fifteen, he was sent to continue his education in Naples, where his family hoped that he, too, would become a physician. After leading what he described as a rather loose and aimless life, he was suddenly inspired, after listening to a sermon at the age of nineteen, to become a secular priest and to found a new group of priests exclusively devoted to prayer. But he was directed by his spiritual mentor, Antonio Torres (1637–1713), superior of the Congregation of the Pious Workers (Congregatio Piorum Operariorum), into a more active life of ministering to the world. He hardly expected upon his ordination in 1705 to be sent to attend a college in Rome that was newly established by Pope Clement XI (r. 1700–1721) and that was attached to the Sacred Congregation for the Propagation of the Faith (Sacra Congregatio de Propaganda Fide).[3] This was a missionary branch established by the Vatican in 1662, during the Counter-Reformation, to convert Protestants and foreign peoples. One of the purposes of the college

1 The events in Ripa's journals generally follow a chronological order. But additional recollections that Ripa later interpolated sometimes appear out of sequence, causing ambiguity about the precise dates of some events. These manuscripts are currently being edited by Professor Michele Fatica and have been published as Matteo Ripa, *Giornale (1705–1724)*, 2 vols. (Naples: Istituto Universitario Orientale, 1991 and 1996). Two volumes covering up to 1716 having appeared so far with a third volume in progress. Few people had access to the manuscripts, however, until they were reedited and printed in 1832 as *Storia della fondazione della congregazione e del Collegio de' Cinesi*. In 1844, *Memoirs of Father Ripa, during Thirteen Years Residence at the Court of Peking in the Service of the Emperor of China; with an Account of the Foundation of the College for the Education of Young Chinese at Naples*, a highly abridged translation into English based on the *Storia*, appeared in London. This was subsequently reprinted in England and the United States in 1846 and in China in 1939. A Chinese translation appeared in 2004. Another abridged translation in French based on the *Storia* appeared in Christophe Commentale, *Matteo Ripa, peintre-graveur-missionaire à la Cour de Chine* (Taipei: Ouyu chubanshe/Victor Chen, 1983), but it is the English *Memoirs of Father Ripa* that have long been the major source for most scholars. Each of these three versions of Ripa's memoirs was created with a different intention for a different audience. As Fatica has characterized them, the *Giornale* focuses on contemporary politics within the Catholic Church and expresses a critique of the Jesuits. The *Storia* was presented as the autobiography of a saint at a time when there was a movement to canonize Ripa, while the much shorter *Memoirs* largely dispenses with religious issues to present a tale of Ripa's adventures in China. See Ripa, *Giornale (1705–1724)*, 1:xxv–clxx, especially page lxxiii.

2 Ripa, *Giornale (1705–1724)*, 1:203, "March 4, 1710"; and Michele Fatica, *Sedi e palazzi dell'Università degli Studi di Napoli "L'Orientale" (1729–2005)* (Naples: Università degli Studi di Napoli "L'Orientale," 2005), 16–19.

3 Matteo Ripa, *Storia della fondatione della Congregazione e del Collegio de' Cinesi* (1832; repr., Naples: Istituto Universitario Orientale, Collana "Matteo Ripa," 1983), 1:8–22; and Ripa, *Memoirs of Father Ripa*, 11–15.

RICHARD E. STRASSBERG

was to train priests in the Chinese language in preparation for proselytizing in China with the ultimate aim of creating an indigenous clergy.[4]

It was not until several years later, however, that unexpected circumstances presented an opportunity for Ripa to make the long voyage from Europe to Macao and from there to enter into the service of Kangxi at the court in Beijing. These involved the eruption of the long-simmering dispute over the so-called Chinese rites.[5] The controversy over how to present Christianity to the Chinese had begun as a debate within the Catholic Church and among European intelligentsia. It eventually led to a disastrous contest of wills between the pope and the emperor that resulted in the collapse of the Catholic missionary effort in China. Ripa was involved in some of these events, which played a central role in his career at the Qing court. Ever since the Jesuit Matteo Ricci (Li Madou 利瑪竇, 1552–1610) had successfully established his mission in the late sixteenth and early seventeenth century, the church had practiced a strategy of accommodating certain Chinese ceremonial practices, such as ancestor-worship and sacrifices to Confucius. The Jesuits had also established the linguistic style for translating Catholic theology into the Chinese language using terms and concepts borrowed from native religion and philosophy. Most of the missionary-experts at the Ming and Qing dynasty courts were Jesuits. Some of them formed close relationships with the emperors, especially Kangxi, who approved of Ricci's approach and issued an edict for the toleration of Christianity in 1692.[6] But those who opposed the Jesuit position had continually

4 The Propaganda Fide was a congregation established by Pope Gregorio XV (r. 1621–1623) in 1622 to convert Protestants and foreign peoples as well as to take the control of foreign missions away from the patronage of Portugal, Spain, and France. It also sought to extend the pope's control over individual orders and societies, including the Jesuits, Dominicans, and Augustinians. See Nicolas Standaert, *Handbook of Christianity in China* (Leiden: Brill, 2001), 1:286–290. Ripa represented Clement IX's position in China, which often brought him into conflict with these other groups. Like a few of the other court missionaries, he was a secular priest, which meant that he was supposed to be more active in the world rather than obliged to live according to the stricter rules of a particular order.

5 The complex historical, theological, and cultural issues raised by the Chinese Rites Controversy have long interested scholars. For general surveys, see George Minamiki, *The Chinese Rites Controversy from Its Beginning to Modern Times* (Chicago: Loyola University Press, 1985), 1–76; David E. Mungello, *The Great Encounter of China and the West* (Lanham, Md.: Rowman and Littlefield, 2005), 15–65; and Standaert, *Handbook of Christianity in China,* 1:358–366, 680–688. For more detailed studies, see Antoine Thomas, *Histoire de la mission de Pékin* (Paris: Louis-Michaud, 1923), 1:135–304, and the symposium papers in David E. Mungello, ed., *The Chinese Rites Controversy: Its History and Meaning* (Nettetal: Steyler Verlag, 1994). The effect on the Jesuit mission in particular is surveyed in Liam Matthew Brockey, *Journey to the East: The Jesuit Mission to China, 1579–1724* (Cambridge, Mass.: Harvard University Press, 2007), 184–203. A contemporary Chinese perspective appeared in Li Tiangang 李天纲, *Zhongguo liyi zhi zheng: lishi, wenxian he yiyi* 中国礼仪之争: 历史, 文献和意义 [The Chinese Rites Controversy: History, Documents, and Significance] (Shanghai: Shanghai guji chubanshe, 1998). For Ripa's role in the controversy, see Giacomo Di Fiore, "La posizione di Matteo Ripa sulla questione dei riti cinesi," in *La conoscenza dell'Asia e dell'Africa in Italia nei secoli XVIII e XIX,* ed. Aldo Gallotta and Ugo Marazzi (Naples: Istituto Universitario Orientale, 1989), 3:381–432.

6 Matteo Ricci's career is treated in Michela Fontana, *Matteo Ricci: A Jesuit in the Ming Court* (Lanham, Md.: Rowman and Littlefield, 2011); and Jonathan D. Spence, *The Memory Palace of Matteo Ricci* (New York: Viking Penguin, 1984). In 1712, there were eighty-nine foreign missionaries in China, including sixty-two Jesuits. The total number of Chinese converts was slightly less than 200,000 out of a population of more than 150 million. See Standaert, *Handbook of Christianity in China,* 1:300–321, 384. Despite the cultural

sought to prevent Chinese Catholics from participating in these rites, which they regarded as idolatrous; they were particularly against the Jesuit identification of Christian concepts such as Heaven and God with the Chinese words *tian* 天 and *shangdi* 上帝, which had a range of other meanings in Chinese philosophy, religion, and political ideology.

The Chinese rites had earlier been condemned by Pope Innocent X (r. 1644–1645) in 1645, only to be later accepted by Alexander VII (r. 1655–1667) in 1656. The controversy erupted again at the end of the seventeenth century, and the anti-Jesuit pope Clement XI once more condemned the rites. In the hope that diplomacy might resolve the issue, the pope dispatched the Patriarch of Antioch Charles Maillard de Tournon (Duo Luo 鐸羅, 1668–1710) to Beijing in December 1705. Although Tournon was well received at first, it had become apparent after eight months of negotiations that his diplomacy had failed. The emperor's attitude towards the Vatican and the missionaries proselytizing in the provinces now began to change. He regarded those prelates opposed to the Chinese rites as ignorant troublemakers and resented the pope's interference in his empire's internal affairs. When Kangxi ordered Tournon to return to Macao at the end of June 1707, the patriarch and his entourage were placed under house arrest by both the Portuguese and Chinese authorities. Although Kangxi would later send court missionaries to Rome on several occasions in the hope of reversing the Vatican's policy, and the Vatican would send one more envoy to Beijing to convince the emperor, the issue by then had become irreconcilable, as neither the pope nor the emperor was willing to compromise.[7]

After his initial reception in Beijing, Tournon had written an optimistic letter to Clement XI that also contained Kangxi's request for more experts in Western arts and sciences to serve him at court. Upon receiving it, Clement XI decided to raise Tournon to the rank of cardinal and to send a delegation of five priests to bring him the appropriate paraphernalia for the ceremony of investiture along with other documents. Matteo Ripa was one of the five chosen for this task. The group departed Rome on October 13, 1707, unaware of the negative turn of events that had already occurred in China. Traveling incognito, they followed a circuitous route through Austria, Germany, and Holland to London, where they boarded a ship of the British East India Company. They clearly avoided an easier, more direct itinerary through France or Portugal. These two countries not only enjoyed the closest ties with China among European nations but also contained powerful supporters of the Jesuits; the Vatican no doubt feared that these elements might interfere with the delegation's mission. After overcoming a number of obstacles, the group finally set sail from Britain on April 8, 1708. While

significance of Ricci's work in China, one of his successors, Nicolas Trigault (Jin Nige 金尼閣, 1577–1628), estimated that the Jesuits had only converted seven hundred people by 1607 and only five thousand by 1613. See Thomas, *Histoire de la mission de Pékin*, 390, 397.

7 These events are presented in Edward J. Malatesta, "A Fatal Clash of Wills: The Condemnation of the Chinese Rites by the Papal Legate Carlo Tommaso Maillard de Tournon," in *The Chinese Rites Controversy: Its History and Meaning,* ed. David E. Mungello (Nettetal: Steyler Verlag, 1994), 211–246. After Tournon's failed mission, Kangxi instituted the *hungpiao* 紅票 in 1708. This was a residency permit requiring all missionaries to swear to follow Matteo Ricci's approach. More than fifty missionaries left China rather than comply with it, considerably reducing the total number of foreign missionaries. See Standaert, *Handbook of Christianity in China,* 1:298, 384.

on board, Ripa kept a journal with sketches of fish, birds, botanicals, and other objects that he observed at sea. Since none of his paintings survive, it is difficult to ascertain the level of his artistic ability aside from these sketches and the engravings done in China. The sketches confirm that he possessed at least an amateur competency as a draftsman.[8]

When Ripa reached Macao on January 5, 1710, he found Tournon gravely ill but determined to reverse the breakdown in relations with Kangxi. A few months later, on April 2, Tournon—recalling the earlier request to the pope for more experts—wrote to the emperor that a group of six missionaries had arrived in Macao, including the secular Lazarist Teodorico Pedrini (De Lige 德理格, 1670–1746), a musician from Fermo, Italy; the Augustinian Guillaume Fabre Bonjour (Shan Yaozhan 山遙瞻, 1670–1714), a French mathematician; and Ripa, who was recommended as a painter. All three represented the Propaganda Fide and were the first of this group to serve at the Qing court (as most other missionaries there were Jesuits).[9] The twenty-eight year-old Ripa initially resisted Tournon's strategy, for it meant committing himself to a lifelong residency in China as an artisan and courtier rather than serving as an active missionary in the field. But when Tournon insisted that the present crisis required that the three missionaries submit to his plan, Ripa reluctantly obeyed and set to work to improve his painting skills.

Tournon succumbed on June 8, 1710. In early July, Kangxi's reply arrived, accepting Pedrini, Fabre Bonjour, and Ripa into his service. He placed the group in the care of the governor-general of Guangdong and Guangxi, Zhao Hongcan 趙宏燦 (d. 1717), ordering that they first spend some time in Guangzhou (Canton), ostensibly to acquire basic skills in the Chinese language. But this decision was probably intended to give the governor-general time to investigate the group, especially Ripa. The emperor specifically requested that sample paintings by Ripa be quickly sent to him so that he could judge his artistic abilities. Ripa's samples proved acceptable and allayed Kangxi's initial doubts.[10] After spending a few months

8 Various sketches from the diary are reproduced in Ripa, *Giornale (1705–1724)*, 1:50ff; and Fatica, *Matteo Ripa e il Collegio dei Cinesi di Napoli (1682–1869)*, 173–189.

9 In light of the Chinese Rites Controversy and the opposition of the Jesuits, it was clear to Tournon that Kangxi would not accept a regular missionary like Ripa, who lacked artistic and scientific credentials and who was really sent to support the Vatican's position. Thus, some means had to be found to disguise him. Because he read a letter that Ripa brought with him containing praise of Ripa as a painter, Tournon was confident that he could recommend Ripa to Kangxi as an artist, despite Ripa's own reservations about his skills. See Ripa, *Giornale (1705–1724)*, 1:203–205, "March 4, 1710."

10 Kangxi was initially skeptical about Ripa's skills, due to reports that reached his ears that Ripa was not really an artist, so he ordered the governor-general to investigate him. In addition to the examples he forwarded to Beijing, Zhao Hongcan had officials observe Ripa painting a portrait of a sitting subject. See Ripa, *Giornale (1705–1724)*, 1:225, "August 14, 1710"; see also Elisabetta Corsi, "Late Baroque Painting in China Prior to the Arrival of Matteo Ripa: Giovanni Gherardini and the Perspective Painting Called '*Xianfa*,'" in *La missione cattolica in Cina tra i secoli XVIII–XIX: Matteo Ripa e il Collegio dei Cinese*, ed. Michele Fatica and Francesco D'Arelli (Naples: Istituto Universitario Orientale, 1999), 116; and Shen Dingping 沈定平, "Ma Guoxian zai Zhongguo de huihua huodong jiqi yu Kangxi, Yongzheng huangdi de guanxi shulun" 马国贤在中国的绘画活动及其与康熙雍正皇帝的关系述论 [A Discussion of Matteo Ripa's Artistic Activities in China and His Relationships with the Kangxi and Yongzheng Emperors], in *La missione cattolica in Cina tra i secoli XVIII–XIX*, 86. For memorials between Kangxi and Zhao about Ripa's qualifications, see Luo Hongbo 罗红波 and Lin Mian 林岷, "Zhongguo guanfang wenxian dui Ma Guoxian de jizai ji Zhongguo dui Ma

in Guangzhou, the group—now joined by two more mathematicians[11]—set out for Beijing on November 27, 1710. They reached the capital on February 5, 1711, and were received by Kangxi in his private residence on the following day. The emperor briefly conversed with Ripa about painting with the aid of missionary interpreters, as Ripa's Chinese was still rudimentary. Nevertheless, Ripa's language skills were to rapidly progress, and he would occasionally become useful to Kangxi as an interpreter and translator. Although he was a highly partisan supporter of the Vatican's position on the Chinese rites, he would also prove himself to be an adroit courtier who made timely compromises with his religious convictions in order to maintain the emperor's confidence.

On the day after the reception, Ripa was sent to work in the section of the Forbidden City where the court artists and craftsmen labored. He was assigned to the studio where seven other artists, who had been previously trained by Giovanni Gherardini (1655–ca. 1723), were engaged in oil painting. These Chinese painters provided Ripa with supplies and were anxious to observe his painting technique. He was surprised to discover that they painted not on linen or canvas but on thick Korean paper, and he was relieved to find that copying other paintings was not disparaged in Chinese art.[12] In addition to portraits, he could also paint landscapes and decorative subjects. Kangxi appreciated his work but was disappointed to learn that—unlike Gherardini—Ripa was not trained in the techniques of European perspective that so fascinated him.[13] About two weeks later, Ripa was reassigned to work in closer

Guoxian de yanjiu" 中国官方文献对马国贤的记载及中国对马国贤的研究 [Official Chinese Documents Recording Ma Guoxian [Matteo Ripa] and Research in China about Ma Guoxian], in *La missione cattolica in Cina tra i secoli XVIII–XIX*, 64–65; and George H. Loehr, "The Sinicization of Missionary Artists and Their Work at the Manchu Court during the Eighteenth Century," *Cahiers d'Histoire Mondiale* 7, no. 3 (1963): 799–800.

11 Ripa, *Giornale (1705–1724)*, 1:227, "November 5, 1710." These were the Jesuits Francisco Cardoso (Mai Dacheng 麦大成, 1676–1723), from Portugal, and Franz Tilisch (Di Lixi 蒂里希, 1667–1716), from Bohemia. The *Storia* version, however, mistakenly gives "Cordero" instead of Cardoso, which was followed in the English, French, and Chinese translations; see Ripa, *Storia della Fondatione della Congregazione e del Collegio de' Cinesi*, 1:350.

12 Ripa, *Giornale (1705–1724)*, 2:12, "February 7, 1711." Ripa stated that Gherardini had been the first painter to introduce oil painting to China. A layman from Modena who had trained in Bologna and worked in France, he arrived in China in 1699 but returned to France in 1704, where he became a member of the Royal Academy. See Corsi, "Late Baroque Painting in China Prior to the Arrival of Matteo Ripa," 115–120; see also George H. Loehr, "Missionary-Artists at the Manchu Court," *Transactions of the Oriental Ceramic Society* 34 (1962–1963): 52–53, 64; and Loehr, "The Sinicization of Missionary Artists and Their Work at the Manchu Court during the Eighteenth Century," 796–798. The workshop Ripa was assigned to was probably the Western Painting Studio (Xiyang huafang 西洋畫房), which existed from the late Kangxi era into the first years of Yongzheng's reign. Shen Yu, who created the original woodblock illustrations of the Thirty-Six Views, was later appointed a supervisor of this studio. See Shen, "Ma Guoxian zai Zhongguo de huihua huodong jiqi yu Kangxi, Yongzheng huangdi de guanxi shulun," 88. None of Gherardini's paintings in China survive. For an example of an oil painting by court artists during the Kangxi period, see *Qingdai gongting huihua* 清代宮廷繪畫 [Court Painting of the Qing Dynasty] (Beijing: Wenwu chubanshe, 1992), 86–87, no. 35.

13 Gherardini decorated the Jesuit Northern Church (Beitang 北堂) in Beijing with *trompe l'oeil* paintings that Kangxi and others viewed. The emperor's appreciation of the realistic effect of Western painting was recorded by one of his favorite literati tutors, Gao Shiqi, when Gao visited Kangxi's Garden of Joyful Spring. Gao was shown two portraits that the emperor praised and also noticed *trompe l'oeil* murals in his

RICHARD E. STRASSBERG

proximity to the emperor in the Garden of Joyful Spring. Quartered nearby in a mansion belonging to one of Kangxi's uncles, Ripa regularly entered the imperial residence to labor in one of its workshops, thus providing him with a rare opportunity to observe Chinese garden design. Unlike some European observers, who found such gardens unimpressive and lacking an appropriate degree of magnificence, Ripa readily appreciated its distinctive aesthetics and ingenious construction. He included a rare description of the garden in his journal:

> This and all the other lordly villas that I saw are of the same taste, exactly the contrary of our European taste, since we artfully attempt to distance ourselves from the natural, making the hills plain, drying out the dead waters of lakes, pruning trees in the wood, straightening roads, creating fountains with great effort, planting flowers in good order, etc; the Chinese, on the other hand, work with art to imitate nature, transforming the terrain into a web of little bridges and hills, with paths that in some places are narrow and in others wider, flat and steep, straight and crooked, through mountains—some of which feature rough stone formations placed to look natural—and through valleys; thence over varied bridges on rivers and streams created with water brought in.[14]

Despite their elegant surroundings, Ripa and the other missionary-artists chafed under the emperor's demand that they produce all kinds of artistic objects for his delight. They regarded their service as but a means for interesting Kangxi in Catholic theology and they hoped that the entire country would follow him if he could be converted to Christianity. They sometimes complained in their correspondence of being overburdened with his incessant commands, which left them little free time for their missionary work. In a letter referring to his colleague Guiseppe Castiglione (Lang Shining 郎世寧, 1688–1766), who would join him a few years later, Ripa wrote:

> The poor fellow has to suffer a great deal, as he has been obliged by His Majesty to work in the palace. This is most grueling for Europeans, as they are obliged to work in a room and are not allowed to walk about freely. They are not permitted

private theatre. See Corsi, "Late Baroque Painting in China Prior to the Arrival of Matteo Ripa," 115–120; Gao Shiqi 高士奇, Pengshan miji 蓬山密記 [A Secret Account from Pengshan], in Guxue huikan 古學彙刊 (1703; repr., Taipei: Lixing shuju, 1964). 4:1451; Loehr, "Missionary-Artists at the Manchu Court," 52–53; and Loehr, "The Sinicization of Missionary Artists and Their Work at the Manchu Court during the Eighteenth Century," 797.

14 Translated in Bianca Maria Rinaldi, The "Chinese Garden in Good Taste": Jesuits and Europe's Knowledge of Chinese Flora and Art of the Garden in the Seventeenth and Eighteenth Centuries (Munich: Martin Meidenbauer Verlagsbuchhandlung, 2006), 236–237, based on the text of the Storia. Although the journal entry is dated March 3, 1711, Ripa clearly revised it later, as he goes on to refer to events that took place in 1721. This residence is different from the later Garden of Eternal Spring (Changchunyuan 長春園, 1749–1860), which became part of the Garden of Perfect Clarity. The names of both gardens employ the same romanization, and Ripa may have created some confusion for later readers by mistranslating Kangxi's "changchun" 暢春 (joyful spring) as "continua primavera" (constant spring). See Ripa, Giornale (1705–1724), 2:18, "February 18, 1711"; 2:21–23, "March 3, 1711." Another English translation appeared in Ripa, Memoirs of Father Ripa, 74–75.

to either speak or laugh loudly. They must always be dressed in the finest of garments. They cannot miss even a single day from working in the palace where they have a hundred guards around them. They are not allowed to leave it, except under great difficulty, and then, only under the guidance of a eunuch."[15]

Ripa's work as an engraver began as the result of a casual inquiry in spring 1711. Kangxi asked Ripa, Pedrini, and Tilisch if they had any other skills besides painting, music, and mathematics. The others replied in the negative, but Ripa was aware that the emperor had begun a monumental project in 1708 to have his Jesuit experts survey and map the entire Qing Empire using Western surveying techniques and that he wanted to reproduce these results using copperplate engravings.[16] To please Kangxi, Ripa acknowledged that he knew something about the process of etching with *acqua forte*. He admitted that he never actually practiced the skill, but he volunteered to make an attempt. Ripa had actually received only one brief lesson in etching a copperplate with acid from an artist in Rome before he departed for China.[17] Kangxi immediately ordered him to produce an example, and Ripa drew a pleasant European landscape on a blackened copperplate. Next, Kangxi ordered him to reproduce a Chinese-style landscape drawn by one of his court artists; he was surprised to find that Ripa not only created an exact copy but did not sacrifice the original sketch in the process, as in Chinese woodblock engraving. From this experience, Ripa gathered that the Western copperplate engraving process was previously unknown in China.[18]

15 Quoted in Loehr, "The Sinicization of Missionary Artists and Their Work at the Manchu Court during the Eighteenth Century," 803.

16 This was the unprecedented project carried out at great expense that resulted in the *Complete Map of the Empire* (*Huangyu quanlan tu* 皇輿全覽圖), also known as the "Kangxi Atlas." The mapping began in 1708 and was not completed until 1717, although there were later revisions and additions. For Ripa's engraving of the map, see Li Xiaocong 李孝聪, "Ma Guoxian yu tongban Kangxi *Huangyu quanlan tu* de yinzhi jianlun zaoqi Zhongwen ditu zai Ouzhou de chuanbu yu yingxiang" 马国贤与铜版康熙《皇輿全览图》的印制兼论早期中文地图在欧洲的传布与影响 [Matteo Ripa and the Printing of Kangxi's Copper-Engraved *Complete Map of the Empire* with a Discussion of the Early Transmission and Influence of Maps of China in Europe], in *La missione cattolica in Cina tra i secoli XVIII–XIX*, 123–134. See also Andreina Albanese, "La carta geographica di Matteo Ripa: Caratteristiche dell'esemplare della Biblioteca Universitaria di Bologna," in *La missione cattolica in Cina tra i secoli XVIII–XIX*, 135–183; and Andreina Albanese, "Matteo Ripa e la carta geografica dell'Impero Cinese commissionata da Kangxi," in *Matteo Ripa e il Collegio dei Cinesi di Napoli (1682–1869)*, ed. Michele Fatica (Naples: Università degli Studi di Napoli "L'Orientale," 2006), 49–70. For a survey of cartography by missionaries in China, see Standaert, *Handbook of Christianity in China*, 1:752–770.

17 Ripa, *Giornale (1705–1724)*, 2:29, "May 9, 1711"; 2:38, "June 20, 1711." Ripa also said that he could create some "optical demonstrations" (*dimostrazioni optiche*). The lesson in engraving copperplates with *acqua forte* (*intagliare i rami ad acqua forte*) was at the suggestion of Ripa's confessor, who thought such knowledge might prove useful to him in China.

18 Ripa, *Giornale (1705–1724)*, 2:29–30, "May 23, 1711." Matteo Ricci and the early Jesuits had brought and distributed books and copperplate prints in China at the end of the sixteenth century. These early missionaries created only woodblock engravings (in addition to paintings) in China, so Ripa is generally credited as being the first to produce copperplate engravings. For Ricci's artistic activities, see Michael Sullivan, *The Meeting of Eastern and Western Art from the Sixteenth Century to the Present Day* (London: Thames and Hudson, 1973), 46–61.

In June 1711, Ripa was commanded to accompany Kangxi to Rehe along with four other missionaries. He wrote in his journal that he arrived after a journey of twenty days and, in an audience at the Mountain Estate, was ordered to complete and print the copperplate example he had been working on. He proceeded to describe the considerable difficulties he faced in creating equivalents from local materials for European *acqua forte* acid and printing ink, which were not available in China:

> I now inquired for the ingredients necessary to make aquafortis, that is, strong white wine vinegar, sal ammoniac, and verdigris. The sal ammoniac could be procured in abundance but the verdigris was greatly inferior to ours, and the vinegar, not being made with grape wine, but with sugar and other articles, was not fit for my purpose. Thus, owing to the inefficiency of the aquafortis, the lines were very shallow, which, added to the badness of the ink, caused the prints to be of the worst possible description. It cost me no small amount of labor before I could bring this kind of engraving to any degree of perfection.
>
> To make the ink, tartar was necessary, but of this a few pounds only could be found in the imperial drug-house, and I was obliged to employ other materials. After many experiments, however, I produced a tolerable specimen.
>
> In the construction of a press I was again encountered by innumerable difficulties, having never even seen one but once, when I paid no particular attention to it. I now ordered one to be made, having the lower cylinder fixed and the upper one moveable. In consequence of this, when it was worked the effect produced was of the worst description, and drew forth the laughter and jests of the eunuchs, mandarins, and many other persons belonging to the court, so that my trouble and confusion were complete. Recollecting, however, the high purpose for which I had come to China, I contrived to bear this with patience and good humor. His Majesty having seen the prints which I had engraved, was kind enough to excuse them, though they were very pale. He even declared that they were excellent; and this he always continued to do, never finding fault with what I produced.[19]

Ripa recorded that about two weeks later, Kangxi, having seen his engravings improve day by day, decided that he should then produce a version of the woodblock images of the Thirty-Six Views. Along with several other missionaries, he was ordered to accompany the Chinese artists who were preparing the images into the Mountain Estate in order to see the entire site for himself. They climbed a hill and surveyed the entire estate—doing so, he stated, was a unique privilege never before bestowed on Europeans. The artists were then ordered to complete their designs so that Ripa could engrave them.[20]

19 Ripa, *Giornale (1705–1724)*, 2:38–39, "June 20, 1711"; and Ripa, *Memoirs of Father Ripa* (1846), 82–83. The abridged English translation is Prandi's, based on the *Storia* text in Ripa, *Storia della Fondatione della Congregazione e del Collegio de' Cinesi*, 1:420–423.

20 Ripa, *Giornale (1705–1724)*, 2:41, "July 6, 1711," and 82, "August 1, 1712." The year (1711) that Ripa gives in his journal for beginning his engraving of the Thirty-Six Views seems too early. As Ripa was dependent on the

The engraving project is not mentioned in Ripa's journal again until the summer of 1712, when he, along with several other missionary-experts, once more accompanied Kangxi to Rehe. His position at the court had improved by then, and both he and Pedrini were given rooms in one of the villas inside the Mountain Estate in close proximity to the emperor.[21] On August 1, he wrote that he had made a number of prints of various subjects that the emperor had praised as "treasures" (baobei 寶貝), and he gives this as the date when Kangxi ordered him to actually begin engraving the Thirty-Six Views. The emperor also requested that he teach the technique to two apprentices, who were promptly summoned from Beijing.[22] Ripa further wrote that he also taught several other apprentices. One of them was apparently Zhang Kui 張奎 (fl. early eighteenth century), for this name appears in the margin of a number of prints in various existing sets to indicate that he was the engraver. These inscriptions confirm that Ripa collaborated with his apprentices, as he acknowledges elsewhere.[23]

When Kangxi ordered Ripa to engrave a version of the Chinese woodblock illustrations, he stated that his intention was to have the scenes interpreted in the European style.[24] A comparison of the engravings with the woodblock originals reveals Ripa's method. The shapes and the dimensions of the architectural elements are exactly the same in both—as are most of the landscape forms, including the trunks of the major trees. Furthermore, random measurements of the distances between buildings and points in the landscape confirm that Ripa began by producing an exact tracing of the woodblocks. The width of both sets of images is virtually the same (30 cm), but the height of the copperplate image (27 cm) is about 2½ cm greater than the woodblock. This discrepancy allowed Ripa to raise or lower

Chinese woodblock prints before he could commence his versions, the actual work probably did not begin until later and must have proceeded as each woodblock image became available. Ripa later gives August 1, 1712, as the date when he was ordered to begin. It is clear from the Manchu memorials between Kangxi and the officials in the Imperial Printing Office in the Hall of Military Glory that the woodblocks had not yet been carved as of September 7, 1712. See Guan and Qu, *Kangxi chao manwen zhupi zouzhe quanyi*, no. 2011. At the beginning of the entry for September 1711, Ripa included the lengthy description of the Mountain Estate. Part of that was subsequently recopied by him as a preface to his titles and captions in the Bibliotheca Nazionale di Napoli (I.G.75) version as "Descrizione della Villa." See Appendix 2. Like his description of the Garden of Joyful Spring, it mentions incidents observed in 1721 and 1722, so it too must have been interpolated into his journal or later revised. See Ripa, *Giornale (1705–1724)*, 2:41–43, "September 1711."

21 This was probably the building in View 16, "Clear Sounds of a Spring in the Breeze" (Fengquan qingting 風泉清聽), which Ripa described in a colophon as a place where the Europeans who serve the emperor reside. Ripa, *Giornale (1705–1724)*, 2:82, "June 3, 1712."

22 Ripa, *Giornale (1705–1724)*, 2:83–84, "August 1 and August 6, 1712." Kangxi also insisted that these apprentices not teach this skill to others.

23 The name Zhang Kui 張奎 does not appear in every set, and no individual set contains all of the prints that bear his name. For more about Zhang Kui's role, see Stephen H. Whiteman's essay that follows. See also Han Qi 韩琦, "Cong Zhongxi wenxian kan Ma Guoxian zai gongting de huodong" 从中西文献看马国贤在宫廷的活动 [Matteo Ripa's Activities in the Palace as Seen in Chinese and Western Documents], in *La missione cattolica in Cina tra i secoli XVIII–XIX*, 71–82. Ripa never added his own signature to the engravings. See Ripa, *Giornale (1705–1724)*, 2:136, "May 22, 1714," where he states that the Thirty-Six Views were "engraved partially by me and partially by my apprentices" (parte da me e parte da miei discepoli intagliato).

24 Ripa, *Giornale (1705–1724)*, 2:83, "August 1, 1712."

the traced composition, depending on whether he wished to enlarge the foreground or to develop the background or sky areas. Once the tracing was complete, Ripa proceeded to alter the images to various extents.

Compared to the Chinese woodblocks, Ripa's engravings display a noticeable degree of stylistic inconsistency. The former employ a generic visual language for illustrating landscapes and architecture that had been distilled by artisans over several centuries. This style reached a height of conventionalization in Qing imperial printing during the eighteenth century and could be reliably executed by a number of trained artists and engravers in the palace workshops.[25] Despite the collaborative nature of the production process, there is a uniform technique employed in the woodblock images that reflects the dominant influence of the Orthodox School of literati painting at the Qing court and the fashion for the style of architectural painting known as *jiehua* 界畫.[26] Ripa, on the other hand, was creating a new, hybrid language of landscape representation as he worked. With no single artistic tradition to rely on and with no experience with the medium, each plate offered him another opportunity to experiment.[27] In addition, he was training apprentices like Zhang Kui as his own skills progressed. The result is that one group of plates, comprising slightly less than half of the total number, convey a more Europeanized atmosphere that only Ripa could have imagined. The remaining plates are more faithful to the style of the woodblocks and were most likely the result of greater or lesser degrees of collaboration with his Chinese assistants.[28]

The most fully realized images display the characteristics that Kangxi most admired in Western painting—namely, its lifelike (*bizhen* 逼真) impact. Even though Ripa did not employ European fixed-point perspective and followed the traditional Chinese perspectives in the woodblocks, his incorporation of shading, along with other devices, created the kind of enhanced perception of depth that Kangxi had found surprising in the work of Gherardini and other Western artists. Furthermore, Ripa added a heightened emotionalism and sometimes a sense of drama to the more serene and impersonal atmosphere of the woodblocks.

25 For a study of the evolution of landscape representation in Chinese woodblock printing during the late Ming dynasty, see J. D. Park, *Art by the Book: Painting Manuals and the Leisure Life in Late Ming China* (Seattle: University of Washington Press, 2012); and Mai-mai Sze, trans. and ed., *The Mustard Seed Manual of Painting* (Princeton, N.J.: Princeton University Press, 1956).

26 On the *jiehua* style, see Anita Chung, *Drawing Boundaries: Architectural Images in Qing China* (Honolulu: University of Hawai'i Press, 2004), 82–100. This represented architectural structure and detail more realistically by employing straighter, unmodulated lines with the aid of a ruler, in contrast to the more expressive, calligraphic brushstrokes used in the *xieyi* 寫意 style of literati painting.

27 Ripa earlier wrote that while he was initially struggling to produce an acceptable print using acquaforte, some of the Jesuits at court showed Kangxi intaglio engravings done by skilled French craftsmen in order to embarrass him. Kangxi admired the superior clarity of intaglio engravings compared to etching and ordered that Ripa also master the use of the burin tool. Thus, the style of Ripa's Thirty-Six Views displays the features associated with intaglio engraving rather than with etching. Ripa, *Giornale (1705–1724)*, 2:43, "September 8, 1711."

28 Ripa's Europeanizing style appears strongest in Views 2, 3, 4, 7, 8, 11, 16, 17, 22, 24, 25, 26, 28, 31, 33, and 34. The other plates, which vary in quality and degree of complexity, are comparatively closer to the woodblock originals. For a slightly different grouping of Ripa's engravings, see the following essay by Stephen H. Whiteman.

In the original Chinese book, the emperor's poems provide the subjective moods; the illustrations were supposed to respectfully supplement the text with information about the sites for the reader and without the intrusion of the lyrical visions or personalities of the artists. Hence, the perspectives in the illustrations are not exactly those described by Kangxi as poet. Since Ripa did not understand the text and had only a superficial grasp of the poetic names, he enjoyed more creative freedom. In his case, the expressive elements he introduced were not regarded as a violation of decorum but appreciated as the exotic delights of Western art. Ripa's hybridized style was consistent with how the European artists at the Qing court generally employed Western techniques—that is, they selectively adapted their techniques to Chinese tastes and were willing to compromise or abandon aesthetic rules that they had learned in order to please the emperors. Ripa's principal techniques of Europeanizing the woodblocks are as follows: a) reshaping some of the landscape forms; b) adding more architectural details to the surfaces of the buildings; c) adding new flora, changing the leaves and the outer shapes of the trees, and more fully articulating the lotuses; d) adding chiaroscuro shading to the sky, architecture, and water areas using cross-hatching and parallel lines; e) introducing other elements, such as the sun, clouds, waves, ducks, and fish; f) thickening and thinning lines for emphasis; and g) substituting the thinner strokes of a stylus or burin for the carved texture strokes in the woodblocks, which were based on calligraphic brushstrokes. In contrast to the Chinese representation of a landscape as a flattened, harmonious interweave of dynamic *qi* 氣 energies, Ripa produced a denser and deeper image of sharper contrasts that evoked a more Cartesian space filled with discrete objects.[29]

This European sensibility is most fully projected in View 11, "Morning Mist by the Western Ridge" (Xiling chenxia 西嶺晨霞), which Ripa titled "Monte occidentale, sul quale la mattina è un bel vedere le nubbi" (Western Mountain on which in the Morning There is a Good View of the Clouds). Kangxi's poem merely mentions the sky clearing after a rain, a conventional poetic topos that the woodblock does not attempt to represent. Ripa, however, added a dramatic sky scene. The power of the radiant sun as it repels the dark, roiling clouds invokes the theatricality of the Italian baroque art of the Counter-Reformation. The theological message would have been obvious to Ripa, though perhaps less so to Kangxi: the Mountain Estate, like every place on earth, lies under the benevolent grace of the Christian God.

The greater sense of depth is primarily achieved through the chiaroscuro shading of the land forms, plants, water, architecture, and clouds. Gradations in tonality and more emotional atmospheres are characteristics of Ripa's own plates, compared to the starker tonal contrasts in many of those that are more faithful to the woodblocks. An example of the latter is View 20, "A Fountainhead in a Cliff" (Quanyuan shibi 泉源石壁), where the textured strokes

29 For a comparison of Ripa's style with the tradition of Chinese landscape prints, see Christophe Commentale, "Les recueils de gravures sous la dynastie des Ch'ing: La série des eaux-fortes du *Pi-shu shan-chuang*, Analyse et comparaisons avec d'autres sources contemporaines, chinoises et occidentales," in *Echanges culturels et religieux entre la Chine et l'Occident* (San Francisco: The Ricci Institute for Chinese-Western Cultural History, 1995).

RICHARD E. STRASSBERG

of the hills are more overtly incised, especially in the articulation of the cliff in the lower left. The strokes follow parallel tracks without cross-hatching and are designed to indicate the harmonious, rhythmic flow of geomantic energy rather than to articulate the planes of a geometric solid in sunlight. The darker ink tones are used to emphasize the principal boundaries and arteries (*lunkuo* 輪廓) of the landforms. These more graphic contrasts contribute to an overall yin and yang patterning that rhythmically juxtaposes light and dark areas instead of indicating discrete objects illuminated by sunlight. The overall dynamic interplay between positive and negative spaces expresses a sense of cosmic unity based on the ceaseless transformations of the Way (*Dao* 道).[30] However, for Ripa—as with most other Catholic artists of the time—the revelation of the world by sunlight, together with other illusions of depth, symbolizes a religious experience designed to lead the viewer along a direct path to God.

Not all of the scenes in the prints primarily by Ripa himself evoke emotions that are consistent with the sentiments of Kangxi's poems. View 31, "Observing the Fish from a Waterside Rock" (Shiji guanyu 石磯觀魚), contains a menacing version of the overhanging cliff that somewhat undermines Kangxi's poetic expression of carefree joy while fishing in the pavilion below it. While the somberness of View 17, "Untrammeled Thoughts by the Hao and Pu Rivers" (Hao Pu jianxiang 濠濮間想), accords with the emperor's tranquil and contemplative mood, the similar treatment in View 22, "Orioles Warbling in the Tall Trees" (Yingzhuan qiaomu 鶯囀喬木), does not match his theme of active engagement in listening to birds and selecting horses for the hunt. But Ripa's representation of the sky and the currents in the stream in View 28, "Shapes of Clouds and Figures in the Water" (Yunrong shuitai 雲容水態), does bring out Kangxi's poetic focus. (Both of these areas are left empty in the woodblock print.) One plate, in particular, may come closest to capturing the emperor's anxieties about growing old that are implicit, though not directly expressed in his poem. In View 16, "Clear Sounds of a Spring in the Breeze" (Fengquan qingting 風泉清聽), the emperor optimistically celebrates a favorite spot where the natural elements are believed to enhance longevity. Ripa added a darkening sky, leafless trees, and dead tree trunks (albeit one that is germinating new growth), as well as a bare alpine mountain in back that is devoid of vegetation. This bleak autumnal scene evokes the physical reality of aging with its accompanying fears of mortality that the emperor struggled with during the final decade of his life.

It does not appear that Kangxi perceived any irony in Ripa's engravings when the first complete set was presented to him on April 24, 1714. Ripa had bound it into a book, probably in the Western style similar to the copy at Dumbarton Oaks. The Chinese and Manchu versions of the *Imperial Poems* were printed in batches rather than in a single run. As with these books, Ripa's engravings were bound in different formats, and various kinds of paper were used, including European paper. Some sets were bound folded in Chinese style together with the printed texts. One recently reprinted set contains only the emperor's descriptions and poems. These were transcribed by a favored official and calligrapher Wang Cengqi 王曾期

30 This is one of the plates where Zhang Kui's name appears. See the copy in the Peabody Essex Museum, Salem, Massachusetts. The four characters on the cliff were certainly engraved by a Chinese artist, as Ripa would not have achieved this technical level in calligraphy.

(fl. early eighteenth century) without the extensive annotations and the "Postscript." Such a deluxe edition was probably meant for the emperor himself.[31]

Very soon after finishing the Thirty-Six Views, Ripa began to send sets back to Europe on his own. On August 26, 1714, he sent two of the volumes to Father Alesandro Bussi in Rome, requesting that one be given to Clement XI. In the accompanying letter, he wrote:

> I reflect that in it I portray, though in rough outline, the famous delights of this supreme monarch, and that I was guided by no other motive than that of serving the Sacred Congregation [i.e., the Propaganda Fide] in these calamitous times. I do consider that it is fit to satisfy the curiosity of anyone who wishes to have a rough idea of these pleasant places; and to observe an evident sign of the divine providence which has enabled me to do this small thing, which I consider was not inconsiderable for one who has had no teacher; and which has given such pleasure to the said monarch, who has always praised it with these words: *"hao, hen hao,"* that is, "good, very good"; and once more added *"pao pei,"* that is, "They are treasures." Up to the present this supreme monarch has accepted from us about seventy volumes, all, in fact, that I have offered him. Some he gave to his sons and daughters, a good many to other royals, and some he retained in his own palace, where he also preserves the articles that have just been presented to him by the Tribunals of Yansintien [Yangxindian 養心殿] and Wintien [Wuyingdian] . . . I think your Reverence may be curious to see the originals of the "delights" that they gave me to engrave, so I include one of them here. His Majesty had the originals made by a Chinese. I declared that I did not know how to paint in their style, but that I had the idea and that I would copy their style, which I have done. This painter is one of the best that His Majesty has here, and is fairly good with oils.[32]

31 Ripa, *Giornale (1705–1724)*, 2:136, "April 24, 1714." See also the Manchu memorial of August 28, 1713, from the officials in the Imperial Printing Office. It indicates that on July 29, Kangxi had ordered that they use the European paper stored in the Hall for Cultivating the Mind (Yangxindian 養心殿), the office that directly supervised the missionary-artists. Four sample copies of the text were to be printed and held for binding until the copperplate engravings were finished. The officials reported that the palace had about 18,400 sheets of this paper suitable for printing. See Guan and Qu, *Kangxi chao manwen zhupi zouzhe quanyi*, no. 2228. For a facsimile reprint of the Wang Cengqi edition, see Kangxi emperor, *Tongban Yuzhi Bishu shanzhuang sanshiliu jing shitu*.

32 Ripa, "Letter to Father Alesandro Bussi," translation provided by the New York Public Library. Alesandro Bussi served at the Chiesa Nova (Santa Maria in Vallicella) in Rome and was addressed by Ripa as his "Superior and Colleague." "Yansintien" (i.e., Yangxindian) refers to the Hall for Cultivating the Mind and "Wintien" (i.e., Wuyingdian) to the Hall of Military Glory, which housed the Imperial Printing Office. The Chinese painter of the originals that Ripa mentions probably refers to Shen Yu. It is also probable that Ripa enclosed one of the woodblock prints that he and his assistants traced—not a leaf from a painted album. This letter was pasted into the album formerly in the collection of Lord George Macartney, who led the British embassy to China in 1793 and was received at the Mountain Estate. It was later acquired by Sir Thomas Phillipps (1792–1872), who was considered the greatest British bibliophile of his time. The thirty-six images are mounted, unfolded, on paper in a Western-style leather bound album with "Chinese Views" and "Ripa" embossed on the spine. Each image bears the Chinese title of the View written by a

Clearly Kangxi intended to distribute Ripa's engravings to an even more exclusive readership than those containing the woodblock illustrations, and there is no evidence that he wished to disseminate them abroad. Yet, Ripa soon began to receive requests for copies that he apparently kept for himself. Some sets were later brought to Europe by returning missionaries. Giuseppe Cordero (Luo Ruode 羅若德, 1665–1740) of the Propaganda Fide stated in a letter dated June 22, 1719, that he possessed four sets; he would bring back one in a bound volume for Cardinal Francesco Barberini (1662–1738), and would give two sets to others.[33] Given the number of copies in Western collections today, Ripa must have sent or brought back himself some twenty or more sets. Some were folded and bound, and some were unbound and unfolded. Some have no additional markings, others bear Chinese titles written in ink. Some also have his Italian translations of the titles, and others contain both his translated titles and his additional handwritten comments.[34]

Following the completion of the Thirty-Six Views, Ripa was ordered to begin engraving the monumental *Complete Map of the Empire* (*Huangyu quanlan tu* 皇輿全覽圖) on May 22, 1714. This project—which consisted of forty-four plates bound into one volume—was completed around 1717.[35] The map and the Thirty-Six Views were to be his major cultural accomplishments while in China. His training of apprentices in the technique of copperplate engraving was also carried on after him. It was undoubtedly his skill as a copyist that suited him to

Chinese calligrapher on a slip pasted in the upper right margin. This set of engravings seems unrelated to the two bound volumes mentioned in Ripa's letter, however.

33 The set intended for Cardinal Francesco Barberini is probably the one he donated to the Vatican Library in November 1720 (Biblioteca Apostolica Vaticana, Mss. Fondo Stampe, Barberini Oriente, 147-13). See Ripa, *Giornale (1705–1724)*, 2:xx. For an excerpt of part of Cordero's letter translated into French, see Christophe Commentale, "Ripa, graveur aquafortiste et la tradition de la gravure sous les Qing," in *La conoscenza dell'Asia e dell'Africa in Italia nei secoli XVIII e XIX*, ed. Aldo Gallotta and Ugo Marazzi (Naples: Istituto Universitario Orientale, 1985), 2:189–209.

34 In addition to those in private collections, the following institutions hold copies: Biblioteca Apostolica Vaticana; Biblioteca Nazionale di Napoli; Bibliothèque nationale de France; Bodleian Library (Oxford); Canadian Center for Architecture (Montreal); Dresden Print Room; National Library/Palace Museum (Taiwan); British Museum; British Library; Dumbarton Oaks Research Library and Collection (Washington, D.C.); Morgan Library (New York); New York Public Library; Peabody Essex Museum (Salem, Massachusetts); and the Philadelphia Museum of Art. Some of these sets are missing one or more plates, while other sets were divided up and dispersed through the art market.

35 Since Kangxi had originally expressed interest in engraving the *Complete Map of the Empire* in 1711, it is possible that engraving the Thirty-Six Views was really intended to enable Ripa to gain technical experience and to train assistants in preparation for this more important enterprise. Several copies of Ripa's map made their way to Europe, including the copy presented to King George I (r. 1714–1727), now in the British Library. For a reproduction of the map, see Wang Qianjin 汪前進 et al., eds., *Qingting sanda shice quantu ji* 清廷三大实测全图集 [Three Maps Based on Surveys from the Qing Dynasty Court] (Beijing: Waiwen chubanshe, 2007), vol. 1; and for photographs, see Michele Fatica, *Sedi e palazzi dell'Università degli Studi di Napoli "L'Orientale" (1729–2005)* (Naples: Università degli Studi di Napoli "L'Orientale," 2005), 88; and Fatica, *Matteo Ripa e il Collegio dei Cinesi di Napoli (1682–1869)*, 206–208. For a study of Ripa and the maps, see Albanese, "La carta geographica di Matteo Ripa"; and Albanese, "Matteo Ripa e la carta geografica dell'Impero Cinese commissionata da Kangxi." According to Li, "Ma Guoxian yu tongban Kangxi *Huangyu quanlan tu* de yinzhi jianlun zaoqi Zhongwen ditu zai Ouzhou de chuanbu yu yingxiang," 126, forty-one of the original plates by Ripa were discovered in the former Qing palace in Shenyang in 1921 and were later reprinted.

this work, as none of his paintings were preserved. Beyond these two engraving projects, Ripa did not have much more to say about his artistic activities, which he always regarded as just a means to further his work as a missionary. In 1715, he was joined by Guiseppe Castiglione, today considered the most accomplished among all the missionary-artists who served the Chinese emperors. It was Ripa who formally presented Castiglione to Kangxi on November 22, acting as his interpreter. He later expressed admiration for Castiglione's superior talent, and they were apparently congenial colleagues for eight years.[36]

The final years of Kangxi's reign were increasingly difficult ones for Ripa and led to his decision to leave China. In his spare time, Ripa had established a small school to train Chinese boys for the priesthood, but he faced much opposition. The position of the court missionaries was always somewhat precarious, as it was dependent on continually pleasing the emperor in order to sustain his interest in Western culture. For Ripa and his group from the Propaganda Fide, it was particularly complicated. They had to publicly support Kangxi's position on the Chinese rites and to defend themselves against antagonists among the Jesuits and various court and provincial officials. At the same time, they were surreptitiously assuring the pope and his representatives of their staunch loyalty to the Vatican. Kangxi naturally expected Ripa to articulate the Qing dynasty's point of view when serving as an interpreter and translator for visiting foreign emissaries. In 1720–1721, Ripa—along with other missionary-experts at the court—served in these capacities for the Russian embassy of Count Lev Vasilievich Izmailov (d. 1738).[37] But it was during the simultaneous visit of the second papal envoy, Carlo Ambrogio Mezzabarba (Jia Luo 嘉樂, 1685–1741), that the contradictions of Ripa's position could no longer be concealed. Like Tournon, Mezzabarba failed to convince Kangxi of the pope's view, and the emperor had by then hardened his attitude toward the Vatican and resolutely insisted that he would only tolerate Matteo Ricci's approach. When his suspicions were confirmed that Ripa and other missionaries were secretly sympathetic to Mezzabarba, he was so furious that, on January 18, 1721, he imprisoned them all. Although the emperor soon relented, Ripa's close associate Pedrini was less fortunate and was again imprisoned.[38]

36 Ripa, *Giornale (1705–1724)*, 2:207–208, "November 22, 1715." Ripa also related how, in the year after Castiglione arrived, the two of them together escaped from an onerous imperial command to paint in enamels by deliberately botching their assignments. See Ripa, *Giornale (1705–1724)*, 2:213, "March 31, 1716"; also Loehr, "Missionary-Artists at the Manchu Court," 55; and Loehr, "The Sinicization of Missionary Artists and Their Work at the Manchu Court During the Eighteenth Century," 803–815. For a study of Castiglione, see M. Ishida, "A Biographical Study of Guiseppe Castiglione (Lang Shih-ning), a Jesuit Painter in the Court of Peking under the Ch'ing Dynasty," *Memoirs of the Research Department of the Tōyō Bunko* 19 (1960): 79–121.

37 Count Izmailov's embassy on behalf of Peter the Great is described in Ripa, *Storia della Fondatione della Congregazione e del Collegio de' Cinesi*, 2:54–77, with an abridged translation in Ripa, *Memoirs of Father Ripa*, 115–126; see also John Bell, *A Journey from St. Petersburg to Pekin, 1719–1722*, ed. J. L. Stevenson (Edinburgh: Edinburgh University Press, 1966).

38 On Mezzabarba's mission, see Giacomo Di Fiore, *La legazione Mezzabarba in Cina (1720–1721)* (Naples: Istituto Universitario Orientale, 1989); Minamiki, *The Chinese Rites Controversy from Its Beginning to Modern Times*, 62–76; Thomas, *Histoire de la mission de Pékin*, 272–304; and Shen, "Ma Guoxian zai Zhongguo de huihua huodong jiqi yu Kangxi, Yongzheng de guanxi shulun," 93–98. During the visit, Ripa and other

The situation deteriorated rapidly after Kangxi died rather unexpectedly on December 20, 1722, following a brief illness. The fourth prince Yinzhen suddenly succeeded to the throne as the Yongzheng emperor under controversial circumstances, and the open conflicts between him and some of his brothers created an atmosphere of fear and suspicion that continued throughout his reign. The new emperor had no interest in Christianity and was wary of the missionaries, especially as some had supported one or another of the contenders among his brothers for the succession. Yongzheng immediately issued orders limiting the access of the missionary-experts to the palace and instead mostly relied on intermediaries in his dealings with them. In January 1723, he agreed to enforce Kangxi's final order to expel all missionaries in the provinces and to confine them to Guangzhou and Macao (with the exception of those in Beijing).[39] Ripa, Pedrini, and a few others managed to maintain their former access, even personally serving the new emperor on several occasions. But, by then, the struggles with the Jesuits and the emperor over the Chinese Rites Controversy, the intrigues and humiliations by supervising officials and eunuchs, the often oppressive working conditions, and the little

missionaries were ordered to translate Clement XI's papal bull "Ex illa die" of 1715 that again condemned the Chinese rites. Kangxi was infuriated to learn that it had been circulating among the missionaries in China for years despite the refutations that he had issued. After reading it, Kangxi wrote an angry response on the document concluding that Europeans should no longer be permitted to proselytize in China in order to avoid trouble. This was not immediately enforced, and the emperor died the following year. For a photographic reproduction of the Chinese text of the papal bull with Kangxi's comments, see Chen Yuan 陳垣, ed., *Kangxi yu Luoma shijie guanxi wenshu yingyinben* 康熙與羅馬使節關係文書影印本 [Photographic Reproductions of Documents Concerning Relations between Kangxi and Envoys from Rome] (Beiping: Gugong bowuyuan, 1932), no. 14; for a memorial with comments criticizing Ripa, Pedrini, and other missionaries involved in the Mezzabarba visit, see ibid., no 12. Excerpts from various other memorials involving Ripa and the Chinese Rites Controversy are presented in Luo and Lin, "Zhongguo guanfang wenxian dui Ma Guoxian de jizai ji Zhongguo dui Ma Guoxian de yanjiu," 66–67. Not surprisingly, Ripa's memoirs contain little about the visit, and he did not mention his own arrest. Unlike the pliable Ripa, the incautious Pedrini was more defiant of court protocols and his superiors, provoking Kangxi into arresting him again. He was only released in 1723 during an amnesty upon the accession of Yongzheng after Ripa petitioned the new emperor for clemency on his behalf. For Pedrini's trials and tribulations, see Thomas, *Histoire de la mission de Pékin*, 1:259–271, 291ff.

39 Under Yongzheng, the golden age of Catholic missionizing in China came to an end, and a century of suppression and persecution began. The new emperor was determined not be vexed like Kangxi by minor issues such as the Chinese Rites Controvery and was suspicious that priests and Christian converts in the provinces would foment rebellion like other heterodox sects. Thus, he readily approved a memorial in 1723 from the governor-general of Fujian to proscribe the religion throughout the country. This gradually eliminated Catholic missionary work or forced it underground in many places. Yongzheng also made an example of João Morão (Mu Jingyuan 穆敬遠, 1681–1726), a Portuguese Jesuit and colleague of Ripa's who had unwisely supported the ninth prince, Yintang 胤禟 (1683–1726), in the struggle for the succession. Both were imprisoned and exiled together in 1723. Three years later, the prince died. Morão was tortured, tried, executed, and his head was publicly displayed. Zhao Chang 趙昌 (d. 1723), one of the Manchu officials in the Hall for Cultivating the Mind who supervised the missionary-experts, was also destroyed for supporting the ninth prince. Partial to the Jesuits, Zhao had been Ripa's nemesis for years, and Ripa at least had the satisfaction of witnessing Zhao's downfall. These events, which undermined the position of all the missionary-experts at the Qing court, helped convince Ripa to leave China. By the end of Yongzheng's reign, there were only twenty-three missionaries left in Beijing. See Ripa, *Storia della Fondatione della Congregazione e del Collegio de' Cinesi*, 2:98–105; and Thomas, *Histoire de la mission de Pékin*, 1:309–315, 354.

progress he had made in proselytizing had taken their toll on Ripa.[40] The widening purges of his brothers and their factions that Yongzheng carried out convinced him that the political situation was becoming ever more dangerous and that the only hope for converting China was to train Chinese priests back in Naples. He, thus, applied on his own for permission to leave China and to return home, even though he was well aware that such permission was rarely granted to the missionary-experts, except in cases of serious illness. As Yongzheng was then officially in mourning for Kangxi, Ripa cleverly argued that the recent deaths of his own father and three of his uncles required him to return home in order to carry out his filial duties. He persuaded the third prince Yinxiang 胤祥 (Prince Yi 怡親王, 1686–1730), one of Yongzheng's most trusted brothers who was in charge of the missionary-experts, to support his request—though only after presenting the prince with all the valuable European objects in his possession. Permission was then quickly granted in remembrance of Ripa's many years of service to Kangxi. Ultimately, Ripa was treated generously when he departed: he was loaded down with valuable farewell gifts from Yongzheng and others, and he was permitted to take various possessions, such as sets of his engravings and five servants. Four of these servants were, in fact, his young pupils, who, together with their schoolmaster, he intended to train as priests back in Naples.[41]

Ripa left Beijing on November 15, 1723, and arrived in Guangzhou about two months later. There, he boarded a ship of the British East India Company on January 23, 1724, with his cargo of valuables and his "servants," arriving in England on September 7. In London, Ripa became a minor celebrity, as his arrival had been announced in the local press. He had been helped in his journey by the generosity of several British merchants, and he was immediately introduced to elite circles in England, including aristocrats at the court. Ripa found himself, literally, royally entertained, as King George I (r. 1714–1727) received him and interviewed him twice at length about China and the Qing court. He had several other meetings with the king and dined with members of the aristocracy. It was during one of these meetings that Ripa presented George I with a copy of his engraving of the *Complete Map of the Empire*, which was an extremely valuable piece of intelligence. In return, the king gave him a gift equivalent to three hundred Neapolitan ducats and cancelled any customs duties on his cargo, as did the directors of the British East India Company, which Ripa stated would have additionally

40 In a letter dated October 6, 1726, just a few years after Kangxi's reign, the Jesuit Antoine Gaubil (Song Junrong 宋君榮, 1689–1759) estimated that there were no more than four thousand Christians in Beijing. Only a handful belonged to official or literati families and even fewer were Manchus or other bannermen. The overwhelming majority were from the poorer classes of Han Chinese. Quoted in Thomas, *Histoire de la mission de Pékin*, 1:391. For a survey of recent revisionist views of the history of Christianity in China, see David E. Mungello, "Reinterpreting the History of Christianity in China," *The Historical Journal* 55, no. 2 (2012): 533–552.

41 Ripa, *Storia della Fondatione della Congregazione e del Collegio de' Cinesi*, 2:124–131; and Ripa, *Memoirs of Father Ripa,* 145–146. Yinxiang was then in charge of the Hall for Cultivating the Mind and was the primary intermediary between the missionary-experts and the emperor. Ripa received about two hundred small imperial porcelains and four bolts of imperial silk from Yongzheng. Kangxi's sixteenth son Yinlu 胤祿 (1695–1767) was also sympathetic to Ripa and gave him gifts when he departed. For biographies of these two princes, see Hummel, *Eminent Chinese of the Ch'ing* Period, 923–926. The four young Chinese became the first students at the Collegio dei Cinesi that Ripa later founded in Naples.

amounted to between five and six hundred ducats.[42] Ripa did not mention making similar gifts of the engravings of the Thirty-Six Views while in London, but it is possible that among the people he met there were those interested in new garden aesthetics, such as Richard Boyle, the 3rd Earl of Burlington (1694–1753), an architect and patron of the arts. One set, now in the British Museum, probably belonged to him.[43] Another set, now in the Morgan Library in New York, was bound in London, perhaps as early as the 1720s.[44] This suggests that sets of Ripa's engravings of the Mountain Estate could well have circulated in London from the time of his visit.

42 Ripa, *Storia della Fondatione della Congregazione e del Collegio de' Cinesi*, 2:194–195. 300 Neapolitan ducats at the time was approximately equivalent to $7,200 today. Similarly, 550 ducats would have been worth about $13,200. If the customs duties and other fees were calculated at 75 percent of the assessed value of the cargo, as Ripa stated, then the value of his cargo from China would have been roughly $16,500. Altogether, Ripa received about $20,400 in benefits from George I and the directors of the British East India Company after presenting the map. The historical ducat value and its equivalence in British pounds are based on Markus A. Denzel, *Handbook of World Exchange Rates, 1590–1914* (London: Ashgate, 2010), 131, 149, and for the dollar-pound conversion, see www.measuringworth.com, accessed May 12, 2015.

43 For a discussion of this set that asserts that it was obtained by the Earl of Burlington directly from Ripa when he passed through London, see Basil Gray, "Lord Burlington and Father Ripa's Chinese Engravings," *The British Museum Quarterly* 12, nos. 1–3 (1960): 40–43; for a contrary argument about its possible influence, see Patrick Conner, "China and the Landscape Garden: Reports, Engravings, and Misconceptions," *Art History* 2, no. 4 (December 1979): 429–440. David Jacques—in "On the Supposed Chineseness of the English Landscape Garden," *Garden History* 18, no. 2 (Autumn 1990): 191n16—suggested that it may have come into Burlington's collection later, between 1741 and 1751. Although the bookplate identifying it as part of Burlington's library at Chiswick is of a later date, the binding is similar to other books that were in his collection. It also resembles the eighteenth-century binding on the Morgan Library copy (see note 44). Originally, the album only contained thirty-four of the thirty-six images, unfolded and mounted on paper. The two missing ones from a different set were added in 1968. Two of the original images, Views 31 and 11, were recently reproduced in Clarissa von Spree, ed., *The Printed Image in China from the Eighth to the Twenty-First Centuries* (London: The British Museum Press, 2010), 114, 116. Each image contains a label pasted in the upper right margins with the Chinese names of the view written by a Chinese calligrapher similar to those on the New York Public Library copy. Below the images are captions in Ripa's handwriting containing his Romanizations of the Chinese and additional comments in Italian. The explanation for View 31 differs from the one in the Bibliotheca Nazionale di Napoli (I.G.75) set, while the one for View 11 is identical. This sequence of images also differs from that of other sets preserved outside China.

44 On the set in the Morgan Library formerly owned by Paul Mellon (1907–1999) and acquired in 1980, see Elizabeth Barlow Rodgers et al., *Romantic Gardens: Nature, Art, and Landscape Design* (New York: The Morgan Library and Museum, 2010), 78. The thirty-six engravings had been folded in the middle but then bound unfolded and unmounted in a red morocco, Harleian-style binding identical to that of another English book bound in London in 1719. Upside down on the bottom of the reverse side of View 17 is Ripa's handwritten title: "[Villa Imperi]ale di Inganterie d China In Tartaria divisa in 36 rami" (The Wonderful Locations of the Imperial Villa of China in Tartary in 36 Copperplates). The first two words are obscured by the binding. There are also two handwritten titles in English. One, written below the first image, is "Series of Landscapes designed and engraved by native Chinese artists." The other—written on the front inner cover by C. Barrow (fl. ca. 1845), probably a previous owner—is "Chinese Etchings & Paintings." The album also includes various Chinese export watercolors mounted on paper. Nowhere is Ripa's name mentioned.

During the first half of the eighteenth century, an interest in Chinese gardens gradually began to spread among the cultured classes, especially in England and France.[45] This was largely connected with the ideal of designing more natural landscapes that accorded with "the genius of the place," rather than creating outdoor spaces that celebrated the human transformation of the environment. In this primarily literary discourse, certain values and techniques attributed to the Chinese—as well as to other foreign or ancient styles—were invoked to legitimize a shift away from the baroque gardens that had spread throughout Europe. The latter were rejected for embodying formal rules of hierarchy, centrality, and geometry, as well as for indulging in ostentatious displays of artifice and ornamentation. They were seen to symbolize royal absolutism and other oppressive political influences from the Continent. Chinese imperial gardens, in contrast, were sometimes cited by English critics to extol the seemingly modest lifestyles of the emperors as models for monarchial reform in Europe. Dwelling in these more natural landscapes, the proponents argued, was consistent with the advocacy of natural rights and even free trade. At the same time, the increasing importation and local production of chinoiserie luxury goods was facilitating new forms of pleasure and sociality. Chinese gardens were also imagined as appropriately stylish settings for this heightened degree of consumption among the affluent, who, along with monarchs and aristocrats, increasingly included members of the ascendant commercial class.[46]

But the bits and pieces of information about Chinese gardens that circulated in Europe at the time were sporadically received and diffused through various sources that were often highly selective and inaccurate. Visual information about gardens was primarily available in the form of decorations on porcelains, furnishings, wall coverings, and other objects, in addition to paintings and prints. Books about China that circulated often included secondhand, fanciful representations. The most accurate descriptions of Chinese gardens were to be found in the letters and reports from the missionary-experts in Beijing, especially the Jesuits. These were sometimes anthologized, cited in other books, or recopied and quoted in the manuscript

45 The discussion about Chinese garden design followed complex currents in the course of the eighteenth century. There were proponents and detractors as well as nationalistic and political ramifications. After 1750, more accurate information began to arrive from China. Although the Chinese garden grew more controversial in England during the second half of the eighteenth century, enthusiasm continued to spread throughout the Continent, with notable examples constructed in France, Sweden, various German states, and Russia. For representative studies of these trends, see Patrick Conner, "China and the Landscape Garden: Reports, Engravings, and Misconceptions," 429–440; Yu Liu, *Seeds of a Different Eden: Chinese Garden Ideas and a New English Aesthetic Ideal* (Columbia: University of South Carolina Press, 2008); George H. Loehr, "L'artiste Jean-Denis attiret et l'influence exercée par sa description des jardins impériaux," in *La mission française de Pékin aux XVIIᵉ et XVIIIᵉ siècles* (Paris: Cathasia, 1976), 69–83; Bianca Maria Rinaldi, *The "Chinese Garden in Good Taste": Jesuits and Europe's Knowledge of Chinese Flora and Art of the Garden in the Seventeenth and Eighteenth Centuries* (Munich: Martin Meidenbauer Verlagsbuchhandlung, 2006); Osvald Sirén, *China and Gardens of Europe of the Eighteenth Century* (1950; repr., Washington, D.C.: Dumbarton Oaks Research Library and Collection, 1990); and Eleanor von Erdberg, *Chinese Influence on European Garden Structures*, ed. Bremer W. Pond (Cambridge, Mass.: Harvard University Press, 1936).

46 For studies and illustrations of European chinoiserie, including gardens, see Hugh Honour, *Chinoiserie: The Vision of Cathay* (London: J. Murray, 1961), 143–174; and Dawn Jacobson, *Chinoiserie* (London: Phaidon, 1993), 151–175.

RICHARD E. STRASSBERG

culture.[47] Their fragmentary information influenced writers such as the Dutch emissary Johann Nieuhof (1618–1672), who wrote an influential book after his trade mission to China in 1655–1657, and the English theorist Sir William Temple (1628–1699). Temple's essays, which were published in 1690, praised the irregularity of Chinese garden designs as worth emulating in the natural landscape gardens in England. He also expressed what was to become a common attitude toward the Chinese artistic style—namely, it did not appear to follow any known rules of proper aesthetic order.[48] Hence, for many admirers, its attraction lay precisely in its apparent freedom to create a delightful—and liberating—experience of nature.

The misreading of the garden in China reflected the asymmetry in cultural exchanges between China and the West: there was no equivalent in Europe of the missionary-experts at the Qing court. No one from China could authoritatively explain the aesthetics or construct an authentic example of a Chinese garden. Although some theorists perceptively grasped key elements, neither they nor local designers in Europe had access to Chinese building methods and materials. Nor did they realize that there were traditional Chinese architectural canons as rigorous as those in the baroque and neoclassical styles. Also unrecognized was the importance of the literary tradition, especially lyric poetry and Daoist philosophy, to understanding Chinese concepts of landscape.[49] European enthusiasts, thus, did not advocate the

47 For a comprehensive presentation of Jesuit and other missionary reports about Chinese gardens, see Rinaldi, The "Chinese Garden in Good Taste," 171–240, especially 231–238 on Ripa's engravings. These began as early as Matteo Ricci's report in 1608 about the gardens that he visited in Nanjing. It is possible that Ripa's descriptions of the Garden of Joyful Spring and the Mountain Estate included in his journal were also transmitted to Europe earlier in letters.

48 Rinaldi, The "Chinese Garden in Good Taste," 195. Following his return to Europe, Nieuhof published Het Gezandtschap der Neêrlandtsche Oost-Indische Compagnie, aan den grooten Tartarischen Cham [An Embassy from the East-India Company of the United Provinces, to the Grand Tartar Cham] in 1665, which was translated into several languages. William Temple's essays "Upon the Gardens of Epicurus" and "On Heroick Virtue" published in 1690 are regarded as inaugurating the discourse on the natural garden in England. See William Temple, Miscellanea, the Second Part: In Four Essays (London: Simpson, 1690); and "Upon the Gardens of Epicurus: Or, Of Gardens, in the Year 1685," in The Genius of the Place: The English Landscape Garden 1620–1820, ed. John Dixon Hunt and Peter Willis (Cambridge, Mass.: MIT Press, 2000), 96–99. For the reception of the Chinese garden in England, see Liu, Seeds of a Different Eden; and Jacques, "On the Supposed Chineseness of the English Landscape Garden."

49 Sir William Chambers (1723–1796) came closest in his attempts to study, publicize, and construct a more authentic version of Chinese landscaping and architecture in his time, but his efforts did not begin until the late 1750s. Despite having traveled to Guangzhou as a merchant and later becoming a well-connected architect, his more learned designs and theories also unavoidably fell into modes of chinoiserie. His most famous construction, the monumental pagoda at the royal estate at Kew (1761), is likewise a citation, probably of the Porcelain Pagoda at Nanjing. This iconic image was earlier popularized through an illustration in Nieuhof's book. Although an awesome achievement for its time, the pagoda at Kew only bears a general, external resemblance to its model, for Chambers did not utilize Chinese structural methods, materials, or ornamentation. See Janine Barrier, Monique Mosso, and Che Bing Chiu, eds. and trans., Aux jardins de Cathay, l'imaginaire anglo-chinois en occident: William Chambers (Besançon: Editions de l'Imprimeur, 2004); John Harris, Sir William Chambers, Knight of the Polar Star (London: A. Zwimmer, 1970); Marcia Reed and Paola Demattè, eds., China on Paper: European and Chinese Works from the Late Sixteenth to the Early Nineteenth Century (Los Angeles: The Getty Research Institute, 2007), 124–129; and Richard E. Strassberg, "War and Peace: Four Intercultural Landscapes," in China on Paper, 89–137.

faithful replication of actual gardens found in China. Their intention was admittedly limited to including a few characteristic features within their own native gardens to achieve specific effects. By consciously employing modes of translation, citation, and adaptation, they sought to selectively incorporate signifiers of "the Chinese taste" to support a convincing illusion of natural simplicity. Picturesque elements—such as irregular lakes and streams, winding paths, and artificial rocks and hills—were used. Certain stereotypical plants, decorative motifs, and fanciful architectural structures (especially bridges, kiosks, pavilions, and pagodas) were deployed to stimulate a range of ideas and emotions. Instead of organizing all of the elements into a single, inclusive perspective, smaller compositional arrangements were assembled to gradually disclose a succession of scenes. These encouraged visitors to casually wander through the garden with expectations of surprise and delight instead of formally parading along tree-lined avenues. Tea drinking in small Chinese pavilions and other forms of outdoor entertainment constituted more relaxed forms of sociality and were welcome escapes from the more formal manners practiced inside the main house of an estate. Of course, the resulting garden would have hardly been recognizable to a Chinese visitor, and it is for good reason that some Europeans referred to this new kind of garden as the "jardin anglo-chinois."[50]

When Ripa arrived in London in 1724, the famous "Chinese House" (1738) at Stowe, which was the first significant attempt to include a Chinese-style building in an English garden, had not yet been constructed. Awareness of the Chinese garden was still primarily conveyed through a literary discourse unsupported by visual evidence from eyewitnesses. Ripa's engravings and comments would have certainly conveyed authentic information hitherto unknown to Europeans. Unfortunately, more specific information about the reception of Ripa's engravings during this early period has not yet come to light. A good indication of how they were viewed appears a few decades later, however. By then, Ripa had already passed from the scene, as the fashion for Chinese-style gardens began to reach a crescendo in England. In a letter dated September 19, 1751, the writer Joseph Spence (1699–1768) listed sixteen principles of garden design, including "To follow Nature." He maintained:

> Our old gardens were formed by the rule and square, with a perpetual uniformity and in a manner more fit for architecture than for pleasure-grounds. Nature never plants by the line, or in angles. I have lately seen thirty-six prints of a vast garden belonging to the present emperor of China: there is not one regular walk of trees in the whole ground, they seem to exceed our late best designers in the natural taste almost as far as those do the Dutch taste, brought over into England in King William's time.[51]

50 See, for example, the titles to illustrations of such gardens published by Georges-Louis Le Rouge (ca. 1712–ca. 1792) in 1776–1789 in Paris. This publication is cataloged in Reed and Demattè, *China on Paper*, 216.

51 Joseph Spence, *Observations, Anecdotes, and Characters of Books and Men: Collected from Conversation,* ed. James M. Osborn (Oxford: Clarendon Press, 1966), 2:647. Spence was a writer who served as a professor of poetry and modern history at Oxford. The following year, under the penname Sir Harry Beaumont, he

The thirty-six views that Spence mentions could only have been a set of Ripa's engravings. Further on in the letter, he discussed borders and fences, providing a sketch of a simple design that he claimed was the most common in the garden of the Chinese emperor. He recommended the authentic form that he found in the engravings and disparaged the style then in fashion known as "Chinese rails." Spence advocated that light areas predominate over shady areas in the garden to create a joyous, rather than a melancholy, atmosphere, and he praised Chinese garden designers as superior in this respect.[52] Parenthetically, he also mentioned that new versions of eighteen of the engravings that he saw were being prepared for a forthcoming publication in London. This publication was *The Emperor's Palace at Pekin, and His Principal Gardens . . .* , which appeared in 1753. Of the twenty engravings numbered and bound together in this volume, the first reproduces Johann Nieuhof's 1665 illustration of the Hall of Supreme Harmony (Taihedian 太和殿) in the Forbidden City and the last presents a Mogul throne in Delhi. In between them are eighteen reiterations of the Mountain Estate selected from Ripa's Thirty-Six Views.[53] The method of reproduction was virtually the same as the one that Ripa employed when working with the Chinese woodcuts—that is, the composition, architecture, and landscape were traced exactly from Ripa's engravings. The new engravings, thus, maintain the same scale as the originals.[54] But a comparison readily indicates the technical sophistication of the professional European engravers as well as the superior materials at their disposal. The unevenness of Ripa's set is replaced by a more consistent

published his English translation of the missionary Jean-Denis Attiret's (Wang Zhicheng 王致誠, 1702–1768) influential letter describing the Yuanmingyuan. It was written in 1743 and published in France in 1749. On the influence of Attiret's letter, see Loehr, "L'artiste Jean-Denis Attiret et l'influence exercée par sa description des jardins impériaux"; and Rinaldi, *The "Chinese Garden in Good Taste,"* 198ff.

52 Spence, *Observations, Anecdotes, and Characters of Books and Men: Collected from Conversation,* 2:648–649. Spence specifically called this criss-cross design "Palladian rail, or wattles," saying that it was the most common type in the emperor of China's garden. It only appears on two bridges in the illustrations, however. See Views 33, 34, and 35.

53 The complete title is *The Emperor of China's Palace at Pekin, and His Principal Gardens, as well in Tartary, as at Pekin, Gehol and the Adjacent Countries; with the Temples, Pleasure-Houses, Artificial Mountains, Rocks, Lakes, etc. as Disposed in Different Parts of Those Royal Gardens.* It was printed and sold by a group of London commercial publishers who also issued prints and other books about China. There is no accompanying text, and, despite the title, no indication that Plates 2–19 specifically illustrate the Mountain Estate or that they were based on Ripa's engravings. The order of the views does not follow the original Chinese woodblock sequence. It is quite possible that only eighteen out of the Thirty-Six Views were chosen because the print of the Mogul throne already existed and was numbered "20." Though Plate 20 is of a different size and style and is unrelated in content, the publishers apparently wished to market the remaining copies by including it in this book. The Nieuhof illustration, however, was re-engraved for this publication to serve as an introductory image. For a description of the copy in the Getty Research Institute, see Reed and Demattè, *China on Paper,* 122–123, 206–207. The entire book may be viewed online at The Getty Research Institute Digital Collection, ID# 92-B26685.

54 The dimensions of the images and the measurements of the architectural elements are exactly the same in both sets. Only London Plate 3 (View 36) significantly altered Ripa's composition. A large white horizontal area in the upper half of the image that originally denoted mist was transformed into a lake with sailing vessels. Whether this was a misreading, as Loehr maintained in "The Sinicization of Missionary Artists and Their Work at the Manchu Court during the Eighteenth Century," 801, or simply an artistic decision, is difficult to assess.

style in the London images, thus resulting in scenes that project a pervasive, bucolic atmosphere of harmony and pleasure. In almost all cases, the sky and water areas have been filled in and further elaborated, while the shapes of the shadows in the water are more realistic.[55] The strong and sometimes dramatic contrasts in Ripa's images are muted by subtler tonal gradations. The lines are also more controlled and delicate, always descriptive rather than calligraphic, with some land surfaces completely textured. In some cases, the composition has been slightly improved by altering the shapes and leaves of the trees. Ripa's amateur images have a graphic emphasis that appeals to the modern eye, but eighteenth-century viewers (even those in China) would certainly have regarded the more refined English version as a considerable improvement.

The most striking difference between the two sets is that the London engravers Europeanized Ripa's engravings even further by catering to the chinoiserie imagination. A variety of human figures—as well as boats, birds, animals, and additional architectural elements—were added to animate the scenes (Figure 4). Many of these elements were copied from earlier published illustrations. Most are improbable and some are quite fantastic. The abundant boats are out of scale to each other and to the architecture, making the scenes appear far more extensive and impressive. Activities showing people swimming, sailing, picnicking, farming, and fishing would not have occurred in these locations at the Mountain Estate. The clothing worn by the figures is inaccurate and the additional buildings placed in the distance appear more Western than Chinese. Most preposterous is a swimmer grasping hold of a dragon-like water serpent and the huge Chinese phoenixes soaring in the air. But the choice of views, which favored those with pavilions, villas, and bridges by irregular streams and lakes, would have accorded with English conceptions of a natural garden.

The London engravers also included at the bottom of each plate even more awkward English translations of Ripa's wooden Italian renderings of the Chinese names of the views as well as some of his brief comments. For example, the poetic name of the bridge in View 34, "A Long Rainbow Sipping White Silk" (Changhong yinlian 長虹飲練), which Ripa rendered as "Arco baleno che succhia l'acqua" (A Rainbow that Sucks at the Water), became in Plate 12 "The Lightning Arch, that Sucks in the Water."[56] *The Emperor of China's Palace at Pekin* was also reissued in the late eighteenth and early nineteenth centuries by another publisher, who had obtained the original plates.[57] Although Ripa did not wish to be known as an artist, especially after his return to Europe, it is nevertheless remarkable that his name does not appear in *The Emperor of China's Palace at Pekin* nor in the existing sets of his engravings. And since he did not include his signature in his engravings, few people knew of his role until Professor Paul

55 The only exception is London Plate 19 (View 3), which leaves the sky area empty.

56 Ripa's Italian caption is taken from the copy in the British Museum that is associated with the Earl of Burlington. The entire set may be viewed online through the collection database at the British Museum under "Thirty-Six Views of the Imperial Summer Palace at Jehol," ID# 1955,0212,0.1.1.

57 This was Robert Wilkinson (fl. 1779–ca. 1835). See note 58.

Pelliot's (1878–1945) research in the 1920s.[58] Yet *The Emperor of China's Palace at Pekin* must have had a much wider circulation among a broader reading public than Ripa's engravings, which were mostly passed down in private collections. It is quite possible, then, that the authentic information about the Mountain Estate that was transmitted by Ripa was most influential in the form of these more fantastic iterations that were created and circulated after he had died.

When Ripa's engravings reached the West, they underwent a transformation in meaning, as they were reframed within the contemporary European understanding of China. Ripa himself contributed to this misrepresentation in the way that he presented them in his handwritten comments. None of these sets of engravings contained Kangxi's poems or descriptions, and virtually no one in Europe at the time could read Chinese anyway. Thus, those who saw the prints were completely unaware of these scenes as illustrating a complex, literary self-portrait by Kangxi. Nor did Ripa's prosaic translations of the names resonate beyond indicating the emperor's sensitivity to nature. He did not realize the importance of the original sequence of the views for providing a narrative shape that was intended to guide the reader on a virtual journey in the mode of a painted landscape scroll. Most of the sets of his engravings in Western collections were bound in haphazard order, and even those sets that Ripa numbered himself differ from each other. Most importantly, Ripa's comments emphasized how the locations functioned within the emperor's personal lifestyle. This, as much as the aesthetics of Chinese garden design, was a preponderant interest of the Europeans who looked at such images as sources of information.

Since the late sixteenth century, European readers had become increasingly interested in trying to understand China through the character of its emperors. In the age of monarchies, nations were often judged through the personalities and habits of their rulers, and these were generally conveyed through idealized portraits and depictions of palaces, as well as through anecdotal information about their behavior. In addition to general books about China, a few illustrated volumes were reproduced that extolled Confucius and virtuous rulers in Chinese

58 See Paul Pelliot, "La gravure sur cuivre en Chine au XVIIIᵉ siècle," *Byblis* 2 (1923): 104–107; Loehr, "The Sinicization of Missionary Artists and Their Work at the Manchu Court during the Eighteenth Century," 801; and Loehr, "L'artiste Jean-Denis Attiret et l'influence exercée par sa description des jardins impériaux," 76. Pelliot obtained a set of Ripa's engravings that was formerly in the collection of Thomas Philip, Earl de Grey (1781–1859), an amateur architect who was the first president of the Society of British Architects. He also obtained a copy of *The Emperor of China's Palace at Pekin,* which was later reissued by Robert Wilkinson (fl. 1779–ca. 1835), a London publisher who indicated in a note dated May 1829 that the original plates had by then been destroyed. Pelliot identified the English captions in *The Emperor of China's Palace at Pekin* as translations of Ripa's based on Ripa's handwritten Italian comments on the Earl de Grey set. These two sets later passed into the collection of the art historian George R. Loehr (1895–ca. 1973), who mentioned that the Wilkinson set was hand-colored. But Loehr mistakenly believed that Wilkinson was the original publisher in 1753. It is not known when the Earl de Grey set entered England, but it is not impossible that Ripa presented it to someone when he passed through London. Lord Macartney's copy in the New York Public Library contains "Ripa" on the binding; but he was aware of Ripa's Collegio dei Cinesi in Naples. More typical of the subsequent erasure of Ripa's role is the title inscribed on the Morgan Library copy, which describes the set as done by "various Chinese artists." There is also no mention of Ripa in the Dumbarton Oaks set despite the inclusion of his inscribed title in Italian.

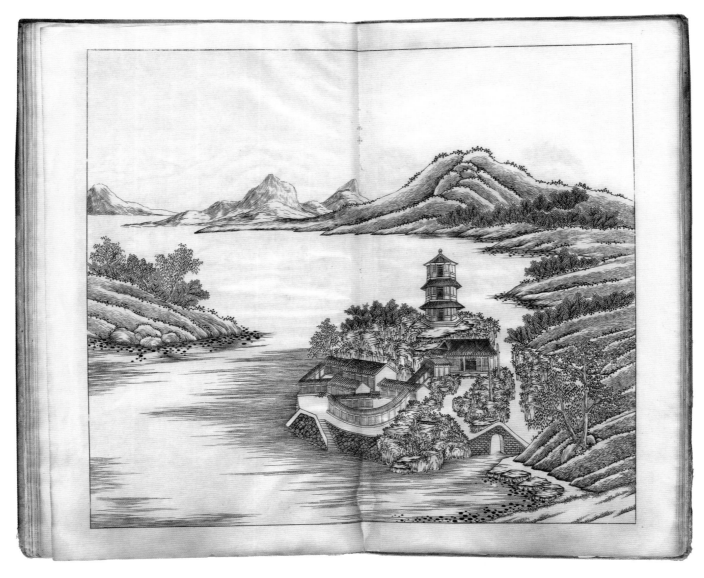

figure 4

Copperplate engravings of View 18, "The Entire Sky Is Exuberant" (Tianyu xianchang 天宇咸暢).

Above: Ripa's engraving is titled "The Figure of the Sky is Perfectly Delightful" (Figura del cielo perfettam.ᵗᵉ dilettevole). Dumbarton Oaks Research Library and Collection, Washington, D.C.

Facing page: Plate 6, "The Figure of Heaven is all Delightful," from *The Emperor of China's Palace at Pekin, and His Principal Gardens, as well in Tartary, as at Pekin, Gehol and the Adjacent Countries; with the Temples, Pleasure-Houses, Artificial Mountains, Rocks, Lakes, etc. as Disposed in Different Parts of Those Royal Gardens* (London: Robert Sayer, Henry Overton, Thomas Bowles, and John Bowles and Son, 1753). The Getty Research Institute, Los Angeles (92-B26685).

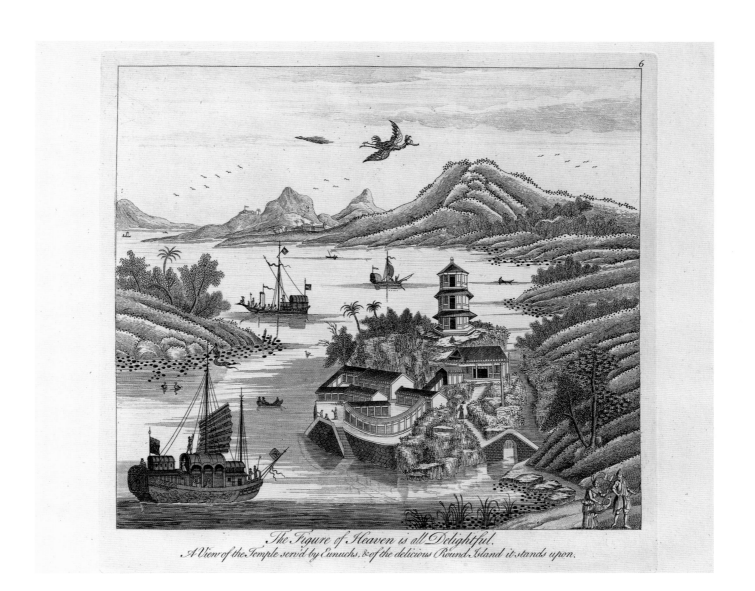

The Figure of Heaven is all Delightful.
A View of the Temple serv'd by Eunuchs, & of the delicious Round-Island it stands upon.

history. These helped to promote the ideal of a philosopher-king during the Enlightenment as a means of reforming monarchial absolutism and curbing royal extravagance. In the late seventeenth century, a flattering biography of Kangxi began to circulate that presented him as a model ruler. This was further supported by many positive reports from the Jesuit missionary-experts at the Qing court, who were anxious to build support for their efforts to convert China.[59] When Europeans viewed Ripa's engravings of the Mountain Estate, many probably compared what seemed to be small rustic pavilions situated in a natural landscape with the artifice and grandiosity of Versailles and similar European palaces and estates. Since Ripa's images were presented as individual views, it would not have been apparent how vast the Mountain Estate was nor would the readers have realized how expensive it was to build and maintain. Ripa's commentary on where the emperor resided and worked presented a simple, modest lifestyle that Europeans could only wish for in their own sovereigns.

At the same time, Ripa's comments, in contrast to the range of themes in Kangxi's poems, also present the Mountain Estate as a villa where the emperor went to enjoy his favorite pleasures, as many of the views are identified by him as places of recreation. In accordance with Chinese decorum, Kangxi nowhere mentioned his wives, who altogether numbered around sixty-four. But Ripa was well aware of his audience's interest in the emperor's private life when he indicated on a number of the views where Kangxi's wives dwelled or where he would relax with them on his frequent excursions. These statements avoid the critical moral judgments voiced in his journal, where he asserts disapprovingly that the emperor spent most of his time at the Mountain Estate in the company of his favorite women.[60] Instead, his comments catered to his viewers' curiosity about the imperial harem by providing a voyeuristic tour of a delightful fantasy world, which was further underscored in *The Emperor of China's Palace at Pekin.*

Ripa returned to Naples in late November 1724 with the cargo and money he had brought from China and Britain. He spent the next seven years navigating the complex politics within the Catholic Church and the shifting governments in Naples in order to establish his Collegio dei Cinesi, which he insisted remain independent of any particular

59 A selection of these early books was exhibited at the Getty Research Institute and cataloged in Reed and Demattè, *China on Paper.* See also David E. Mungello, *The Great Encounter of China and the West,* 111–123. A flattering biography of Kangxi by the Jesuit missionary Joachim Bouvet (Bai Jin 白晉, 1656–1730), *Histoire de l'empereur de la Chine (Cang-Hy),* first appeared in 1697. Dedicated to Louis XIV, it was quickly translated into two languages and reprinted a number of times. It was Bouvet who recruited Gherardini to serve as a court artist, and he was later appointed one of the primary cartographers for the *Complete Map of the Empire.* By the mid-eighteenth century, such figures as Voltaire (1694–1778) were advocating that European monarchs emulate the Chinese emperors. See Strassberg, "War and Peace," 95–96.

60 Some of the unflattering observations of Kangxi that Ripa included in his journals clearly attempted to deflate the unrealistic portrait of the emperor disseminated by Jesuits such as Bouvet. While Ripa acknowledged that Kangxi was a man of considerable intelligence who had a great interest in Western technology and learning, he denied that the emperor had achieved competency in such subjects as mathematics and music, as many Europeans had been led to believe. Ripa, in particular, expressed disapproval of polygamy, foot-binding, and of what he claimed was the near-constant attendance of the emperor's favorite wives at the Mountain Estate. See, for example, Ripa, *Giornale (1705–1724),* 2:25; *Memoirs of Father Ripa,* 2:75–76, 128–129; and *Storia della Fondatione della Congregazione e del Collegio de' Cinesi,* 2:78–81.

religious order.[61] In addition to gaining the necessary official permissions by April 1732, he was also quite successful in raising funds for its buildings and endowment. It is probable that many of the sets of the Thirty-Six Views now in Western collections, especially those with his handwritten comments, were originally exchanged for donations or sold to collectors at this time. In his later years, Ripa also became something of a local celebrity in Naples; he was sometimes sought out by prominent visitors to the city, such as the French philosopher Montesquieu (1689–1755), who met with him in 1729. Ripa died in Naples on March 29, 1746, shortly after finishing the last revisions to his journal.

Ripa regarded his engravings as but a means to please Kangxi in order to facilitate his missionary activities. Yet they have proved to be as important a legacy as his memoirs and his founding of the Collegio dei Cinesi. As one of the European artists who served the Qing court, he can be seen as having occupied a transitional position between the first wave of missionary-experts (which lasted from Ricci to Gherardini) and the second wave (which began with Castiglione). His training of Chinese engravers also introduced a technical skill that continued under Castiglione and that later resulted in more court publications employing copperplate engraving, including the exquisite set of twenty views of the European Pavilions 西洋樓 (Xiyanglou, 1747–1860) in the Garden of Perfect Clarity that were printed in 1783–1786.[62] Ripa's pioneering set of images of the Thirty-Six Views of the Mountain Estate reflected processes of cultural hybridization that were occurring on two continents. Within the Qing Empire, it expanded Kangxi's poetic representation of himself and his garden into an even more intercultural dimension beyond Han Chinese and Manchu imaginaries. When transmitted to Europe, these images were also reframed for a broader public as visual evidence of Chinese garden aesthetics and the imperial lifestyle. The nearly simultaneous appearance of these views on opposite sides of the world was a quantum event within an earlier process of globalization, like a particle sent forth that materializes in two places at once and whose ultimate meaning is only determined by the observer. The different receptions of their strange beauty reveal some of the profound cultural differences that existed and, to a certain extent, continue to play a role in the contemporary dynamics between China and the West.

The Dumbarton Oaks copy was acquired by Mildred Barnes Bliss (1875–1969) in 1955 from Emil Offenbacher (1909–1990), an antique book dealer in New York, to add to her collection

61 The Collegio dei Cinesi continued to operate on its own for more than a century after Ripa's death. Two Chinese students at the Collegio were selected as interpreters for Lord George Macartney's embassy to China in 1793. See Mungello, *The Great Encounter of China and the West*, 127–128. It also became a tourist attraction; a short account of a visit around 1840 by a German traveler, Karl August Mayer (1808–1892), was appended to the English translation of Ripa's memoirs in Ripa, *Memoirs of Father Ripa*, 171–174. The Collegio was secularized in 1888 and later incorporated into what is now the Università degli Studi di Napoli "L'Orientale." For a history of these schools, see Francesco D'Arelli, "The Chinese College in Eighteenth-Century Naples," *East and West* 58 (2008): 283–312; Fatica, *Sedi e Palazzi dell'Università degli Studi di Napoli "L'Orientale" (1729–2005)*; and Fatica, *Matteo Ripa e il Collegio dei Cinesi di Napoli (1682–1869)*.

62 For the set in the Getty Research Institute, see Strassberg, "War and Peace," 104–119; and Reed and Dematté, *China on Paper*, 204–205.

figure 5

Matteo Ripa, handwritten title appended to the Dumbarton Oaks copy of his engravings of the Thirty-Six Views: "La Villa Impèriale detta <u>Gê hô Kīng</u>, ouè l'Impèratorè dèlla Cina tiene lè sue Deliziè, e spècialm.te dèlla Caccia, è Pèsca &c" (The Imperial Villa of Jehol, where the Emperor of China Enjoys His Delights, Especially Hunting and Fishing, etc.). Dumbarton Oaks Research Library and Collection, Washington, D.C.

of rare books on botany and gardens. It contains the complete set of Ripa's thirty-six engravings. The images were backed, folded in the middle, attached to a spine, and bound as a Western-style book. The covers are of cardboard covered in Chinese imperial yellow silk. Unlike many versions now in Western collections, the order of the prints in the Dumbarton Oaks version follows the correct sequence of the Thirty-Six Views according to Kangxi's text.[63] Therefore, it may have been bound in China, where the original book could be referenced. Ripa had stated that the first complete set presented to Kangxi was bound in one volume; he also stated that he had produced seventy volumes for the emperor. It is quite possible, therefore, that this copy was similarly bound at this time. The engravings do not contain any titles in Chinese or Italian, or additional comments by Ripa. Pasted on the front fly-leaf is a handwritten title by Ripa in Italian: "La Villa Impèriale detta <u>Gê hô Kīng</u>, ouè l'Impèratorè dèlla Cina tiene lè sue Deliziè, e spècialm.ᵗᵉ dèlla Caccia, è Pèsca &c" (The Imperial Villa of Jehol, where the Emperor of China Enjoys His Delights, Especially Hunting and Fishing, etc.) (Figure 5).

63 It is clear from the different sequences in various sets of Ripa's handwritten comments on the engravings that he did not know or remember the original order of the Thirty-Six Views.

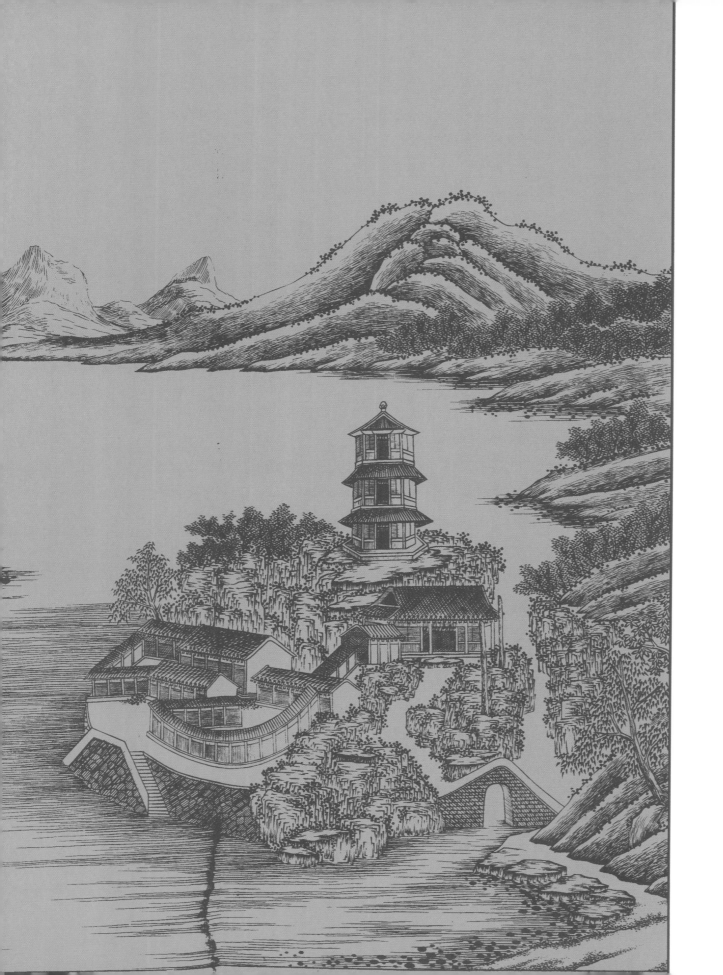

TRANSLATING THE LANDSCAPE

Genre, Style, and Pictorial Technology in the Thirty-Six Views of the Mountain Estate for Escaping the Heat

Stephen H. Whiteman

I n the late summer of 1711, the Kangxi emperor commemorated the completion of the Mountain Estate for Escaping the Heat with two acts of naming central to the garden building process, both imperial and private, as it had arisen in China over the previous millennium or more. A gilt bronze plaque bearing the site's permanent name, "Bishu shanzhuang" 避暑山莊, cast after the emperor's own calligraphy, was installed in the Inner Meridian Gate (Neiwumen 內午門), which stands in front of the formal audience hall, Calm and Tranquil, Reverent and Sincere (Danbo jingcheng 淡泊敬誠), located behind the main entrance of the part-palace (Figure 6).[1] Signaling through literary reference the emperor's most basic vision for the site, the name drew upon models set by historical rulers and sites to establish Kangxi's intention to govern the empire attentively while retreating from the oppressive environment of the Beijing summer.[2]

Shortly thereafter, Kangxi commissioned court artists to create a series of images depicting thirty-six scenic sites within the park's precincts. These compositions, the so-called Thirty-Six Views, served as pictorial complements to the emperor's literary descriptions of the

1 Chen Baosen 陈宝森, *Chengde Bishu shanzhuang Waibamiao* 承德避暑山庄外八庙 [The Mountain Estate for Escaping the Summer Heat and the Outer Eight Temples in Chengde] (Beijing: Zhongguo jianzhu gongye chubanshe, 1995), 4.

2 From the Kangxi emperor's poem to View 1, "Misty Ripples Bringing Brisk Air" (Yanbo zhishuang 烟波致爽), 124–125. For the "aspirational" aspect of naming in Chinese gardens, see John Makeham, "The Confucian Role of Names in Traditional Chinese Gardens," *Studies in the History of Gardens and Designed Landscapes* 18, no. 3 (Autumn 1998): 195–197.

garden's most scenic spots (*jing* 景).³ Imperial text and painted image were joined together in an album originally intended for the emperor's own consumption that was later transformed through printing into a book intended to share this private landscape with a broader audience. The two editions of the *Imperial Poems on the Mountain Estate for Escaping the Heat* reproduced in this volume—one woodblock printed, the other engraved in copperplate—represent a process of pictorial and material translation not unlike that which first rendered the emperor's Chinese texts in Manchu and has now brought the Chinese into English.⁴

3 The translation "View," with a capital "V," is used here to distinguish the View as a designated site within the garden or its pictorial representation from its more common usage as the object of one's field of vision from a given vantage point, sight, or prospect (e.g., "there is a spectacular view from the top of the mountain"). In this respect, Kangxi sought to emulate Chinese gardens even in the earliest iterations of imperial building at Rehe. Originally numbering sixteen, as attested to in Zhang Yushu's account of his visit to Rehe in 1708 (see Appendix 3), by the completion of the garden's construction under Kangxi in 1711, the number of Views had expanded to thirty-six. Kangxi's grandson, the Qianlong emperor, designated an additional thirty-six Views to match those of his grandfather. Qianlong's Views, to which he assigned three-character, rather than four-character, names, include a mixture of Kangxi-era sites and Qianlong-era construction. They are recorded in several extant painted albums (see below, note 34), but were never reproduced by the court in publications analogous to Kangxi's *Imperial Poems*.

4 In this essay, translation serves as a metaphor not only for transcultural interaction, but also, and perhaps particularly, for transmediality, which is to say, the creation of an image or object in a medium other than the one in which it was originally rendered. Others have considered the question of translation in early modern artistic production; for two recent examples, see Finbarr Barry Flood, *Objects of Translation: Material Culture and Medieval "Hindu-Muslim" Culture* (Princeton, N.J.: Princeton University Press, 2009);

An exploration of the Thirty-Six Views raises a wide variety of questions regarding the visuality and materiality of early Qing imperial art, the mechanisms of its production and dissemination, and the interlacing of these issues with the performance of imperial identity. Though ultimately important to a fully contextualized understanding of the *Imperial Poems*, many of these concerns necessarily extend beyond the scope of what follows; here, the focus will be on understanding cultural, visual, and technological appropriation, adaption, and recontextualization in the *Imperial Poems* as a process of translation particularly characteristic of the artistic, intellectual, and political milieu of the Kangxi court.

Originating as a unique album of painting and calligraphy, the *Imperial Poems* combined text and image to form a holistic intellectual, emotional, and multisensory environment that replicated the emperor's experience of visiting and dwelling within the garden. The transformation of the original album into an object intended for a broader audience through woodblock and copperplate printing was almost immediate and may have been part of the emperor's original conception for the work; in any case, the three versions were created so closely together in time and with such strong physical and visual similarities that the *Imperial Poems* is best understood as a work in which the material and conceptual realities of a unique object and those of the multiple coexist.

Produced in parallel Chinese and Manchu editions totaling four hundred sets, the woodblock-printed versions were perhaps intended as gifts at the celebration of the emperor's sixtieth birthday in 1713.[5] These volumes offered the viewer an unprecedented access to the

and Anton Schweizer and Avinoam Shalem, "Translating Visions: A Japanese Lacquer Plaque of the Haram of Mecca in the L. A. Mayer Memorial Museum, Jerusalem," *Ars Orientalis* 39 (2010): 148–173. The problem of transcultural interaction is, of course, central to the present case, particularly with respect to the issues of patron, artist, and audience that are at play between the multiple poles of Han Chinese culture, Manchu and Chinese language, multiple and multilingual audiences, and European artistic technologies and labor that are present in the various versions of the *Imperial Poems* discussed in this volume. Common examples of transmediality in art include the reuse of pictorial motifs on Chinese porcelain or French furniture of the eighteenth century. In these cases, the profound difference in materiality between the two mediums across which the image has moved is such that "translation" may no longer apply as a useful concept. Instead, the novelty of the pictorial transposition and the experience of visual echoes in new contexts help drive the interest in such works (my thanks to Susan Wager and Michael Hatch for their stimulating discussions of these examples). In the case of the *Imperial Poems*, however, the strikingly similar media at play, including album painting, woodblock printing, and copperplate engraving; the obvious material connections between different versions, such as nearly identical image sizes and related binding types; and, most importantly, the processes of production that in several cases began with some form of copying or close imitation, or with instructions to render an image from one cultural tradition into the artistic idiom of another, together suggest a pictorial analog to a tension that is at the heart of literary translation, namely the problem of preserving meaning created in one cultural and linguistic context in the process of rendering it legible in another. Here, the media of representation—painting, woodblock, and intaglio— are, in a rather oversimplified sense, much like languages, as they are capable of broadly similar expressive functions while also having distinct capacities and limitations particular to themselves. It is in highlighting these overlaps and exceptions, as well as the changes in representation and meaning that they engender, that the metaphor of translation is most apropos to what follows.

5 Guan and Qu, *Kangxi chao manwen zhupi zouzhe quanyi*, nos. 2001 and 2218. The exact audience for the *Imperial Poems* is not recorded, but based on the size of the print run relative to other imperial printing projects, it may be supposed to have included members of the imperial clan, other powerful figures within the

emperor's exclusive precincts. Bound so that the reader encountered the emperor's introduction and poem before turning to the first image, the virtual visitor's experience of each View was framed by the emperor's thoughts, with word and image complementing each other as the imperial tour progressed through the paper landscape. The images were printed from a single block on a full sheet of paper and folded in half—a rare technique that, when unfolded, presented the viewer with broad panoramas of the garden that were uninterrupted by the book's binding.

In combining text and image in this manner, the *Imperial Poems* drew upon the long history of poems and illustrations (*tuyong* 圖詠), a broad artistic genre dating to at least the Tang dynasty (618–907) that included scenes of famous sites and depictions of gardens. Canonized sets of famous views had long served as vehicles for perpetuating the collective memory of cultural landscapes in China proper,[6] as paintings and inscriptions passed between friends or were replicated for new owners through copying. With the explosion of commercial and vanity woodblock printing during the Ming dynasty (1368–1644), these images became available to a larger and more diverse audience, both through the consumption of comparatively precious books and through an increasingly shared visual culture. The depiction of an imperial landscape in this manner was unprecedented, however, as it represented an effort by the Kangxi court to engage non-imperial genres and modes of cultural production in pursuit of a more diverse communication of imperial identity, one which would become characteristic of Qing court culture.

In addition to their synergistic operation in tandem with the emperor's poems, the Views may be explored as independent illustrations, and, in particular, as a series of pictorial translations, first from brush and ink to woodblock and then from woodblock to copperplate. The landscapes depicted in the images are at once literal and idealized, as they portray the emperor's favorite sites in a highly rhetoricized manner that drew upon a range of Chinese and European stylistic and compositional conventions to convey Kangxi's particular vision of Qing imperial identity in pictorial terms. From this perspective, meaning resides not only in what the scenes depict or how they are described but also in the embedded references to other forms and styles: genres depicting, and contributing to, the formation of, cultural landscapes meant to frame the Qing dynasty in historically meaningful terms; painting styles current in the Qing court that incorporated diverse sources into a distinctively new manner; and even the physical object itself, which evoked the materiality

Qing conquest elite (such as Mongol leaders), and important officials within the palace; see Weng, *Qingdai neifu keshu tulu*, 15–17. It should also be considered that the nature of textual and material circulation in premodern China suggests the likelihood that the audience exposed to the emperor's texts and to the book itself extended beyond the original circle of recipients. While paintings of imperial gardens and palaces were produced by previous rulers, the nature of Kangxi's depiction of the Mountain Estate and the fact of its wider distribution via printing are without imperial precedent; see Whiteman, "Creating the Kangxi Landscape," 184–186.

6 "China proper" refers to the core regions that constituted unified Chinese empires since the Han dynasty, an area also roughly contiguous with the borders of the Ming. Referring to China proper helps remind us that "China" is itself a conceptual construction, or rather several overlapping but not identical constructions, of which territory is one.

of, and viewing practices associated with, the unique painted album after which the woodblock-printed book was created.

The Views went through not one, but two such pictorial transformations, as the woodblocks were then further reinterpreted through the unfamiliar European technology of copperplate engraving. Ordered by the emperor to create versions of the images in the European style, Matteo Ripa and his two Qing assistants executed prints that clearly represented new iterations of a familiar landscape, as they fundamentally transformed their models stylistically and materially. Divorced from the emperor's texts,[7] the copperplate engravings gained not only a new status as independent images but also a new audience, as many—perhaps most—of the engraved sets found their way to Europe upon Ripa's return in 1724.[8] Equally important, in these prints, the pictorial translation of the Views was not a closed, defined process that resulted in a single, coherent outcome, as in the woodblock prints. Rather, an open-ended process in which three artists—Ripa and his two Qing apprentices—approached the task of translation with different visual vocabularies and understandings of what constituted a picture resulted in an album of images that were stylistically and compositionally distinct from one another, thus calling into question what it meant for an image, or anything else, to be "in the European style" in the Qing court of the early eighteenth century.

When the last wars of conquest and consolidation finally concluded with the death of the Mongol khan Galdan in 1697, Kangxi faced the challenge of creating conceptually what he had finally succeeded in forming physically—a unified state comprised of peoples and territories historically constructed as "within and beyond the passes" (*guannei guanwai* 關內/關外), or "Chinese and foreign" (*Huayi* 華夷). Kangxi rejected the traditional Chinese valorization of the charismatic force of a Chinese civilization that absorbed non-Chinese populations through acculturation, instead articulating a vision for a state—the Qing Empire—that transcended such boundaries and divisions.[9] At the same moment, the Qing

7 The extant exceptions are two copies in which the copperplate engravings are joined with the emperor's poems in the calligraphy of, or after, Wang Cengqi (see notes 55 and 68). In his diary, Matteo Ripa suggests that at least some sets of the prints were bound with imperial poetry, but it is unclear from his description whether all thirty-six imperial poems were included, as in the two copies just noted; see Matteo Ripa, *Giornale (1705–1724)*, ed. Michele Fatica (Naples: Istituto Universitario Orientale, 1996), 2:82, "August 1, 1712."

8 While Ripa mentions on at least two occasions that the copperplate prints were intended as gifts for imperial intimates (Ripa, *Giornale [1705–1724]*, 2:83 and 2:136), all but two known surviving sets are now in Europe and America. Among the sets that I have personally examined (London, Washington, D.C., Philadelphia, and New York) or for which I have high-resolution photographs (Paris and Dresden), there is no evidence of the prints having been originally bound in a Chinese manner, suggesting that these sets arrived unbound with Ripa upon his return to Europe in 1724 (or in any case were not bound by the Kangxi court as gifts). The exception is the complete set in the Bibliothèque nationale de France, which appears to have originally been mounted and bound in China, though its current binding is a late eighteenth or early nineteenth century French leather one.

9 Elliott, "The Limits of Tartary," 603–646; and Stephen H. Whiteman, "Kangxi's Auspicious Empire: Rhetorics of Geographic Integration in the Early Qing," in *Chinese History in Geographical Perspective*, ed. Du Yongtao and Jeffrey Kyong-McClain (Lanham, Md.: Lexington Books, 2013), 34–54. It is important to note that this was a rhetorical position, not a legal one. Ethnically based distinctions were a notable part of Qing society, and at least some of the markers of ethnic homogeneity—the requirement that all men,

Empire was becoming more and more enmeshed in the global web of early modern international relations, a central element of which was Kangxi's great interest in European mathematics, science, and technology—all of which had an impact on the production of visual and material culture in the Qing court. The admixture of historical models and foreign ideas in various forms and iterations in both the *Imperial Poems* and the Thirty-Six Views produced images and objects that nonetheless formed coherent artistic and ideological expressions that reflected the diverse, yet coherent, aspects of empire and emperorship under Kangxi.

Constructing the View: Image and Association in the *Imperial Poems*

The designation of *jing*, or Views, was a standard part of Chinese garden building practices dating to perhaps as early as the Tang dynasty.[10] Although the most common English translations of *jing*, "view" or "scene," emphasize the visual aspect of the landscape, the experience of *jing* was intended not only as visual, or more broadly sensory, but also as emotional, intellectual, and physical.[11] In addition to the natural or designed landscape, the visitor's experience of a View was mediated by a poetic tradition that served to define the terms in which the landscape was consumed and appreciated. Among Kangxi's Views, for instance, were sites intended to capture the scent of lotuses, the singing of orioles nesting in trees, and the warm glow of the evening light on distant hills.[12] At the Mountain Estate for Escaping the Heat and elsewhere, the Views were named and eulogized poetically, with the resultant texts often physically affixed to the site through horizontal nameboards (*bian'e* 匾額) and vertical couplets (*bianlian* 匾聯) hung above doorways and on prominent pillars (Figure 7). These architectural inscriptions mediated the visitor's experience of the site by filtering it through the emperor's chosen cultural and emotional lenses.[13]

In combining word and image, Kangxi's *Imperial Poems* evoked, if not precisely recreated, the holistic experience of the physical site's mediated landscape for the book's viewers. The words of the emperor framed the virtual experience as the viewer explored each scene,

regardless of ethnic background, cut their hair in the style of the Manchu queue, for instance—reinforced the primacy of a particular ethnic group over all others. Cf. Ning Chia, "The Li-fan Yuan in the Early Ch'ing Dynasty" (PhD diss., Johns Hopkins University, 1992); Mark C. Elliott, "Manchu Widows and Ethnicity in Qing China," *Comparative Studies in Society and History* 41, no. 1 (1999): 33–71; and Elliott, *The Manchu Way*.

10 For a history and theorization of *jing*, see Hui Zou, "*Jing* (景): A Phenomenological Reflection on Chinese Landscape and *Qing* (情)," *Journal of Chinese Philosophy* 35, no. 2 (2008): 353–368.

11 Here, I point to the conventional usage of "view" or "scene" in English, not its meaning within the context of the garden. European landscape gardens were often designed around an itinerary of scenic views tied to specific narrative or poetic references. For instance, Stourhead, near Mere, Wiltshire, England, was designed around the story of the *Aeneid*; see Malcolm Kelsall, "The Iconography of Stourhead," *Journal of the Warburg and Courtauld Institutes* 46 (1983): 133–143.

12 See Views 15, 22, and 12, respectively.

13 On naming in Chinese gardens, see Robert E. Harrist, "Site Names and Their Meaning in the Garden of Solitary Enjoyment," *Journal of Garden History* 13 (1993): 199–212; and Makeham, "The Confucian Role of Names in Traditional Chinese Gardens."

STEPHEN H. WHITEMAN

gradually coming to occupy the site at its center. In some instances, the sensory description through which the emperor recreated the physical experience of dwelling in the Mountain Estate predominates, enhancing the viewer's perception of the natural setting beyond that presented visually through the prints. At other times, the poems focused on the emperor himself, rather than on his surroundings. Kangxi emphasized his dedication to righteous and humane rule, his reasons for constructing an estate to which he could retreat, and his feelings about growing older. In these cases, the scenes represented an architectural metonymy for the emperor's life, a spatial instantiation of the autobiographical narrative that he sought to construct through his texts.

In the most literal sense, the title of each View names both a particular piece of architecture and the physical and sensory environments that surround it, while the texts record the emperor's subjective sensory, emotional, or intellectual experiences of either or both. Rather than depicting the perspective from the eponymous structure, however, the named architecture forms the centerpiece of each illustrated View, initially situating the viewer outside of the spatial and experiential subject of the scene.

Yet the images are composed to simultaneously draw the eye into the image as a whole and to the architectural object of the specific View. Paths lead the viewer into the scene,

figure 7

Nameboard and couplets at the main entrance to Lustrous Heart Hall (Yingxin tang 瑩心堂). The couplet reads, "I possess mountains and rivers stretching far to the north / The Natural landscape surpasses that of West Lake." Bishu shanzhuang, Chengde, Hebei. Photograph by Stephen H. Whiteman.

traversing islands, lakes, and mountains as the eye explores the varied, rolling landscape. The images inevitably direct the viewer to the architectural focal point, whether by means of motif (i.e., the bridge and path in View 6) or composition, as in the treatment of the lake in View 17, in which the "> <"-shaped ripples link the eponymous architectural subject of the scene, the pavilion Untrammeled Thoughts by the Hao and Pu Rivers (Hao Pu jianxiang 濠濮間想), on the near shore, with Clear Ripples with Layers of Greenery (Chengbo diecui 澄波疊翠, also View 30), the pavilion visible on the far bank.

Once there, the rendering of the architecture frequently distorts or departs from the actual structures depicted in order to emphasize the eponymous focus of the scene while deemphasizing or eliminating superfluous elements. For instance, in View 15, "The Scent of Lotuses by a Winding Stream" (Qushui hexiang 曲水荷香), a large pavilion stands at the front of a courtyard, noticeably taller than the covered walkways that connect it to the nearby hall. The pavilion contains a common Chinese garden feature, the winding stream, used to play a game involving wine and poetry writing connected to the famous Orchid Pavilion Gathering of Wang Xizhi 王羲之 (ca. 303–ca. 361) in 353.[14] View 23, "Fragrance Grows Purer in the Distance" (Xiangyuan yiqing 香遠益清), depicts the same complex, yet here the pavilion is much smaller and a new courtyard has appeared to its right. At the center of the courtyard, there is a small lotus pond, the smell and sight of which could be appreciated from the hall at its rear. In this way, differences in scale and architecture help guide the viewer to the particular focal point of each image.

The landscapes that surround the architecture also depart from topographical reality to make rhetorical gestures. In most cases, the primary physical features of each scene, such as lakes or mountains, generally reflect the actual landscape. Mountain forms are frequently exaggerated or simplified to follow compositional conventions of landscape painting, however, which often favor a central massif around which the rest of the landscape is arranged. In many of the views, that peak is situated to form a compositional backdrop for the architectural focus of the scene, reinforcing other elements, such as bridges, paths and groves of trees, that draw the viewer's eye and imagination toward the named structures. In certain cases, the departures from the actual site may also have been intended to create images that evoked the landscape of southern China, thus reinforcing visual references present in the architecture of the Mountain Estate's central lakes and in some of the emperor's poems about, and inscriptions on, various Views.

There are also several cases in which two successive Views may be joined to form a single composition out of scenes that were not, in reality, continuous. These pairings draw connections between Views that emphasize poetic values explored in the texts, such as the experience of the senses. View 11, "Morning Mist by the Western Ridge" (Xiling chenxia 西嶺晨霞) and View 12, "Sunset at Hammer Peak" (Chuifeng luozhao 錘峰落照), for instance, describe the iridescent light of sunrise and sunset, together forming a highly

14 On winding stream garden features, see Nancy Berliner, "Gardens, Water, and Calligraphy: The Development and References of the Curving Waterway Garden Element," unpublished conference paper, Harvard University, November 12, 2010.

STEPHEN H. WHITEMAN

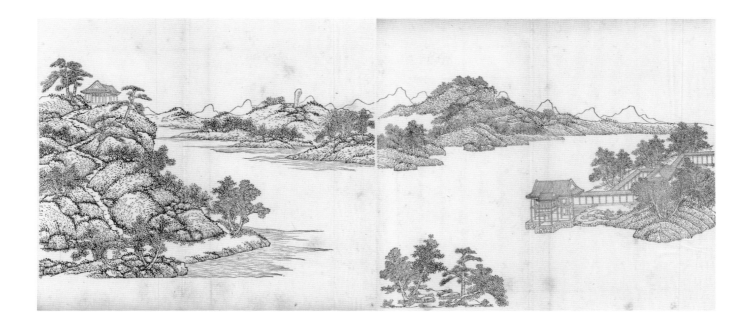

atmospheric pair. When the images are joined, the two pavilions appear to sit on opposite shores of a large lake facing each other, but in reality there is no immediate topographic relationship between them (Figure 8). The territory stretching between the pavilion "Sunset at Hammer Peak," on the left, and the eponymous object of its view, a tower-like rock formation located several kilometers east of the Mountain Estate, has been significantly altered in the interest of compositional unity, thus permitting the creation of single scene in which the two Views are connected not through their topographic proximity but through their poetic affinities. The product is a hyperreal landscape that suggests for the viewer relationships that extend beyond those present at a single time and place within the physical site; it captures the progress of light and, with it, time through the park, adding an experiential dimension beyond text and image to the viewer-guest's understanding of the environment.

Thus, the Views simultaneously operate on three levels to recreate not only the appearance but also the emperor's subjective appreciation of the Mountain Estate. Each image is informative (it describes the landscape to the viewer), indicative (it directs the viewer to the focus of the scene), and, in combination with the poetry, prescriptive (it seeks to define the viewer's subjective experience of the site as that of the emperor). When viewed in tandem with Kangxi's texts, the Thirty-Six Views simulate the experience of both occupying and knowing the landscape, thus moving beyond casual familiarity to communicate an intimate knowledge of the Mountain Estate and the personal response that such a connection would engender in the author and, the emperor anticipated, in the viewer.

Although unprecedented within the context of court production and imperial self-representation, the *Imperial Poems* were not created *sui generis*, but drew heavily upon the genres of views of famous sites and gardens, both well established by the early Qing. Using these conventional forms as a framework for presenting the emperor's park, the landscape of the *Imperial Poems* was then invested with cultural tropes—such as a harmonious realm,

figure 8

View 11, "Morning Mist by the Western Ridge" (Xiling chenxia 西嶺晨霞) (left), and View 12, "Sunset at Hammer Peak" (Chuifeng luozhao 錘峰落照) (right). Chinese Collection, Harvard-Yenching Library, © President and Fellows of Harvard College.

moral emperorship, and refined retreat—that were essential in presenting the emperor and the nascent Qing to viewers in a particular light. As a series of scenic views of a famous site, the *Imperial Poems* framed the Mountain Estate in terms similar to those that framed the most important cultural landscapes of China proper, thereby allowing the represented garden to stand as a metaphor for the emperor's ideal construction of the dynasty. In creating a portrait of his newly completed precincts, Kangxi, like many garden owners before him, depicted not only his property but also himself as a garden builder and owner. The garden then came to stand for its maker, deepening the nesting of implied metonymic relationships linking landscape, ruler, and polity.

Over time, the accumulation of poetry, personal essays, inscriptions, paintings, prints, and other representations of a particularly famous place or region contributed to a broad appreciation of such locales as cultural landscapes, sites through which cultural identities shared across particular social groups and populations were recorded, negotiated, and consumed. Views of famous sites were especially important in defining certain landscapes as culturally meaningful and in shaping the visual and textual representations of such sites, as they were copied, reinterpreted, reproduced in printed form, and distributed among various audiences. Popular subjects such as the *Eight Views of the Xiao and Xiang Rivers* (*Xiaoxiang bajing* 瀟湘八景), *Ten Views of West Lake* (*Xihu shijing* 西湖十景), and *Eight Views of Beijing* (*Yanjing bajing* 燕京八景) captured the natural and experiential qualities of culturally significant locales or regions through a selection of certain precise scenes that came to carry particular political or social connotations.

The *Eight Views of the Xiao and Xiang Rivers* represents one of the earliest and most famous examples of a set of famous views.[15] First given form in painting and short verse in the 1060s and early 1070s by the Northern Song official Song Di 宋迪 (ca. 1015–ca. 1080), the eight scenes captured the beauty of the region around the confluence of the Xiao and Xiang Rivers in modern Hunan province.[16] A contemporary of Song Di, Shen Gua 沈括 (1031–1095), recorded titles for the eight Views, such as "Evening Bell from a Mist-Shrouded Temple" (*Yansi wanzhong* 煙寺晚鐘) and "Sunset Glow over a Fishing Village" (*Yucun xizhao* 漁村夕照), encapsulating in these descriptions both the name of the place being depicted and the optimal moment for experiencing it.

Song Di's Views were almost immediately read by contemporary educated elites from a variety of backgrounds. The late eleventh and early twelfth centuries were a period

15 On the *Eight Views of the Xiao and Xiang Rivers*, see Alfreda Murck, "Eight Views of the Hsiao and Hsiang Rivers by Wang Hong," in *Images of the Mind*, ed. Wen C. Fong (Princeton, N.J.: The Art Museum, Princeton University, 1984), 213–235; Alfreda Murck, "The Meaning of the Eight Views of Hsiao-Hsiang: Poetry and Painting in Sung China" (PhD diss., Princeton University, 1995); and Valérie Malenfer Ortiz, *Dreaming the Southern Song Landscape: The Power of Illusion in Chinese Painting* (Leiden: Brill, 1999), 28–41 and 64–99. The earliest extant version of the composition is thought to be a set of eight short compositions mounted as a pair of handscrolls in the collection of the Princeton University Art Museum; for images and a complete bibliography, see http://etcweb.princeton.edu/asianart/selectionsdetail.jsp?ctry=China& pd=&id=1035437, accessed January 30, 2013.

16 Song Di's paintings are no longer extant, but a list of the Views was recorded by the official in 1090; see Ortiz, *Dreaming the Southern Song Landscape, 65.*

STEPHEN H. WHITEMAN

of dynastic decline and conquest in Song China. In 1127, the Song armies were defeated by Jurchen invaders from Northeast Asia, resulting in the loss of northern China to the newly established Jin dynasty (1115–1234) and the confinement of the Song state to its territory south of the Yangtze River. The region of the Xiao and Xiang Rivers and the names of the eight Views came to carry elegiac associations of exile rooted in older poetic traditions, such as *Songs of the South* (*Chuci* 楚辭), traditionally attributed to Qu Yuan 屈原 (trad. ca. 343–278 BCE) and works by the Tang poet Du Fu 杜甫 (712–770); thus, they were well suited to coeval expressions of dislocation as well as to those in later centuries who sought to make sense of their own times through the evocation of Northern Song cultural paradigms.[17]

The *Eight Views of the Xiao and Xiang Rivers* set a precedent for the capacity of landscapes to embody cultural memory, thus preserving not only a particular site through pictorial representation but also the cultural and historical events associated with that site. Like those of Song Di and Shen Gua, the site names, prose introductions, and poems composed by Kangxi provided an interpretive context for the images of the Thirty-Six Views, while the images rooted the viewer's experience of the landscape to geographically specific spaces, albeit through representations that depended as much on particular pictorial rhetorics as on topographic verisimilitude. While the *Eight Views of the Xiao and Xiang Rivers* came to represent the physical and emotional exile associated with dynastic decline in the Northern Song, the views in the *Imperial Poems* connected the landscape of Rehe with dynastic rejuvenation. Taken together, the text and image framed the imperial garden experientially and intellectually through an established literary and pictorial language that was broadly accessible to the emperor's intended audience, thus creating a metaphor for a harmonious realm at peace under his diligent and humane rule through the landscape.

Although structurally related to the *Eight Views of the Xiao and Xiang Rivers*, the *Ten Views of West Lake* is perhaps a closer model for the emperor's album. Like the *Eight Views of the Xiao and Xiang Rivers*, the *Ten Views of West Lake* emerged during the Song period in the context of a landscape of exile. After its defeat in northern China in 1127, the Song court fled south to the lower Yangzi region, reestablishing their capital in the modern city of Hangzhou for the remainder of the dynasty, a period now known as the Southern Song (1127–1279). Just outside the city's walls stood West Lake, a public district dotted with temples, mansions, and wine houses that—to say nothing of the lake itself—became the focal point for an efflorescence of Song artistic, religious, and popular culture. West Lake would become the quintessential scenic landscape of southern China, embodying for later generations not only the lyric poignancy of a dynasty in exile but also the experiences of countless later artists, writers, and literati who explored their own identities through an engagement with the physical and mnemonic landscape.

Unlike the *Eight Views of the Xiao and Xiang Rivers*, which unified a largely imaginary itinerary of isolated sites under regional and thematic rubrics, the *Ten Views of West Lake* recorded a series of specific, repeatable experiences set within a single, finite locale. Even before the

17 Murck, "Eight Views of the Hsiao and Hsiang Rivers by Wang Hong," 214–216; Murck, "The Meaning of the Eight Views of Hsiao-Hsiang," 239; and Ortiz, *Dreaming the Southern Song Landscape,* 29–32.

Southern Song, West Lake was a popular tourist attraction that had been transformed by writers and artists into an important cultural landscape. The influential poets and officials Bo Juyi 白居易 (772–846) and Su Shi 蘇軾 (1037–1101) served as magistrates here, and during their tenures each constructed lengthy dikes as parts of public works projects that permanently altered both the hydrology and the scenery of the lake. These dikes, which in time bore their builders' names, became focal points in local scenic itineraries, including the *Ten Views of West Lake*, in no small part as celebrations of the men who built them.[18]

Albums of the *Ten Views of West Lake* that combined poetry and images—including one by the Southern Song painter Ye Xiaoyan 葉肖巖 (fl. ca. 1253–1258) (Figure 9)—fixed the iconography of these cultural touchstones and determined the ideal manner of their consumption through associations with particular people, places, and times. The *Ten Views of West Lake* and Views of other culturally mediated landmarks formed itineraries of cultural practices—particularly the visual and aural consumption of the landscape and associated refined activities—that strengthened contemporary connections to the region surrounding the new capital through the celebration of the seasonal beauty of Hangzhou.[19] Yet the transmission of these Views—as well as of many other accounts, depictions and poetic representations of the lake—over the ensuing centuries attests to the degree to which the landscape of West Lake was not simply associated with a specific individual, or even a particular class, but was integrally associated with literati culture as a whole. The rendering of the *Ten Views of West Lake* in woodblock print permitted the dissemination of this vision to a far larger audience.[20] By the late Ming period, numerous versions of the album existed in various media, as the *Ten Views of West Lake* evolved into a popular itinerary that not only reified the collective memory of West Lake but also came to serve as a changing guide to contemporary cultured behaviors.[21]

This broadening of the function of *Ten Views of West Lake* is suggested by a comparison of two versions of "Autumn Moon over a Calm Lake" (Pinghu qiuyue 平湖秋月). In Ye

18 Bo's Dike (*Baidi* 白隄) begins at "Lingering Snow at Broken Bridge" (Duanqiao canxue 斷橋殘雪), while "Listening to Orioles in the Wavy Willows" (Liulang wenying 柳浪聞鶯) and "Spring Dawn at Su's Dike" (Sudi chunxiao 蘇隄春曉) both refer to Su's Dike.

19 Hui-shu Lee, *Exquisite Moments: West Lake and Southern Song Art* (New York: China Institute Gallery, 2001), 31–33 and 57n50. For the itinerary as cultural mnemonic and touchstone, see Maurice Halbwachs, "The Legendary Topography of the Gospels of the Holy Land," in *On Collective Memory*, ed. Lewis A. Coser (Chicago: University of Chicago Press, 1992), 193–235.

20 For examples, see *Xihu shijing* 西湖十景 [Ten Views of West Lake] (Shanghai: Shanghai renmin chubanshe, 1979).

21 For a discussion of different printed versions of the *Ten Views of West Lake*, including the series from the *Extraordinary Sights within the Seas* (Hainei qiguan 海內奇觀, 1609) discussed below, see Eugene Y. Wang, "The Rhetoric of Book Illustrations," in *Treasures of the Yenching: Seventy-Fifth Anniversary of the Harvard-Yenching Library*, ed. Patrick Hanan (Cambridge, Mass.: Harvard-Yenching Library, 2003), 190–205; for explorations of the evolving meaning of the *Ten Views of West Lake* and West Lake more broadly, see Eugene Y. Wang, "Perceptions of Change, Changes in Perception—West Lake as Contested Site/Sight in the Wake of the 1911 Revolution," *Modern Chinese Language and Culture* 12, no. 2 (Fall 2000): 73–122; and Eugene Y. Wang, "Tope and Topos: The Leifeng Pagoda and the Discourse of the Demonic," in *Writing and Materiality in China: Essays in Honor of Patrick Hanan*, ed. Judith T. Zeitlin and Lydia H. Liu (Cambridge, Mass.: Harvard University Asia Center, 2003), 488–552.

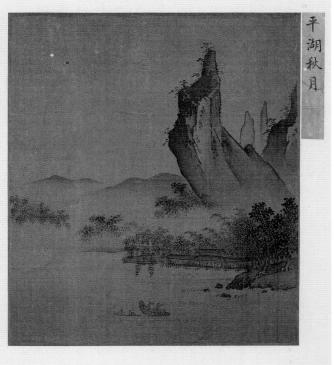

平湖秋月

放知月到秋末好
秋月平湖昏未
憑杏是畫圖披
觀面蓄情向日
此翻勝

Xiaoyan's painted version of this scene, the focus is on the lakeside peak that rises along the right side of the composition, towering precipitously over the water and dwarfing the figures floating on the lake in boats. Their presence serves as a point of entry into the composition for the viewer, who could imagine himself as one of the boaters, occupying the landscape. The viewer's gaze is directed toward the scenery, not its occupants, so the two viewers, real and depicted, share a common experience.

By contrast, in the version of this scene included in the late Ming illustrated book of famous places, *Extraordinary Views within the Seas* (*Hainei qiguan* 海內奇觀, 1609; Figure 10), the viewer's focus has shifted. Seen from behind a screen of reeds, two gentlemen are enjoying an evening on the lake, with wine, food, and servant at the ready. While key iconographic elements defining the scene remain, the landscape itself has shrunk. The eponymous moon hangs over the boaters, doubled through its reflection in the water, and Su's Dike stretches across the background, clearly marking the location of the scene as West Lake, but the distinctive towering mountain that so dominated the Southern Song painting has been transformed into a generic backdrop of distant hills. The figures have become the focus of the scene. The format of the publication, which combines image and text on facing pages, as well as the preservation of the now well-established titles and the inclusion of iconic features within each image all serve to tie this version of the *Ten Views of West Lake* to its historical

figure 9

Ye Xiaoyan 葉肖巖, "Autumn Moon over a Calm Lake" (Pinghu qiuyue 平湖秋月), from *Ten Views of West Lake* (*Xihu shijing* 西湖十景), mid-thirteenth century, album leaf, ink and color on silk, 23.9 × 26.2 cm. The Collection of the National Palace Museum.

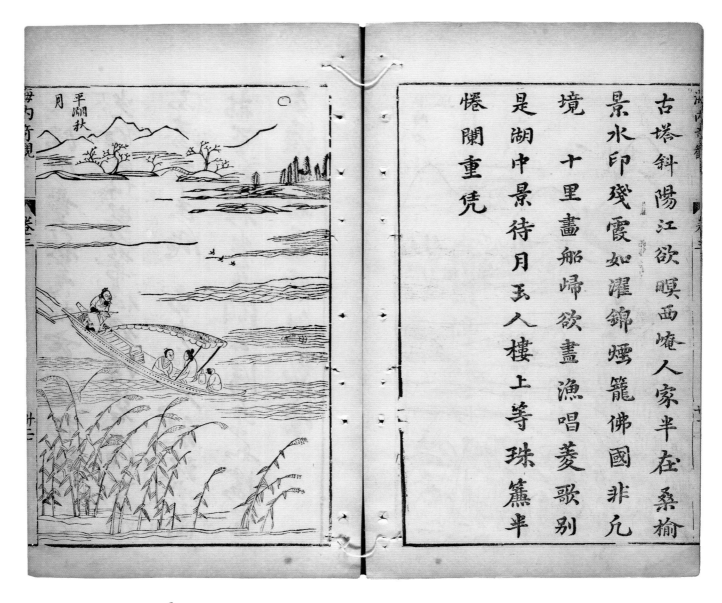

figure 10

"Autumn Moon Over a Calm Lake" (Pinghu qiuyue 平湖秋月) from *Ten Views of West Lake*,
in *Extraordinary Views within the Seas* (*Hainei qiguan* 海內奇觀), 1609, woodblock printed book.
Chinese Collection, Harvard-Yenching Library, © President and Fellows of Harvard College.

STEPHEN H. WHITEMAN

models, even as the focus of the composition itself has shifted from the broader landscape to the cultured performance within it. By the Ming dynasty, in other words, the *Ten Views of West Lake* not only represented the scenery of West Lake and the remembered tradition by which the sites were canonized but also captured the evolution of their consumption, conveying the scenes as a series of prescriptive experiences that specified weather, activity, company, and dress for the viewer's personal enjoyment (or social enlightenment) from the privacy of the foreground screen.[22]

The Thirty-Six Views echo aspects of both Ye Xiaoyan's paintings and the Ming prints. Visually more open and accessible, the Views are compositionally closer to the former, but the combination of the emperor's texts with the images produces a prescriptive effect similar to that of the latter.[23] Although the broad perspectives and elevated points of view in the *Imperial Poems* offer nearly unfettered visual access to the scenes, the viewer nevertheless enters the landscapes of the Mountain Estate bearing in mind a carefully constructed image of empire and emperorship, one established through the preceding texts. Thus, the winding dike leading to the cluster of islands at the center of the lakes in View 2, "A *Lingzhi* Path on an Embankment to the Clouds" (Zhijing yundi 芝逕雲隄), is framed by a meditation on the prosperity and harmony that mark the Qing dynasty at peace, the emperor's concern for his people, and his rejection of excessive luxury in favor of imperial modesty and restraint, while the viewer of View 9, "Clouds and Peaks on All Sides" (Simian yunshan 四面雲山) is first given a description of the all-encompassing view available from this mountaintop pavilion before his mind wanders with the emperor's to a reflection on growing old.

The design of the park-palace itself reinforced the connections between its Views and those of famous sites of China proper, particularly those of the south. View 12, "Sunset at Hammer Peak" (Chuifeng luozhao 錘峰落照) recalls the seventh of the *Eight Views of the Xiao and Xiang River*, "Evening Glow over a Fishing Village" (Yucun xizhao 漁村夕照), which is sometimes also called "Sunset over a Fishing Village" (Yucun luozhao 漁村落照), as well as one of the *Ten Views of West Lake*, "Evening Glow on Thunder Peak" (Leifeng xizhao 雷鋒夕照). Furthermore, the Mountain Estate included numerous architectural

22 In a famous essay on viewing the midsummer moon at West Lake in which he describes the pleasure of "watching people watch the moon," Zhang Dai 張岱 (1597–1689) describes both the degree to which proper behavior was defined and aspired to and the centrality of voyeurism to the experience of famous places in the late Ming. See Strassberg, *Inscribed Landscapes: Travel Writing from Imperial China*, 342–345. This shift in focus toward a more voyeuristic perspective in representations of scenic sites and cultured activities had already begun by the Yuan dynasty (1279–1368); see Stephen H. West, "Body and Imagination in Urban Gardens of Song and Yuan," in *Gardens and Imagination: Cultural History and Agency*, ed. Michel Conan (Washington, D.C.: Dumbarton Research Library and Collection, 2008), 40–64.

23 Here, I am specifically comparing the Ming image to the combination of text and image in the Kangxi text. Unlike the texts of the *Imperial Poems*, which were not altered in subsequent editions except for the later addition of matching poems by the Qianlong emperor, various versions of the *Ten Views of West Lake* employed different poems drawn from the rich and ever-growing corpus of literature describing the famous sites. Thus, the relationship between text and image is more fluid across the entire corpus of the *Ten Views of West Lake* than is the case for the *Imperial Poems*. In the case of the *Extraordinary Sights within the Seas*, the author of the matching poems is not identified, but is in any case not Song Di; see Wang, "The Rhetoric of Book Illustrations," 196 and 216n35.

and literary references to West Lake, as the contemporary account by the official Zhang Yushu (Appendix 3) and the texts of the *Imperial Poems* attest. Examples are found not only in naming—as Views 10, 12, and 31 all make nominal reference to the *Ten Views of West Lake*—but also in architecture and landscape design, as in the small bridges and willows of the central lakes, which strongly resembled the famed dikes of West Lake and evoked the riverine landscape of the south more generally (Figure 11). These connections, borrowed from the cultural landscapes of China's past, drew upon Han collective memory to help contextualize the Mountain Estate for viewer and visitor, while presenting Rehe as essentially distinct. As the emperor wrote in one of his halls: "There are mountains and rivers stretching to the Northern Pole Star; And a natural landscape to surpass that of West Lake."

In combination with the garden itself and other accretions—visitors' accounts, stelae, architectural inscriptions, various associated texts, and paintings—the Thirty-Six Views constituted the originary monument in the creation of a cultural landscape at Rehe akin to those of China proper. It represented the primary literary and artistic interpretation of the site with which subsequent visitors would at some level engage, and which superseded all previous marks of cultural mediation. Although there was, in fact, a long history of human occupation in Rehe,[24] Kangxi clearly sought to frame the region as fallow, unused territory—as "wilderness" (*huangye* 荒野), in the words of his "Imperial Record of the Mountain Estate for Escaping the Heat," free for the development of an architectural environment that could contain within it both land and cultural meaning.[25] Through terms founded in the Chinese cultural past, Rehe served as a tableau for the articulation of a cultural landscape that referred particularly and distinctively to Kangxi and his vision of emperorship, which he then invited his viewer-guests to share in through the pages of the *Imperial Poems*.

Kangxi was not the first to see the political potential of cultural landscapes for asserting the legitimacy of new regimes. In preparing to move the Ming capital north from Nanjing to Beijing after usurping the throne, the Yongle emperor 永樂 (r. 1402–1424) recognized the need to define Beijing as a city worthy of its new status. In the early 1410s, Yongle commissioned a handscroll, the *Eight Views of Beijing*, that recorded the most famous sites in the capital city in verse, prose, and image.[26] Two of these Views, "Crystal Clear Waves at Taiye Pond" (Taiye qingbo 太液清波) and "Spring Clouds at Qionghua Island" (Qiongdao chunyun 瓊島春雲), highlighted portions of the Ming imperial gardens in the area west of the Forbidden City now known as the "Three Seas" (Sanhai 三海), the location of successive imperial gardens since the twelfth century. Within the context of a pictorial program that was "clearly part of the efforts of the Yongle emperor's supporters to endow the area in and

24 See Thomas J. Barfield, *The Perilous Frontier: Nomadic Empires and China* (Cambridge, Mass.: Basil Blackwell, 1989), 12, 16–19, 186; and Owen Lattimore, *Inner Asian Frontiers of China* (New York: Oxford University Press, 1988), 3, 103–105, 242–246. Cf. Whiteman, "Creating the Kangxi Landscape," 83–101.

25 See below, 122.

26 The original Yongle paintings, by the official and painter Wang Fu 王紱 (1362–1416), are now in the collection of the National Museum of China, Beijing (formerly the Chinese Historical Museum, Beijing). For reproductions and analysis, see Kathlyn Liscomb, "'The Eight Views of Beijing': Politics in Literati Art," *Artibus Asiae* 49, no. 1/2 (1988): 127–152.

STEPHEN H. WHITEMAN

figure 11

View of the willows
along A *Lingzhi* Path
on an Embankment
to the Clouds (Zhijing
yundi 芝逕雲隄). Bishu
shanzhuang, Chengde,
Hebei. Photograph by
Stephen H. Whiteman.

around Beijing with a heritage worthy of an imperial capital,"[27] the particular attention paid
to imperial gardens in the *Eight Views of Beijing* highlights the potential significance of the
landscape in general, and imperial garden building in particular, in the processes of dynas-
tic legitimation.

Garden building allowed Kangxi the opportunity to follow this historical line, con-
structing landscapes that were clearly associable with legitimate regimes of the past. As a
record of his newly constructed garden, the *Imperial Poems* became a source through which
the emperor's audience could access a particular vision of empire and emperorship, expand-
ing beyond the culturally familiar using established tropes and language. The connection
between Rehe and the empire, and between the present and the past, created through refer-
ences to cultural landscapes of China proper allowed this assertion of legitimacy to apply not
only to the dynasty but also to the territory.

In addition to being part of the broad genre of famous views, the *Imperial Poems* may
also be read as garden paintings. Similar to views of famous sites, which permitted the
expression of collective identities through shared experiences that transcended time and
space, garden paintings offered a means to convey individual identity through the private
landscape of the garden. Pictorial records of private gardens are generally traced to Tang

27 Liscomb, "'The Eight Views of Beijing,'" 130.

painters such as Wang Wei 王維 (699–759), whose representations of their country estates offered models of cultural expression to garden owners seeking to portray themselves through their gardens in suitably refined terms.[28] By the Ming period, garden painting had emerged as a substantial artistic genre among literati and merchant elites.

Whether through a single view, the unfurling panorama of a handscroll, or the sequential progress of a multi-leaf album, the purpose of a garden painting was twofold. First, artists sought to convey some sense of the appearance of the landscape by including its most prominent features and scenic environs. The images were usually not strictly topographical, and the degree of mimetic accuracy varied depending on the format of the work, the individual style of the artist, and the desires of the patron. Nor was mimetic accuracy necessarily a priority, for while verisimilitude was, to a degree, important for recording the site's most iconic elements, it stood outside the second, and perhaps more significant, function of the garden painting as a form of "portraiture-by-metonymy," in which the garden came to signify its owner. While these works often included at least one literal portrait of the owner *in situ*, relaxing in a boat or taking tea in a hall, their ultimate goal was the formation of a figurative equation between the site and its occupant. Through them, an owner sought to be identified with his garden, a site that indicated not only his wealth and property-owning status but also his position within elite social networks that took gardens as principal stages for various types of cultural performance; the garden, in turn, reflected his ethical identity, for which the natural world was a ready and longstanding metaphor.

Although garden paintings took many forms, a particularly close comparison for the *Imperial Poems* may be found in an album of thirty-one leaves by the mid-Ming master Wen Zhengming 文徵明 (1470–1559). Wen painted the *Garden of the Artless Official* (*Zhuozheng yuan tuce* 拙政園圖冊) in 1533 for the property's owner, the official Wang Xianchen 王獻臣 (ca. 1460–after 1533).[29] Like the *Imperial Poems*, this album begins with a "record" in which the

28 Wang Wei's handscroll may already have been lost a millennium ago. It survives through numerous later copies and adaptations, however, including both anonymously or spuriously signed paintings and genuine works by important later artists. Examples include works by Wang Yuanqi 王原祁 (1642–1715) in the Metropolitan Museum of Art, New York, and by Song Xu 宋旭 (1525–ca. 1606) in the Freer Gallery of Art, Washington, D.C. (F1909.207). Spuriously signed works are often attributed to the painter Guo Zhongshu 郭忠恕 (d. ca. 977), as is a scroll in the National Palace Museum, Taipei; see Guoli gugong bowuyuan 國立故宮博物院, ed., *Yuanlin minghua tezhan tulu* 園林名畫特展圖錄 [Catalog of the Special Exhibition of Famous Paintings of Gardens] (Taipei: Guoli gugong bowuyuan, 1987), no. 27. For the record of another in a private collection, see Robert E. Harrist, *Painting and Private Life in Eleventh-Century China: Mountain Villa by Li Gonglin* (Princeton, N.J.: Princeton University Press, 1998), 131n8.

29 Wen Zhengming painted two versions of the *Garden of the Artless Official*. The first album, dated 1533 and comprised of thirty-one leaves, is now lost, but is reproduced in Wen Zhengming and Kate Kirby, *An Old Chinese Garden: A Three-fold Masterpiece of Poetry, Painting, and Calligraphy*, trans. Mo Zung Chung (Shanghai: Chung Hwa Book Co., 1923). Five leaves are reproduced in Craig Clunas, *Fruitful Sites: Garden Culture in Ming Dynasty China* (Durham, N.C.: Duke University Press, 1996), 25–29, one of which also appears in Craig Clunas, *Elegant Debts: The Social Art of Wen Zhengming, 1470–1559* (London: Reaktion, 2004), 47. A second version consisting of only eight leaves, dated 1551, is now in the Metropolitan Museum of Art and may be found in Roderick Whitfield and Wen C. Fong, *In Pursuit of Antiquity: Chinese Paintings of the Ming and Ch'ing Dynasties from the Collection of Mr. and Mrs. Earl Morse* (Princeton, N.J.: The Art Museum, Princeton University, 1969), 66–75. See Clunas, *Fruitful Sites*, 23–59, for an extended discussion of the garden.

artist creates a link between the biography of the garden and that of its owner, describing the garden as a place of retreat from the travails of imperial politics for Wang, who had recently retired from life in Beijing after a career spent in the Imperial Censorate. Following this introduction, Wen Zhengming's album offers the viewer a pictorial and textual tour of the garden similar to that in the *Imperial Poems*. The album opens with a view of a small thatch-roofed building, Almost-a-Villa Hall (Ruoshu tang 若墅堂), which is set against the garden's crenellated wall (Figure 12). A bamboo fence marks off an open area in front, in the midst of which stand Wang Xianchen and his servant. According to Wen's description, Almost-a-Villa Hall sits at the center of the garden, serving as the site's main hall despite its modest proportions. The "record" confirms its preeminence among the garden's structures, noting that it was the first structure that Wang Xianchen built as he laid out the garden.[30]

The album, thus, begins as a sort of biography-by-garden, a theme maintained throughout the work. Although Wen Zhengming's texts describe the physical relationship between the various scenes, the images themselves offer little sense of the layout of the garden.[31] Instead, they focus largely on Wang Xianchen, who is featured in at least nineteen of the thirty-one leafs, and on his lived relationship with the site. Through image and poetry, Wen Zhengming depicts him, often with a guest, enjoying the most scenic spots in his garden. Even in scenes in which Wang does not appear, the firm association between garden and owner established from the outset means that he is never far from the viewer's mind. Thus, the album takes not only the landscape, but also Wang's ownership of, and presence within, it as its principle subjects.

In almost all regards, this description applies equally well to the *Imperial Poems*. The imperial tour opens with a structure closely associated with the person of the emperor, his living quarters, in View 1, "Misty Ripples Bringing Brisk Air" (Yanbo zhishuang 烟波致爽), bypassing the gates, forecourts, and throne room that one in reality would have first encountered when entering through the Mountain Estate's main gate. From there, the viewer proceeds not according to the topographic logic of the site (though the first six Views do progress through the front palace and out onto Wish-Fulfilling Island [Ruyizhou 如意洲]), but in a manner that may be read as recreating the experience of actually living at the estate, visiting sites one-by-one over the course of a summer, rather than as part of a single, continuous tour. This experiential structure offers an analogy to narratives defined by biography, chronology, and psychology that are sustained through the emperor's texts. Like the thirty-one scenes of the *Garden of the Artless Official*, the geographic relationships among the emperor's Thirty-Six Views are largely subordinated to the poetic presentation of individual, lyric moments.

As such, both albums are clearly defined by the narrative of the garden owner. In the *Garden of the Artless Official*, this connection is made explicit through Wen Zhengming's

30 Clunas, *Fruitful Sites*, 141.

31 Cf. Andong Lu, "Deciphering the Reclusive Landscape: A Study of Wen Zheng-Ming's 1533 *Album of the Garden of the Unsuccessful Politician*," *Studies in the History of Gardens and Designed Landscapes* 31, no. 1 (2011): 40–59.

figure 12

Wen Zhengming 文徵明, "Almost-a-Villa Hall" (Ruoshu tang 若墅堂), from *Garden of the Artless Official* (*Zhuozheng yuan tuce* 拙政園圖冊), 1533, album leaf, ink on paper, 26.4 × 30.5 cm. Reproduced from Wen Zhengming and Kate Kirby, *An Old Chinese Garden: A Three-Fold Masterpiece of Poetry, Painting, and Calligraphy*, translated by Mo Zung Chung (Shanghai: Chung Hwa Book Co., 1923).

92 STEPHEN H. WHITEMAN

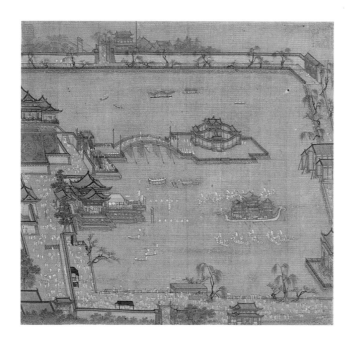

figure 13

Zhang Zeduan 張擇端, *Reservoir of Metal's Luster* (*Jinmingchi tu* 金明池圖), first half of the twelfth century, album leaf, ink and colors on silk, 28.6 × 28.5 cm. Tianjin Museum of Art.

depictions of Wang Xianchen. In the *Imperial Poems*, however, the figure of the emperor is completely absent from the pictured landscape—an approach that was likely unprecedented in China. Past depictions of imperial space generally featured the emperor prominently, either through an explicit representation of his body or through a metaphoric substitution, such as the royal barge in *Reservoir of Metal's Luster* (*Jinmingchi tu* 金明池圖) by the Northern Song court painter Zhang Zeduan 張擇端 (1085–1145) (Figure 13), which signified the emperor through its grand architecture and his implied presence within it.[32] The effect of this conventional focus on the emperor was to displace the viewer, compelling a voyeuristic perspective that necessarily placed him at a physical and psychological remove from the object of the gaze and subordinated his own positionality.

By contrast, in the *Imperial Poems,* while the emperor's presence is clearly implied through the sharing of his inner thoughts (however rhetorically constructed) within the physical context of his private garden (however deliberately presented), his physical absence offered the viewer a level of imaginative access that would have been impossible were the emperor explicitly depicted. This access was, of course, virtual, temporary, and above all, highly mediated, bounded by the limits of the text, the borders of the images, and even the opening and closing of the silk-covered wrapper (*han* 函) in which the poems were stored. Nonetheless, it was available to the recipients of the book at will, the landscape reconstituted

32 See Stephen H. West, "Spectacle, Ritual, and Social Relations: The Son of Heaven, Citizens, and Created Space in Imperial Gardens in the Northern Song," in *Baroque Garden Cultures: Emulation, Sublimation, Subversion,* ed. Michel Conan (Washington, D.C.: Dumbarton Oaks Research Library and Collection, 2008), 291–321. The painting is also known as *Military Games in the Reservoir of Metal's Luster* (*Jinmingchi zhengbiao tu* 金明池爭標圖).

and reimagined with each tour of the album. Through the *Imperial Poems*, Kangxi constructed an alternate and parallel persona, that of a highly cultured Chinese literati garden owner. The culture to which the *Imperial Poems* referred, and to which it linked the emperor, was one that was actively being constructed within the Kangxi court. The Thirty-Six Views were themselves an important part of this effort. This culture transcended the literati milieu to which the *Imperial Poems* generically referred, encompassing instead all that the empire was intended to incorporate. Kangxi's imperial identity, in turn, was defined through this, as ruler, possessor, and host of a unified empire at peace.

From Painting to Woodblock to Copperplate: Pictorial Translation in the Thirty-Six Views

Stylistically, the Thirty-Six Views defy simple characterization, as they combine formal elements of diverse origins to create coherent compositions that both engaged with and transcended the formal models from which they derived. Strictly ordered architecture rendered in a precise manner known as ruled-line painting (*jiehua* 界畫) is set within a more restless landscape, with densely textured hills and mountains emerging from an assemblage of smaller forms, striking a balance between order and disorder. The sense of pattern in these landscapes, in which the various elements all seem to be made of the same discrete parts combined in a limited number of different ways, sometimes makes the topography look almost generic. So, too, do the images as a whole, with each View presenting the landscape through one variation on only a few basic compositional formulae—for example, a shoreline or island in the fore- or middle ground giving way to a body of water or open piece of land that divides it from a background of steep hills.[33] Together, these motifs and compositions form a landscape that stands in sharp contrast to the distinctive, recognizable architecture set within it.

From this tension between patterning and particularity emerges an often neutral, almost impersonal landscape that at first seems to be at odds with the emotion-laden imagery of the emperor's texts. Both architecture and landscape are devoid of any signs of the physical or psychological animation created through the poems. This feeling of neutrality is heightened by the nature of the medium, as the stark white and black of the woodblock prints creates settings that are drained of color, both literally and figuratively. Yet within the restrained compositions and monochrome marks of the block cutter's knife lies a wealth of pictorial information, references to genres and styles legible to the pictorially literate Qing viewer, whose mental vocabulary of images and associations made the Views as imaginatively rich as they were visually reserved.

33 Even images that lack open bodies of water, such as Views 7 and 16, often still depend on the basic compositional model described here, simply substituting open land, a valley, or some other space for the water. Another particularly frequent variation is seen in Views 9 and 13, in which mountains fill almost the entire picture plane. Despite their basic structural similarities, however, these compositions did not necessarily have common origins. Rather, the basic types each represent standardized interpretations of compositions associated with particular ancient masters.

STEPHEN H. WHITEMAN

Little information is available to modern scholars concerning the original designs or painted albums of the Thirty-Six Views upon which the woodblock prints were based. No versions of the paintings from the Kangxi period seem to have survived,[34] and their commissioning and production do not feature in the extant archival record.[35] There is only a brief

34 The only versions of the Thirty-Six Views from the Kangxi era known to have existed are the woodblock designs by Shen Yu, whose whose name appears in the last scene of the book; a finger-painted album by Dai Tianrui 戴天瑞 (active early eighteenth century), now kept in the Palace Museum, Beijing; and an album, now lost, by Wang Yuanqi, which is listed in the catalog of the imperial collection, the *Precious Record of the Stone Moat* (*Shiqu baoji* 石渠寶笈, 1745). For Dai Tianrui's album, see Gugong bowuyuan 故宮博物院, ed., *Tianlu zhencang: Qinggong neifuben sanbainian* 天禄珍藏：清宮內府本三百年 [A Treasury of Heavenly Objects: Three Hundred Years of Imperial Household Department Editions from the Qing Court] (Beijing: Zijincheng chubanshe, 2007), 112; for a record of Wang Yuanqi's, see Guoli gugong bowuyuan 國立故宮博物院, ed., *Midian zhulin, Shiqu baoji* 秘殿珠林, 石渠寶笈 [Forest of Pearls of the Secret Hall, Precious Works of the Stone Moat] (Taipei: Guoli gugong bowuyuan, 1971), 2:745–751. Shen Yu's album, if it existed, apparently did not survive and is not recorded in any collection catalog. Qianlong-era versions are far more numerous. Extant versions of Kangxi's Thirty-Six Views include albums by Zhang Zongcang 張宗蒼 (1686–1756; Yu Jianhua 俞劍華, *Zhongguo meishujia renming cidian* 中国美术家人名词典 [Biographical Dictionary of Chinese Artists] (Shanghai: Shanghai renmin meishu chubanshe, 2004), 830; Daphne Lange Rosenzweig, "Court Painters of the K'ang-Hsi Period" (PhD diss., Columbia University, 1978), 244–245; and Osvald Sirén, *Chinese Painting: Leading Masters and Principles* (New York: Ronald Press, 1956), 7:292; see Guoli gugong bowuyuan 國立故宮博物院, ed., *Midian zhulin, Shiqu baoji xubian* 秘殿珠林, 石渠寶笈續編 [Forest of Pearls of the Secret Hall, Precious Works of the Stone Moat: Second Catalog] (Taipei: Guoli gugong bowuyuan, 1971), 4:768–771), dated 1752, and Zhang Ruoai 張若藹 (1713–1746; Yu, *Zhongguo meishujia renming cidian*, 839; Rosenzweig, "Court Painters of the K'ang-Hsi Period," 237; and Sirén, *Chinese Painting*, 7:289), dated 1739, both in the National Palace Museum, Taipei. An undated album depicting Qianlong's thirty-six additional Views by Qian Weicheng 錢維城 (1720–1772; Yu, *Zhongguo meishujia renming cidian*, 1434; Hummel, ed., *Eminent Chinese of the Ch'ing Period*, 158; and Sirén, *Chinese Painting*, 7:311) is in the Palace Museum, Beijing (presumably Guoli gugong bowuyuan 國立故宮博物院, ed., *Midian zhulin, Shiqu baoji sanbian* 秘殿珠林, 石渠寶笈：三編 [Forest of Pearls of the Secret Hall, Precious Works of the Stone Moat: Third Catalog] (Taipei: Guoli gugong bowuyuan, 1969), 9:4454). A set of all seventy-two Views by Li Zongwan 勵宗萬 (1705–1769; Yu, *Zhongguo meishujia renming cidian*, 1446; Hummel, ed., *Eminent Chinese of the Ch'ing Period*, 490–491) is now in the in the Palace Museum, Beijing (Guoli gugong bowuyuan, ed., *Midian zhulin, Shiqu baoji sanbian*, 9:4424–4433); another by Qian Weicheng is in the National Palace Museum, Taipei (Guoli gugong bowuyuan, ed., *Midian zhulin, Shiqu baoji sanbian*, 9:4452–4453). In both cases, the paintings of Kangxi's Views are dated 1752, while Qianlong's Views are dated 1754. Finally, four sets of fans with paintings on one side and calligraphy on the other are in the Palace Museum, Beijing. The paintings of three are unsigned; of these, the calligraphy of one is by Wang Jihua 王際華 (1717–1776; Yu, *Zhongguo meishujia renming cidian*, 124), while the other two have calligraphy by Li Zongwan. The set penned by Wang Jihua and one of the sets by Li Zongwan depict Kangxi's Thirty-Six Views, while the subject matter of the second Li Zongwan set—Kangxi or Qianlong—is presently unclear. The fourth set pairs paintings by Qian Weicheng and calligraphy by Yu Minzhong 于敏中 (1714–1779; Yu, *Zhongguo meishujia renming cidian*, 14). At least one other set of Views, with paintings by Fang Cong 方琮 (active eighteenth century; Yu, *Zhongguo meishujia renming cidian*, 46) and calligraphy by Qian Weicheng, is listed in the *Precious Works of the Stone Moat* (Guoli gugong bowuyuan, ed., *Midian zhulin, Shiqu baoji sanbian*, 9:4511). Paul Pelliot also mentions a set by Shen Yinghui 沈映輝 (active early eighteenth century; Yu, *Zhongguo meishujia renming cidian*, 427), though it does not appear in the *Precious Works* (Paul Pelliot, "Les conquêtes de l'empereur de Chine," *T'oung Pao* 20 (1921): 239–240; and John R. Finlay, "'40 Views of the Yuanming yuan': Image and Ideology in a Qianlong Imperial Album of Poetry and Paintings" (PhD diss., Yale University, 2011), 131 and note 319). Cf. Finlay, "'40 Views of the Yuanming yuan,'" 131–139.

35 In contrast, see the highly detailed reconstruction of the production of the *Imperial Poems on the Forty Views of the Garden of Perfect Clarity* in Finlay, "'40 Views of the Yuanming yuan,'" 30–42.

figure 14

Detail of Shen Yu's 沈喻 signature in the lower left corner of View 36, "Clouds Remain as Water Flows On" (Shuiliu yunzai 水流雲在). Chinese Collection, Harvard-Yenching Library, © President and Fellows of Harvard College.

comment by Matteo Ripa, who described touring the Mountain Estate on July 6, 1711, "with the Chinese painters whom [Kangxi] had ordered to make the drawings"; unfortunately, he mentions no names.[36]

At least one set of images—the compositions from which the woodblocks derived—was completed over the course of the following year (1712).[37] These were executed by the court painter Shen Yu 沈喻 (1649–after 1728),[38] whose name is inscribed in the lower left corner of the final scene, "Clouds Remain as Water Flows On" (Shuiliu yunzai 水流雲在). Though it has generally been presumed by art historians that Shen's compositions took the form of a painted album, there is no evidence to support this: the only evidence to date of his involvement in the project, the printed cartouche (Figure 14), uses the verb *hua* 畫, which means not just, "to paint," but, more generally, "to create pictorially," and is used in contrast to the contributions of the publication's two primary block cutters, Zhu Gui 朱圭 and Mei Yufeng 梅裕鳳 (both fl. ca. 1696–1713), whose names appear as well. Indeed, the fact that no album attributable to Shen survives or is recorded in any imperial catalog or extant archive supports the hypothesis that his works may have been the more functional designs that Zhu and Mei would have followed line-by-line in preparing the printing blocks, rather than freer, more painterly compositions bound together as an album. Zhu and Mei, the most talented woodblock artisans in the Hall of Military Glory at the time, also prepared the blocks for the imperial version of the *Images of Tilling and Weaving* (*Gengzhi tu* 耕織圖, 1696; Figure 15), an album depicting scenes of rural harmony and agricultural production that represents one of the most important precedents within Kangxi court art for the *Imperial Poems*.[39]

Shen Yu remains a somewhat enigmatic figure. He was born in 1649, most likely in or around the pre-dynastic Manchu capital Shengjing 盛京 (modern Shenyang). His family was classified as Han Bannermen (*hanjun* 漢軍), ethnic Chinese who participated in the Manchu conquest of the Ming.[40] At the time of his involvement in the production of the *Imperial*

36 Ripa, *Giornale (1705–1724)*, 2:41, "July 6, 1711"; and Ripa, *Memoirs of Father Ripa*, 72.

37 Guan and Qu, *Kangxi chao manwen zhupi zouzhe quanyi*, no. 1993 (dated KX51/7/22 [August 23, 1712]), is the first extant memorial to the throne on the subject of printing the *Imperial Poems*.

38 Also 沈喻. For Shen Yu's biography in various, generally consistent forms, see Hummel, ed., *Eminent Chinese of the Ch'ing Period*, 330; Lu Fusheng 卢辅圣, *Zhongguo shuhua quanshu* 中国书画全书 [Complete Catalog of Chinese Painting and Calligraphy] (Shanghai: Shanghai shuhua chubanshe, 1992), 10:435 and 11:333, 749; Rosenzweig, "Court Painters of the K'ang-Hsi Period," 290–291; Sirén, *Chinese Painting*, 7:396; and Yu, *Zhongguo meishujia renming cidian*, 432.

39 On the history of *Images of Tilling and Weaving* and the Qing court's interests in it, see Roslyn Hammers, *Pictures of Tilling and Weaving: Art, Labor, and Technology in Song and Yuan China* (Hong Kong: Hong Kong University Press, 2011); Philip K. Hu, "Idealized Labor: Material and Social Manifestations of Riziculture and Sericulture in Imperial China," unpublished conference paper, presented in the conference "Discourses and Practices of Everyday Life in Imperial China," Institute of History and Philology, Academia Sinica, October 25–27, 2002; and Hui-chi Lo, "Political Advancement and Religious Transcendence: The Yongzheng Emperor's (1678–1735) Deployment of Portraiture" (PhD diss., Stanford University, 2009), 67–106.

40 On Han Bannermen and the conquest elite, see Pamela Kyle Crossley, "The Conquest Elite of the Ch'ing Empire," in *The Cambridge History of China*, vol. 9, pt. 1, *The Ch'ing Dynasty to 1800*, ed. Willard J. Peterson (Cambridge: Cambridge University Press, 2002), 310–359.

STEPHEN H. WHITEMAN

Poems, Shen was serving as a low-ranking official in the Imperial Household Department.[41] Specific details of his artistic career are scarce, and no works that are reliably attributable to him appear to survive.[42] Moreover, descriptions of his painting style are largely generic. Biographies say that he specialized in landscapes after Dong Yuan 董源 (d. ca. 962), Juran 巨然 (fl. tenth century), and other early masters, and that he was also skilled in depicting architecture.[43] Although highly conventionalized, these characterizations suggest particular affinities with the preferred styles of the Kangxi court as well as interesting congruences with the unusual contrast between architecture and landscape in the Thirty-Six Views.

Despite the ambiguity surrounding their production, the images produced by Shen Yu, Zhu Gui, and Mei Yufeng are exceptional examples of Chinese printed landscapes. In keeping with the rise of popular printed painting manuals in the sixteenth and seventeenth centuries, in which woodblock designers and cutters sought to communicate as much of an original painting or artist's style in a different medium as possible, Zhu and Mei's dense, yet sensitive delineation of forms and voids seem to capture something of the

41 Specifically, Warehouseman in the Imperial Storehouse (Neiwufu siku, 內務府司庫); see Charles O. Hucker, *A Dictionary of Official Titles in Imperial China* (Stanford: Stanford University Press, 1985), 449. Cf. Whiteman, "Creating the Kangxi Landscape," 142 and 155n41 for further discussion and citations.

42 Only four works by Shen were considered important enough for inclusion in the three Qianlong-era and Jiaqing-era imperial painting catalogues—*Precious Works of the Stone Moat* (Shiqu baoji 石渠寶笈, 1745), *Precious Works of the Stone Moat, Second Catalog* (Shiqu baoji xubian 石渠寶笈續編, 1793), and *Precious Works of the Stone Moat, Third Catalog* (Shiqu baoji sanbian 石渠寶笈三編, 1816). The most valuable of these to Kangxi appears to have been a hanging scroll painted on silk entitled *Level Forests and Distant Peaks* (Pinglin yuanxiu 平林遠岫), which bore an inscription by the emperor himself; see Guoli gugong bowuyuan, *Midian zhulin, Shiqu baoji*, 1:454; Lu, *Zhongguo shuhua quanshu*, 11:749; and John C. Ferguson 福開森, *Lidai zhulu huamu* 歷代著錄畫目 [A Catalogue of Paintings from Different Dynasties with Notes] (Beijing: Renmin meishu chubanshe, 1993), 162a. The three others are all landscapes included in an album of paintings by various artists active in the Kangxi court (Guoli gugong bowuyuan, *Midian zhulin, Shiqu baoji*, 2:761; and Ferguson, *Lidai zhulu huamu*, 162a). Only two published attributions to Shen Yu have been identified thus far. The first, *Transporting Grain to the Capital on the Gentle, Flowing River* (Tonghuihe caoyun tu 通惠河漕運圖), is a handscroll formerly in the collection of the Chinese History Museum, a detail of which is reproduced in Zhu Chengru 朱誠如, ed. *Qingshi tudian: Qingchao tongshi tulu*, vol. 3–4, *Kangxi chao* 清史图典: 清朝通史图录, 第三、四册: 康熙朝 [Pictorial History of the Qing Court, vol. 3–4, The Kangxi Court] (Beijing: Zijincheng chubanshe, 2002), 306–307. The detail reproduced there shows a bustling scene of urban commerce reminiscent of the climactic scene in Zhang Zeduan's *Going Upriver at Qingming Time* (Qingming shanghe tu 清明上河圖), in the Palace Museum, Beijing. Having had neither the opportunity to inspect the work firsthand nor access to photographs or other documentation of it, the attribution is currently impossible to assess. The second, a hanging scroll of a mountain landscape that appears to be generally in the Orthodox manner, is published in *Nanshū meigaen* 南宗名畫苑 [A Garden of Famous Paintings of the Southern School] (Tokyo: Shinbi Shoin, 1904–1916), vol. 23. Sirén describes the painting as inscribed with a poem (he does not note the text or calligrapher), signed and dated to 1708 (Sirén, *Chinese Painting*, 7:396). The catalog entry for the painting in *Nanshū meigaen* provides dimensions, media, and a title for the painting, as well as a brief biographical sketch of Shen Yu, but does not transcribe the poem or note whether the scroll is indeed signed. The location of this painting is unknown. For further discussion of all these works, see Whiteman, "Creating the Kangxi Landscape," 142–162.

43 Yu, *Zhongguo meishujia renming cidian*, 432.

style and feeling of the paintings they used as models, thus providing a useful window onto Shen Yu's lost compositions.[44]

Historically, the representation of architecture in Chinese painting took many forms, ranging from the quite casual to the structurally precise, the former generally being connected to amateur or literati modes of painting and the latter to a more professionalized style often associated with urban ateliers and the court. In the Thirty-Six Views, Shen Yu employed a form of the latter, known as *jiehua*.[45] *Jiehua* originally appears to have been used in the design and construction of actual buildings, a function that persisted in later periods. By the Song dynasty (960–1279), however, *jiehua* had also acquired rhetorical associations, including the signification of imperial power, the state's control over science and technology, and the state's ritual and practical roles in engendering prosperity within the realm.[46] At the same time, *jiehua* became associated with the representation of certain iconic subjects, including historical or mytho-historical events, imaginary visions of emperors and palaces of the past, and paradisiacal realms, such as those of Daoist immortals (Figure 16).[47]

These associations made *jiehua* an important genre of painting for imperial courts, whose power and legitimacy lay partly in being able to govern in the present while transcending their particular moments in order to engage in the long line of history. The Qing, in particular, frequently employed *jiehua* in their idealized portrayals of the court and realm, in which architectural spaces were a major element. Examples of this—such as Leng Mei 冷枚 (fl. ca. 1677–ca. 1742), *View of the Rehe Traveling Palace* (*Rehe xinggong tu* 熱河行宮圖, ca. 1708–1710; Figure 17), a depiction of the Mountain Estate at an earlier stage of development—underline the importance of architectural representation in emphasizing notions of Qing imperial hegemony, dynastic legitimacy, and an auspicious realm.[48] Although Leng's architecture here lacks the exact delineation of structure generally associated with *jiehua*, his buildings retain many elements of the style, including an elevated perspective from which the viewer looks upon the structures from an angle, rather than head-on. The panoramic viewpoint and

44 Examples of large landscape publications include *Views of Famous Mountains* (*Mingshan tu* 名山圖, 1633) and the *Extraordinary Sights within the Seas* (*Hainei qiguan* 海內奇觀, 1609), as well as portions of the *Collected Illustrations of the Three Realms* (*Sancai tuhui* 三才圖會, 1609). For the *Views of Famous Mountains* and *Extraordinary Sights within the Seas*, see *Zhongguo gudai banhua congkan erbian* 中国古代版画丛刊二遍 [Second Collection of Ancient Chinese Woodblock Printing] (Shanghai: Shanghai guji chubanshe, 1994), vol. 8; for a reprint of the *Collected Illustrations of the Three Realms*, see Wang Qi 王圻 and Wang Siyi 王思義, eds., *Sancai tuhui* 三才圖會 (1609; repr., Taipei: Chengwen chubanshe, 1970).

45 For a historical overview of *jiehua*, see Chung, *Drawing Boundaries*, chap. 1; and Robert J. Maeda, "*Chieh-hua*: Ruled-Line Painting in China," *Ars Orientalis* 10 (1975): 123–141.

46 Heping Liu, "'The Water Mill' and Northern Song Imperial Patronage of Art, Commerce, and Science," *The Art Bulletin* 84, no. 4 (2002): 566–595.

47 For *jiehua* in the late imperial period, see Chung, *Drawing Boundaries*; and James Cahill, "Yuan Chiang and His School," *Ars Orientalis* 5 (1963): 259–272, and 6 (1966): 191–212. These associations were not necessarily with *jiehua* in isolation; rather, *jiehua* was used in various combinations with other styles and motifs, such as blue-and-green landscape, auspicious animals, and banquet scenes; see Whiteman, "Creating the Kangxi Landscape," 115–117.

48 Whiteman, "Creating the Kangxi Landscape," 109–118.

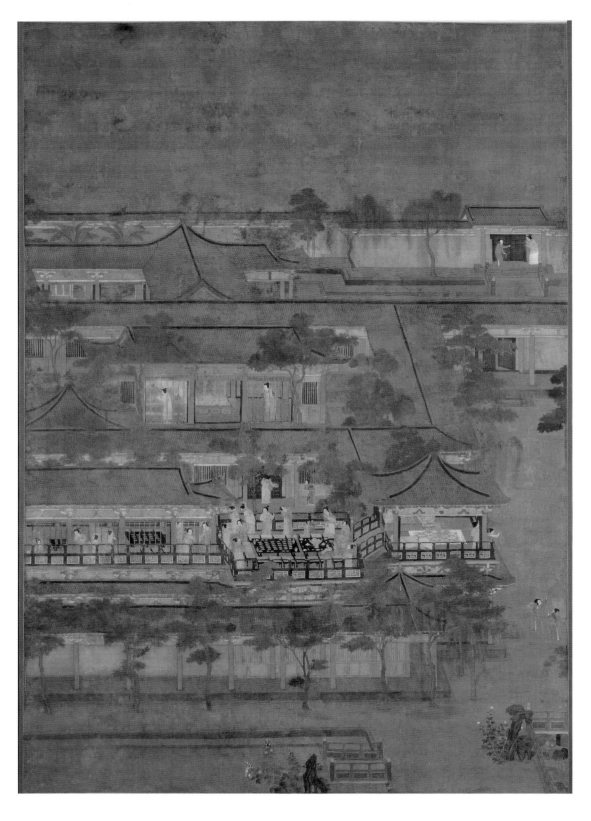

STEPHEN H. WHITEMAN

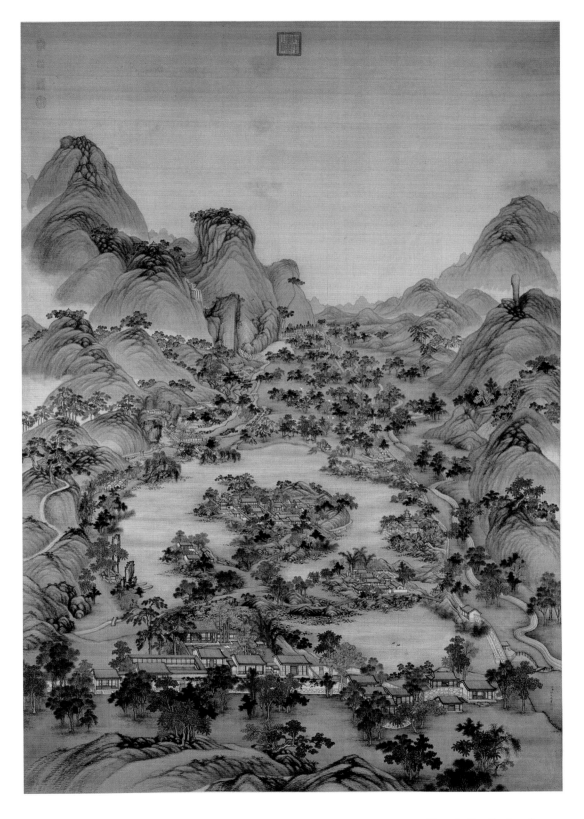

figure 17

Leng Mei 冷枚, *View of the Rehe Traveling Palace* (*Rehe xinggong tu* 熱河行宮圖), ca. 1708–1710, hanging scroll, ink and color on silk, 254.8 × 172.5 cm. The Palace Museum, Beijing.

almost map-like quality with which space is rendered gives the observer a totalizing view of the Rehe valley, one that may be read as a metaphor for the omniscient imperial gaze.

In formal terms, the architecture of Shen Yu's Thirty-Six Views shares many of the qualities seen in *View of the Rehe Traveling Palace*. Shen's buildings are, to be sure, more precise than those of Leng Mei, which is a function both of scale and the viewer's relationship with the image, as the smaller format of Shen Yu's album encourages the reader to first read the emperor's text and then linger within the spaces he has described. Yet like those of Leng Mei, Shen Yu's buildings are pushed back from the picture plane, offering the viewer a broad panoramic vision of the landscape within a single frame that reinforces the ultimate association between the emperor and the landscape established in the texts.

On closer examination, Shen Yu's structures also reveal an innovation particular to architectural representation at the Kangxi court. Many of the Thirty-Six Views clearly reflect the use of a modified form of European linear perspective in the representation of architecture, a technique uncharacteristic of traditional Chinese *jiehua*. This is evident, for example, in the depiction of many of the Views' corridor-lined courtyards, particularly in the lozenge-shaped courtyard in View 16, "Clear Sounds of a Spring in the Breeze" (Fengquan qingting 風泉清聽) or the boat-shaped hall in View 26, "Moon Boat with Cloud Sails" (Yunfan yuefang 雲帆月舫).[49]

This unexpected combination of approaches to rendering architecture was characteristic of representational developments in the palace since the late 1690s. In particular, Leng Mei and his teacher Jiao Bingzhen 焦秉貞 (fl. ca. 1689–1726) were among the early innovators of a Qing imperial style that integrated Western painting techniques with Chinese formal elements, combining *jiehua* with aspects of spatial recession derived from techniques of mathematical perspective imported by European missionaries.[50] Shen Yu's coupling of *jiehua*'s elevated point of view with the illusion of spatial recession made possible by European perspective created a hybrid that was ultimately neither one nor the other. Although the terms of this hybridization are not yet completely resolved into a seamless presentation of architecture in space, Shen Yu's Views are a significant step in the development of architectural representation in Qing court painting, and they are evidence of the importance of Western scientific knowledge at the Kangxi court.[51]

In contrast to his treatment of architecture, Shen Yu's landscape style derived not from professional ateliers, imperial courts, or foreign ideas, but from their near antithesis, the

49 Another interesting case is the two mountaintop pavilions in Views 9 and 12. This style of rendering a pavilion, such that one is looking up at the structure, breaks the conventional Chinese use of a variable point of view, clearly placing the viewer at the base of the mountains. The use of a fixed point of view, on the other hand, is a hallmark of European single-point perspective.

50 Jiao studied both astronomy and perspectival painting with European missionaries at the court; see Catherine Jami, *The Emperor's New Mathematics: Western Learning and Imperial Authority during the Kangxi Reign (1662–1722)* (Oxford: Oxford University Press, 2011), 241–243. Although distinct from Shen Yu's approach to this problem, Jiao Bingzhen's depiction of architecture in the *Images of Tilling and Weaving* is a prime example of these efforts, one of several ways in which this earlier album served as a particularly important model for the *Imperial Poems*.

51 For more on science and technology in the Kangxi court, see Jami, *The Emperor's New Mathematics*.

STEPHEN H. WHITEMAN

so-called Orthodox School of the early Qing.[52] Building upon the ideas of the late Ming artist and theorist Dong Qichang 董其昌 (1555–1636), the Orthodox School looked to the great masters of Northern Song and Yuan painting for inspiration, refining these models to create a style intended as the culminating synthesis of literati painting. Under the influence of Wang Hui 王翬 (1632–1717) and Wang Yuanqi 王原祁 (1642–1715),[53] the Orthodox style became established as the predominant landscape mode in Kangxi court painting by the 1690s.[54] Wang Yuanqi is of particular relevance in this context, as he was the preeminent painter in the court at the time of the creation of the *Imperial Poems* and he painted a version of the Thirty-Six Views himself.[55]

Although Wang Yuanqi's album is now lost, and thus cannot be called directly upon for reconstructing Shen's designs, Wang's dominance of court art discourse at this time, coupled with ample visual evidence in the woodblock prints, suggests the likely importance of his images to Shen's own. Despite the necessary changes to style that result from the translation of painting to woodblock, Shen Yu's basic approach to constructing mountain forms is clearly recognizable as Orthodox, as small modules are assembled in a dynamic pattern to create large masses. The texture strokes are shortened and the ink gradations are lost, but the basic effect—that of shape and volume emerging from a dense accretion of strokes—remains. Furthermore, Shen's standard range compositions include ones associated with past masters favored by Wang Yuanqi and other Orthodox artists, particularly Juran and the Yuan master Ni Zan 倪瓚 (1301–1374).

52 For studies of the Orthodox School in the early Qing, see James Cahill, "The Orthodox Movement in Early Ch'ing Painting," in *Artists and Traditions: Uses of the Past in Chinese Culture*, ed. Christian F. Murck (Princeton, N.J.: The Art Museum, Princeton University, 1976), 169–181; Wen C. Fong, "The Orthodox School of Painting," in *Possessing the Past: Treasures from the National Palace Museum, Taipei*, ed. Wen C. Fong and James C. Y. Watt (New York: Metropolitan Museum of Art, 1996), 473–491; Chu-Tsing Li, *A Thousand Peaks and Myriad Ravines: Chinese Paintings in the Charles A. Drenowatz Collection*, Artibus Asiae Supplementum 30 (Anscona: Artibus Asiae, 1974); and Whitfield and Fong, *In Pursuit of Antiquity*.

53 For Wang Hui, see Yu, *Zhongguo meishujia renming cidian*, 130; Hummel, ed., *Eminent Chinese of the Ch'ing Period*, 823–824; and Sirén, *Chinese Painting*, 7:425. For Wang Yuanqi, see Yu, *Zhongguo meishujia renming cidian*, 93; Hummel, ed., *Eminent Chinese of the Ch'ing Period*, 844–845; Sirén, *Chinese Painting*, 7:439; and Rosenzweig, "Court Painters of the K'ang-Hsi Period," 309.

54 Maxwell K. Hearn, *Landscapes Clear and Radiant: The Art of Wang Hui (1632–1717)* (New York: Metropolitan Museum of Art, 2008); Huang Weiling 黃瑋鈴, "Huatu liuyu renkan: You Wang Yuanqi de shitu yu huaye kan Qingchu gongting shanshuifeng de dianli" 畫圖留與人看: 由王原祁的仕途與畫業看清初宮廷山水風的奠立 [Paintings to Remain for People to See: The Establishment of Landscape Painting Trends in the Early Qing Court from the Perspective of Wang Yuanqi's Official Career and Painting Oeuvre] (MA thesis, National Taiwan University, 2005); and Wang Shen, "Wang Yuanqi and the Orthodoxy of Self-Reflection in Early Qing Landscape Painting" (PhD diss., University of Pennsylvania, 2010).

55 Consisting of seventy-two leaves, the album combined Wang Yuanqi's Views with calligraphy by the court official Wang Cengqi 王曾期 (fl. early eighteenth century). Wang Cengqi is also credited with the calligraphy included in a unique set of the copperplate printed views now in a private Asian collection (reproduced in Kangxi emperor, *Tongban Yuzhi Bishu shanzhuang sanshiliu jing shitu*), suggesting that the creation of the Thirty-Six Views may be best understood as a collective process including not only Shen Yu, but also Wang Yuanqi, Wang Cengqi, Matteo Ripa, and others.

Shen Yu's prints are, thus, very much a product of the diverse artistic context in which they were produced. At the Kangxi court, formal architectural painting, or *jiehua*, and experimentation with Western perspectival techniques coexisted with early Qing Orthodox-style landscape painting to create what at first might have seemed to be an incongruous image. But by patronizing Orthodoxy—a manner associated especially with the literati—Kangxi identified himself with the mode of landscape painting that many connoisseurs regarded as the most proper and refined, thereby affirming his support of Han elite culture. By employing *jiehua*, Kangxi drew upon another, even older Chinese pictorial language associated with both imperial authority and a peaceful, prosperous realm, and by employing a modified form of European perspective, he was signaling his interest in certain aspects of Western knowledge. This combination of styles was also quintessentially of the moment, as Kangxi ruled over a court and an empire that was larger and more open to the outside (and particularly European) world than any previous court or empire in Chinese history. The Thirty-Six Views thus came to stand both for emperor and empire, ideally conceived: the emperor, a master of multiple rhetorical languages represented through Orthodoxy, *jiehua*, and Western perspective, ruling over an empire that was both a successor to dynasties of the past and fundamentally new in its incorporation and naturalization of territory, people, and ideas from abroad.

The *Imperial Poems* involves another case of artistic translation—one that reflects not the court's simultaneous engagement with, and transcendence of, Chinese history and culture, as the woodblocks might be said to do, but the growing connections with European powers that emerged as a central element in the imperial court during the seventeenth and eighteenth centuries. These connections, which arose within the context of an increasingly global economy and included the transfer of Western knowledge (especially science and technology) and greater levels of contact between European and Asian courts through missionaries and diplomats, are also legible in the spread of artistic styles and media. The copperplate edition of the Thirty-Six Views created under the direction of the Italian missionary Matteo Ripa is the quintessential manifestation of this new early modern milieu in the Qing court of the Kangxi period.

In his diary, Ripa offered a variety of details regarding the specific technical challenges he faced in the process of creating the prints, including mixing appropriate chemicals, building a functional press, and devising a workable substitute for European ink.[56] Yet his account is mute in many other regards, as he shares nothing of the artistic process of translating the woodblocks into engravings, the training he offered his apprentices, the technical process by which the transformation was executed, or his own understanding of the artistic or cultural stakes of his task. The creation of the album was prompted by the emperor's request for a

56 Ripa, *Giornale (1705–1724)*, 2:38–39, "June 20, 1711"; and Ripa, *Memoirs of Father Ripa*, 82–83. Ripa's account of his initial attempts at printing, retold in greater detail above, appears to describe a chemical etching process. This seems to be confirmed by his statement elsewhere that he had been shown the process of etching once before his travels to China; Ripa, *Giornale (1705–1724)*, 2:29, "May 9, 1711" and 2:38, "June 20, 1711." The copperplate Thirty-Six Views are undoubtedly primarily engraved, however, and no clear signs of etching have been identified. The readiest explanation is that after initial attempts at etching failed to produce adequate results—Ripa reports that the line quality, in particular, was unsatisfactory—he then turned to the technologically simpler, though technically more challenging medium of burin engraving.

STEPHEN H. WHITEMAN

version of the woodblocks in the European style, a task to which Ripa and two Qing assistants, likely experienced woodblock cutters from the Hall of Military Glory, were assigned. The precise meaning of this order from the perspective of either Kangxi or Ripa is not clear, yet the images themselves argue that the emperor's interest in, and understanding of, "the European style" lay as much in harnessing the technology of copperplate printing as it did in capturing the aesthetics of a European image. In their varying approaches to visual translation and stylistic integration, the engravings not only confirm the presence of multiple hands at work but also reveal distinctive manners suggesting that, more so than many joint artistic projects, these hands did not necessarily share artistic and aesthetic goals, equal or complementary skills, or even a common visual vocabulary upon which to draw.

The engravings reveal multiple solutions to the challenge of visual translation. Here, the artists were not only translating media, as the images moved from painting to woodblock before being transformed again in copperplate, but also visual culture—that is, the distinct vocabulary of images, and ideas about images, that each individual collects through his daily visual engagement with the world around him. Just as the woodblock prints designed by Shen Yu both captured and departed from certain aspects of their painted models, so, too, do the different approaches to rendering the woodblocks into copperplate engravings reflect, to greater or lesser degrees, the original medium in the new one. At the same time, elements of European style, composition, and technique were introduced in the process, rendering images originally conceived in one idiom transformed through their movement to another. Yet the resulting prints defy singular description; they insist on presenting the possibilities of pictorial translation as similar to those of textual translation—multiple, highly varied, and dependent not only on the original "text" but also on the language into which the translation is occurring as well as the experiences, habits, and inclinations of the individual translator.

The copperplates both are and are not copies of the woodblock prints upon which they were based. The process of creating each engraving involved at least two steps, which may or may not have been the work of a single artist.[57] A compositional field was first defined on the surface of the copperplate by delineating a rectangle roughly 27 by 30 centimeters, making the engraved images slightly wider than the woodblock originals.[58] The basic composition

57 Given that Ripa's apprentices were accustomed to working within the palace workshops, it is appropriate to wonder whether the copperplates, too, might have been a collaborative production. The basic tenets of the workshop production of art suggest that the two stages described below, tracing and elaboration, might have been done by different artists. A close examination of the prints is agnostic on the question, however, as individual cases suggest any of a number of possible combinations. A detailed analysis of these combinations is beyond the scope of the current study, but remains an important question for future research.

58 The extant prints show no indentation from the plate, meaning that the plate was larger than the paper onto which it was impressed. The border seen in the images, normally left by the edges of the plate, was thus engraved, not through the printing process. Unlike the engravings, the woodblocks do not have a clearly delineated border on all four sides; that, in addition to their binding, makes it impossible to determine the exact measurements of the original woodblocks. At roughly 27 × 30 centimeters, however (the variation from plate to plate is +/- 2 milimeters), the engravings appear to be approximately a half centimeter wider than the woodblocks, a difference that was filled in simply by extending the existing composition; any difference in height is consumed by sky. These are also very close to the dimensions of

was then transferred from woodblock to copperplate, perhaps by drawing over the woodblock print and then laying it face down onto the copperplate, leaving a chalk sketch on the new surface.[59] This outline included the architecture, which was precisely copied, and the major landforms, including the mountains, islands, and rocks, for which the degree of fidelity to the original varied from plate to plate and from one portion of any given image to another (the distance often being more freely adapted than the foreground). Any difference in height between the woodblock and the copperplate was simply consumed by the sky, sometimes filled with atmospheric lines or clouds, while the differences in width between the two, a vertical strip of as much as a half centimeter in some cases, was filled by extending the original woodblock composition to the borders of the copperplate field.[60]

Following the tracing of the basic composition, the landscape and architecture were then further elaborated with elements such as texture strokes in the mountains, rocks, and water or shading of the architecture, trees, and other foliage. The styles used to render these atmospheric elements, as well as the degree to which their rendering followed the original woodblock prints, varies from plate to plate, ranging from almost precise copying to the substantial introduction of wholly new elements.

Comparing this process of elaboration across the thirty-six copperplates and between the engravings and the woodblock prints allows the copperplates to be divided into four groups. Three of these—Groups A, B, and C—are more or less coherent and may each be the work of a single artist. The fourth, Group D, is perhaps not a proper "group" at all, as its prints do not reflect a consistent style or approach, but instead appear at times like an experimental mixture of elements from Groups A, B, and C, thus suggesting collaborative or more explicitly hybrid productions.[61] Given the context of their commission and production, as well as their subject matter, it is fair to describe all the images as Qing, yet their varied appearances, the diverse ethnic backgrounds of their artists, and the imported technique of their production compels an increasingly inclusive definition of that term.

The defining quality of Group A is the sometimes quite precise re-creation of the formal appearance of the woodblock prints in engraving, despite the markedly different potentials

the Wang Yuanqi album of the Thirty-Six Views recorded in the 1745 edition of *Precious Works of the Stone Moat*, which measured 26.5 × 29.75 centimeters; see note 34.

59 This was a common European technique for transferring an existing image to a plate for engraving. As mentioned above, Kangxi was particularly impressed by Ripa's ability to transfer the image without destroying the original print (Ripa, *Giornale [1705–1724]*, 2:29–30, "May 23, 1711"). This suggests that the emperor had expected Ripa to employ a process similar to that traditionally used in China for creating a new printing block, which involved transferring the outline from a drawing or print to the new block in a way that destroyed the original; Tsuen-hsuin Tsien, "Technical Aspects of Chinese Printing," in *Chinese Rare Books in American Collections,* ed. Sören Edgren (New York: China House Gallery, China Institute in America, 1984).

60 Compare, for instance, the treatment of the architecture along the upper right edge of View 6. The woodblock print shows only the two columns forming the side of the building and its gabled eave, while the copperplate includes nearly two bays of the structure's rear facade.

61 Given the inconsistent composition of Group D relative to the other groupings, the following discussion will only address Groups A, B, and C, leaving D for future study.

of the two media. View 6, "Pine Winds through Myriad Vales" (Wanhe songfeng 萬壑松風),
is an example. The relationship between the basic structures of the two images follows the
tracing process described above. On the surface, the images are nearly exactly the same—
not only does the architecture of the engraving accord perfectly with that of the woodblock
print, but the outlines of the hills, the line of the shore, the flat stones around the lake, and
the bridge all follow the original precisely. The elaboration of the engraving is also very close
to that of the woodcut. The texture that shapes the background hills is rendered through
the same accumulation of short, comparatively thick strokes used in the woodblock prints
(Figure 18); these marks are uncharacteristic of the longer, finer lines found in European
engravings. Trees are rendered either in forests or in individualized groups, but, in either
case, the copperplates follow the woodblocks quite closely. In depicting forests, the dense
arrangements of leaves and trunks create a tight form that reads primarily as a patterned
whole. The rendering of individual trees, on the other hand, permits the differentiation of
at least seven different species, illustrated through careful attention to distinct leaves, includ-
ing pinwheels, small and sharp triangles, hand-like fronds, simple circles, and clusters of
dots (Figure 19).[62] In both cases, the engraver of View 6 followed his model almost exactly,
creating an image that, in many regards, translates the woodblock print quite literally. Rather
than adopting the technical and artistic vocabulary of engraving and translating the origi-
nal woodblocks into a copperplate idiom, the prints in Group A seem to do just the reverse:
the artist or artists have, by and large, sought to create engravings that look like woodblock
prints, compelling one technical process to imitate another.

Yet View 6 and the other prints in Group A also display elements characteristic of the
pictorial manners and techniques drawn from European printmaking, particularly in terms
of the introduction of shadow. The woodblock prints show no indication of the effects of light
and shadow upon surfaces, yet the artist of View 6 suggests light in a number of ways that
indicate familiarity with, if not mastery of, European pictorial habits. This is particularly

figure 18

Comparison of texture
strokes between the
woodblock (left) and
copperplate (right) versions
of View 6, "Pine Winds
through Myriad Vales"
(Wanhe songfeng 萬壑松風).
Left: Chinese Collection,
Harvard-Yenching Library,
© President and Fellows
of Harvard College.
Right: Dumbarton Oaks
Research Library and
Collection, Washington, D.C.

62 Christophe Commentale, "Les recueils de gravures sous la dynastie des Ch'ing: La série des eaux-
fortes du *Pi-shu shan-chuang*, Analyse et comparaisons avec d'autres sources contemporaines, chinoises et
occidentales," in *Echanges culturels et religieux entre la Chine et l'Occident* (San Francisco: The Ricci Institute
for Chinese-Western Cultural History, 1995), table 2.

figure 19

Detail of varieties of leaves in the copperplate version of View 6, "Pine Winds through Myriad Vales" (Wanhe songfeng 萬壑松風). Dumbarton Oaks Research Library and Collection, Washington, D.C.

evident in the treatment of architecture, in which shadow contributes to a heightened sense of three-dimensionality in the structures. It also appears in the depiction of light reflecting on the surface of the water, indicated through thin parallel lines that stretch out from the shore. The presence of shadows does not correlate here to the introduction of a consistent light source, however. While the lines on the water would suggest light coming from the upper right (as the lake's surface is darkest close to the shore and grows lighter as the eye moves to the open water along the left edge of the composition), the shadows drawn across the architecture indicate that the light is coming from the upper left (as the roofs are darkest in that corner and grow lighter as the shadows move diagonally toward the lower right). Nor is there any tonal variation across the composition, as there would be in European prints, which tend to become gradually lighter as the composition moves into the distance, a technique known as aerial perspective that heightens the illusion of depth. In other words, in View 6 and other Group A prints, the treatment of light is confined to shadows across a particular surface; it does not extend either to the introduction of a consistent source of light as a determinant compositional element or to a concern with the role of light in the eye's perception of spatial depth—both widespread in European printmaking of this time. Instead, the shadows represented a shorthand by which difference was superficially applied to an image that was, in most other respects, a close imitation of its Chinese model.

Many of the same pictorial effects are evident in the prints of Group B, which are the only prints among the thirty-six copperplates that may be firmly assigned to the hand of a particular named artist. Views 1, 12, 15, 18, 20, 27, 29, 30, and 36 all bore the printed name of

STEPHEN H. WHITEMAN

Zhang Kui 張奎,[63] whose name still appears several centimeters outside the compositional frame in one set of surviving prints (though not those in the collection of Dumbarton Oaks reproduced here).[64]

Comparing an example from Group B, "Sunset at Hammer Peak" (Chuifeng luozhao 錘峰落照) (View 12), with View 6, it is evident that, in many regards, Zhang Kui's prints are very similar to those of Group A. This is immediately evident in the foliage, as Zhang employed the same combination of patterned forms and periodic differentiation to create both forests and individual trees. More fundamentally, Zhang depends on the same basic mark that was used in the Group A engravings, and his short, sharply tapered strokes imitate those of the woodblock cutter's knife.

While generally sharing a vocabulary of marks, however, Zhang's use of these marks differs somewhat from that of the artist of View 6. Here, and in other Group A engravings, a curvature in rock forms is expressed through the shifting orientation of accumulated texture strokes, which gradually move from more vertical to roughly horizontal and back again; the lines themselves do not change, however, either in form or spacing (see Figure 18). These marks are either distributed evenly throughout the landform, as in the woodblock prints, or grow sparser near the top of a given mound, perhaps acknowledging the effect of light on the uppermost surface of a form. Zhang's curved rocks differ in a number of ways. First, in the forms of many distant mountains, such as those in the upper right of View 12, Zhang clusters his texture strokes quite densely near the upper edge, leaving the bottom of the form white (Figure 20). Even more striking are the smaller forms that make up the spine of the mountain running up the left half of the composition. Here, Zhang breaks up the continual arc of texture strokes seen in almost all the other engravings, clustering them densely at either end of the curve (Figure 21). The facet most exposed to direct light is then left white, caught between the darker edges almost as though the surface of the landform has been torn open.

The opposing approaches to light on an exposed surface within a single composition as well as the dense articulation (or stark absence) of texture on these surfaces help to invest Zhang's prints with a dynamic tension not only within the surfaces of individual forms but

63 The existence of this group raises a number of possibilities that, while beyond the scope of the current discussion, merit further study. Zhang Kui's signature suggests that he was the primary or sole artist for each of the plates bearing his name. This, in turn, implies that Ripa and the anonymous second Qing apprentice were also each principally responsible for the plates that they produced. Furthermore, the mathematics of the groupings raises the possibility that each of the three artists produced nine plates, thus accounting for Groups A, B, and C, and that the remaining nine plates, loosely categorized here as Group D, were in some way collaborative efforts. These hypotheses do not offer explanations for why Zhang Kui appears to have been alone in signing his prints or what the nature of the possible collaboration in Group D might have been; the latter, in particular, is a compelling problem that merits further explanation.

64 The only complete intact set of prints in this regard is that in the collection of the Dresden Print Room (Ca 139). Other surviving sets have been trimmed inside the printing of Zhang Kui's name. In some cases, the strip of paper containing the characters was retained from the trimmings and glued outside the margin of the image. More common is the trimming and reapplication of a narrow strip recording the name and number of the View, which also appeared in the margin of many, if not all imprints of the copperplates. Detailed examination indicates that the titles and signatures were not incised on the original copperplates, but were instead applied with woodblock stamps or, in some cases, handwritten.

also across the entire image. This is heightened by Zhang's treatment of open ground along the shoreline or on the winding path that extends up the left side of the image. Here, the addition of discrete clusters of strokes creates small contours in areas left blank in the woodblock (see Figure 21). Individually, these clusters denote delicate shadows created by light catching the surface of the ground, though as in View 6, they betray no consistent source for that light. Collectively, these strokes combine with Zhang's use of texture in the landforms to create a constant, shifting play between positive and negative throughout the composition.

Zhang is arguably even less interested in depicting the actual effects of light and shadow than the artist of Group A, as he generally applies little or, as in View 12, no shadow to his architecture, for instance. His engravings reveal instead an intense engagement with the graphic qualities of the medium—that is, the aesthetic impact of the dynamic contrast between the sharp, black marks and the blank ground, an impact that would have been all the stronger given the bright whiteness of the paper when new. Although this stark contrast was an inherent quality of traditional woodblock printing in China, in which the line was either on or off and contrasted clearly with the surface of the paper, it was not necessarily so in European engraving and etching, in which a greater modulation in the thickness and intensity of the mark was possible, thus allowing an artist to more subtly depict the effects of light upon an individual line. In other words, although Zhang (like the artist of Group A) expressed interest in aspects of European picture making, his intent was not to make something that looked European. Rather, he took advantage of copperplate's potential for especially crisp and dark lines to highlight the graphic qualities already present in woodblock printing, thus making his prints even more woodblock-like than the woodblocks themselves.

In contrast, the images of Group C—while not precisely European in appearance (as none of these would have been mistaken for something produced in Europe in the early eighteenth century)—depart from their woodblock models in ways that suggest a strong familiarity with European examples. These engravings—of which View 16, "Clear Sounds of a Spring in the Breeze," is an example—are characterized by a number of features, ranging from interpolated motifs to the quality of the line with which the images are created, that reflect the pictorial habits of contemporary European engraving. Rooted in the styles of sixteenth-century

figure 21
Detail of the treatment of rocks by Zhang Kui 張奎 in the copperplate version of View 12, "Sunset at Hammer Peak" (Chuifeng luozhao 錘峰落照). Dumbarton Oaks Research Library and Collection, Washington, D.C.

Northern Renaissance artists, such as Albrecht Dürer (1471–1528), and publishers, such as Hieronymous Cock (1518–1570; Figure 22), this vocabulary of marks and motifs had become ubiquitous among printmakers throughout Europe by the late seventeenth century.

The most fundamental difference between View 16 and Views 6 and 12 is the quality of line that predominates in each. In contrast to the marks seen in the engravings from Groups A and B, the predominant line found in the Group C engravings is finer, longer, and less modulated. It tapers to a point only at the very end, and is the type of line most readily drawn with the sharp point of an engraver's burin (Figure 23). Various pictorial elements not present in the woodblock prints are also introduced in a number of images, including entirely new types of trees (Figure 24);[65] the addition of fish, birds, and other wildlife; indications of environmental qualities, such as clouds or a sun (Figure 25); and a more substantial elaboration of deep distance than that found in either Groups A and B or their woodblock models.

These images also reveal a more consistent and nuanced interest in the effects of light. Superficially, this is emphasized through the addition of long, closely spaced parallel lines in the sky, as well as those already seen delineating the water of Group A, a motif widely used in both Northern Renaissance and contemporary Italian prints. The overall effect of these lines is quite significant, as the sky and water add a visual cue to environmental conditions that are distinct from those conveyed in the emperor's descriptions of the Views, thus allowing

65 Cf. trees numbered 18–24 in Commentale, "Les recueils de gravures sous la dynastie des Ch'ing," table 2.

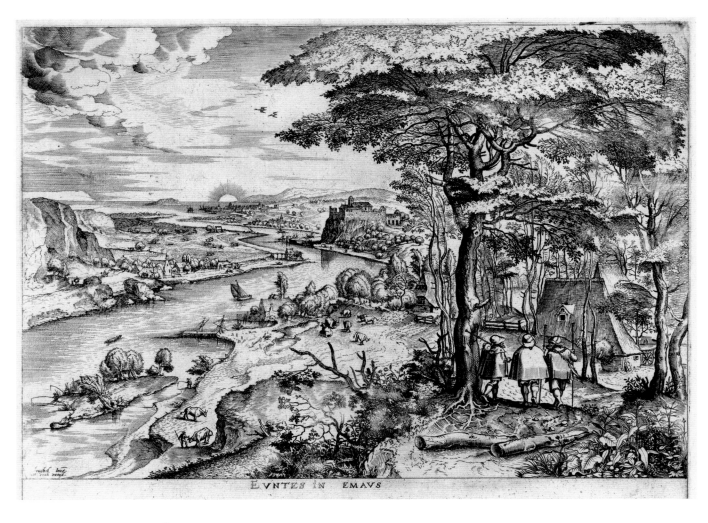

EVNTES IN EMAVS

figure 22

Johannes van Doetecum and Lucan van Doetecum, *Euntes in Emaus* (*Landscape with Pilgrims at Emmaus*), from the series *The Large Landscapes*, after Pieter Brueghel the Elder, published by Hieronymous Cock, ca. 1555–1556, etching and engraving, 32.5 × 43 cm. The Metropolitan Museum of Art (26.72.21), Harris Brisbane Dick Fund, 1926.

the images to function independently of the now absent textual accompaniments in ways that the woodblocks and the engravings of Groups A and B could not. Further, compositions in Group C contain a gradual shift in tonal quality from fore- to background (which is not seen in Groups A and B) that helped to reinforce the perception of recession into space, as the lighter line was read by the eye as more distant.

Finally, in many of the prints in Group C, the artist has either opened pictorial space that was closed off in the woodblock version or developed portions of the image that were left blank in the original. The effect of this and the other European interpolations can be seen in

STEPHEN H. WHITEMAN

figure 23

Detail of texture strokes in the copperplate version of View 16, "Clear Sounds of a Spring in the Breeze" (Fengquan qingting 風泉清聽). Dumbarton Oaks Research Library and Collection, Washington, D.C.

a close reading of View 16, which depicts a side-chamber attached to the empress dowager's residence, View 7, "Sonorous Pines and Cranes" (Songhe qingyue 松鶴清越). Comparing the woodblock and copperplate versions of View 16, the artist of the copperplate reduced the large hill in the foreground to a grassy plateau, eliminating the various clusters of trees in favor of a single broken stump on the left and a small sapling on the right. In the middle ground, the open space of the woodblock is populated with a variety of trees, which define an otherwise blank white area. Beyond the architectural complex, the reverse has occurred, as the small groves of trees that lined the base of the mountains in the woodblock print have been completely eliminated in the copperplate. Finally, the primary mountain at the center of the composition has been denuded, while the mountains in the deep distance are well defined relative to the simple outlines of the woodblock, creating a more specific, almost Alpine backdrop in place of the generic peaks found in the original.

The combined effect of these changes transforms the way the composition is read. In the woodcut, the structure at the center of View 16, a hall in which the emperor rested after visits to his mother, is clearly framed as the primary focus of the scene. The darker, more densely textured hills of the fore- and backgrounds bracket the halls, which are isolated in an otherwise blank middle ground. The greater height of the hills in the foreground emphasizes the viewer's elevated point of view, encouraging the eye to linger within the architectural space instead of moving deeper into the image. This inclination is reinforced by the groves of trees at the base of the far mountains, which are relatively small compared to both the architecture and the peaks beyond, creating a sense that the mountains are further away than they might otherwise appear to be. In contrast, in the copperplate, the engraver lowered the foreground, opening a more level view of the landscape and inserting a dead tree and sapling in the lower left. These serve to lead the viewer into the image, a European technique known

figure 24

Details of trees in the copperplate version of View 11, "Morning Mist by the Western Ridge" (Xiling chenxia 西嶺晨霞) (left), and *Euntes in Emaus* (right). Left: Dumbarton Oaks Research Library and Collection, Washington, D.C. Right: The Metropolitan Museum of Art (26.72.21), Harris Brisbane Dick Fund, 1926.

figure 25

Details of the sun in the copperplate version of View 11, "Morning Mist by the Western Ridge" (Xiling chenxia 西嶺晨霞) (left), and *Euntes in Emaus* (right). Left: Dumbarton Oaks Research Library and Collection, Washington, D.C. Right: The Metropolitan Museum of Art (26.72.21), Harris Brisbane Dick Fund, 1926.

as *repoussoir*.[66] Trees added in the middle ground animate the space, balancing the center of a composition originally weighted toward the architecture on the left, while the elimination of the groves of distant trees found in the woodblock draws the central mountain closer to the architecture and the picture plane. Finally, the articulation of the deep distance, through which nondescript outlines are transformed into more individualized peaks, permits the eye to continue past the center of the composition to the furthest reaches of sight. In combination with a much darker foreground created through the dense accumulation of lines in the grassy plateau, the pale distance unifies the entire image through a gradual tonal progression from dark to light.

Together, the various interpolations and shifts—including the composition, the introduction of new motifs, and the attention to lighting—alter the image through means and methods that were European in origin. In essence, these changes transformed the original composition from a View focused upon a specific architectural site to a less-bounded landscape that drew elements of the entire composition into more or less equal tension. Moreover, they seem to reflect a fundamentally different native visual vocabulary than those operative in Groups A and B, suggesting that the engravings of Group C may have been primarily or exclusively the product of Ripa's own hand.

Nevertheless, this resemblance to European images was essentially superficial. The images themselves neither convey the sorts of meaning that a landscape composition might have in Europe nor fundamentally reinterpret the original woodcuts through a European lens. The artist deployed European motifs and techniques in ways that complimented his understanding of a satisfactory image but that were divorced from any symbolic or iconographic content that might have been associated with such elements in their original context. Here, they bear no meaning except as markers of Europeanness, signals that the foreign has, like so many other things, been assimilated into the emperor's understanding of his rule.

View 16 illustrates this distinction. Many of the new elements here, including bare trees, blasted stumps, and the dramatic cast of light, were characteristic of the evolving baroque interest in proto-romantic scenes, often connected through mythological or historical narratives to ideas of morality or divinity. Yet in a Chinese context, the depiction of halls associated with the emperor and the empress dowager—or any elderly person, for that matter— surrounded by dying trees against a backdrop of bare mountains would have been viewed as distinctly inauspicious.[67] Similarly, the compositional de-emphasis of the halls themselves undermines the relationship between text and image explicitly established in the *Imperial Poems*, in which the two media worked in tandem to focus the reader's attention on the object of the View—here, the architecture and, by metonymy, the emperor's filial devotion to his

66 Chinese techniques for drawing the viewer visually or imaginatively into the image include the placement of figures in key positions within the composition; the elements here are not characteristic of Chinese solutions to this problem, however, which tend to be narrative in some way (e.g., figures or architecture), rather than decorative or structural (e.g., cliffs, rocks, or trees), as is generally the case in European images. Furthermore, Chinese *repoussoir* need not appear in the foreground, whereas European devices tend to be placed fairly close to the picture plane or in a progression from fore- to background.

67 See p. 53, above.

mother. In other words, the ways in which View 16 and the other engravings in Group C were altered from the original woodblock prints move them toward looking more European in many regards. Yet in terms of the relationship between image and ideas, it is doubtful that they were intended to express anything particularly European, especially any sort of religious or moral subtext, or that Kangxi would have even understood them in such terms. Instead, they likely represented for the emperor another example of artistic appropriation, the assimilation of all that fell under his gaze into a coherent image of cosmopolitan emperorship.

The prints of Groups A, B, and C reveal three distinct approaches to the idea of visual translation. In each, the artist or artists employed marks, motifs, and conceptions of what constituted a properly composed picture to create images that reflected their own visual vocabularies while rendering the Thirty-Six Views in a new medium. Although the prints from Group C, it might be argued, were the most "European" among them, to understand them as such requires acknowledging a divorce between pictorial elements or styles and the cultural meanings conventionally attached to them. For all three groups to be seen as fulfilling the emperor's command that Ripa and his apprentices recreate the Views in the "European style," it is necessary to shift our understanding of this request as one exclusively concerned with appearance to one that engages medium, technology, and perhaps even labor. Although the record is ultimately silent on the subject, there is no reason to believe that the emperor was not pleased with the product the three engravers ultimately produced—one extant set, likely the emperor's personal copy, includes calligraphy of the original imperial texts by the court official Wang Cengqi, creating a volume in direct imitation of the woodblock and painted versions that preceded it.[68] Since the emperor presumably would not have gone to this trouble for a work of which he did not approve, we can only assume that, while he undoubtedly demanded aesthetically pleasing and artistically successful images, he was not exclusively, or even primarily, interested in aesthetic consistency. There was no single visual answer to the question of what looked European to him.

His request for the "European style," therefore, likely included the medium of copperplate engraving itself. Following Ripa's work on the Thirty-Six Views, the Italian directed the engraving of the Jesuit-surveyed atlas of the Qing under Kangxi, the *Complete Map of the Empire*. Like European surveying techniques, through which the most topographically accurate map of imperial territory in China ever produced was created, the use of copperplate engraving to render images of the emperor's park harnessed a foreign tool and foreign expertise in the service of a Qing goal. Despite the emperor's request, none of the Thirty-Six Views were ultimately European; rather, in their integration of diverse materials and aesthetic inputs into a single artistic product, they were quintessentially Qing. By the same token, the rendering of woodblock prints as engravings by an Italian artist and his Qing apprentices naturalized both a foreign technology and the knowledge and skill required to employ it, thus further broadening the definition of the new dynasty as articulated through the Thirty-Six Views.

68 See note 55. A second, unsigned set with calligraphy that appears to also be by Wang Cengqi is now in the Bibliothèque nationale de France (Hd90).

STEPHEN H. WHITEMAN

Conclusion: Translation as a Form of Naturalization

From an art historical perspective, the illustrations of the *Imperial Poems* are highly anomalous. The many iterations of the project are the product of multiple layers of translation—from painting to print, from woodblock to engraving, from unique object to multiple objects, from literatus to emperor, from Song to Ming to Qing, and so on. The work was undertaken in a period of fundamental artistic change at the Qing court, the moment of a visual turn in which divergent strands of Chinese art were being drawn together, even as the court was grappling with both Western pictorial techniques and the broader realms of science and technology that underpinned them. The Kangxi emperor's motivations for commissioning the different versions of the album began with the desire to appropriate a Han Chinese cultural form and ended with an experiment utilizing a new medium imported from Europe. The artists who produced the images were similarly diverse, including Han Chinese, Bannermen, perhaps Manchus, and an Italian missionary.

As a series of pictorial translations, the sets of images of the Thirty-Six Views manifest many of the same limitations and possibilities inherent in textual translation. The poems and texts translated below proceeded first from Chinese to Manchu, and now the Chinese has been brought into English. Through each stage of the process, the texts have retained essential meaning and have been fundamentally transformed. The same may be said for the Thirty-Six Views. In each iteration, the Views continued to convey the underlying aspects of the images from which they were drawn, even while they lost something of the original and incorporated new ideas and meanings.

Although bound as a book, the woodblock prints also refer to and play with the compositional and material possibilities of formats, such as painted albums and handscrolls, most commonly associated with painting, thus evoking the highly personal viewing practices of a unique object in the more readily reproducible medium of the woodblock printed book. Through the medium of printing, Kangxi presented visions of emperorship and empire to a broader audience by extending the exclusiveness of both the painted album and its subject, the imperial garden. As a garden owner, his garden portrait served as a vehicle for a sort of role play, in which he posed not as ruler, but as an individual and peer, inviting the viewer to visit with him simply by opening the book. Yet that book employed both the visual and poetic language, as well as the structure and techniques, connected to the formation and canonization of cultural landscapes. By creating a new "famous site" that was quintessentially Qing, Kangxi presented his empire as historically grounded, yet simultaneously exceptional. Reading the emperor's poems and imagining themselves within the landscape tied Kangxi's readers to him, to the dynasty, and to each other.

The translation from woodblock to copperplate raises different questions that involve not only the shift from one medium to another but also the introduction of new ideas and techniques from Europe. As the products of not one, but at least three distinct hands, the copperplates might be thought of as translations from one language into multiple dialects, related but not precisely the same. That some of the copperplates sought to compel engraving to behave like woodblock printing runs counter to what one might expect in cases of cross-cultural encounter and exchange, as there is less interest in the fresh opportunities

The many Rivers and Air, that Breaths from the Pine Tree Its Partner.
Apartments where the Europeans, were Employ'd by the Emperor.

figure 26

"The many Rivers and Air, that Breaths from the Pine Tree Its Partner," from *The Emperor of China's Palace at Pekin, and His Principal Gardens, as well in Tartary, as at Pekin, Gehol and the Adjacent Countries; with the Temples, Pleasure-Houses, Artificial Mountains, Rocks, Lakes, etc. as Disposed in Different Parts of Those Royal Gardens* (London: Robert Sayer, Henry Overton, Thomas Bowles, and John Bowles and Son, 1753). The Getty Research Institute, Los Angeles (92-B26685).

STEPHEN H. WHITEMAN

presented by a new medium and more interest in how to turn that medium into something familiar. The contributions to the album presumed to be by Ripa, on the other hand, attempt to apply aspects of contemporary European picture making derived from Northern Renaissance and baroque prints to images that remain, at their core, Chinese landscapes. Although these pictorial values often connected to certain moral or religious values in their native context, when they were transposed to a new milieu, their meaning seems lost, whether by artist, audience, or both. Thus, in the pictorial translation, the relationship between language and meaning is a fluid one, dependent on the complex of maker, viewer, medium, intention, and articulation.

In every case, however, the process of translation was also one of appropriation and naturalization. At its heart, translation transforms the foreign and impenetrable and makes it familiar and navigable, eliding its origins and rendering it anew in the cultural context of its translator. The creation of the Thirty-Six Views, in both its formal and material aspects may, thus, be seen as a metaphor for imperial expansion, consolidation, and rule, for the emperor's imagination and expression of the Qing itself. By engaging genres, media and styles, time, technology, geography, and imperial, popular, and foreign culture, the emperor and his artists created a series of images that represented not just a garden, but the empire itself—an empire, moreover, that was defined by the integration and naturalization of all that it encompassed.

Of course, translation is not a closed process; there is no such thing as the definitive or final translation, and individuals are free to create their own versions of a text, appropriating for themselves that which others have already sought to possess. The production and dissemination of Kangxi's woodblock and engraved views did not end with the printing of the copperplates in 1714. In an effort to create a sense of continuity across generations of rulers, the Qianlong emperor added poems matching those of his grandfather, printing a new version of the *Imperial Poems* in 1741.[69] In the late nineteenth and early twentieth centuries, the woodblocks found a far larger readership through lithographic reproductions in both China and Japan, where the audiences' interests in High Qing landscapes were very different from that of Kangxi's original recipients. Similarly, the engravings made their way to Europe, where what few accounts we have of their reception were immune to the rhetoric of style, focusing instead on the images as records of an imperial landscape and as testaments to Chinese garden design. Their later reinterpretation in the London publication, *The Emperor of China's Palace at Pekin, and His Principal Gardens* (1753; Figure 26), in which mandarins, square-sailed junks, and long-plumed birds—the language of chinoiserie—populate the lakes and shores, adds yet another layer of translation. In this case, of course, the process of appropriation and naturalization worked in the opposite direction, resulting in an image driven not by the emperor's rhetoric, but by that of the English construction of the Orient—a new text entirely.

69 Cf. Whiteman, "Kangxi's Auspicious Empire," 265–268.

Imperial Poems on the Mountain Estate for Escaping the Heat

IMPERIAL POEMS ON THE MOUNTAIN ESTATE FOR ESCAPING THE HEAT

御製避暑山莊詩

By the Kangxi Emperor

Translated from the Chinese by Richard E. Strassberg

Preface

Imperial Record of the Mountain Estate for Escaping the Heat

Yuzhi Bishu shanzhuang ji 御製避暑山莊記

From Gold Mountain there issues forth a vein in the earth where a warm current is fed by many springs. Clouds hover over vales deep and wide, and there are rocky lakes with purplish mists. This extensive domain was a fertile grassland; no harm has come to fields or homes. The air is pure and invigorating in summer, most efficacious for nurturing health. It was created by the activity of Heaven and Earth, and its panoply of things all belong to Nature.

We had made several inspection tours to the Yangtze region, so We became well acquainted with the refined beauty of the South. Twice We visited the Qin-Long area [modern Shaanxi and Gansu] and realized even more the thorough sparseness of the West. To the north, We crossed the desert sands. Eastward, We toured the Long White Mountains. The majesty of the mountains and rivers and the unspoiled simplicity of the people are beyond description, yet none of these places did We choose.

Only here, in Rehe, is there a road that keeps Us near to Our Divine Capital, where coming and going requires no more than two days. Though this land was developed from wilderness, how could Our purpose be to neglect affairs of state? Thus did We proceed to survey the variances between high points and flat land and between things near and far in order to bring out the natural dispositions of the mountains and vapors. A studio was built amongst the pines, and the caves and cliffs enhanced the scene. A stream was led beside a

pavilion, and hazelnut mists emerged from the valley. None of this could have come from the mere efforts of man: the flourishing land was employed to aid Us. And nothing was spent for carved rafters or painted pillars.

We delight in embracing simplicity amongst springs and forests. We quietly observe the myriad things and closely scrutinize the many kinds of life. Patterned birds play by green waters without flying away in fear. Deer, illuminated in the sunset, gather together in groups. Hawks fly and fish leap: upward and downward, they follow their natures. There are distant colors and purple mists: rising and falling, they form beautiful scenes.

When traveling or for pleasure, Our concern never ceases for the fortunes of the harvest. Whether attending to affairs in the morning or evening, We never forget the cautions in the classics and histories. We encourage planting in the southern fields, anticipating baskets filled with abundant crops. We cease when things have flourished and harvest in autumn, celebrating the season's blessings of sunlight and rain. This is a general description of Our residence at the Mountain Estate for Escaping the Heat.

As for appreciating virtuous behavior by enjoying irises and orchids, thinking of steadfast integrity by observing pines and bamboo, valuing frugality and purity by standing beside clear streams, despising greed and corruption by looking at creepers and grasses—this is also how the ancients employed things as metaphors. One cannot fail to recognize that what a ruler receives is obtained from the people. Those who do not feel love for them are deluded indeed. Thus have We committed this to writing so that morning and evening We shall not alter. In this can be found Our reverence and sincerity.

Written during the final ten days of the sixth lunar month in the fiftieth year of the Kangxi era [August 5–13, 1711]

御製避暑山莊記
　　金山發脉. 暖流分泉. 雲壑淳泓. 石潭青靄. 境廣草肥. 無傷田廬之害. 風清夏爽. 宜人調養之功. 自天地之生成. 歸造化之品彙. 朕數巡江干. 深知南方之秀麗. 兩幸秦隴. 益明西土之彈陳. 北過龍沙. 東遊長白. 山川之壯. 人物之樸. 亦不能盡述. 皆吾之所不取. 惟茲熱河. 道近神京. 往還無過兩日. 地闢荒野. 存心豈惟萬幾. 因而度高平遠近之差. 開自然峯嵐之勢. 依松為齋. 則竁崖潤色. 引水在亭. 則榛煙出谷. 皆非人力之所能. 借芳甸而為助. 無刻楠丹楹之費. 喜泉林抱素之懷. 靜觀萬物. 俯察庶類. 文禽戲綠水而不避. 麀鹿暎夕陽而成群. 鳶飛魚躍. 從天性之高下. 遠色紫氛. 開韶景之低昂. 一遊一豫. 罔非稼穡之休戚. 或旰或宵. 不忘經史之安危. 勸耕南畝. 望豐稔筐筥之盈. 茂止西成. 樂時若雨暘之慶. 此居避暑山莊之概也. 至於玩芝蘭則愛德行. 覿松竹則思貞操. 臨清流則貴廉潔. 覽蔓草則賤貪穢. 此亦古人因物而比興. 不可不知. 人君之奉. 取之於民. 不愛者. 即惑也. 故書之于記. 朝夕不改. 敬誠之在茲也.
　　康熙五十年六月下旬書.

1. Misty Ripples Bringing Brisk Air

Yanbo zhishuang 烟波致爽

This complex was the residential quarters of the emperor located at the rear of the palace area. It was constructed by the southern bank of Clearwater Lake (Chenghu 澄湖) and includes a three-bay central reception chamber. Here, in the morning, Kangxi would receive greetings from his empresses and consorts, who lived in the apartments to the east and west. The palace eunuchs were housed in the side rooms of the front building. In 1711, during the second phase of construction, a more formal palace complex, which Kangxi named Calm and Tranquil, Reverent and Sincere (Danbo jingcheng 淡泊敬誠), was completed in front of these residential quarters. It contained a throne hall where the emperor received officials and distinguished visitors.

The land at Rehe is high and open. The air is also fresh and clear. There is no fog or obscuring haze. This is what Liu Zongyuan described in one of his accounts as "boundless."[1] Brisk air is brought over from the fine mountains on all four sides across the several miles of Clearwater Lake. To the south of Scenes of Clouds and Mountains [View 8] is a building seven bays in width. I therefore named it "Misty Ripples Bringing Brisk Air" and inscribed it on a placard that is hung here.

> I often come to the Mountain Estate to escape the heat.
> Here is peace and quiet with hardly any noise.
> It controls the north, where distant wars have ceased[2]
> And faces south, near beautiful vales.
> When spring returns, fish leap from the waves;
> At fall harvest, geese stretch across the sands.
> Wherever I look are longevity herbs;
> Spreading forth from the windows are medicinal flowers.
> Northeast breezes bring brisk air by day;
> Drizzles extend throughout the night.
> The soil, so rich, yields double-headed grain;
> The spring water is so sweet, we can cut open green melons.[3]
> In the past armed men fortified this area;
> Now, soldiers no longer sound martial flutes.
> Farmers and merchants attend to life's needs,
> And the people have increased to myriad households.

熱河地既高敞. 氣亦清朗. 無蒙霧霾氛. 柳宗元記所謂曠如也.
四圍秀嶺. 十里澄湖. 致有爽氣. 雲山生勝地之南. 有屋七楹.
遂以烟波致爽顏其額焉.

山莊頻避暑. 靜默少喧譁. 北控遠烟息. 南臨近壑嘉. 春歸魚出
浪. 秋斂雁橫沙. 觸目皆仙草. 迎窗遍藥花. 炎風晝致爽. 綿雨
夜方賒. 土厚登雙穀. 泉甘剖翠瓜. 古人戎武備. 今卒斷鳴笳.
生理農商事. 聚民至萬家.

RIPA'S TITLE AND COMMENT

"The River's Water and the Clouds on the Mountains Bring Me Enjoyment." The emperor, followed by two or three boats of his ladies, on the days when he did not fast, would come to these houses where, after handling affairs of state, he would dine with the ladies in his retinue.[4]

L'acqua del fiume, e le nubbi sù i monti mi recreavano. = L'Imp.ᵉ seguitato da due o trè barche delle sue donne, nei giorni che non digiunava, veniva in queste Case, dove doppo d'aver trattato gl'affari del Regno, mangiava colle sue donne di seguita.

1 Liu Zongyuan 柳宗元 (773–819) was a literatus and official of the Tang dynasty who was later canonized as one of the Eight Masters of Tang and Song Poetry and Prose (*Tang Song bajia* 唐宋八家). He was an influential travel writer, and the reference is to an expression in "A Record of the Hill East of the Longxing Temple in Yongzhou" (Yongzhou Longxingsi dongqiu ji 永州龍興寺東丘記).

2 A reference to Kangxi's military and diplomatic successes in pacifying the northern frontier. In 1689, the Qing signed the Treaty of Nerchinsk with Russia to settle border issues. By 1691, the Eastern Mongol Khalkha tribes had submitted to the Qing, and, in 1696, Kangxi led his armies to decisively defeat the Western Mongol leader Galdan 噶爾丹 (Dga'-ldan, r. 1671–1697). Two tours of inspection in 1698 and 1700 further consolidated Qing control of the north.

3 See View 35, which contained melon and vegetable patches.

4 Ripa's thirty-five titles and comments were written by him on five separate pages of the Bibliotheca Nazionale di Napoli (I.G.75) copy. These begin with his "Descrizione della Villa" (Description of the Villa; see Appendix 2), followed by a numbered list entitled "Le Vedute della Villa dell'Imp.ᵉ Cinese in Tartataria, nel luogo detto Gehol" (The Views of the Villa of the Chinese Emperor in Tartary in the Place Called Gehol [Jehol]). The numerical order does not follow the original Chinese version, and the inscription for Chinese View 9 is missing along with the copperplate engraving. Translations from the Italian are by Paola Demattè and Richard E. Strassberg. The transcriptions by Richard E. Strassberg follow Ripa's orthography.

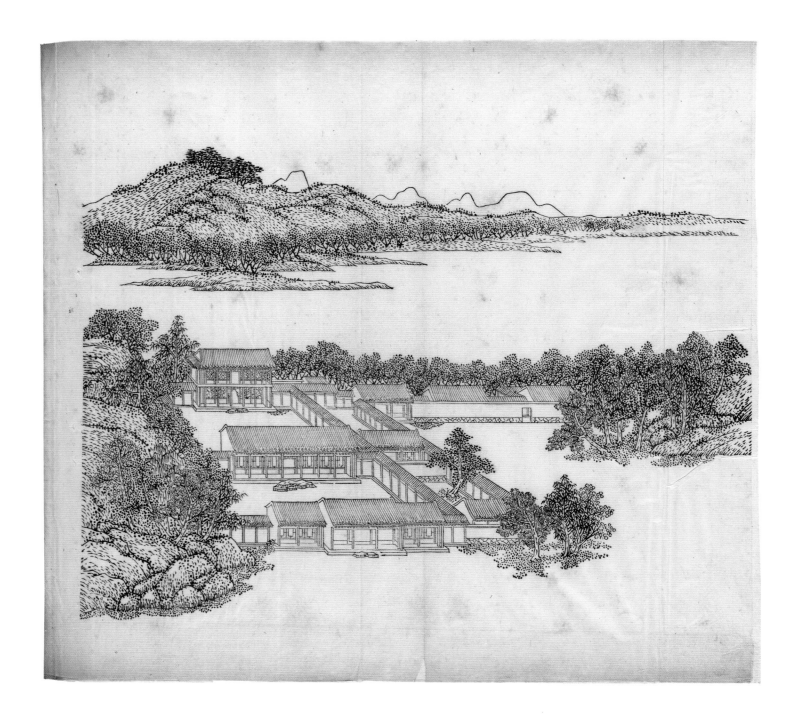

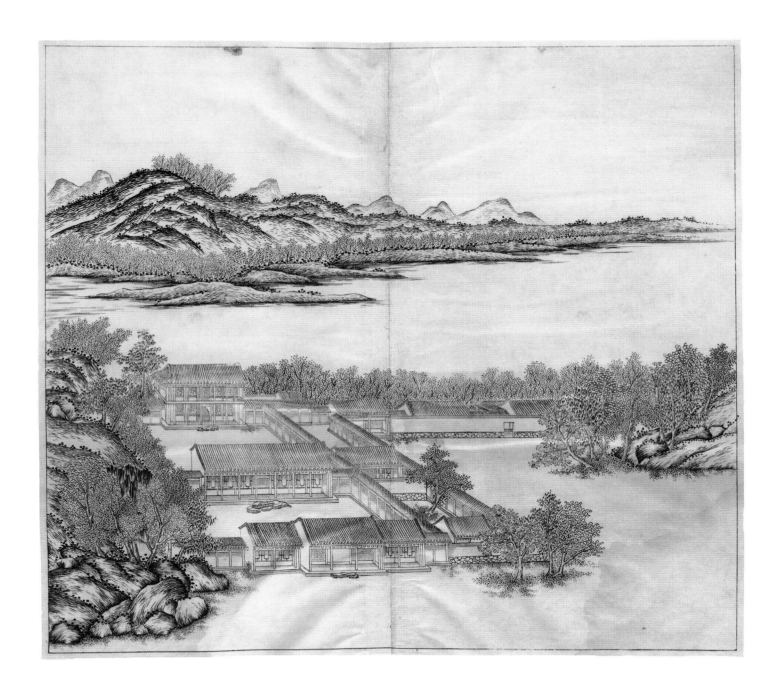

2. A *Lingzhi* Path on an Embankment to the Clouds

Zhijing yundi 芝逕雲隄

This path on an embankment is located north of Pine Winds through Myriad Vales (View 6). It leads from the palace area to the lake area and separates Upper Lake (Shanghu 上湖) from Wish-Fulfilling Lake (Ruyihu 如意湖). It invokes the famous embankment at West Lake (Xihu 西湖) in Hangzhou built by Su Shi 蘇軾 (1037–1101). A lingzhi 靈芝 is an auspicious plant shaped like a fungus with several growths on its stalk. It symbolizes longevity, especially in Daoist culture, and was sometimes represented as a decorative object known as a wish-fulfilling wand (ruyi 如意). Kangxi stated that the name of this view derived from the resemblance of the shape of the path and the three islands it connected to a lingzhi. The three islands were referred to as Sounds of the River in the Moonlight (Yuese jiangsheng 月色江聲), Surrounded by Greenery (Huanbi 環碧), and Wish-Fulfilling Island (Ruyizhou 如意洲).[5]

An embankment was built flanked on both sides by water. It meanders as it divides into three paths leading to three islets, large and small. They are shaped like a *lingzhi*, like clouds, and also like a wish-fulfilling wand. Two bridges permit boats to pass underneath.

> Despite myriad affairs, I found some time
> to leave my gated palace.
> With my passion for streams and mountains,
> it was hard not to linger on the way.
> I escaped the heat near the northern desert
> where the land is fertile and rich.
> Local elders were consulted
> as I searched for old inscriptions.
> They all said that these are plains
> where Mongols pastured horses.
> There were also few inhabitants
> and no bones of vanquished warriors.
> Grasses and trees flourish.
> No mosquitoes or scorpions.
> And the spring water is excellent:
> People are seldom ill.

5 "Un-Summerly Clear and Cool" is also the name of View 3. *Lingzhi*, clouds, and wish-fulfilling wands are motifs associated with religious Daoism and the cult of Transcendents (*xian* 仙), who possess the secret of longevity. For Kangxi's explanation of the origin of this view's name, see also Zhang, "Hucong ciyou ji," 7:5. Translated in Appendix 3.

So I saddled up and rode off
 to inspect the river bend.
Twisting and turning,
 it meandered through shady groves.
I surveyed the extent of the wilderness
 and measured the water level.
There was no need to destroy fields
 or cut down any trees.
For the land conforms in shape
 to Heaven's natural design.
It needed no human labor
 for artificial constructions.
Do you not see Hammer Peak?
Solitary and erect, it stands forth to the east.
And do you not see the pines in myriad vales?[6]
A canopy drooping over layered forests
 in accord with nature's way.
Nurtured by warming ethers,
 receiving the glistening dew,
The verdant crops ripen
 with good harvests year after year.
Mindful always of straining the people
 when traveling for pleasure,
I also feared burdening them
 to obtain construction workers.
Designers were told to first build
 the embankment and *Lingzhi* Path
And to follow the form of the land
 in making it properly even.
The Chamberlain was not to use
 government treasury funds.
I preferred the rustic and rejected flamboyance
 to accord with the people's taste.

6 "Pine Winds through Myriad Vales" is also the name of View 6.

How could I ever build a Great Wall
 and rely on border guards?[7]
History has well recorded
 those cruel and extravagant rulers.
This is a reason to urge myself
 towards caution and restraint.
Then I can become a model for all,
 pacifying near and far.
Though it lacks imposing structures,
 there are towers that touch the clouds.
Yet climbing them can not disperse
 layers and layers of sorrows.
The mountain chains and remote ravines
 offer views in every season,
Pitying me that in old age,
 the worries of ruling remain.
If they would help to nurture my health
 and sustain my energy and strength,
I'll continue to strive in every way
 to govern together with worthies.
Promoting farming in accord with the seasons
 is my imperial ambition
So the beacons of war will no longer flare
 for millions and millions of autumns.

7 Kangxi had previously rejected proposals to repair the Great Wall as a form of border defense, arguing
that his pacification of the Mongols and his use of them to patrol the area rendered such efforts unnecessary.

夾水為隍. 透迤曲折. 逕分三枝. 列大小洲三.
形若芝英. 若雲朵. 復若如意. 有二橋通舟楫.

萬幾少暇出丹闕. 樂水樂山好難歇. 避暑漠北
土脈肥. 訪問村老尋石碣. 眾云蒙古牧馬場.
並乏人家無枯骨. 草木茂. 絕蚊蝎. 泉水佳.
人少疾. 因而乘騎閱河隈. 灣灣曲曲滿林樾.
測量荒野閱水平. 莊田勿動樹勿蘗. 自然天成
地就勢. 不待人力假虛設. 君不見磬錘峰. 獨
崎山麓立其東. 又不見萬壑松. 偃盖重林造化
同. 煦嫗光臨承露照. 青葱色轉頻歲豐. 遊豫
常思傷民力. 又恐偏勞土木工. 命匠先開芝逕
隍. 隨山依水揉輻齊. 司農莫動帑金費. 寧拙
捨巧洽群黎. 邊垣利刃豈可恃. 荒淫無道有青
史. 知警知戒勉在茲. 方能示眾撫遐邇. 雖無
峻宇有雲樓. 登臨不解幾重愁. 連巖絕澗四時
景. 憐我晚年宵旰憂. 若使扶養留精力. 同心治
理再精求. 氣和重農紫宸志. 烽火不煙億萬秋.

RIPA'S TITLE AND COMMENT

"Road Similar to the Famous Herb called 'Ci' [zhi 芝] and Riverbank Similar to the Clouds
in the Sky." When the emperor went by land to handle affairs of state, by horseback or in a
sedan chair along with his retinue of many concubines, he would cross these two bridges.

Via simile alla famosa erba chiamata Ci: e ripa simile alle nubbi del cielo. = L'Imp.ᵉ quando
per terra andava a trattare gl'affari del Regno, a cavallo, e in sedia colla seguita di molte
Concubine passava per gli due ponti.

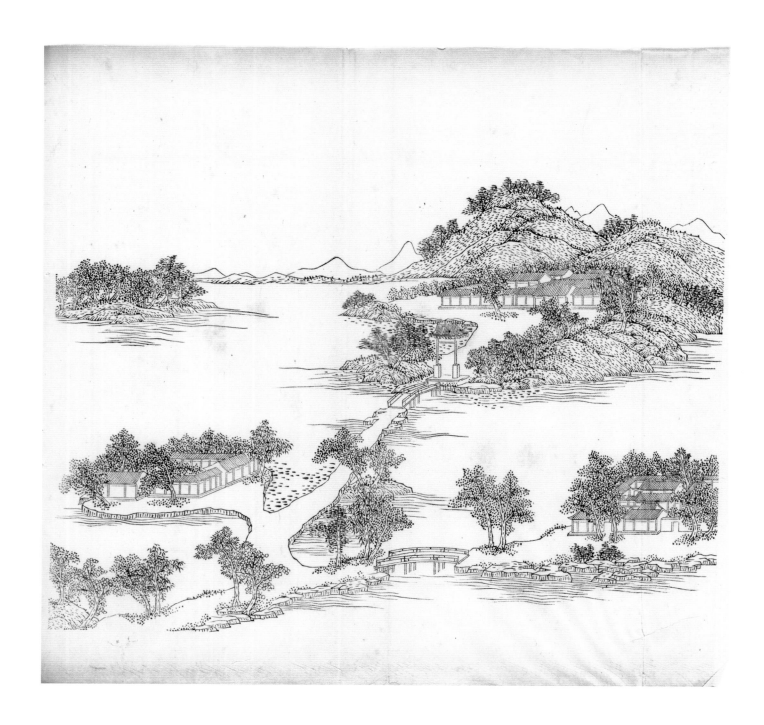

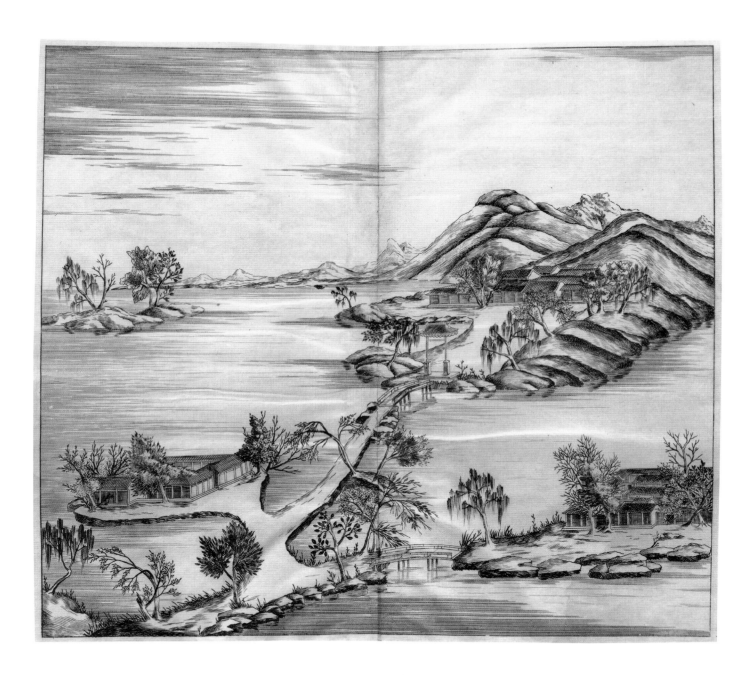

3. Un-Summerly Clear and Cool

Wushu qingliang 無暑清涼

Located on Wish-Fulfilling Island, this building forms part of a larger complex that includes Views 4 and 5. The five-bay hall is the first of a series of three similar structures separated by courtyards. The entire complex originally served as a palace that included an audience hall, Kangxi's office, and conference rooms. When the more formal buildings named Calm and Tranquil, Reverent and Sincere were constructed in front a few years later, the spaces dedicated to government affairs were moved and this complex was reserved for the emperor's private use.

Walking north along *Lingzhi* Path [View 2], then turning slightly east, one passes by a hill. The lake is filled with red lotus blossoms and the embankment is lined with green trees. A large, open building faces south flanked by connecting verandas. This is Un-Summerly Clear and Cool. The brisk mountain air arrives in the morning as light breezes waft across the water. The refreshing chill is indeed excellent.

> In hot weather I worry first
> about long and endless days.
> Preferring tranquility in my old age,
> this adds to my disquiet.
> But here in high summer the heat subsides
> as refreshing breezes arrive.
> Encountering coolness in this season,
> I appreciate the beauty of things.
> Constantly mindful
> of my imperial ambitions,
> I ponder, indecisively,
> how to rule in these times.
> When I can no longer hold to the Valley Spirit,[8]
> I'll go back to Venerating Governance.[9]
> For now, I cultivate Returning the Mind[10]
> on this estate of mountains and streams.

循芝逕北行. 折而少東. 過小山下. 紅蓮滿渚. 綠
樹緣隄. 面南夏屋軒敞. 長廊聯絡. 為無暑清涼.
山爽朝來. 水風微度. 泠然善也.

畏景先愁永晝長. 晚年好靜益徬徨. 三庚退暑清
風至. 九夏迎涼稱物芳. 意惜始終宵旰志. 踟躕自
問濟時方. 谷神不守還崇政. 暫養回心山水莊.

"Freshness without Heat." This is a part of the house where some of the many ladies that the emperor took with him to Tartary dwelled. The emperor often took a walk over to this place.

Frescura senza calore. = Questa è una parte dell'abitazione, nella quale dimorava una parte delle molte donne, che l'Imp.ᵉ portava seco in Tartaria. L'Imp.ᵉ spesse volte andava a spasso in questo Luogo.

8 The Valley Spirit (*gushen* 谷神) is mentioned in chapter 6 of the Daoist philosophical text *The Old Master* (aka *Laozi* 老子, ca. fourth–third century BCE): "The Valley Spirit never dies. It is called the mysterious feminine. The gate to the mysterious feminine is the root of Heaven-and-Earth" 谷神不死. 是謂玄牝. 玄牝之門. 是謂天地之根. It can refer either to an internal spirit cultivated as part of a health regimen or to an aspect of universal reality; in both cases, it possesses the qualities of etherealness and inexhaustibility. Kangxi was attracted to this ideal, as seen in his poem to View 27. Here, however, he states that he cannot pursue it just by dwelling in nature and abandoning his responsibility to govern the empire.

9 The Hall for Venerating Governance (Chongzhengdian 崇政殿) was where emperors during the Song dynasty attended lectures by leading officials on the Confucian principles for ruling the empire.

10 Returning the Mind (*huixin* 回心), according to the "Treatise on Ritual and Music," in the *History of the Western Han Dynasty* (*Hanshu*: "Liyue zhi" 漢書: 禮樂志, 92 CE), refers to leading the people to return to the excellent moral and cultural practices of the Way as practiced in antiquity. Here, Kangxi blends this Confucian ideal with a Buddhist interpretation, where the phrase signifies the individual's practice of self-reflection to achieve enlightenment by realizing the true nature of things, including the self.

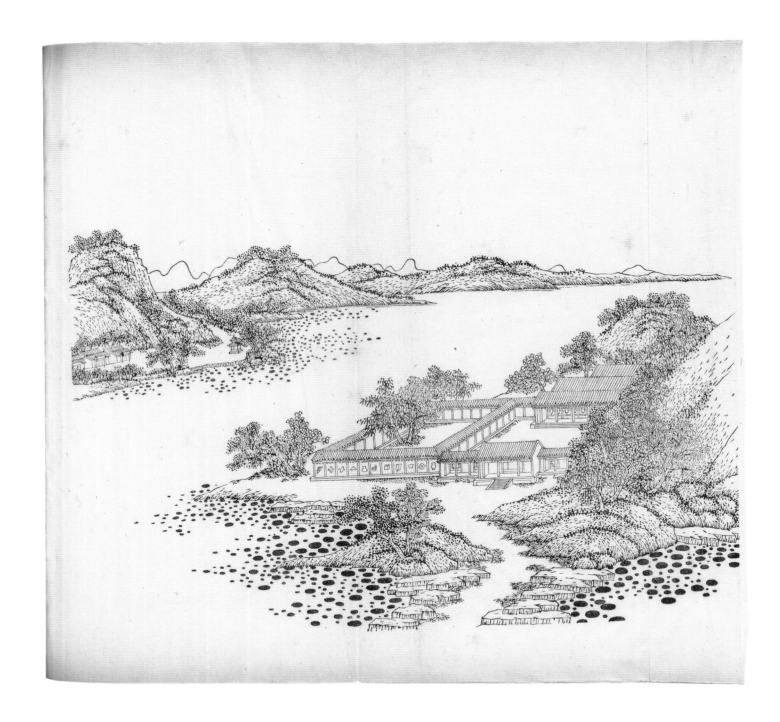

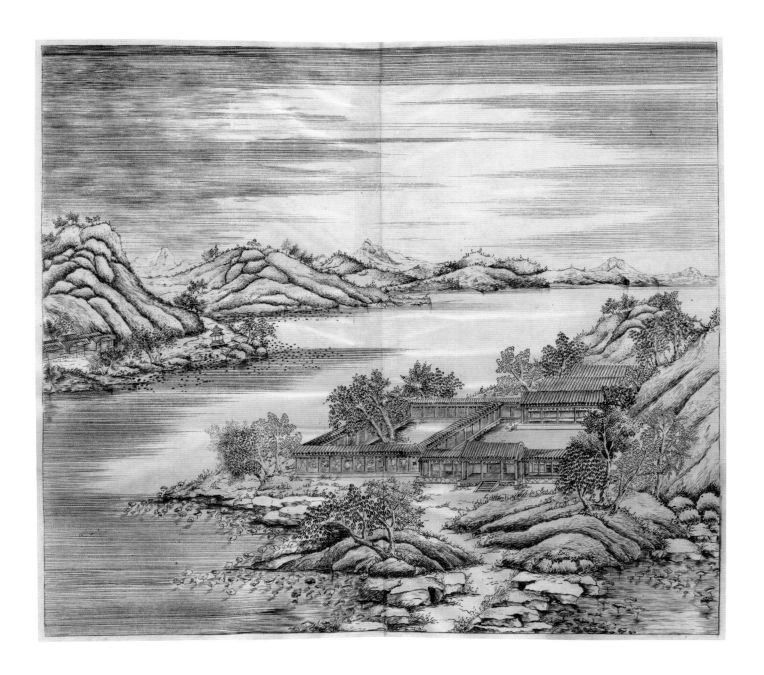

4. Inviting the Breeze Lodge

Yanxun shanguan 延薰山館

This lodge is the second and principal structure in the complex that includes Views 3 and 5. Seven bays wide and flanked by verandas, it served as an audience hall for officials and distinguished visitors. The informality of its name underscores its rustic style devoid of the usual palatial decoration. It also alludes to an anecdote about the ancient thearch Shun 舜 (trad. r. late third millennium BCE), who was said to have composed a song about the balmy southern breezes that could sooth his people.[11] Kangxi imagines this lodge as bringing over such soothing breezes, which can also refer to the Confucian ideal of carrying out benevolent government. After the formal palace complex was built, the lodge was used as a residence for Kangxi's wives.

After entering Un-Summerly Clear and Cool [View 3] and turning west, there is Inviting the Breeze Lodge. The style of the buildings embrace an unadorned simplicity without any painted decoration and ornate carvings. Such taste captures the refined beauty of dwelling in the mountains. Opening the doors on the north side admits refreshing breezes so that one almost forgets that it is the sixth lunar month.[12]

> Summertime trees create deep shade,
> a canopy covering the muggy heat.
> Northeast winds waft gently by
> from the gaps in protective peaks.
> Nothing else in these mountains
> can relieve the malaise.
> If not for the cool breezes
> I would take off my shirt.

11 See the "Discussion of Music," in *Anecdotes from the School of Confucius* (*Kongzi jiayu*: "Bianyue jie" 孔子家語: 辯樂解, Warring States period–Wei dynasty), which states that Shun invented the five-stringed *qin*-zither 琴 and performed the song "Southern Breeze" (Nanfeng 南風). It contained the lines "Oh, the balmy infusion of the southern breeze. It can relieve the malaise of my people" 南風之薰兮, 可以解吾民之慍兮. Kangxi alludes to this again in his poems on Views 9 and 26.

12 The sixth lunar month normally falls in August and is considered the height of summer.

入無暑清涼轉西. 為延薰山館. 楹宇守
樸. 不腹不雕. 得山居雅致. 啟北戶引
清風. 幾望六月.

夏木陰陰蓋溽暑. 炎風款款守峰衙.
山中無物能解慍. 獨有清涼免脫衫.

RIPA'S TITLE AND COMMENT

"Vapors from the Earth that Cover the House on the Mountain." Another section of the dwelling of a group of concubines, where the emperor goes for a walk.

Vapore dell terra, che covre le Case sul monte. = Un altra parte dell' abbitaz.[ne] d'una parte della Concubine, e dove l'Imperadore andava a spasso.

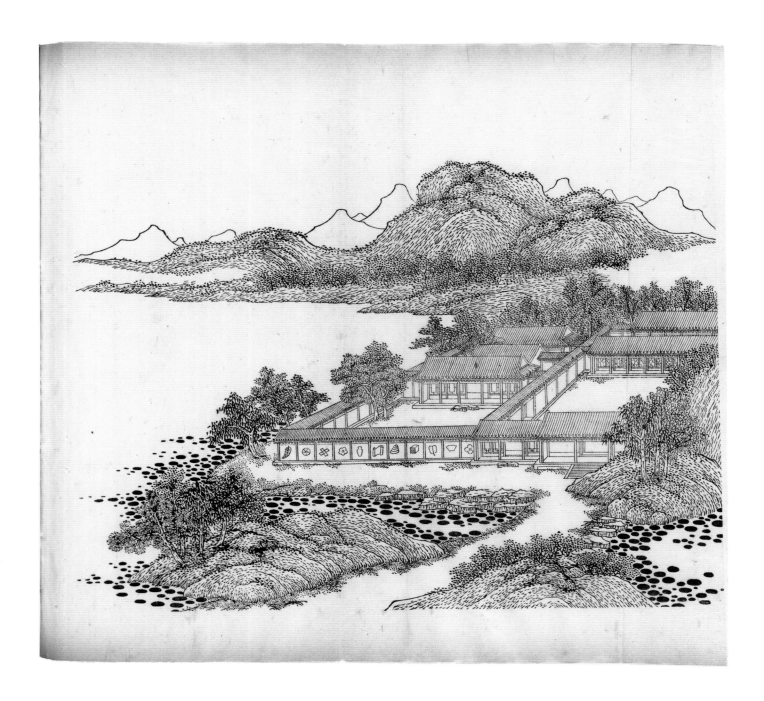

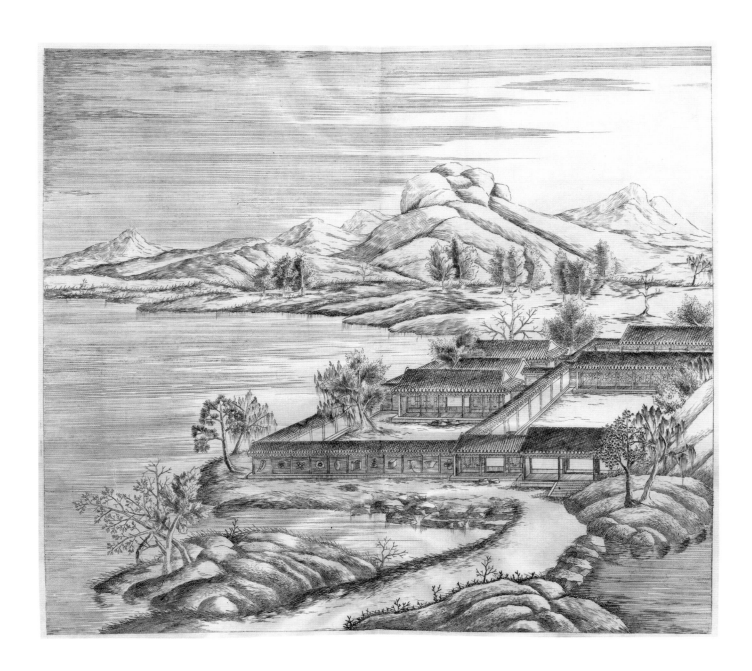

5. Fragrant Waters and Beautiful Cliffs

Shuifang yanxiu 水芳巖秀

This building comprises the third section of the complex that includes Views 3 and 4. It is situated closer to the rocky shore of Clearwater Lake. The main hall is seven bays wide and is flanked by verandas; there is a three-bay chamber to the side. This building was used as a private study by Kangxi, who liked to celebrate the Double Seventh festival here with his wives and high-ranking officials. It also included a Buddhist altar, and it was used for a while as a residence for Empress Dowager Xiaohui.[13]

When water is pure, it emits a fresh fragrance; if mountains are tranquil, they possess a refined beauty. Here, there are sweet springs with pure water so I chose this fitting spot to build a secluded house several dozen bays in size. Here, I can intone poetry and nurture my vitality undisturbed by affairs. I can wash away cares and delight my own nature. I composed this poem as a caution to always practice restraint.

Water, by nature, mixes bitter and sweet.
Its fragrance is due to the depth of its source.
I have visited many famous springs
But none surpass the ones found here.
The hexagram "Nourishing" means proper diet.[14]
Living correctly nurtures longevity.
I chose the right spot to build a simple lodging.
The foundation was designed to long endure.
Here, I practice "control and release":[15]
No lagging behind in effort and thrift.
Through the windows are a thousand cliffs surrounding.
Their sharp walls seem to slice the sky.
I dispatch my thoughts to the far-off Milky Way
And my spirit, delighted, arrives at the Big Dipper.
I carefully study the masters of calligraphy
But my hand is becoming stiffer when I try to write.
Light and mild is my food and drink.
Always, I have disliked fine wine.
I shall keep reading "No Ease"[16] in old age
And celebrate good harvests year after year.

水清則芳. 山靜則秀. 此地泉甘水清. 故擇其所宜.
遼宇數十間. 扵焉誦讀. 幾暇靜養. 可以滌煩. 可以
悅性. 作此自戒始終之意云.

水性雜苦甜. 水芳即體厚. 名泉亦多覽. 未若此為首.
頤卦明口實. 得正自養壽. 擇地立偃房. 根基度長久.
節宣在茲求. 勤儉勿落後. 朝窗千巖裏. 峭壁似天剖.
遠託思雲漢. 怡神至星斗. 精研書家奧. 臨池愈澀手.
清淡作飲饌. 偏心惡旨酒. 讀老無逸篇. 年年祝大有.

RIPA'S TITLE AND COMMENT

"Fragrant Water and Perfect Mountains." View of a part of the house where the emperor slept.

Acqua che odora e Monti perfetti. = Veduta d'una parte dell'abbitaz.^ne, nella quale l'Imp.^e dormiva.

13 The Double Seventh festival (Qiqiao 七巧) falls on the seventh day of the seventh lunar month, when folklore regards the two stars Ox Herd (Niulang 牛郎; Altair) and Weaving Maid (Zhinü 織女; Vega) as romantically reuniting after crossing a bridge formed by magpies to span the Silver River (Yinhe 銀河; the Milky Way). The Buddhist altar was mentioned by Zhang Yushu when he visited it in the summer of 1708. See Zhang, "Hucong ciyou ji," 7:5. See also Appendix 3. As a residence for the Empress Dowager Xiaohui, see Xiaotian 嘯天, *Chengde mingsheng* 承德名勝 [Famous Places in Chengde] (Hailaer: Neimenggu wenhua chubanshe, 2004), 25.

14 The hexagram *Yi* 頤 (Nourishing) in *The Book of Changes* (*Yijing* 易經, Zhou-Han dynasties) emphasizes the role of consuming proper food in nurturing vitality and longevity.

15 "Control and release" (*jiexuan* 節宣) denotes a general principle in the practice of self-cultivation as recorded in various classical texts. It generally refers to regulating the body's flow of *qi*-energy 氣. The "Inscription on Subtle Forces" (*Ji ming* 幾銘) by the Tang dynasty poet and official Quan Deyu 權德輿 (759–818) states: "Control and release desires and dislikes and you will avoid transgression in the five kinds of activity" 節宣好惡; 無愆五事. Kangxi, *Yuzhi Bishu shanzhuang shi* (1712), 2b.

16 "No Ease" (Wuyi 無逸) is a chapter in the *The Book of Documents* (*Shujing* 書經, Zhou dynasty) that cautioned the ruler against indulging in relaxation and pleasure in order that he remain focused on governing.

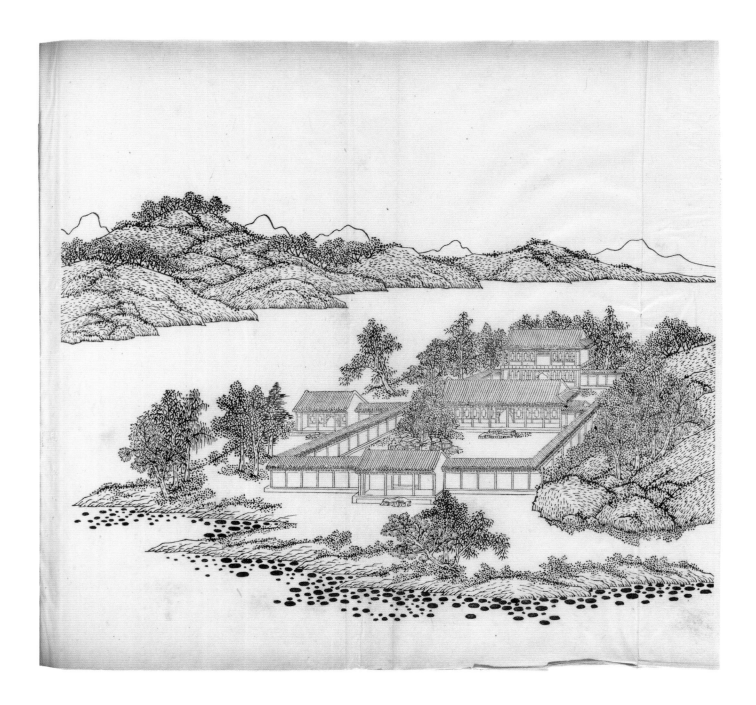

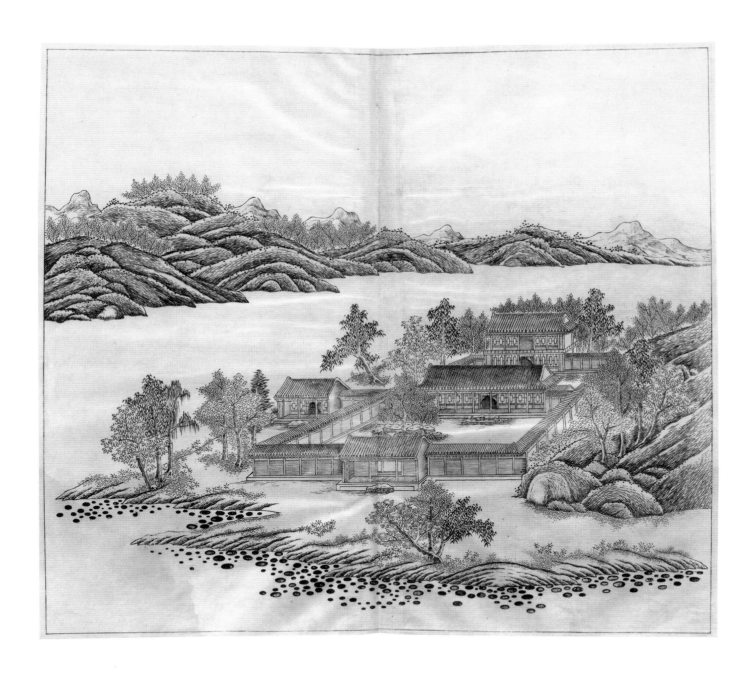

6. Pine Winds through Myriad Vales

Wanhe songfeng 萬壑松風

This was part of the first complex constructed in the front palace area. It was composed of several buildings surrounded by pines that served as the emperor's office, private study, and reception chamber. The five-bay main hall faces the lake to the north. In 1722, Kangxi invited his eleven-year-old grandson Hongli 弘曆 (1711–1799) to reside here so that he could observe him conducting official affairs. Hongli became the Qianlong emperor 乾隆 (r. 1735–1795) and later renamed it "The Hall Commemorating Benevolence" (Jientang 紀恩堂). The illustration shows the main hall looking north with the bridge below leading to View 2. The first two lines of the poem describe the views from the main hall toward the mountain section and valleys to the west and toward the lake section with the embankment and islands to the north. The last two lines invoke the theme of filial piety, thus forming a bridge to View 7. The name derives from several masterpieces of Chinese landscape painting with the same name, such as the one by the Northern Song artist Li Tang 李唐 (1066–1150), now in the National Palace Museum, Taipei.

Located south of Un-Summerly Clear and Cool [View 3], it is built against a tall hill and faces the deep, flowing water. Lofty pines surround it with their greenery. When the wind blows through the hollow vales, the sounds are like a performance of pitch-pipes and large bells. The trees here are not fewer than those on Myriad Pines Ridge at West Lake.[17]

> A tangled cover of dragon-scaled pines
> > turns myriad vales green.
> A path meanders among fragrant flowers
> > strewn on cloud-shaped islands.
> The white blossoms and vermillion calyxes
> > urge me towards filial devotion.[18]
> With love and respect for the poem "South Mound,"[19]
> > I rejoice in the "Correct Classic."[20]

17 Myriad Pines Ridge (Wansongling 萬松嶺) is the name of a scenic mountain south of the city of Hangzhou.

18 The "Little Preface" to *The Book of Songs* (Shijing: "Xiaoxu" 詩經: 小序, Western Han dynasty) refers to the lost poem "White Blossoms" (Baihua 白華) as signifying the purity of a filial son's devotion to his parents. A filial son stands out from among his brothers like "white blossoms and vermillion calyxes" (*baihua zhue* 白華朱萼) in a forest. This phrase is borrowed from "A Supplement of Lost Poems" (Bu wang shi 補亡詩) by the Western Jin dynasty poet Shu Xi 束皙 (ca. 261–ca. 300).

在無暑清涼之南. 據高阜. 臨深流. 長松環翠. 壑虛
風度. 如笙鏞迭奏聲. 不數西湖萬松嶺也.

偃蓋龍鱗萬壑青. 逶迤芳甸雜雲汀. 白華朱萼勉人事.
愛敬南陔樂正經.

RIPA'S TITLE AND COMMENT

"Many Rivers and Winds that Blow through the Pines." View of another group of houses where on the days when the emperor was not fasting, he would go to handle the affairs of his realm. In three rooms of these houses dwelled the Europeans serving at the court.

Molti fiume e vento, che soffia dagl'alberi di pino. = Veduta d'un altra parte delle Case, nelle quali ne giorni, che l'Imp.ᵉ non digiunava, andava a trattare gl'affari del suo Regno. = In tré Camere di queste Case sedevano gl'Europei di Servizio.

19 The "Little Preface" to *The Book of Songs* also refers to the lost poem "South Mound" (Nangai 南陔) about filial sons admonishing each other to support their parents.

20 "Correct Classic" (Zhengjing 正經) specifically refers to those sections of the "Airs" (Feng 風) and "Odes" (Ya 雅) in *The Book of Songs* that were regarded as celebrating the virtues of the Zhou dynasty, as opposed to other sections that contained poems voicing critical sentiments.

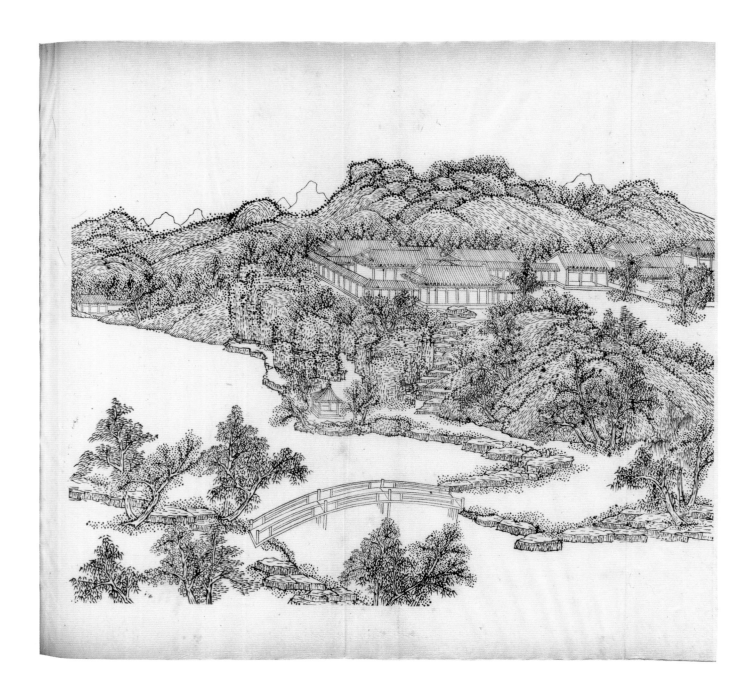

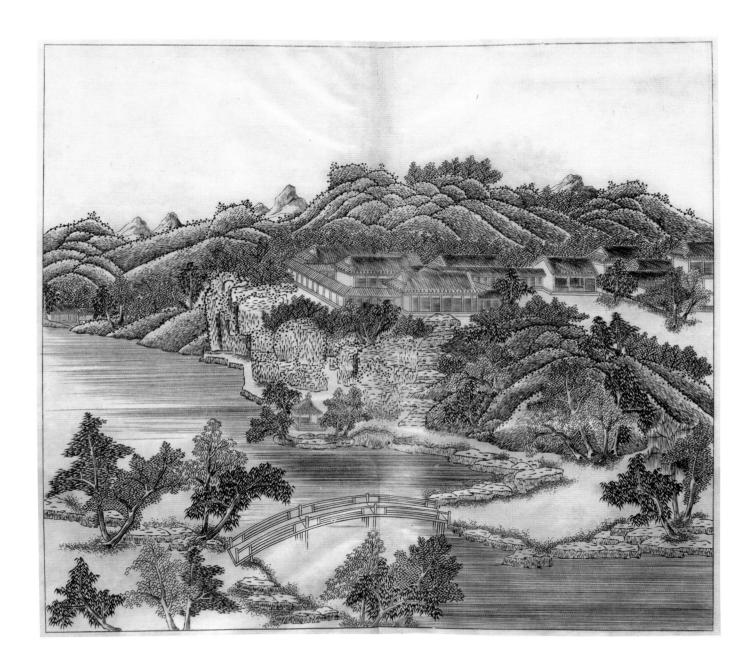

7. Sonorous Pines and Cranes

Songhe qingyue 松鶴清越

This complex stood in Hazelnut Glen (Zhenziyu 榛子峪), where the mountain area begins. The central and right sections, each with halls five bays in width, served as the residence of Empress Dowager Xiaohui. Kangxi visited the complex regularly to pay filial respects to her as his mother.[21] The name, description, and poem refer to the theme of longevity and invoke the Daoist cult of Transcendents. The illustration also includes a smaller, adjacent set of buildings on the left, which the emperor named "Clear Sounds of a Spring in the Breeze" (View 16).

On entering Hazelnut Glen, one encounters fragrant plants covering the ground and rare flowers dotting the cliffs. Coiling pines between the hills form a lush verdure. Cranes cry out as they soar above. It is like disembarking at the paradise isles of Penglai and Yingzhou or approaching the divine garden on Mount Kunlun.[22] One's spirit is delighted and one's mind feels boundless. Truly it is where Transcendents would establish their residence, a court where one could never grow old.

> May she live as long
> as the evergreen pines
> Whose needles endure
> for a thousand years.
> With bronze dragons above,
> how strong she is despite crane-white hair.[23]
> How delightful and affecting it is
> with such agreeable seasons here.

21 Kangxi's biological mother was Empress Xiaokang, but he had little contact with her. After 1653, Dowager Empress Xiaohui assumed the role of his mother, and he remained devoted to her throughout her life. Following her death in 1718, the complex remained unoccupied for the remainder of the Kangxi era out of respect for her memory. It was used as a study under the Qianlong Emperor, but it later fell into disrepair and it no longer exists. Until recent years, cranes could still be seen here annually in autumn. *Kangxi sanshiliu jing shi xuanzhu* 康熙三十六景诗选注 [Kangxi's Poems on the Thirty-Six Views of the Mountain Estate for Escaping the Heat with Commentary], ed. Chengde shizhuan Bishu shanzhuang shiwen yanjiu xiaozu (Chengde: Chengde shizhuan xuebao bianjibu, 1985), 27n1.

22 Penglai 蓬萊 and Yingzhou 瀛洲 are two of the mythical islands in the Gulf of Bohai where Daoist Transcendents were believed to dwell. Mount Kunlun (Kunlunshan 崑崙山) is a mythical mountain in the distant west that contained a divine garden known as the Dark Garden (Xuanpu 玄圃, aka Suspended Garden [Xuanpu 懸圃]). Transcendents gathered at Mount Kunlun to banquet on peaches that enhanced longevity in a ritual hosted by the Daoist goddess Queen Mother of the West (Xiwangmu 西王母).

進榛子峪. 香草遍地. 異花綴崖. 夾嶺虬松蒼蔚.
鳴鶴飛翔. 登蓬瀛. 臨崑圃. 神怡心曠. 洵仙人所
都. 不老之庭也.

壽比青松願. 千齡葉不凋. 銅龍鶴髮健. 喜動四
時調.

RIPA'S TITLE AND COMMENT

"A Pine and a Very Fine Bird." Houses where the mother of the emperor dwelled. After her death they later always remained empty out of respect for the departed one who had lived there.

Pino ed. ucello bonissimo. = Case, nelle quali dimorava la Madre dell'Imp.ᵉ. Doppo la sua morte poi stiedero sempre vuote in riverenza della defonta, che l'abbitò.

23 The bronze dragons allude to ornaments on the roofs of ancient palaces. Here, they refer to the residence of the empress dowager.

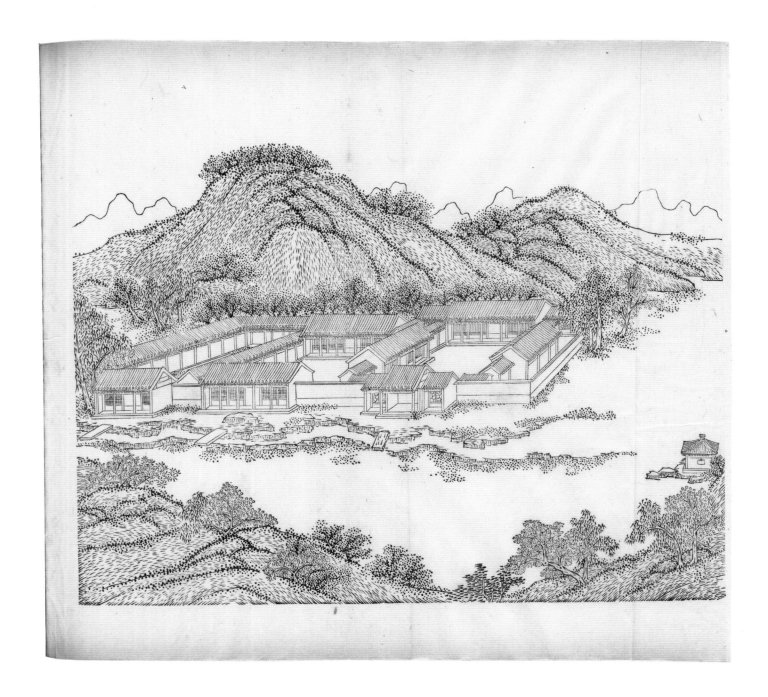

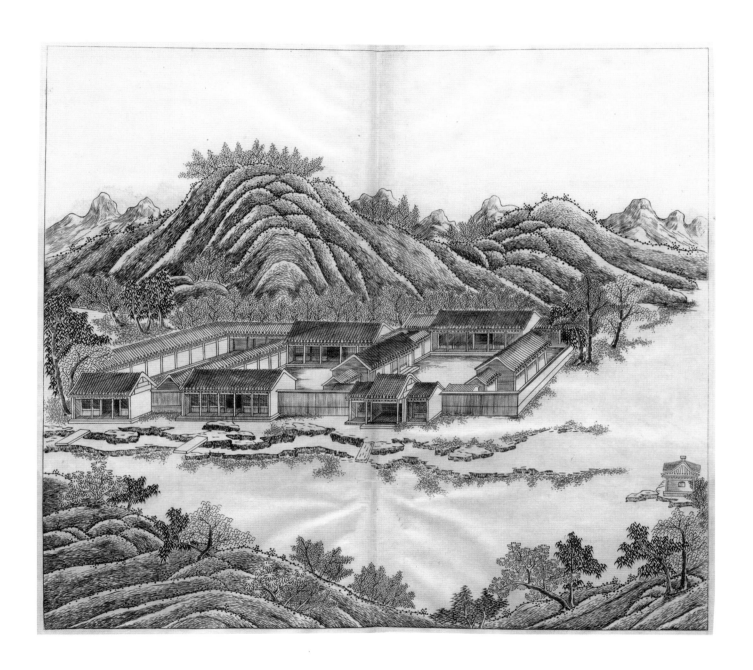

8. Scenes of Clouds and Mountains
Yunshan shengdi 雲山勝地

Located at the rear of the palace area behind Misty Ripples Bringing Brisk Air (View 1) and next to Pine Winds through Myriad Vales (View 6), this two-story structure is five bays in width. The upper story can be reached only by steps ingeniously placed in the artificial rockery outside. It also contained a Buddhist shrine.[24] From here, Kangxi and his wives enjoyed the panoramic vista, especially for moon-gazing.

West of Pine Winds through Myriad Vales is a towering pavilion facing north. When I gaze through its windows into the distance, the forested peaks and misty waters stretch without end as clouds undergo myriad transformations. Truly, ascending it provides a grand view.

> This garden of thousands of acres
> extends to distant fields.
> Lake's glimmer and mountain colors
> are worthy of a poem.
> Clouds part and I can see the reason
> why water is calm and clear.
> Still unable to prevent overflows,[25]
> I practice "control and release."[26]

24 This room was later named "The Lotus Chamber" (Lianhuashi 蓮花室) by the Qianlong emperor.

25 The graph *yan* 衍 (overflow) refers here both to controlling floods and to exercising self-restraint to avoid transgression.

26 See note 15.

萬壑松風之西. 高樓北向. 憑窗遠眺. 林巒
煙水. 一望無極. 氣象萬千. 洵登臨大觀也.

萬頃園林達遠阡. 湖光山色入詩箋. 披雲見
水平清理. 未識無惥守節宣.

RIPA'S TITLE AND COMMENT

"Renowned Mountain with Clouds." Another section of the houses where, on the days when he was not fasting, the emperor would go to handle the affairs of his realm.

Monte con nubbi rinomati. = Un'altra parte delle Case nelle quali ne'giorni non di digiuno, l'Imp.ᵉ andava a trattare gl'affari del suo Regno.

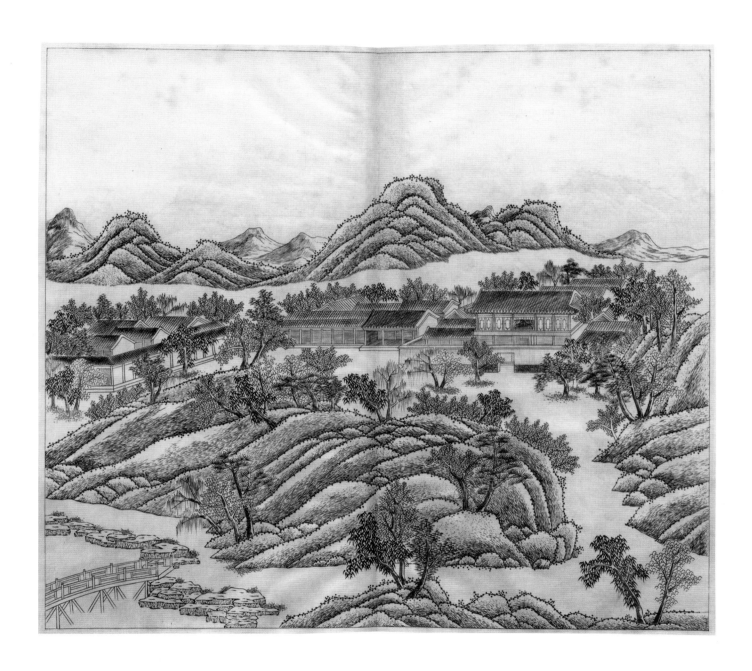

9. Clouds and Peaks on All Sides

Simian yunshan 四面雲山

This square, open pavilion is located on a hilltop in the northwest of the mountain area. It offers one of the most panoramic vistas and forms a group with three other similarly sited pavilions (Views 10, 12, and 13). Moon-gazing from here was especially enjoyed by the emperor at the Double Ninth festival (Chongyang 重陽) on the ninth day of the ninth lunar month, when a banquet was often held with his officials and other distinguished guests at the end of the season before returning to the capital.

Meandering west from A Clear Spring Circling the Rocks [View 29] past a fountainhead, through hills that twist and turn, one comes across "a pavilion with eaves like wings."[27] It emerges above the summits of the multitude of mountains. The peaks all form an array, bowing as if in greetings. The sky is bright and the air is clear. For more than a hundred miles, the glimmer of the mountains and the shadows of the clouds can be distinguished in the distance. During the height of summer, distant breezes reach the pavilion from all four directions so that it feels as somber and brisk as in autumn.

> How strangely shaped, these lofty mountains,
> Whose paths could lead into a fine poem.
> Distant peaks seem to compete in beauty;
> Nearby ridges contest for uniqueness.
> After the rain passes, strong winds arrive;
> The mountains' cold delays the falling blossoms.
> This lofty pavilion is first to see the moon;
> Among the dense trees, the tallest branches stand forth.
> Currents are calm without surging waves;
> Mists have cleared, less confusion along the paths.[28]
> Gently flow the waters, like Golden Brilliance Lake,
> Merging and swelling, like Gathered Verdure Pond.[29]
> I always worry about relieving my people's malaise;
> When pleased with my ambitions, a slight regret remains.
> A lifetime spent in study as advisors have grown old;
> Without even realizing it, I, myself, will turn sixty.

27 An allusion to a well-known line in the classic travel account "The Pavilion of the Old Drunkard" (Zuiwengting ji 醉翁亭記, 1046) by the influential Northern Song dynasty literatus and official Ouyang Xiu 歐陽修 (1007–1072), who was another of the Eight Masters of Tang and Song Poetry and Prose. The phrase suggests that the pavilion is located so high up that it resembles a bird in flight.

澄泉繞石迤西. 過泉源. 盤岡紆嶺. 有亭翼然. 出眾山之巔.
諸峰羅列. 若揖若拱. 天氣晴朗. 數百里外巒光雲影. 皆可
遠矚. 亭中長風四達. 伏暑時蕭爽如秋.

殊狀崔嵬裏. 蘭衢入好詩. 遠岑如競秀. 近嶺似爭奇. 雨過
風來緊. 山寒花落遲. 亭遙先得月. 樹密顯高枝. 潮平無湧
浪. 霧淨少多岐. 脉脉金名液. 溶溶積翠池. 常憂思解慍.
樂志餘清悲. 素學臣鄰老. 耆年自不知.

RIPA'S TITLE AND COMMENT

"Simian yunshan." On all sides are misty mountains.

Su mien yun xan. Da tutt' ī lati monti nubulosi.[30]

28 An allusion to a fable in the Daoist philosophical work *Master Lie* (*Liezi* 列子, Warring States period–fourth century CE) where sheep lost at a forking path indicates the difficulty to finding the Way (*Dao* 道).

29 Golden Brilliance Lake (Jinmingye 金明液) and Gathered Verdure Pond (Jicuichi 積翠池) refer to famous imperial lakes in the past.

30 This image is missing from the Bibliotheca Nazionale di Napoli (I.G.75) copy. This title has been added from Ripa's inscription on the copy in the British Museum (1955,0212,0.1.29).

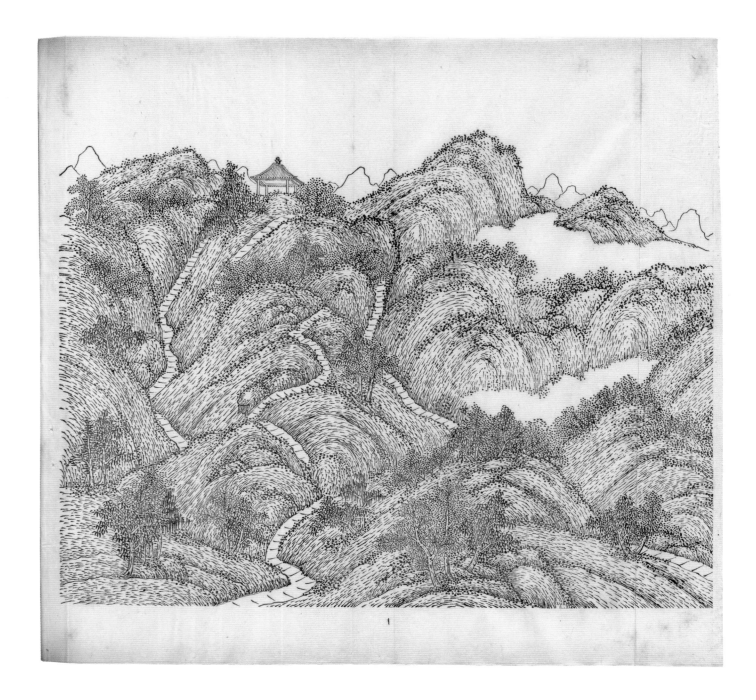

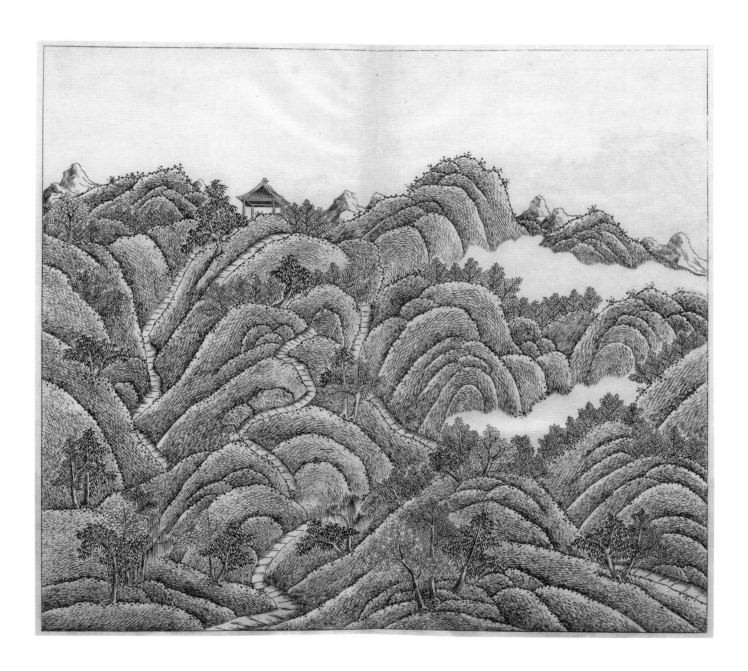

10. Nestled in the North between a Pair of Peaks

Beizhen shuangfeng 北枕雙峰

This square, open pavilion was constructed on a high point in the north of the mountain area. It provided a commanding view and appeared to stand even with Gold Mountain and Black Mountain, prominent peaks more than thirty miles away that Kangxi named because of their cosmological significance. Incorporating these distant elements into a view exemplifies the aesthetic of "borrowed scenery" (jiejing 借景) in Chinese garden design. Standing to the right of the pavilion in the illustration are two thin vertical rocks shaped like bamboo shoots.[31]

Completely surrounding the Mountain Estate are—mountains. They become especially tall toward the north. Northwest of this pavilion, the peak that rises precipitously with an undulating, twisting form is—Gold Mountain. Northeast of it, the peak that thrusts upwards with an imposing, lofty form is—Black Mountain.[32] These two peaks resemble embracing wings. Together with this pavilion, they are like the three legs of a bronze tripod.

> These precipitous mountains are like imperial palace towers.
> Northwest is Gold Mountain with Black Mountain to its north.[33]
> In the wretched heat, clouds emerge from the bellies of this pair of peaks.
> Instantly, as if spilled from a tray, rain falls on the streams and bays.

31 These rocks were later inscribed with Kangxi's poem and a poem by the Qianlong Emperor. The pavilion has been restored but the rocks have disappeared.

32 This sentence reproduces the distinctive syntax of the opening lines of Ouyang Xiu's "The Pavilion of the Old Drunkard."

33 The Chinese text employs the cosmic symbolism of the "Discussion of the Trigrams" chapter that was later appended to *The Book of Changes* (*Yijing*: "Shuogua" 周易: 說卦, Western Han dynasty). According to the Latter Heaven (*houtian* 後天) arrangement of the Eight Trigrams (*bagua* 八卦), *Qian* 乾 (The Creative) denotes the northwest and is correlated with "Metal" (*jin* 金), one of the Five Cosmic Phases (*wuxing* 五行). Jinshan 金山 could be translated as either Gold Mountain or Metal Mountain. The trigram *Kan* 坎 (The Abysmal) denotes the north and is correlated with the phase "Water" (*shui* 水). In other texts, "Water" is also correlated with the color black, hence the name "Black Mountain."

環山莊皆山也. 山形至北尤高. 亭之西北. 一峰峻出. 勢陂陀而逶迤
者. 金山也. 其東北. 一峰拔起. 勢雄偉而崒嵂者. 黑山也. 兩峰翼抱.
與兹亭相鼎崎焉.

嶔崎岡岫紫宸關. 乾地金峰坎黑山. 苦熱雲生雙嶺腹. 盆傾瞬息落
溪灣.

RIPA'S TITLE AND COMMENT

"Two Sticks in the North." These are a pair of rocks. It is a house for recreation on a high mountain. Nearby are two rustic rocks. They are as big and tall as two columns.

I due legni settentrionali, questo coppia di pietra A. a. Casino di recreaz.ne sù d'un alto monte, vicino ad esso vi sono due pietre rustiche A. a. grosse ed alte quanto due colonne.

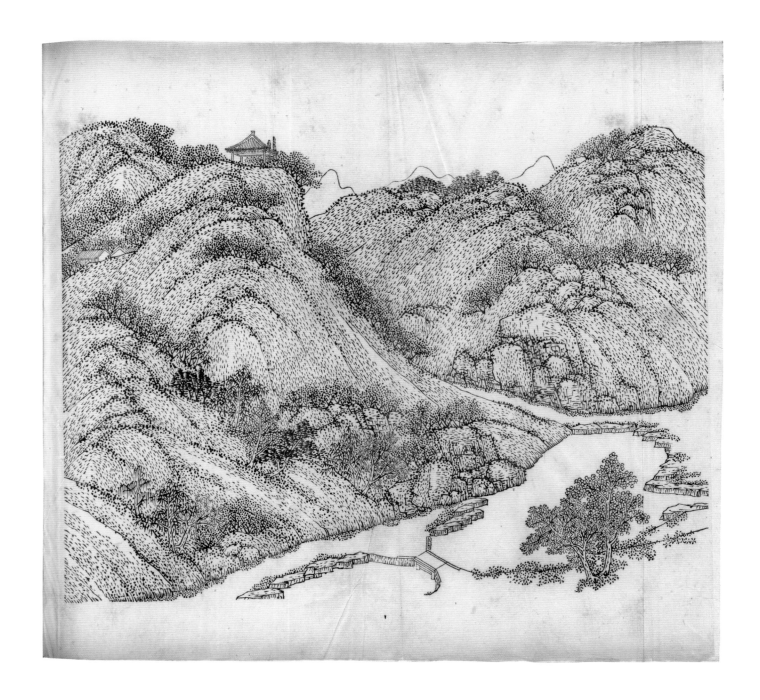

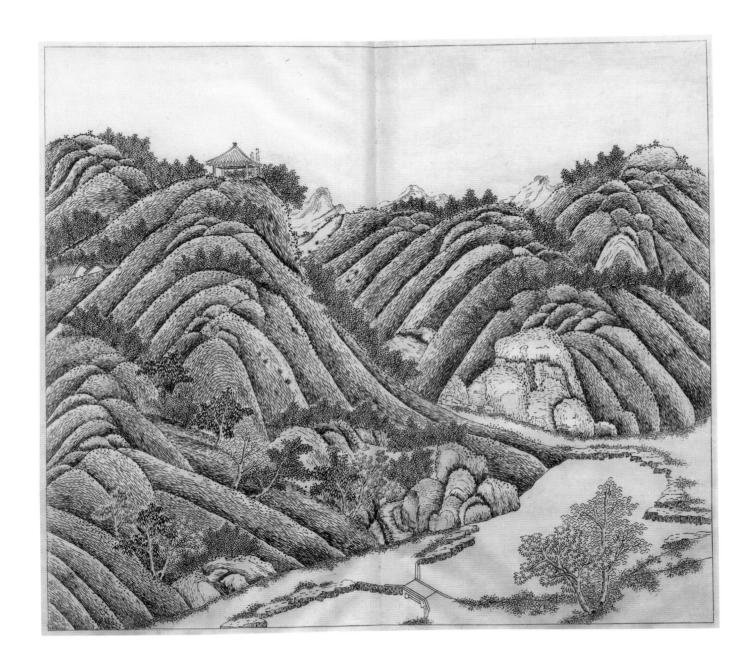

11. Morning Mist by the Western Ridge

Xiling chenxia 西嶺晨霞

This two-story pavilion, located on the western shore of Wish-Fulfilling Island, looked west across the lake toward the hills in the mountain area. Its main entrance was through a gallery located on the ground level that led to the second floor. One could then descend to the first floor from stairs inside.[34]

This distinctive pavilion strides across the waves, its windows opening to all four directions. As soon as the rosy morning clouds are illuminated, shadows throughout the forest form an intricate embroidery. A beautiful view of the western hills makes its way inside to where I am seated. At first, entering the pavilion is like walking on flat ground. Only when descending by a stairway does one realize that there are two stories.

> When rains cease at daybreak
> and the Dipper points east,[35]
> Colorful mists gather and disperse
> with winds from all directions.
> How can lines that "traverse the clouds"
> capture such natural beauty?[36]
> Reducing faults and no Pure Talk
> protects my inner being.[37]

34 Only the foundation of this pavilion currently exists.

35 When the stars in the handle of the Big Dipper point east, it indicates springtime.

36 The Western Han dynasty poet Sima Xiangru 司馬相如 (ca. 179–ca. 118 BCE) wrote "Ode on the Great Man" (Daren fu 大人賦), which he submitted to Emperor Wu of the Western Han 漢武帝 (r. 140–87 BCE). Originally written to criticize the emperor's search for Transcendents in his pursuit of the secret of longevity, the piece was unexpectedly praised by the emperor as "soaring high with the energy of traversing the clouds, like traveling between Heaven and Earth" 飄飄有凌雲之氣, 似遊天地之間矣. In stating that the natural beauty of the scene does not require elaborate description by poets, Kangxi is implicitly criticizing Sima Xiangru's piece. But he also had no faith in the search for Transcendents or in Daoist elixirs of longevity.

37 Pure Talk (qingtan 清談) refers to a mode of philosophical conversation originally practiced by scholars during the Wei-Jin period (220–420) who wished to avoid discussing worldly affairs. The reference to guarding one's inner being alludes to the final lines in chapter 5 of *The Old Master*: "A ruler who speaks much is frequently depleted, better that he guard his inner being" 多聞數窮, 不若守於中. Variously interpreted, "inner being" (zhong 中) is generally understood as an impersonal, empty state within the self that functions like the natural, spontaneous, and non-intervening activity of the Way. Here, Kangxi rejects detached philosophical speculation in favor of practicing a more concrete and circumspect form of moral cultivation.

傑閣凌波. 軒窗四出. 朝霞初煥. 林影錯
繡. 西山麗景. 入几案間. 始登閣. 若履平
地. 忽緣梯而降. 方知上下樓也.

雨歇更闌斗柄東. 成霞聚散四方風. 時
光豈在凌雲句. 寡過清談宜守中.

RIPA'S TITLE AND COMMENT

"Western Mountain on which in the Morning There is a Good View of the Clouds." A house for recreation. In the Villa, there are different houses that have no function other than to provide beauty and ornament, and to go to sometimes to enjoy the fresh air.

Monte occidentale, sul quale la mattina è un bel vedere le nubbi. = Casino di recreaz.ne. Nella Villa vi sono diversi Casini, ché non anno uso, che per bellezza, ed adornam.to, e per andarvi qualche volta a prender fresco.

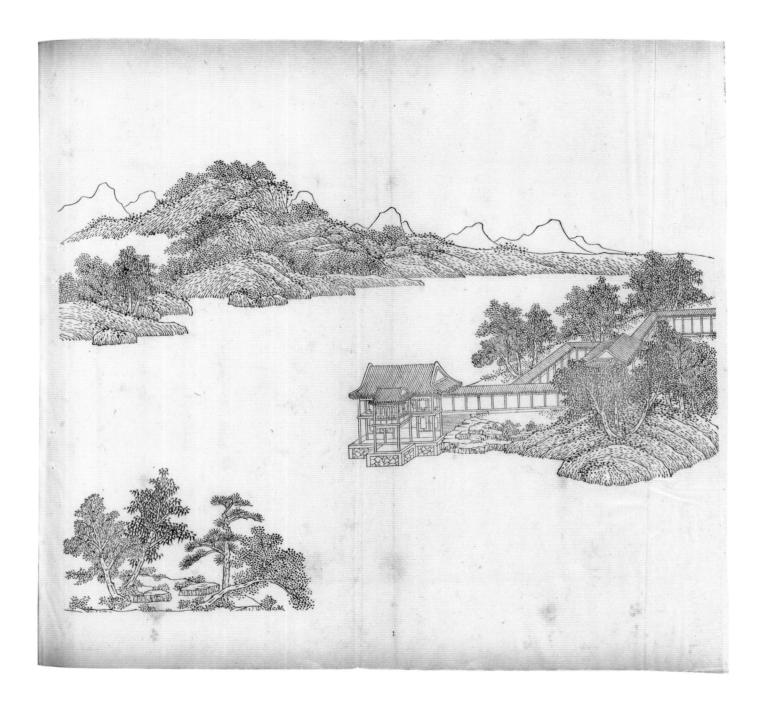

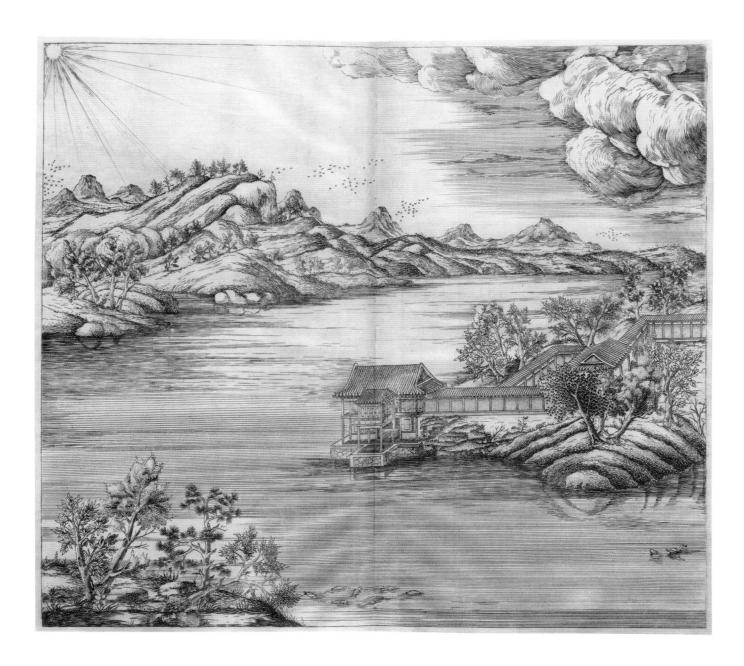

12. Sunset at Hammer Peak

Chuifeng luozhao 錘峰落照

This small rectangular pavilion, located in the southern portion of the mountain area, affords panoramic views. It looks directly toward Hammer Peak (Chuifeng 錘峰), which is about two miles to the east beyond the walls of the Mountain Estate. Named by Kangxi, this peak is a prominent, club-shaped rock 125 feet high. It was recorded as early as Li Daoyuan's 酈道元 (d. 527) Guide to Waterways with Commentary (Shuijingzhu 水經注). *The rock's glow in the sunset is especially striking.*

On a flat hilltop, an open pavilion faces east where many peaks stand arrayed before one. The sunset glow from the west creates myriad shapes of clouds in reds and purples. It is just like unrolling Huang Gongwang's landscape, *Floating Mountain Haze and Warm Greenery.* The mountain thrusting upwards against the sky that particularly displays gold and viridian colors is—Hammer Peak.[38]

> My eyes roam over lakes and mountains
>> that have endured for a thousand years.
> White clouds nestling in a ravine
>> announce the depths of autumn.
> Precipitous cliffs each compete
>> to present a beautiful scene.
> But none can match this one peak
>> for its profound solitude.

38 A reference to a landscape painting, *Floating Mountain Haze and Warmed Greenery* (*Fulan nuancui tu* 浮嵐暖翠圖), by the Yuan dynasty master Huang Gongwang 黃公望 (1269–1354), which was in the imperial collection. The last sentence again employs the distinctive syntax of Ouyang Xiu's "The Pavilion of the Old Drunkard." Here, Kangxi refers to the rock by an alternate name, Chime-hammer Peak (Qingchuifeng 磬錘峰).

平岡之上. 敞亭東向. 諸峰橫列扵前. 夕陽
西映. 紅紫萬狀. 似展黃公望浮嵐暖翠圖.
有山矗然倚天. 特作金碧色者. 磬錘峰也.

縱目湖山千載留. 白雲枕澗報深秋. 巉巖
自有爭佳處. 未若此峰景最幽.

RIPA'S TITLE AND COMMENT

"A Slanting Mountain that Overlooks Below." A house for recreation above a little hill with a view of the rock. This is larger at the summit than at the base. It is approximately as high as thirty men. It stands atop a high mountain that on one side is very precipitous. It stands outside the wall of the Imperial Villa. This rock is called "Xang," that is, "Scian." For those who climb to the top of the mountain, the entire Villa is revealed.

Monte pendente, che guarda giù. = Casino di recreazione sopra un monticello, colla veduta della pietra B. più grossa nella sommità, che nella di lei radice. E' altra quanto 30. uomini in circa. Stà sopra un'altissimo monte, che da una parte è assai precipitoso. Stà fuora del recinto dell'Imperiale Villa, si chiama questa pietra Xang scivi scian, chi và sopra il monte C; scopra tutta la Villa.

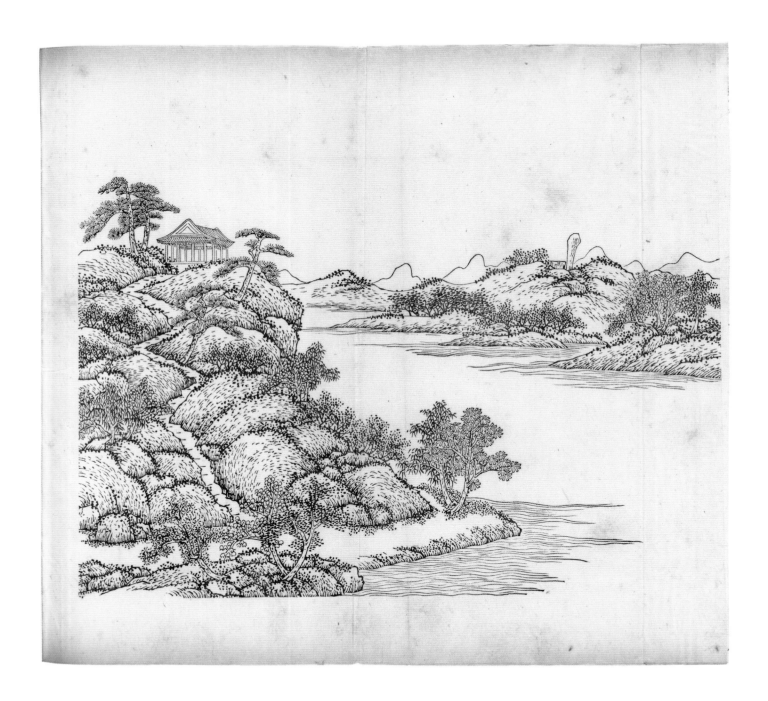

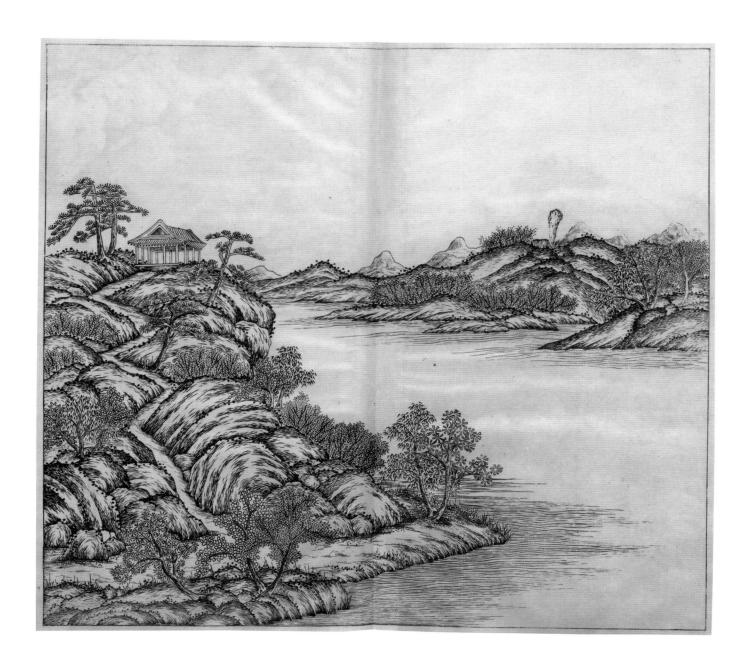

13. Southern Mountains Piled with Snow

Nanshan jixue 南山積雪

This open square pavilion in the northern part of the mountain area affords a view of the snow-covered mountains to the south. The snow begins to fall in late autumn and remains on the ground well into the spring.

A doubled cordon of mountains surrounds the Mountain Estate on the south. The snow piled on them remains through the seasons. When one gazes at the snow in the distance from this pavilion to the north, it looks bright white, pure, solid, and shiny. It is striking in the clear morning light, and fine jade pales against it. It is quite comparable to the scenes at Eyebrows, Bright Moon, Kunlun, and Langfeng mountains.[39]

> A painting would find it hard to capture
> the face of these hills and vales.
> Whether their make-up is heavy or thin,
> these pines endure the cold.
> The rivers' heart and the mountains' bones
> remain steadfast throughout,
> Never changing through ice and frost
> despite winter's piles of snow.

39 These are four celebrated mountains. Eyebrows Mountain (Emeishan 峨嵋山) in modern Emei, Sichuan, is one of the four sacred Buddhist mountains. Its name derives from the shape of two facing peaks. Bright Moon (Mingyueshan 明月山) in modern Pengxi, Sichuan, is named after the reflection of two of its peaks in the Fu River (Fujiang 涪江). Langfeng (Langfengshan 閬風山) was a peak on Mount Kunlun. For Mount Kunlun, see note 22.

山莊之南. 複嶺環拱. 嶺上積雪. 經時不消.
於北亭遙望. 皓潔凝映. 晴日朝鮮. 瓊瑤失
素. 峨嵋明月. 西崑閬風. 差足比擬.

圖畫難成丘壑容. 濃粧淡抹耐寒松. 水心
山骨依然在. 不改冰霜積雪冬.

RIPA'S TITLE AND COMMENT

"Mountains in the South with Much Snow." Two houses for recreation.

Monte di mezzodì con mucchio di neve. = Due Casini di recreazione.

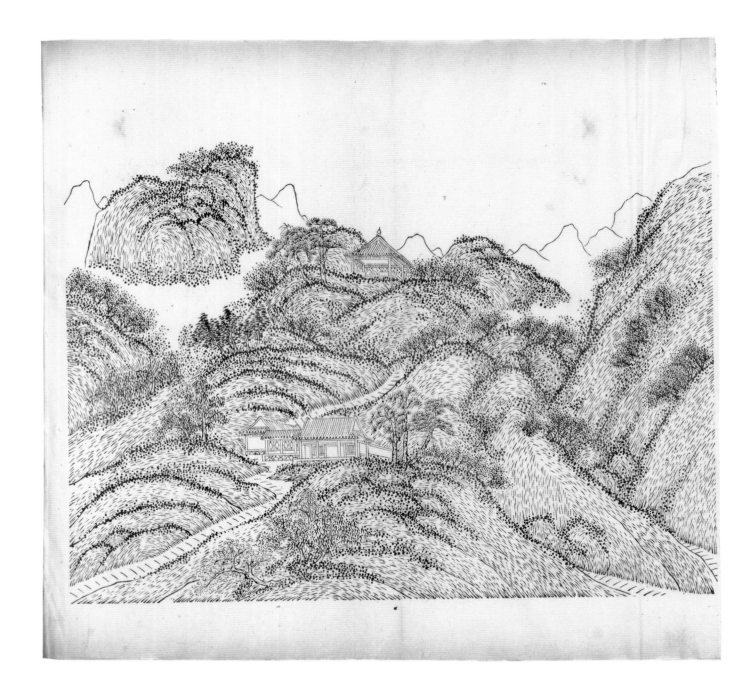

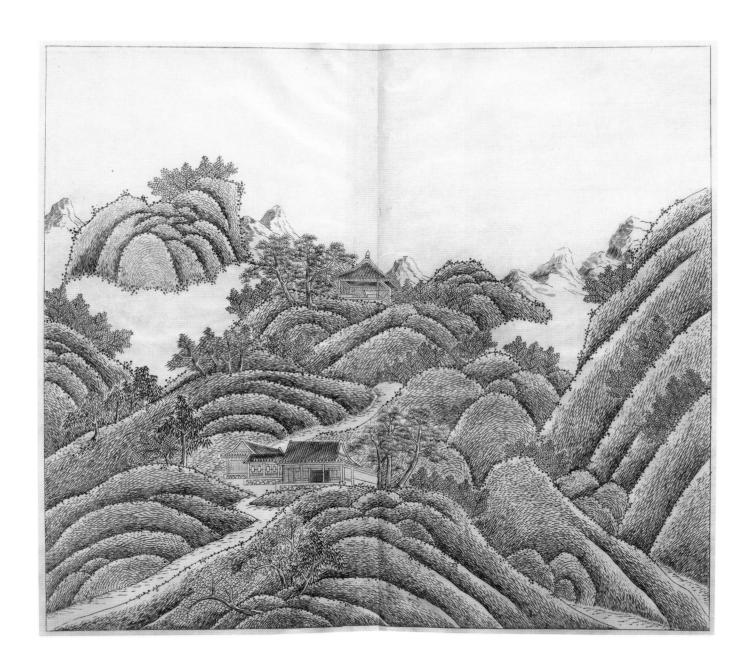

14. Pear Blossoms Accompanied by the Moon

Lihua banyue 梨花伴月

Built against a hillside in the northwestern part of the mountain area, this complex was surrounded by many pear trees. Their white blossoms in the moonlight produced an otherworldly scene. The rooms were linked by stepped corridors and the front courtyard contained a small pond. Kangxi often came here to study and to enjoy the view of the flowers in the moonlight together with his wives. He named the main hall the House of Eternal Tranquility (Yongtianju 永恬居) and the similarly sized rear structure the Studio of Noble Simplicity (Sushangzhai 素尚齋).[40]

Enter Pear Tree Vale, pass by Triple Fork, then follow along the stream west for about a half a mile. A building was constructed here up against a mountainside. Winding galleries lead up and down the slope. The storied pavilions are a mix of high and low. An emerald green ridge forms a screen behind, and there are myriad pear blossom trees. When wispy clouds and a faint moon appear, the purity of this view is unexcelled.

Cloud-wrapped windows gaze out on a cliff;
Moonlit eaves accompany the pear blossoms.
Throughout the four seasons, this scene is exquisite;
With a thousand peaks, the land's energy is superb.
The blossoms' crystal-clear feelings are like the white sun;
They intend to join with the cinnabar clouds.
The night is quiet: no one about for conversation;
When morning comes, I shall praise all this to guests.

40 The Studio of Noble Simplicity and the House of Eternal Tranquility were later chosen by Qianlong as nos. 35 and 36 of his additional thirty-six Views.

入梨樹峪. 過三岔口. 循澗西行可里許. 依巖架屋. 曲廊上
下. 層閣參差. 翠嶺作屏. 梨花萬樹. 微雲淡月時. 清景尤絕.

雲窗依石壁. 月宇伴梨花. 四季風光麗. 千巖土氣嘉. 瑩情
如白日. 託志結丹霞. 夜靜無人語. 朝來對客誇.

RIPA'S TITLE AND COMMENT

"Pear Blossoms Coupling with the Moonlight." Other houses that were inhabited by several other concubines.

Fiori di pero accoppiati collo splendore della luna. = Altre Case, nelle quali abbitavano diverse altre Concubine.

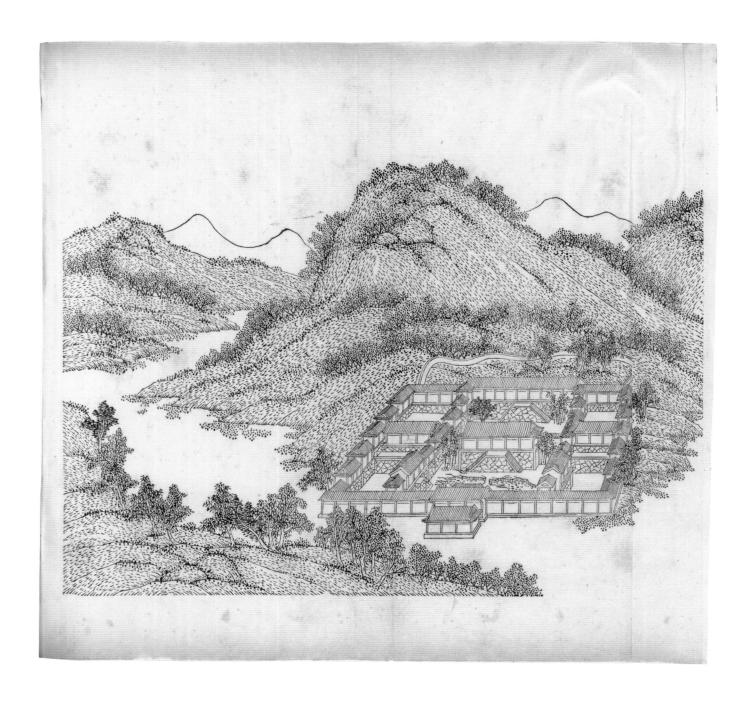

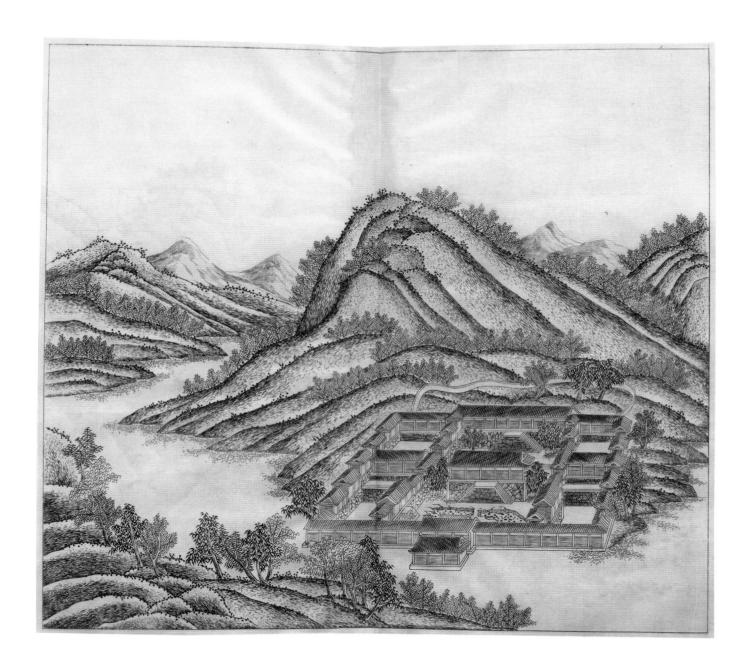

15. The Scent of Lotuses by a Winding Stream

Qushui hexiang 曲水荷香

This complex was constructed on rocks artfully placed in a stream so that water could flow around and through the open square pavilion. Originally, the complex was located north of Warm Currents and Balmy Ripples (View 19). Kangxi held receptions for imperial relatives and high officials here in imitation of Wang Xizhi's 王羲之 (ca. 303–ca. 361) famous poetry gathering at the Orchid Pavilion (Lanting 蘭亭) in 353, when wine-filled cups were floated down a stream and eminent guests were supposed to compose poems before the cups passed by. The original event and the resultant writings became icons of Han literati culture.[41]

A blue-green stream is clear and shallow. It twists and turns among the rocks as it flows into a small pond. There are innumerable lotus blossoms with green leaves high and low. Every year right after the spring rains, the water fills up to the level of the embankment. Red petals fall onto the rippling surface, remaining steady like floating wine-cups. Even the poetry gathering at the Orchid Pavilion did not produce such a natural delight.

> Aromas of lotuses wafting and waning
> are purer from a distance.[42]
> The winding stream at the Orchid Pavilion
> hardly deserves its fame.[43]
> A worthy before us had renounced
> the eight delicacies and fine wine.[44]
> How useless it is to float wine-cups
> or serve "gold-and-jade" porridge.[45]

41 The site was moved during the Qianlong era to its present location south of the Hall of the Ford of Literature (Wenjin'ge 文津閣), which Qianlong built in 1774 to house a set of the *Complete Library of the Four Treasuries* (Siku quanshu 四庫全書, 1772–1781). See *Qinding Rehe zhi*: 27:16a, and "Map of the Thirty-Six Views," xv.

42 An allusion to a line from the essay "My Love for the Lotus" (Ailian shuo 愛蓮說) by the Northern Song dynasty Neo-Confucian philosopher Zhou Dunyi 周敦頤 (1017–1073). Zhou praised the lotus for symbolizing moral purity.

43 Wang Xizhi immortalized the gathering in his "Preface to *Collected Poems from the Orchid Pavilion*" (Lantingji xu 蘭亭集序, 353). His handwritten text became the most influential model of the running-style of calligraphy throughout East Asia; this style was also adopted by various emperors, including Kangxi. Guests were occasionally invited to this View to write poems as wine cups were floated down a stream.

碧溪清淺. 隨石盤折. 流為小池. 藕花
無數. 綠葉高低. 每新雨初過. 平隄水
足. 落紅波面. 貼貼如泛杯. 蘭亭觴詠.
無此天趣.

荷氣參差遠益清. 蘭亭曲水亦虛名. 八
珍旨酒前賢戒. 空設流觴金玉羹.

RIPA'S TITLE AND COMMENT

"Water that Coils, Water Lilies that Perfume." A house for recreation.

Acqua che serpeggia, limfee, che odorano. = Casino di recreazione.

44 The eight delicacies (*bazhen* 八珍) were reserved for royal feasts according to the Confucian classic *The Government Organization of the Zhou Dynasty* (*Zhouli* 周禮, Warring States period). The worthy referred to here is the ancient thearch Yu the Great 大禹 (trad. r. early second millennium BCE), regarded as the founder of China's first dynasty, the Xia (ca. twentieth–sixteenth century BCE). In the "Intrigues of Wei" in the *Intrigues of the Warring States* (*Zhanguo ce*: "Wei ce" 戰國策: 魏策, Warring States period–Han dynasty), he rejected the fine wine that was offered to him, stating that it would lead to the destruction of the state in future generations. Yu the Great was also praised in the chapter "Li Lou 2" in the Confucian classic *Mencius* (*Mengzi*: "Li Lou xia" 孟子: 離婁下, Warring States period) as preferring excellent advice to fine wine.

45 Gold-and-jade porridge (*jinyugeng* 金玉羹) was a rural delicacy that combined various herbs in a stock made from lamb, according to the classic cookbook *Elegant Country Recipes* (*Shanjia qinggong* 山家清供) by the scholar Lin Hong 林洪 (fl. 1137–1162). Kangxi employs the name of the dish poetically to indicate extravagance.

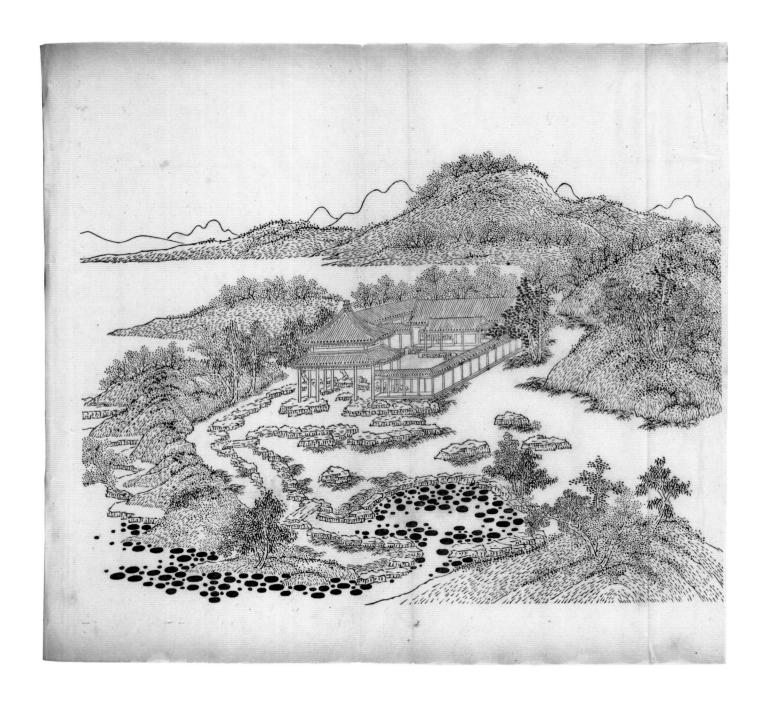

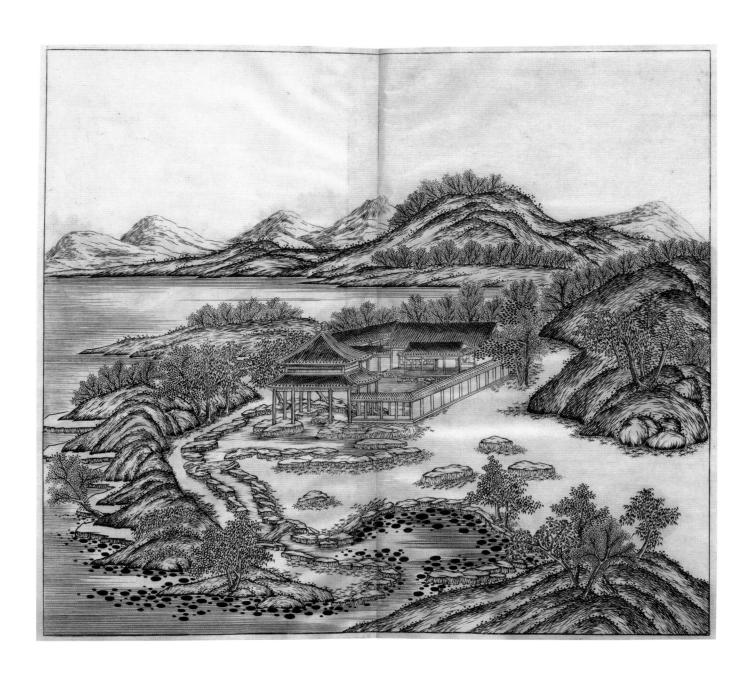

16. Clear Sounds of a Spring in the Breeze

Fengquan qingting 風泉清聽

This structure, depicted on the left side of the illustration, actually comprises the western section of a larger complex. It includes front and rear rooms, each three bays in width. The adjacent section on the right constituted part of Sonorous Pines and Cranes (View 7), which was the residence of Empress Dowager Xiaohui.[46] After his visits to her, Kangxi would relax in this smaller compound, often enjoying melons and other fruits into the afternoon. The name derives from a line by the Tang dynasty poet Meng Haoran 孟浩然 (689–740).[47] Here, the breeze in Hazelnut Glen conveyed the sound of gurgling water from a nearby spring that supplied the stream in front.[48]

A flowing spring gushes forth from between two peaks and is stroked by a light breeze. As it trickles down over the rocks, it sounds like zithers responding to the calls of cranes and rustling pines. The water's taste is sweet and fragrant, delighting the spirit and enhancing longevity. It is just like the lines from Zhang Xiaobiao's poem, "The Spring beneath the Pines": "Smooth as mica as it drips into a bottle; fragrant as *fuling* when rinsing the teeth."[49]

> A Turquoise Pond, a palace with *lingzhi*,
> and the filial heart of Master Laocai.[50]
> A new spring gushes forth
> amidst nature's myriad chants.[51]
> I stand by a railing where fragrance surges
> as vapors from divine liquid rise,[52]
> Pointing out nearby South Mountain
> as clear sounds of music play.[53]

46 In this illustration of View 16, only the middle and western sections of Sonorous Pines and Cranes is represented. For an illustration of the complete complex comprised of three walled sections, see View 7. The small pavilion in the upper right is probably Sunset at Hammer Peak (View 12).

47 See the poem "Spending the Night at Buddhist Master Ye's Mountain Lodge Awaiting Ding Da, Who Did Not Arrive" (Su Ye Laoshi shanfang qi Ding Da bu zhi 宿業老師山房期丁大不至): "Among pines in the moonlight, an evening coolness arises; a spring and a breeze fills the air with pure sounds" 松月生夜涼; 風泉滿清聽.

48 The buildings of this complex no longer exist.

49 These are famous lines from "The Spring beneath the Pines at Mt. Fang Temple" (Fangshansi songxia-quan 方山寺松下泉) by the Tang dynasty poet Zhang Xiaobiao 章孝標 (presented scholar, 819). The *fuling* 茯苓 fungus, also known as China Root, is used in herbal medicine. It was said to grow at the roots of thousand-year-old pines and to enhance longevity.

兩峰之間. 流泉滴滴. 微風披拂. 滴石作琴筑
音. 與鶴鳴松韻相應. 泉味甘馨. 怡神養壽. 恰
合章孝標松下泉詩. 注瓶雲母滑. 漱齒茯苓香.

瑤池芝殿老萊心. 涌出新泉萬籟吟. 芳檻依欄
蒸靈液. 南山近指奏清音.

RIPA'S TITLE AND COMMENT

"The Noise of the Wind and the Water is not Clamorous." A house where the emperor went with a retinue of his favorites towards nine o'clock in the evening to eat watermelons and other fruits and where he would ordinarily stay past midnight.

Il rumor del vento, e dell'acqua non è strepitosa. = Casa nelle quale l'Imp.ᵉ colla seguita delle sue piu carite, verse le 21. ore del giorno andava a mangiar cocumeri, ed altri fruitti; e dove poi per ordinario dimorava sino passate le 24. ore.

50 The Turquoise Pond (Yaochi 瑤池) was located at the mythical Mount Kunlun and associated with the longevity cult of the Queen Mother of the West. In many accounts, it was where she held the banquet of peaches for Transcendents. A *lingzhi* fungus found growing in front of the palace in 64 CE during the reign of Emperor Ming of the Eastern Han 漢明帝 (r. 57–75 CE) was considered an auspicious omen for the emperor's longevity. The legendary Daoist Transcendent Master Laocai 老菜子, said to have been a contemporary of Confucius 孔子 (551–479 BCE), was regarded as a paragon of filial piety. All three allusions express Kangxi's devotion to the Empress Dowager Xiaohui.

51 "Nature's myriad chants" (*wanlai yin* 萬籟吟, literally, the chants of myriad pipes) alludes to a Daoist image in the chapter "Discussion on Equalizing Things" in the *Master Zhuang* (Zhuangzi: "Qiwu lun" 莊子: 齊物論, ca. fourth century BCE), where winds from the "pipes of heaven" (*tianlai* 天籟) enable each of the myriad things in the world to make its own natural sound without anyone acting to stimulate them.

52 See Duan Zhongrong 段钟嵘, ed. *Bishu shanzhuang qishier jing dingjingshi dianping* 避暑山庄七十二景定景诗点评 [Poems on the Seventy-Two Views of the Mountain Estate for Escaping the Heat with Commentary] (Huhehaote: Yuanfang chubanshe, 2003), 54, where the character *jian* 檻 (banister) is read as *lan* 濫 (surging), and *lingye* 靈液 (divine liquid) is interpreted as signifying the powerful purity of the spring water.

53 "South Mountain" (Nanshan 南山) alludes to lines from the fifth of Tao Qian's 陶潛 (365–427) cycle of twenty poems, "Drinking Wine" (Yinjiu 飲酒): "Picking chrysanthemums by the eastern hedgerow, I gaze at South Mountain in the distance" 採菊東籬下, 悠然見南山. It became a conventional reference to longevity.

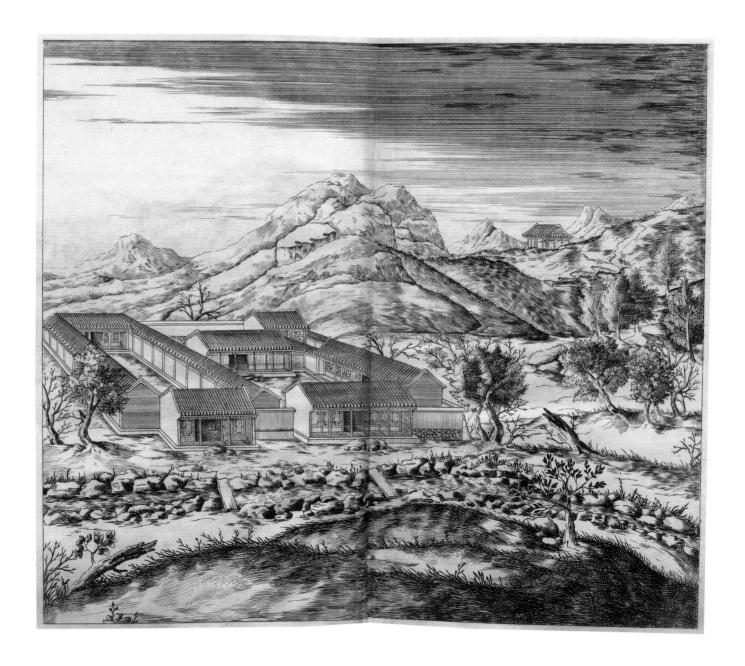

17. Untrammeled Thoughts by the Hao and Pu Rivers

Hao Pu jianxiang 濠濮間想

This small hexagonal pavilion is one of four similar structures along the northern shore of Clearwater Lake. Its solitary atmosphere invited the emperor to escape from the cares of ruling by communing with nature. The name alludes to a remark made by the Eastern Jin dynasty emperor Jianwen 晉簡文 (r. 371–372) when he visited the Flourishing Grove Park (Hualinyuan 華林園) and praised it as a "place that suits the mind" (huixinchu 會心處). Jianwen expressed his desire for reclusion by alluding to two anecdotes in the chapter "Autumn Floods" in the Daoist philosophical work Master Zhuang 莊子 (Zhuangzi: "Qiushui" 莊子: 秋水, ca. fourth century BCE) that take place at the Hao and Pu Rivers.[54] The view in the illustration looks northward across the lake with Green Lotus Island (Qingliandao 青蓮島) in the foreground.

The clear current is like white silk. There are green peaks and extensive forests, fine birds on the tips of the branches, and fish swimming among the ripples. It is unquestionably naturally endowed. This place that suits the mind lies by Master Zhuang's autumn floods.

> In a flourishing grove beside still waters,
> Untrammeled thoughts bring a body peace.
> Soaring birds and leaping fish are tranquil.
> Their appearance is hard to describe.

54 As recorded in Liu Yiqing 劉義慶 (403–444), *A New Account of Tales of the World (Shishuo xinyu* 世說新語, ca. 430), Emperor Jianwen, a devotee of "pure talk" and Buddhism, famously remarked to his entourage: "A spot that suits the mind need not be located far away. A shady grove with a stream can give rise to untrammeled thoughts by the Hao and Pu Rivers, where one feels that the birds and animals draw close of their own accord." The chapter "Autumn Floods" in the *Master Zhuang* contains the two anecdotes alluded to here. The first presents Master Zhuang gazing at the fish happily swimming in the Hao River and sympathizing with their joyful freedom. This is often alluded to in Chinese gardens by naming sites that invoke "the joy of fish" (*yule* 魚樂); see View 33. The other anecdote tells of Master Zhuang fishing in the Pu River, when the king of Chu sends emissaries to invite him to assist in ruling the kingdom. Master Zhuang refuses to become involved in government, comparing himself to a tortoise that would prefer to remain alive in the mud than to be dead and venerated as a sacred relic.

清流素練. 綠岫長林. 好鳥枝頭. 遊魚波際.
無非天適. 會心處在南華秋水矣.

茂林臨止水. 間想託身安. 飛躍禽魚靜. 神情
欲狀難.

RIPA'S TITLE AND COMMENT

"A Solitary Place Suitable for Thinking." A house for recreation situated opposite a little
island in the river.

Logo isolito atto a pensare. = Casino di recreaz.ne situato di rimpetto ad un'Isoletta nel fiume.

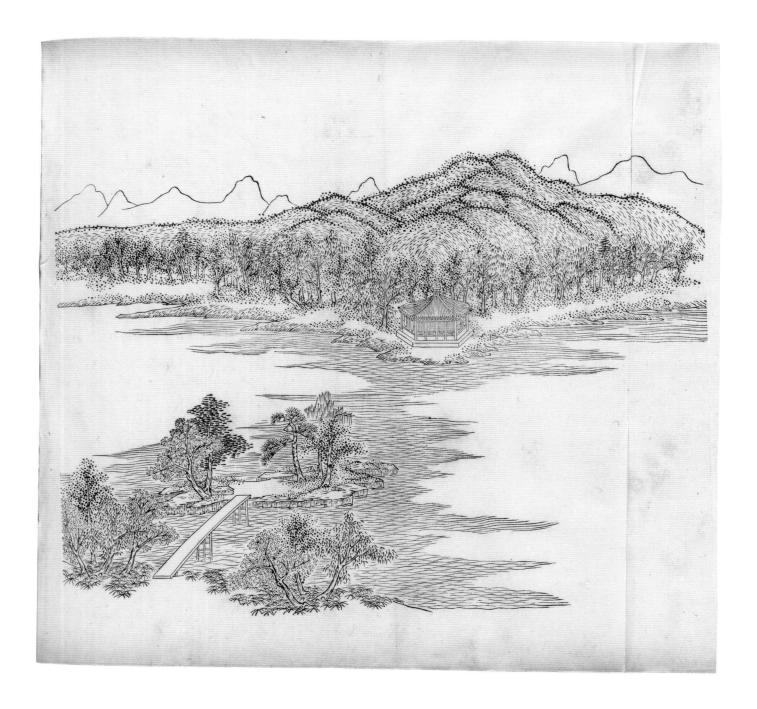

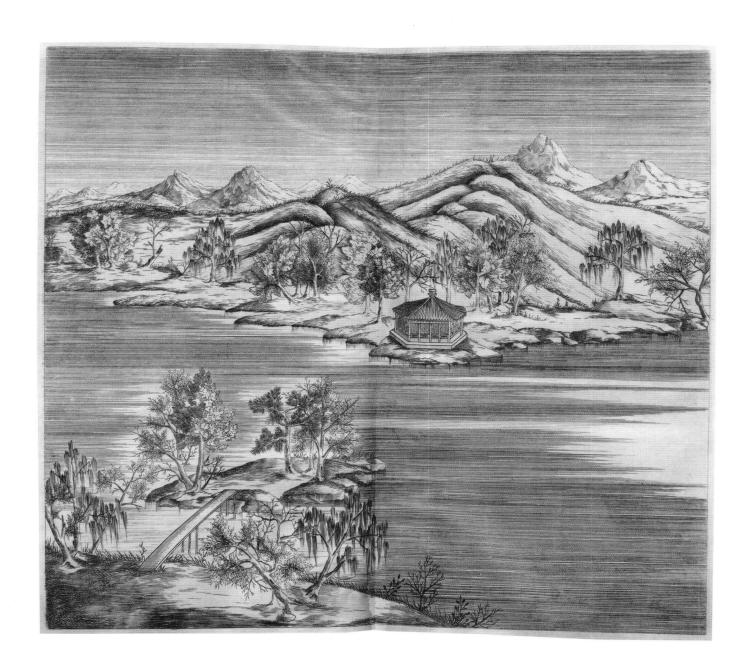

18. The Entire Sky Is Exuberant

Tianyu xianchang 天宇咸暢

This is the scenic focus in the lake area and serves as a climax in Kangxi's sequence of thirty-six Views. The complex was built on the eastern shore of Clearwater Lake; it was situated on an artificial island piled high with giant rocks. It invokes the scenery of the lower Yangtze River near Zhenjiang, Jiangsu, that was visited by Kangxi on his southern tours. An island there contains the famous Gold Mountain Temple (Jinshansi 金山寺), which also has a prominent pagoda providing a panoramic view. The name of this View specifically denotes the three-bay-wide pavilion at the base of the pagoda. Behind it stands a three-story pagoda, the Tower of the Supreme God (Shangdige 上帝閣). The emperor would come here with his wives to make offerings to the Daoist gods Dark Warrior (Xuanwu 玄武), guardian of the north, and Jade Emperor (Yudi 玉帝), the supreme god.[55] Another section of the complex, in the lower left of the illustration, is actually Clouds and Peaks in the Mirroring Water (View 32). Kangxi indicated that his poem follows the form of a tune titled "Myriads of Years" (Wansinian qu 萬斯年曲).[56]

A single mountain protrudes from the lake. On top is a plateau where a building three bays in width has been constructed. Just north of this is the Tower of the Supreme God. Gazing upward, one makes contact with the empyrean; looking down, one stands beside blue-green water. It is just like ascending to the summit of Marvelously High Peak, where the mists and clouds by Resolute North Mountain and the breeze and moon at Ocean Gate are all encompassed within a single vista.[57]

> A soaring tower among patches of clouds
> is a fitting place to dwell.
> Smoke from people never reaches
> so close to the clear empyrean.
> The puffs of clouds are pale and marvelous
> while myriad peaks are bright.
> Wild geese begin to appear.
> They pair up with later arrivals.
> Under light drizzles, autumn flowers
> have spread across the islands.

湖中一山突兀. 頂有平台. 架屋三楹. 北即上
帝閣也. 仰接層霄. 俯臨碧水. 如登妙高峰上.
北固煙雲. 海門風月. 皆歸一覽.

通閣斷霞應卜居. 人烟不到麗晴虛. 雲葉淡巧
萬峰明. 雁過初. 賓鴻侶. 鷗雨秋花遍洲嶼.

RIPA'S TITLE AND COMMENT

"The Figure of the Sky Is Perfectly Delightful." A view of the temple of the idols that the emperor worshipped together with his ladies. Officiating at this temple are many *Tausci* [*daoshi* 道士], which is what the priests of the idols are called: they are all eunuchs. It is situated on a little island in the middle of a river, which is most delightful.

Figura del cielo perfettam.ᵗᵉ dilettevole. = Veduta del Tempio degl'Idoli, che l'Imp.ᵉ colle sue donne adorava. Questo Tempio è uffiziato da molti <u>Tausci</u>, sacerdoti degl'Idoli cosi chiamati: sono però tutti Eunuchi. Stà situato sù d'un'Isoletta in mezzo al fiume, che è assai deliziosa.

55 The pagoda alluded to is the Pagoda of Charity and Benevolence (Cienta 慈恩塔) on Gold Mountain in Zhenjiang. Kangxi inscribed the first story of the Tower of the Supreme God with the words "May Heaven Eternally Protect" (*huangtian yongyou* 皇天永佑) and the second story, where the sacrifice to Xuanwu was held, with the words "The Awesome Spirit of Yuanwu" (*Yuanwu weiling* 元武威靈). Note that the graph *yuan* 元 was substituted for *xuan* 玄 in Xuanwu 玄武 because the graphs in Kangxi's personal name Xuanye 玄燁 became taboo. The third story was inscribed "Heaven on High Hears Everything Below" (*tiangao tingbei* 天高聽卑). *Kangxi sanshiliu jing shi xuanzhu*, 62n1.

56 Kangxi may have chosen this poetic form because of its auspicious title. The phrase originated in the poem, "Following in the Footsteps," in *The Book of Songs* (*Shijing*: "Xiawu" 詩經: 下武): "For myriads of years, may Heaven bestow its blessings" 于萬斯年, 受添之祜. Traditionally, these lines have been interpreted as praising King Kang of the Zhou dynasty 周康王 (r. ca. 1005–978 BCE) as a worthy successor and wishing eternal blessings upon the Zhou state. The graph *kang* 康 in King Kang's name is also the same as the first graph in Kangxi 康熙.

57 Marvelously High Peak (Miaogaofeng 妙高峰) is the highest point on Gold Mountain in Zhenjiang. Resolute North Mountain (Beigushan 北固山) is located to the north of Zhenjiang, and Ocean Gate (Haimen 海門), where the Yangtze River flows into the sea, is to the east.

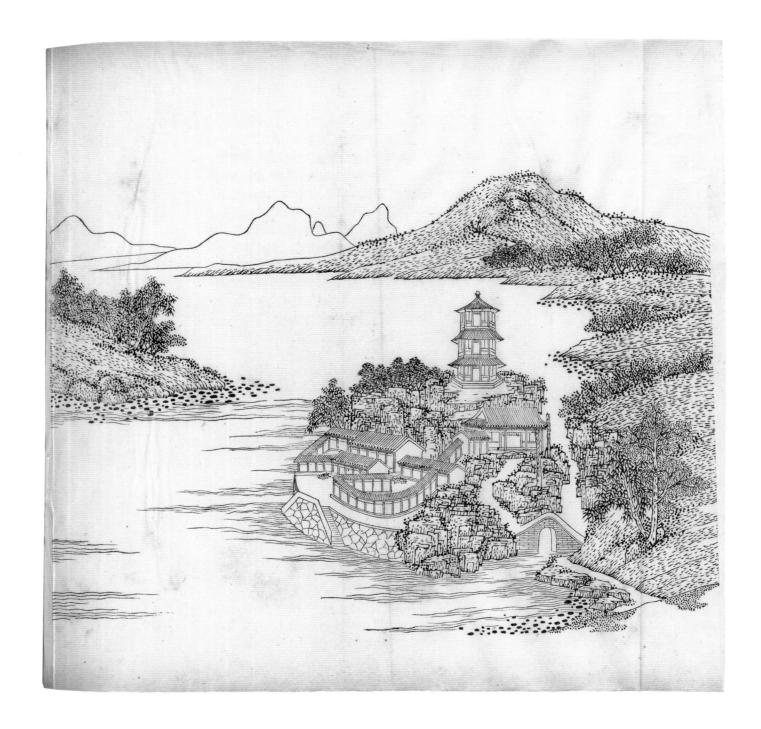

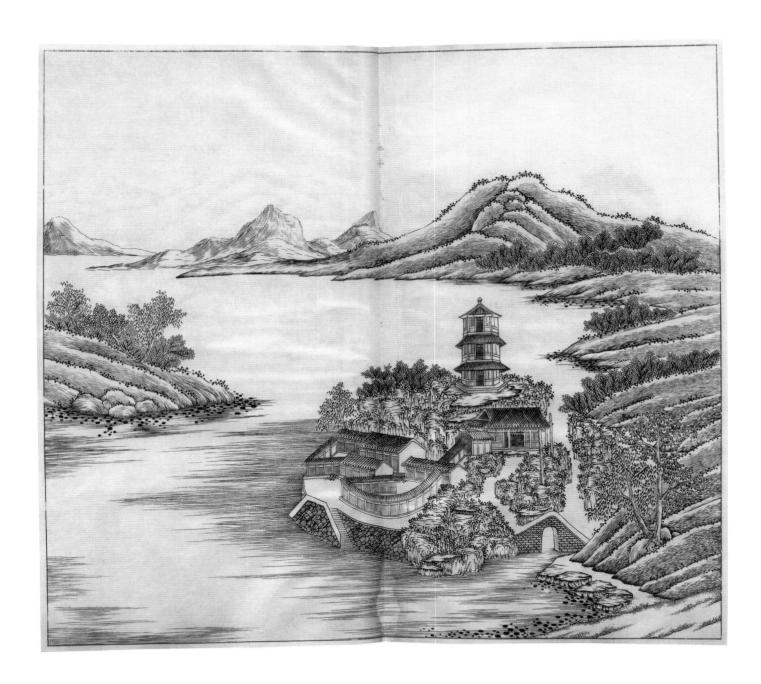

19. Warm Currents and Balmy Ripples

Nuanliu xuanbo 暖溜暄波

This structure consists of a three-bay, two-story pavilion built on top of a water gate that also admitted boats. Located on the northeastern side of the Mountain Estate, the gate forms part of the surrounding wall. A branch of the Rehe River (Rehe 熱河), now known as the Wulie River (Wuliehe 武烈河), enters through here. The pavilion contained a shrine to the river god. The stream follows along the foothills of the mountain section in the north, then it turns south and east as it enters Clearwater Lake beside Clouds Remain as Water Flows On (View 36). The name of this View describes the warm water that Kangxi believed originated at Hot Springs Mountain (Tangshan 湯山) twenty-five miles to the northeast, which then flowed into the Rehe River.[58]

After crossing over a hill south of The Scent of Lotuses by a Winding Stream [View 15], one comes across a river that flows in from beyond the palace wall. It is a sidestream of the river from Hot Springs Mountain.[59] The water gushes forth and surges down over rocks arrayed like a row of teeth. It looks like they are being rinsed with liquid jade as pearls splatter and foam forms. Moreover, it exudes vapors like rising clouds and gathering mists.

> Warm currents from the river's fount
> quickly relieve all ills.
> Bubbling forth with yin and yang
> to cleanse every thing.
> The succoring current divides its flow
> for those both near and far.
> From the poorest dwellings all sing praise
> of nature's bounteous gift.

[58] See Qianlong's "An Investigation into the Rehe River" (Rehe kao 熱河考, 1768), in *Qinding Rehe zhi* 69:2b–4a, for a description of the origins of the Rehe River and its nomenclature. The Wulie River, as it is known today, was an ancient name that was largely forgotten in early Qing times. Qianlong's survey discovered three tributaries to the Rehe River. There is also a hot springs within the Mountain Estate just north of View 18 that was also named "Rehe" and is marked by an inscribed rock.

[59] See Kangxi's account, "A Record of the Buddhist Temple of the Dragon King at Hot Springs Mountain" (Tangshan Longzunwang fomiao ji 湯山龍尊王佛廟記), cited in Duan, *Bishu shanzhuang qishier jing dingjingshi dianping*, 63.

198

曲水之南. 過小阜. 有水自宮牆外流入.
蓋湯泉餘波也. 噴薄值下. 層石齒齒. 如
漱玉液. 飛珠濺沫. 猶帶雲蒸霞蔚之勢.

水源暖溜輒蠲痾. 湧出陰陽滌蕩多. 懷保
分流無近遠. 窮簷盡誦自然歌.

RIPA'S TITLE AND COMMENT

"Warm River." Three houses for recreation.

Fiume tiepido. = Trè Casini di recreazione.

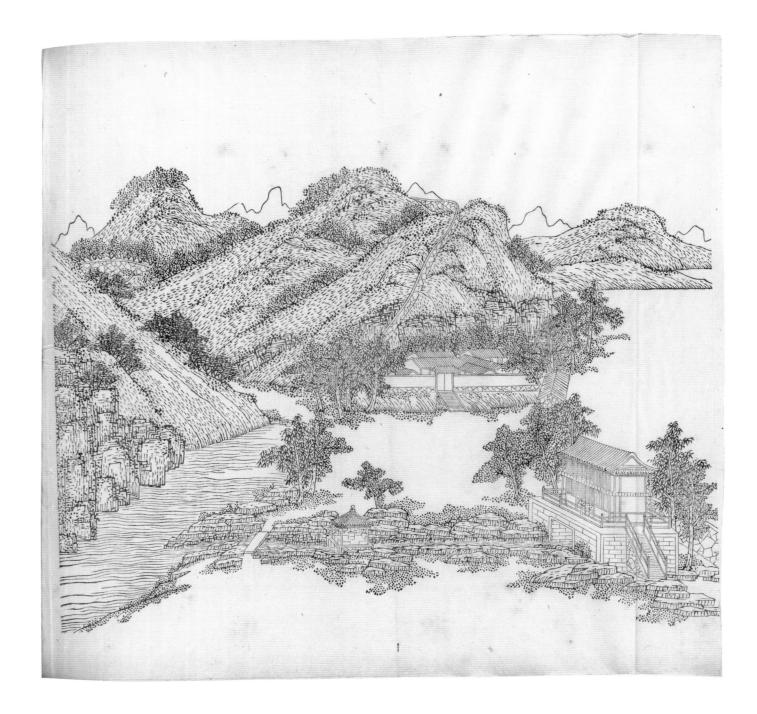

200

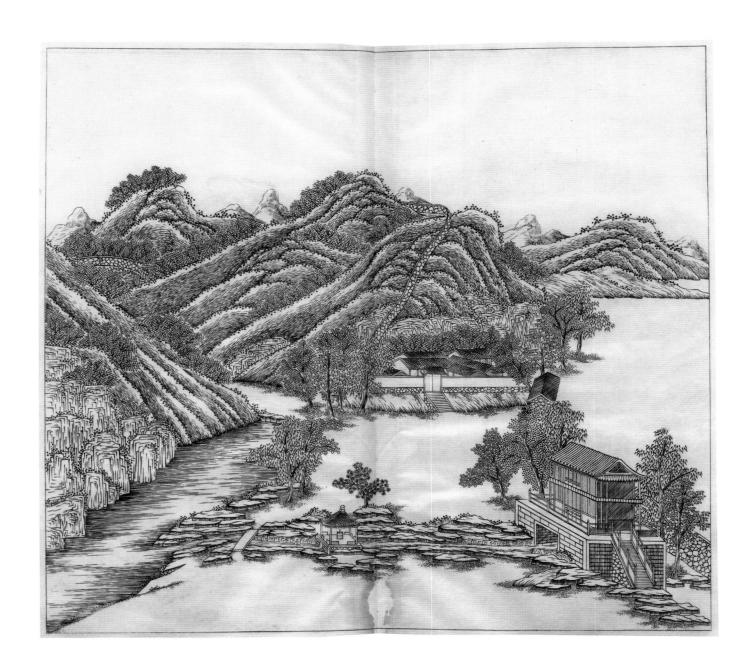

20. A Fountainhead in a Cliff

Quanyuan shibi 泉源石壁

This view looks toward a spring issuing from a crevice in a sheer cliff more than twenty feet high.
The spring cascades down into a stream that then flows west into Crescent Lake (Banyuehu 半月湖).
Kangxi named the pavilion opposite the cliff, illustrated to the right, "Gazing at the Fountainhead"
(Wangyuanting 望源亭) and the pavilion to the west, shown higher up, "Observing the Morning
Clouds" (Zhuzhaoxia 矚朝霞). The four characters of the name of this view were engraved on the face
of the cliff in 1704.[60]

North of Lion Path,[61] hills and ridges twist and turn for more than a mile. There is an emerald green crag like a sheer cliff that is reflected in the flowing stream below. The water is placid and deep. I walked about in search of the source, resting now and then, and chanted the lines from Master Zhu Xi's poem, "I asked the pond, 'Where do you obtain such clarity'? 'From fresh water that comes from a fountainhead.'"[62] In this casual manner, I realized the poem's profundity.

> A fountainhead lies within a wall of stone.
> Its scattering streams leap into the river bend
> Whose clear mirror splits the empyrean in two
> As bands of ripples splatter green moss.
> During long summer days, I rectify mathematics.[63]
> As my hair whitens, I study the Three Realms.[64]
> Auspicious omens are not worth celebrating.[65]
> I concentrate on contemplating the Way.

60 This site was damaged long ago and has been recently restored. Previously, the cliff also included engravings of Kangxi's poem and Qianlong's later response to it. *Kangxi sanshiliu jing shi xuanzhu*, 70n1.

61 A reference to the route to and through Lion Valley (Shiziyu 獅子峪), which lies in the northwestern portion of the Mountain Estate.

62 These lines are from the poem "Moved while Reading a Book" (Guanshu yougan 觀書有感) by the Neo-Confucian philosopher Zhu Xi 朱熹 (1130–1200), who was regarded as the paragon of intellectual orthodoxy under the Ming and Qing dynasties. The poem praises the mirror-like reflection of the sky in a small pond and celebrates the value of study. *Kangxi sanshiliu jing shi xuanzhu*, 71n4.

獅逕之北. 岡嶺蜿蜒數里. 翠崖如壁. 下映流泉.
泉水靜深. 尋源徒依. 咏朱子問渠那得清如許.
為有源頭活水來之句. 悠然有會.

水源依石壁. 雜踏至河隈. 清鏡分霄漢. 層波減
碧苔. 日長定九數. 髮白考三才. 天貺名猶鄙. 居
心思道該.

RIPA'S TITLE AND COMMENT

"Water with Its Source and a Rock with Its Cliff." A view of a part of a mountain cliff, on which the emperor had four letters sculpted, with which he praises and describes this place.

Acque che hà il suo fonte, e pietra che hà le sue scoglie. = Veduta d'una parte d'un monte scoglioso, sù il quale l'Imp.ᵉ vi fè scolpire quattro lettere, colle quale loda, e descrive questo luogo.

63 Kangxi was an enthusiastic student of both Chinese and Western mathematics. Qianlong later recalled in a note to his poem "Six Rhymes on the Studio of Clear Observation" (Chengguanzhai liuyun 澄觀齋六韻) that Kangxi assembled experts in the traditional Chinese Nine Forms of Calculation (*jiushu* 九數) at this studio in the Mountain Estate. Together they produced an imperially sponsored publication, *Essential Principles of Mathematics* (*Shuli jingyun* 數理精蘊, 1713–1722) about Chinese and Western mathematics. *Kangxi sanshiliu jing shi xuanzhu*, 71n8.

64 The Three Realms (*sancai* 三才) are heaven, earth, and man. This refers to Kangxi's study of *The Book of Changes*, which was regarded as elaborating the principles of the Three Realms. According to Wei Boyang's 魏伯陽 (Eastern Han dynasty) *Combined Interpretations to* The Book of Changes (*Yijing cantongqi* 易經參同契), mastering this classic in connection with Daoist practices for cultivating longevity could result in a revitalization that turned white hair to black. *Kangxi sanshiliu jing shi xuanzhu*, 71n9.

65 The Northern Song emperor Zhenzong 宋真宗 (r. 997–1022) proclaimed the sixth day of the sixth lunar month a holiday to celebrate the divine revelation of texts that officials reported had appeared as signs of heaven's approval. Here, Kangxi is criticizing both the belief in auspicious omens as indicating an emperor's virtue and the reliance on divine revelations. Instead, he avows the Neo-Confucian practice of self-cultivation of the Way through studying the classics.

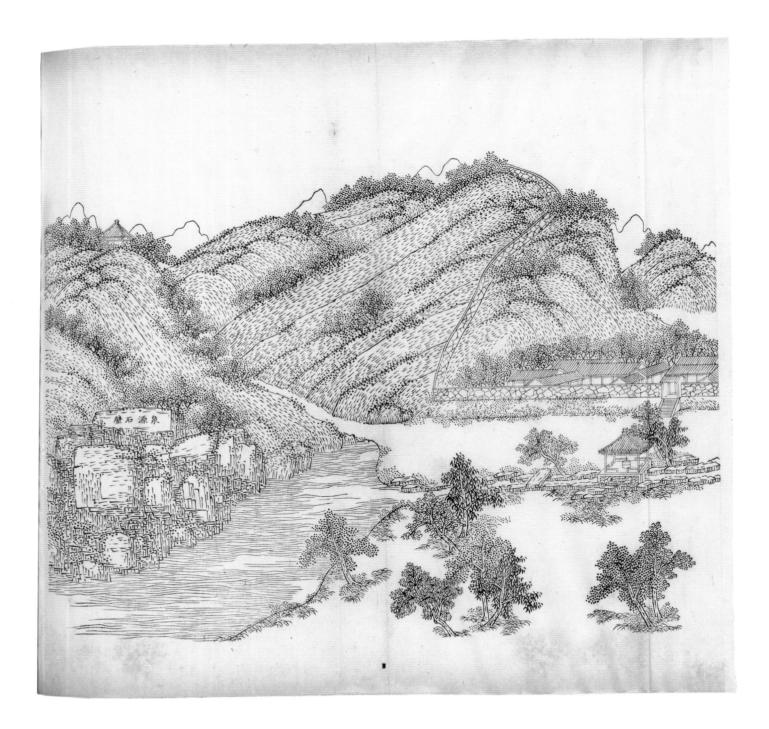

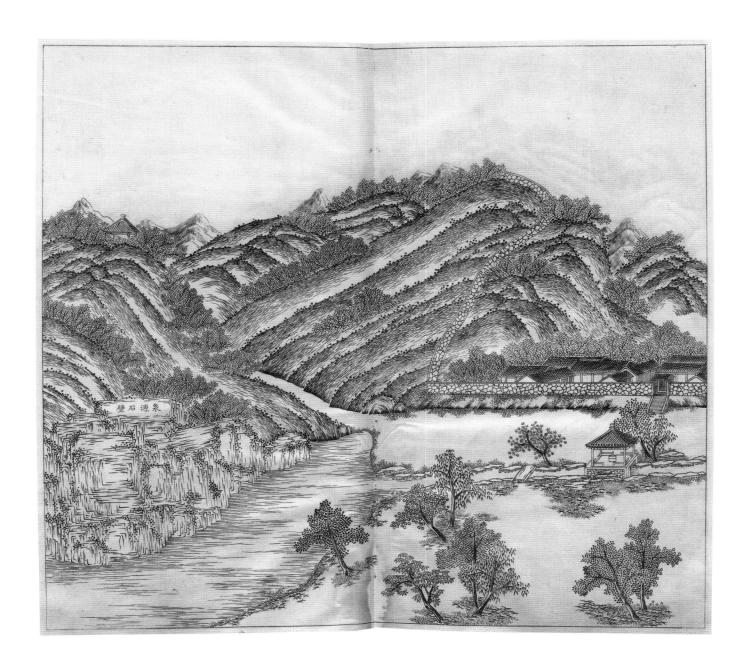

21. Verdant Isle of Green Maples

Qingfeng lüyu 青楓綠嶼

Located between Views 10 and 13, this complex of three structures was built in a small hollow beside a cliff. A grove of surrounding maples creates the illusion of being on a green island. It contains two court-yards and a rear garden. The front courtyard was entered through a round gate in a lattice fence; it contains a three-bay pavilion to the east that Kangxi named "Signpost Amidst Rosy Clouds" (Xiabiao 霞標)[66] to celebrate the autumn scene. He named the five-bay, main pavilion "Filled with Clear Sounds of a Spring and the Breeze" (Fengquan manqingting 風泉滿清聽), and inscribed both names on placards. There is also a four-bay adjacent room in the back that Qianlong later named "Singing of Red Trees" (Yinhongshu 吟紅榭). The wall on the east is pierced with individually shaped windows providing views of Hammer Peak (View 12), shown here across the river on the right.

There are many maples throughout the hills in the north. Their leaves are abundant and provide excellent shade, and the glossiness of their color is no less than the *wutong* tree or banana plant. They are hidden and revealed by the latticed windows, and an ethereal coolness naturally arises. Vines and creepers intertwine as they hang down alongside the cliffs. "The river is like a sash of blue gauze while the mountains resemble hairpins of green jade."[67] This unique world exists "between the door and the windows."[68]

> Stone steps wind upwards to a lofty place
> Where green maples attract nature's finest things.
> Listening to the sounds, I can tell the trees are dense;
> Gazing at the view, I cut off the noisy world.
> This verdant isle lies beside the windows
> As clouds in the clear sky chase colorful mists.
> I have lost the words for such pure tranquility[69]
> While gazing transfixed at the beauty of life.

66 The name derives from a line in Sun Chuo's 孫綽 (314–371) "Rhapsody on a Journey to Terrace of Heaven Mountain" (You Tiantaishan fu 遊天台山賦): "Red Citadel Mountain rises through the rosy clouds, erect as a signpost" 赤城霞起而建標. *Kangxi sanshiliu jing shi xuanzhu*, 75n1.

67 These lines are from a poem, "For Grand Master Yan of Guizhou" (Song Guizhou Yan Dafu 送桂州嚴大夫), by the Tang dynasty poet and official Han Yu 韓愈 (768–824). Han, renowned as a staunch advocate of Confucian government, was another one of the Eight Masters of Tang and Song Poetry and Prose. *Kangxi sanshiliu jing shi xuanzhu*, 76n3.

北嶺多楓. 葉茂而美蔭. 其色油然. 不減梧桐
芭蕉也. 疏窗掩映. 虛凉自生. 蘿蔦交枝. 垂掛
崖畔. 水似青羅帶. 山如碧玉簪. 奇境在戶牖之
間矣.

石磴高盤處. 青楓引物華. 聞聲知樹密. 見景
絕紛譁. 綠嶼臨窗牖. 晴雲遍綺霞. 忘言清靜
意. 頻望群生嘉.

"Black Trees and Green Rocks." A house for recreation on a high mountain with two rustic rocks. As these were delineated in another print, here, we have added a view of several other houses for recreation, which are situated halfway up the mountain in the middle, and the view of the rock, of which we speak in another print.[70]

Albore nero, e pietre verde. = Casino di recreazione sù d'un alto monte con due rustiche pietre. A. a. come stà delineato in un'altra Stampa. Qui è aggiunto la prospettiva d'alcuni altri Casini di recreaz.[ne], situati verso la metà del med.º monte, e la veduta della pietra B. della quale si parlerà in altra stampa.

68 See the chapter "Imperial Audiences" in the Confucian classic *The Book of Ceremonial* (*Yili*: "Jinjian" 儀禮: 覲見, Warring States period–Western Han dynasty), which states that the Son of Heaven should place a screen "between the door and the windows" (*huyou zhi jian* 戶牖之間) in rooms where he holds audiences. Kangxi is implying with some pride that, instead of following the restrictions of ancient court protocol and installing a screen that would block the view, he has created a more relaxed space that is open to the poetic landscape outside.

69 An allusion to the concluding lines of the fifth poem in the cycle titled "Drinking Wine," in Tao Qian's cycle of twenty poems: "In this, there lies a true meaning. I want to express it but have lost the words" 此中有真意. 欲辯已忘言.

70 The pavilion with the two rustic rocks on top of the mountain here constitutes View 10. The other rock mentioned refers to Hammer Peak to the right, which Ripa also comments on in View 12.

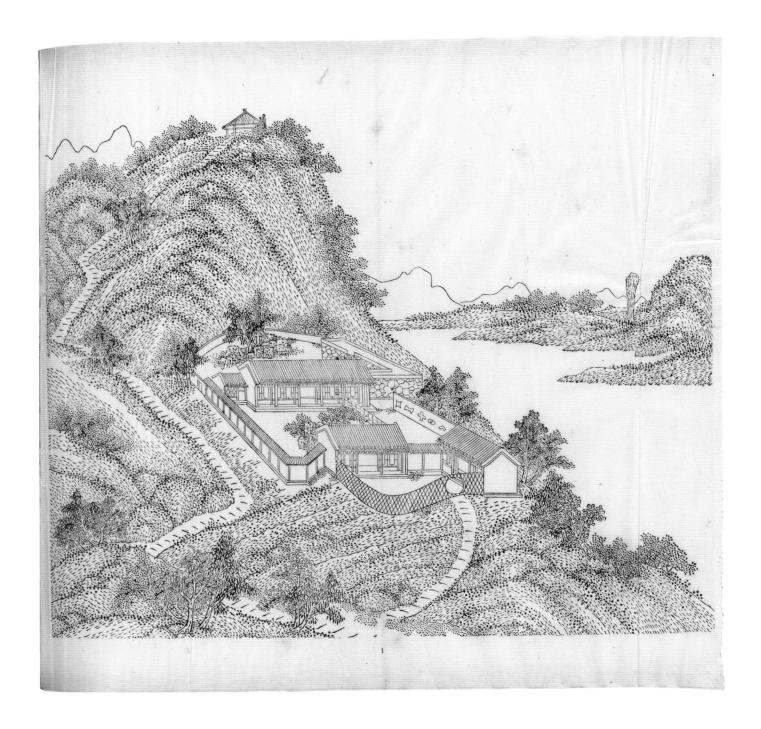

208

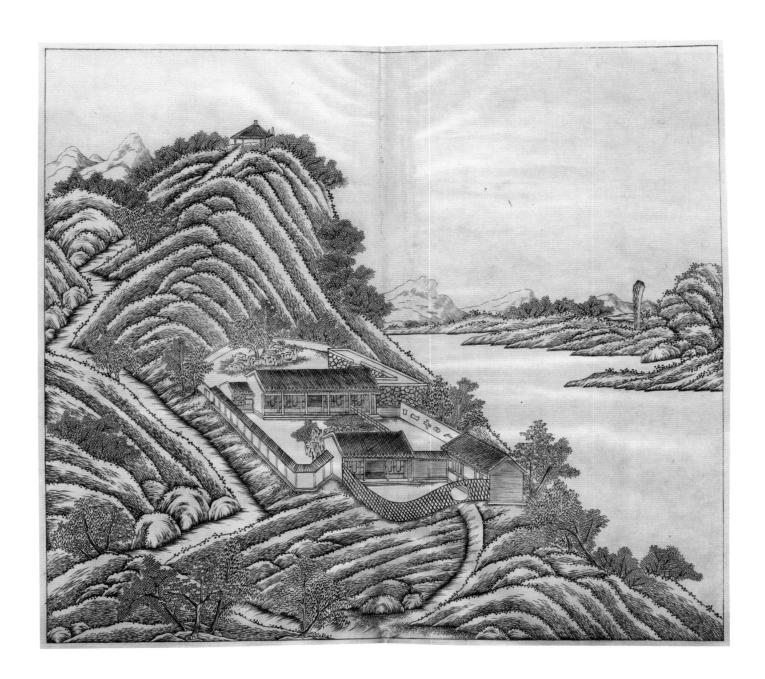

209

22. Orioles Warbling in the Tall Trees

Yingzhuan qiaomu 鶯囀喬木

This singular pavilion is one of four situated along the northern bank of Clearwater Lake.[71] It is an elongated, six-sided structure, shown from the rear in the lower portion of the illustration, located across the lake from Clear Ripples with Layers of Greenery (View 30). It is also near a flat ground in the plains area, where Kangxi would inspect the riding skills of potential participants in the autumn hunt at the Mulan hunting grounds, northeast of the Mountain Estate. The name of this view alludes to a line in The Book of Songs *(Shijing 詩經, Zhou dynasty) about birds seeking refuge in tall trees, and the first line of Kangxi's poem invokes Listening to Orioles in the Wavy Willows (Liulang wenying 柳浪聞鶯), one of the ten famous views of West Lake.[72]*

West of An Immense Field with Shady Groves [View 35], a thousand giant trees provide copious shade for more than a mile. When the sun shines forth at dawn and the nighttime dew has not yet vanished, the orioles' fine tones harmonize with the soothing, southern breeze. The flowing sounds possess a graceful resonance, like a set of reed pipes in the mountains.

> Yesterday I heard orioles singing in the willows.
> Today, I inspected horses by tall flag posts.[73]
> Vermillion-blossom and purple-flower appear on the green plain.
> "Moon" and "Cloud" thoroughbreds form a herd of many colors.[74]

71 The present pavilion was reconstructed in 1979 but employs a different architectural design than the original.

72 See the lines in the poem "Felling Trees" in *The Book of Songs* (*Shijing*: "Famu" 詩經: 伐木): "[the birds] flee the secluded valley and take refuge in the tall trees" . . . 出自幽谷, 遷于喬木. The name "Listening to Orioles in the Wavy Willows" refers to the scene along Su's Embankment (Sudi 蘇堤), which Su Shi constructed at West Lake in Hangzhou. See also View 2.

73 Manchu horsemanship skills included riding, archery, and military maneuvers. This ritual was later revived under Qianlong, who named the area "Equestrian Banks" (Shimadai 試馬埭), no. 21 of his additional thirty-six Views.

74 Vermillion-blossom (*zhuying* 朱英) and purple-flower (*zituo* 紫脫) are auspicious plants whose appearance marks an era of peace and good government. This scene refers to the colorful, grassy plains area. Moon-horse (Yuesi 月駟) and Cloud-stallion (Yunli 雲驪) were literary expresssions denoting extraordinary thoroughbreds. Kangxi would select the finest horses, especially those from Mongolia and Central Asia, for the autumn hunt.

甫田叢樾之西. 夏木千章. 濃陰數里. 晨曦始旭. 宿露未晞. 黃鳥好音.
與薰風相和. 流聲逸韻. 山中一部笙簧也.

昨日聞鶯鳴柳樹. 今朝閱馬至崇杠. 朱英紫脫平原綠. 月駒雲駬錯落驦.

RIPA'S TITLE AND COMMENT

"Hawks Crying on a High Tree." Two houses for recreation.

Sparviere sù alto albore che grida. = Due Casini di recreazione.

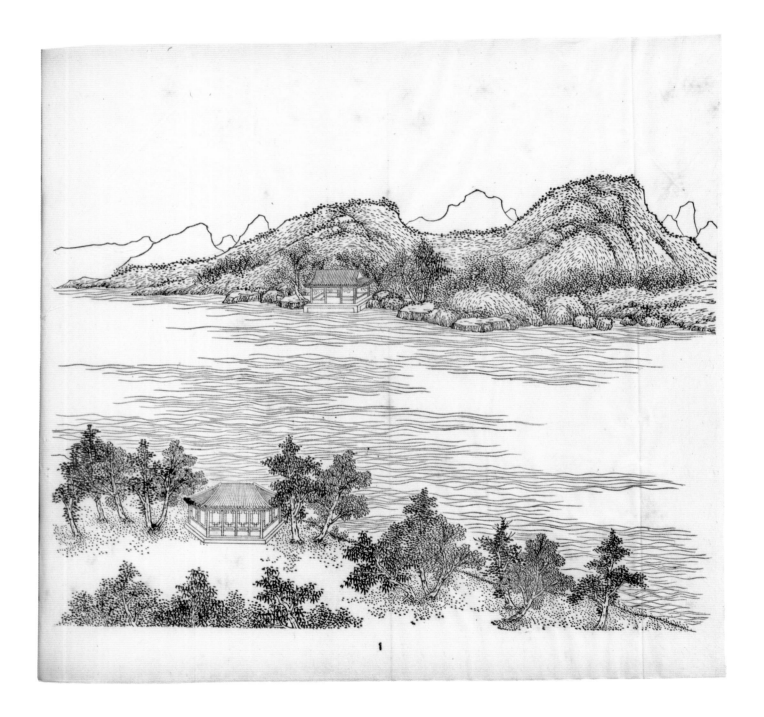

1

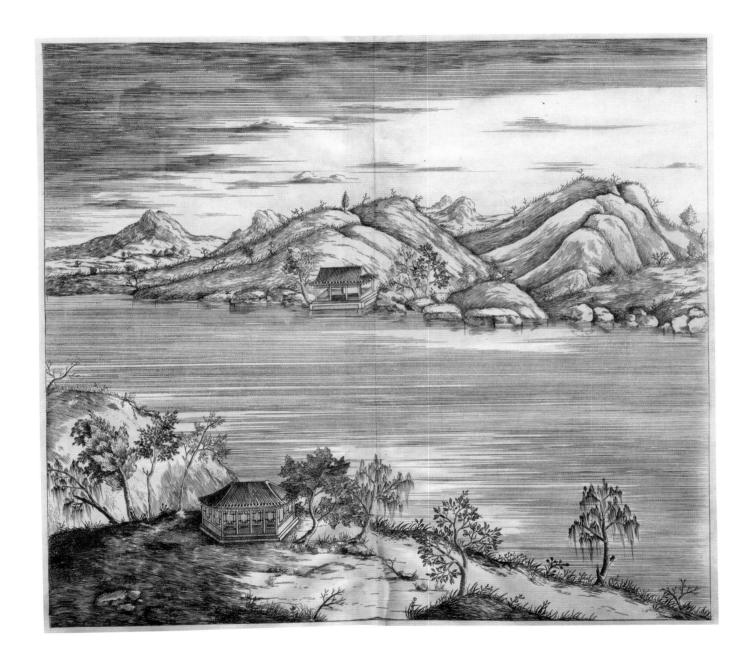

23. Fragrance Grows Purer in the Distance

Xiangyuan yiqing 香遠益清

This complex is located on the eastern bank of Clearwater Lake, opposite the source of the hot springs within the Mountain Estate.[75] The name of this View denotes the five-bay main building, which faces a winding stream leading to a pond. It alludes to a line in the famous essay "My Love for the Lotus" (Ailian shuo 愛蓮說) by the Northern Song dynasty Neo-Confucian philosopher Zhou Dunyi 周敦頤 (1017–1073). The three-bay rear structure was named "Floating Purple" (Zifu 紫浮), and the eight-bay structure to the left was named "The Studio beside Greenery" (Yilüzhai 依綠齋) because of the many tall pines that surrounded it. The stream flows under the open pavilion in front and through a pond in back. The abundant lotuses provide a pervasive fragrance that is spread by the breezes, especially after a rainfall.

East of a winding stream, a cool pavilion was built. It looks out over ponds front and back. Famous varieties of lotus including "Double-blossoms" and "Thousand-leaves" were planted there.[76] They resemble emerald-green parasols strolling across the ripples with red buds retaining the dew drops. Light breezes slowly waft, filling the vales with fragrant aromas.

[To the pattern of "Green Willow Tips"][77]

Emerging above the faint ripples,
Their fragrance grows purer in the distance,
Unsullied and extraordinary.
Are they from the White Dragon Mounds of the desert?
Or are they fragrant plants from Green Lake?[78]
I suspect they are, but who knows?
Transplanted from everywhere in all shapes and sizes,
Where do they come from?
Why bother choosing amongst them?
Rising like towers a thousand stories high,
These lotuses occupy acres and acres
Just like a scene in the south.[79]

75 The hot springs within the Mountain Estate were marked by a natural vertical rock that was inscribed with the characters 熱河 (Rehe). This complex was recently partially reconstructed.

76 Double-blossom (*chongtai* 重台) lotuses were a specialty of horticulturists in Suzhou. Thousand-leaves (*qianye* 千葉) lotuses were celebrated by writers such as Pi Rixiu 皮日休 (ca. 834–ca. 883) in his poem "Listening to the Pines Hermitage in Huishan" (Huishan Tingsongan 惠山聽松庵). *Kangxi sanshiliu jing shi xuanzhu*, 84n4.

77 "Green Willow Tips" (Liushaoqing 柳梢青) is the name of a *ci* 詞 lyric and a *qu* 曲 aria form.

曲水之東. 開涼軒. 前後臨池. 中植重臺千葉諸名種.
翠盖凌波. 朱房含露. 流風冉冉. 芳氣竟谷.

[調柳梢青] 出水蓮漪. 香清益遠. 不染偏奇. 沙漠龍堆.
青湖芳草. 疑是誰知. 移根各地參差. 歸何處. 那分公私.
樓起千層. 荷占數頃. 炎景相宜.

RIPA'S TITLE AND COMMENT

"Scent at a Distance is Good." Other houses where another group of concubines dwell.

Odor da lontano, e buono. = Altre Case, nelle quali abbitava un'altre parte delle Concubine.

78 White Dragon Mounds (Bailongdui 白龍堆) are long winding sand dunes; the name originally referred to the distant desert south of the Tianshan Mountains (Tianshan 天山) in modern Xinjiang, where a type of lotus grew that was known for its brilliant color and large petals. Here, it refers to the land of the Aohan Confederation 敖漢, a Mongolian tribe that dwelled in modern Inner Mongolia and pastured flocks in the Rehe area in Kangxi's time. Greengrass Lake (Qingcaohu 青草湖) in the south near modern Yueyang, Hunan, is one of the five famous lakes of antiquity. These two places denote opposite environments—north and south—where lotuses can flourish. *Kangxi sanshiliu jing shi xuanzhu*, 84n10.

79 The graphs 炎景 (*yanjing*, literally, "hot-weather scenery") can refer to the seasonal weather or can specifically denote the south. Thus, Kangxi could be saying that this view provides an appropriate refuge from the summer heat at the Mountain Estate or that it matches the scenery of the Jiangnan area.

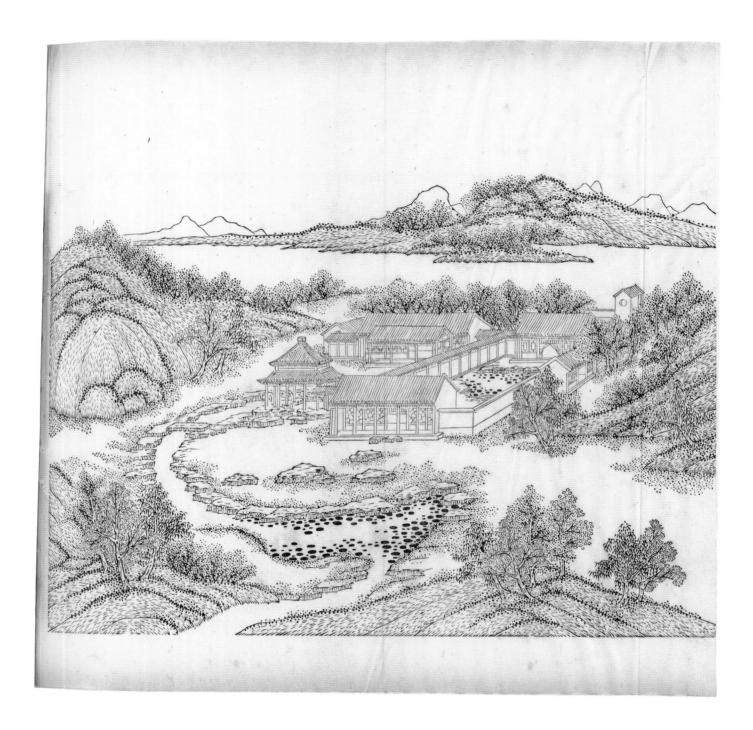

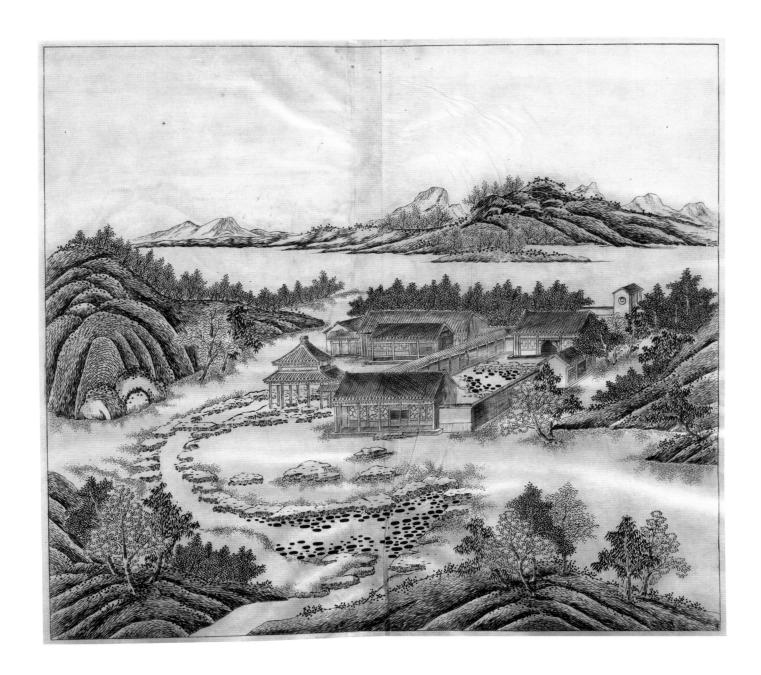

24. Golden Lotuses Reflecting the Sun

Jinlian yingri 金蓮映日

This complex consists of a five-bay, two-story hall that faced west on Wish-Fulfilling Island. A rectangular flower garden in front is enclosed by loggias on three sides. The Golden Lotus Flower (jinlianhua 金蓮花), also known as the "Dry Land Lotus" (handilian 旱地蓮), produces a small yellow flower resembling a lotus blossom that is cultivated on land rather than in water. It was used in herbal medicine and flourished in the north, especially at Five Terraces Mountain (Wutaishan 五臺山) in modern Shanxi. One of the four Buddhist sacred mountains, it was dedicated to the Buddha Mañjuśrī, the guardian of wisdom who was also associated with the flower in folklore. Kangxi visited the temples at Five Terraces Mountain and transplanted many examples of the Golden Lotus Flower to the Mountain Estate. Its blossoms were appreciated for reflecting a golden glow in the sunlight.

Myriad Golden Lotuses were planted in the large courtyard covering about half an acre. The stalks and leaves grow tall and straight. The diameter of the flowers is a little more than two inches. When the sun's rays strike them, their brilliance is dazzling. When one gazes down on them from upstairs in the pavilion, it absolutely looks like a ground covered in gold.[80]

> Its pure color is beautiful, like these mountains and streams.
> The Golden Lotus comes from Five Terraces.
> Neither prunus nor bamboo grows north of the Great Wall,
> But in summer's heat, it blossoms, reflecting the sun.

80 This may allude to a Buddhist anecdote in Baochang 寶唱 (fl. early sixth century), ed., *Unusual Phenomena from the Sutras and Vinayas* (*Jinglü yixiang* 經律異相, 516), where a wealthy merchant covered a large area of ground in gold when preparing a garden residence to host Śakyamuni Buddha. *Kangxi sanshiliu jing shi xuanzhu*, 88n3.

廣庭數畝. 植金蓮花萬本. 枝葉高挺. 花面圍徑二寸餘. 日光照射. 精
采煥目. 登樓下視. 直作黃金布地觀.

正色山川秀. 金蓮出五臺. 塞北無梅竹. 炎天映日開.

RIPA'S TITLE AND COMMENT

"Sun that Shines on the Beautiful Water Lilies."[81] A house for recreation, where, on the second floor, there was a large clock that would beat the quarters and the hours. In front of it there is a flower garden.

Sol che risplende sù bellism.ᵉ Limfee. = Casino di recreazione, nel di cui 2do appartam.ᵗᵒ vi stava un gran orologgio, che batteva i quarti e le ore. Avanti esso vi è un giardino di fiori.

81 Ripa mistakenly regarded these lotuses as water lilies.

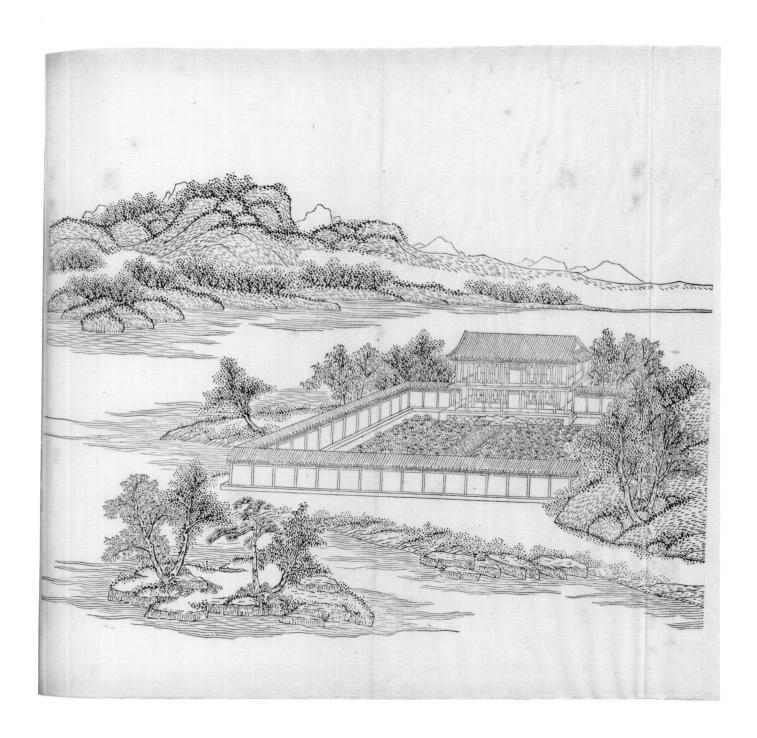

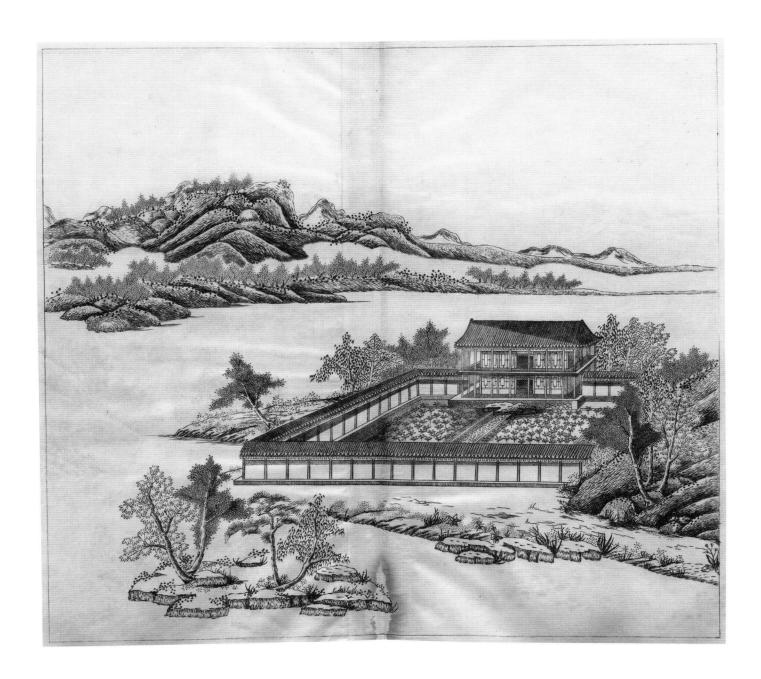

25. Sounds of a Spring Near and Far

Yuanjin quansheng 遠近泉聲

Situated on the eastern bank of the Inner Lake (Neihu 內湖)—also known as West Lake (Xihu 西湖)—this complex stands opposite Surging Greenery Cliff (Yongcuiyan 涌翠巖), where a spring becomes a sonorous waterfall. The name of this view denotes the three-bay main hall, which is surrounded by loggias with lotus ponds in front and in back. To its right is a smaller, two-bay hall named "The Studio of Accumulated Fragrance" (Juxiangzhai 聚香齋). To its left is an open pavilion named "Listening to the Waterfall" (Tingpu 聽瀑).[82]

In the north is Leaping Spring,[83] which surges up from the ground, gushing and gurgling. To the west is a waterfall like the Milky Way splashing down, a crystalline curtain reflecting the cliffs. Light winds furl it sideways and a spray of pearls disperses through the air. In front and back are ponds filled with myriad white lotuses. With the fragrance of the blossoms and the sounds of the spring, one enters straight into a scene on Hermitage Mountain.[84]

> A spring was led to become a waterfall.
> From its spouting spray pearls fly forth.
> Like jangling jade, the lofty cliffs reply.
> Such forms are empty, existing, yet not.[85]

82 The original buildings were probably destroyed during the Japanese occupation of Manchuria from 1931–1945, when the lake was filled in and the area was used for target practice. The complex was recently reconstructed.

83 Leaping Spring (Baotuquan 趵突泉) invokes the name of the most celebrated of the seventy-two famous springs of Jinan in modern Shandong.

84 Hermitage Mountain (Lushan 廬山) is a famous mountain in modern Jiangxi province that has been long celebrated for its scenery, especially its waterfalls. It was also a location for Buddhist and Daoist temples through the centuries. Kangxi's focus on the waterfall and the image of the Milky Way falling down, followed by the connection to Hermitage Mountain, alludes to a famous poem, "Gazing at the Waterfall on Hermitage Mountain" (Lushan wangpu 廬山望瀑), by the Tang dynasty poet Li Bo 李白 (701–762).

85 An allusion to the Buddhist concept of the non-duality of form (se 色) and emptiness (kong 空) as expressed, for example, in the popular *Heart Sutra* (Xinjing 心經, ca. early seventh century). From the perspective of an unenlightened mind, things are treated as independent entities, each with its own self-nature. But Buddhism regards all things as only possessing a temporary, conditional existence, for they arise as aggregates of interdependent elements due to karmic cause and effect. Thus, they are in reality "empty" in that they lack any basis for an enduring and independent self. An enlightened Buddhist consciousness is aware that this conditional existence of forms and their fundamental emptiness are ultimately identical.

北為趵突泉. 涌地齧沸. 西為瀑布. 銀河
倒瀉. 晶簾映崖. 微風斜捲. 珠璣散空.
前後池塘. 白蓮萬朵. 花芬泉響. 直入廬
山勝境矣.

引泉開瀑布. 迸水起飛珠. 鏘玉雲嚴應.
色空有若無.

"From a Distance and Nearby, the Sound of a Spring." Houses for recreation, one of which is
on top of a little hill of neatly piled stones, artfully made, from where, together with a large
entourage, it is possible to see a brook cascading, which comes from a mountain nearby.

Da lontano, e da vicino rumor di fonte. = Casini di recreaz.ne, un da essi stà sù d'un mon-
ticello di pietre si ben disposte, che par fatto d'arte, da dove con molto degl'astanti si vide
cadere un ruscello d'acqua, che viene dal monte a lui vicino.

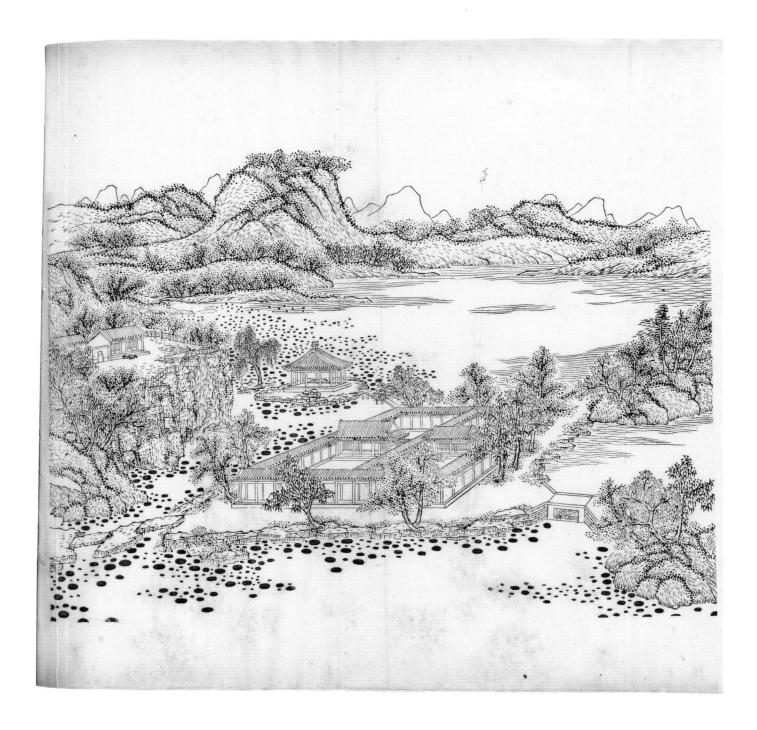

224

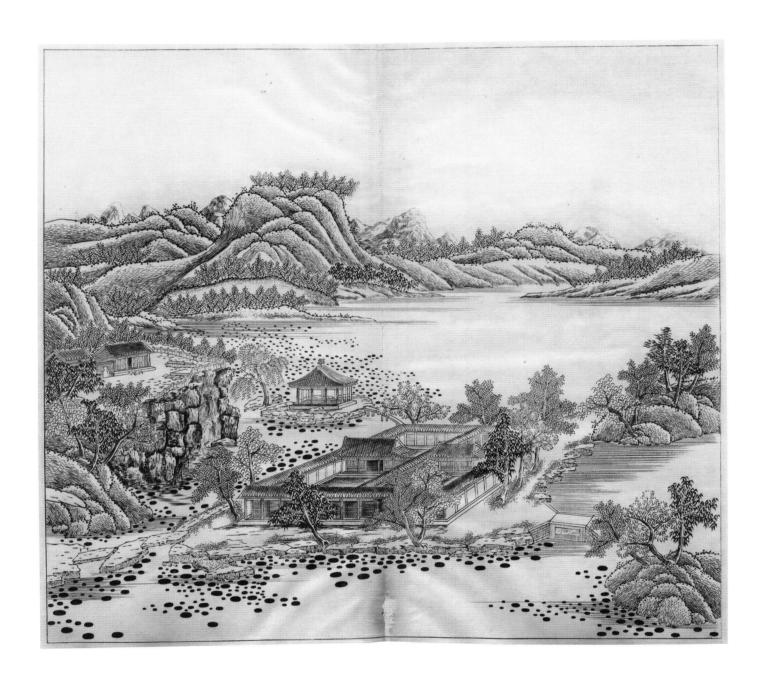

26. Moon Boat with Cloud Sails

Yunfan yuefang 雲帆月舫

Waterside pavilions shaped like boats were popular structures in southern gardens that were adapted to gardens in the north. This grand, two-story version was built along the eastern shore of Wish-Fulfilling Lake with cabins in front and in back. It burned down during the Qianlong era and was not rebuilt.

Beside the water is a pavilion shaped like a boat. It is the width of a room but extends several times that in length from north to south. Surrounding it is a stone balustrade. Latticed windows both hide and reveal the scenery. It feels just like sailing on light clouds or floating up to the bright moon. There is a second story that can be ascended for a distant view, and the room there resembles a steering cabin.

[To the pattern of "Peaceful Times"]

The pavilion's shadow glides over ripples without stirring up waves—
We've been met by a divine tortoise.[86]
It's another palace on Penglai suspended in the clouds—[87]
What a glorious painting.
It never ceases throughout the four seasons—
I lie down and hear ancient flutes.[88]
Thoughts of "defer pleasure, feel concern," "relieve the people's cares"—
Fuxi's *Changes* are contained in all this.[89]

86 A reference to an anecdote in the Daoist anthology *Master Lie* that describes how the Supreme God commanded divine tortoises underwater in the Gulf of Bohai to support Penglai and the other mythical islands so that they would not float away. See note 22.

87 Penglai is frequently represented in paintings as a mountainous island with towering palatial halls surrounded by clouds. These are the residences of Daoist Transcendents and are inaccessible to mortals.

88 The ancient flutes (*xiao* 簫), associated here with the sounds of the water, refer to the musical piece "Continuity" (Shao 韶) said to have been performed at the court of the ancient thearch Shun. As celebrated in various classical sources, this auspicious music manifested his perfect government.

89 Kangxi combines several allusions to indicate that the scene inspires him to govern wisely. "First feel concern for the concerns of the world. Defer pleasure until the world can take pleasure" 先天下之憂而憂. 後天下之樂而樂 is a well-known statement of Confucian moral commitment by the Northern Song dynasty official Fan Zhongyan 范仲淹 (989–1052) from "A Record of the Yueyang Pavilion" (Yueyanglou ji 岳陽樓記, 1046). This is followed by another allusion to the song "Southern Breeze" performed by the thearch Shun. See note 11. For Kangxi, both thoughts manifest the essence of the sixty-four hexagrams in *The Book of Changes*, whose early strata were attributed to the ancient thearch Fuxi 伏羲 (trad. r. early third millenium BCE).

臨水傚舟形為閣. 廣一室. 袤數倍之. 周以石闌. 疏窗掩映. 宛如駕輕雲
浮明月. 上有樓可登眺亦如舵樓也.

[調太平時] 閣影凌波不動濤. 接靈鼇. 蓬萊別殿掛雲霄. 粲揮毫. 四季
風光捻無竭. 臥聞簫. 後樂先憂薰絃意. 蘊義爻.

RIPA'S TITLE AND COMMENT

"A Sail Similar to a Cloud, and a Little Boat Similar to the Moon." Houses of recreation with two floors are quite rare in China, where most houses are on one floor. At this house, the emperor often took walks with his ladies to enjoy the fresh air during the hot weather.

Vela simile ad'una nubbe, e barchetta simile alla luna. = Casini di recreaz.ᵉ di due appartam.ᵗᵒ in Cina rari, essendo quasi tutte le Casi in piano. In questo Casino l'Imp.ᵉ andava spesse volte a spasso colle sue donne a prender fresco ne gran calori.

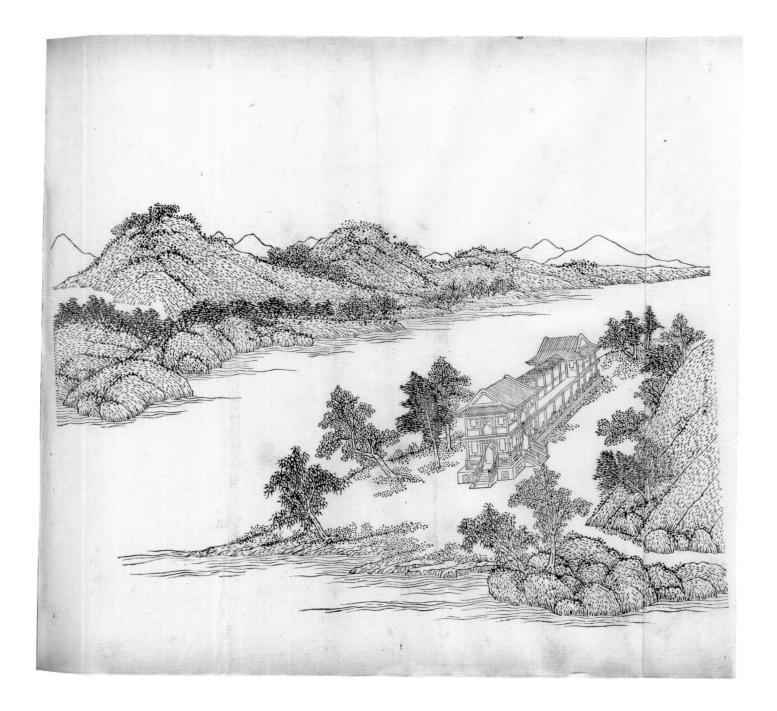

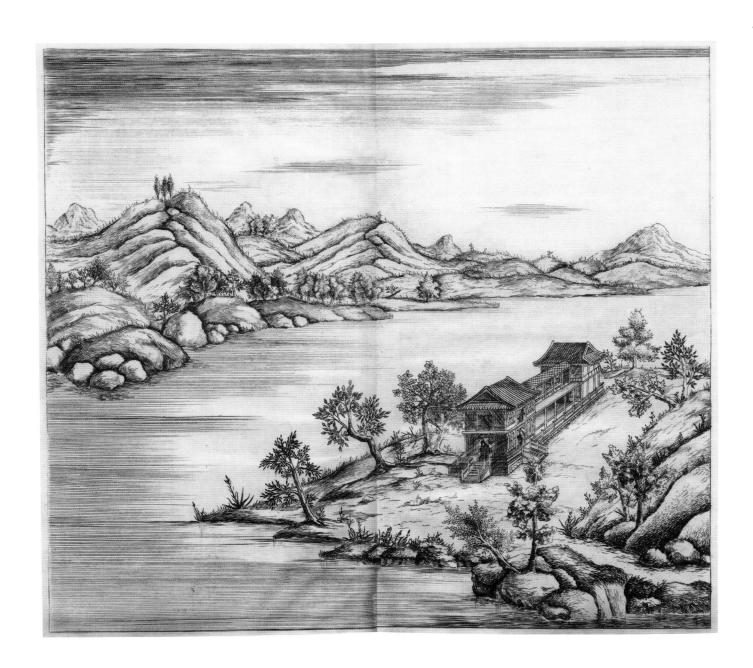

27. A Fragrant Islet by Flowing Waters

Fangzhu linliu 芳渚臨流

This open square pavilion stands on a small point along the sandy western bank of Wish-Fulfilling Lake. Facing south, it is surrounded by the lake on three sides. Kangxi imagined the scene as islet covered with fragrant plants. The Long Bridge (Changqiao 長橋) to the northwest is located at the top of the illustration. [90]

A pavilion stands at the edge of a winding islet. Giant rocks lie beside the flowing waters. The lake water gushes forth from under Long Bridge. When it reaches this point, it turns and proceeds south. To the right and left of the pavilion, naturally shaped rocks line the shore, extending for nearly a mile. There are green and purple mosses along with abundant grasses and bushes. It very much resembles a painting by Fan Kuan.[91]

> Willows stretch along sandy banks—
> a carpet of emerald green.
> In the clear stream by a fragrant isle,
> ordinary fish are jumping.[92]
> Groves of trees line the shores
> as wildflowers bloom.
> I sit alone by the flowing waters,
> cherishing the Valley Spirit.[93]

90 Long Bridge, also known as Stone Bridge (Shiqiao 石橋), separates the Inner Lake from Wish-Fulfilling Lake. See also see Views 33 and 34. The water from the former enters the latter through an opening under the bridge. The scene alludes to the design of West Lake in Hangzhou, which also has an Inner Lake separated from the main lake by an embankment and a bridge. The present pavilion was reconstructed in 1955. *Kangxi sanshiliu jing shi xuanzhu*, 99n1.

91 Fan Kuan 范寬 (d. 1036) was one of the great masters of Northern Song dynasty landscape painting. One of his masterpieces, *Traveling among Streams and Mountains (Xishan xinglü* 溪山行旅), was part of the Qing imperial collection by the Qianlong era and probably was known to Kangxi. It is now in the National Palace Museum, Taipei.

92 "Ordinary fish" refers to common species of fish, as opposed to the extraordinary fish that leap over Dragon Gate (Longmen 龍門) and turn into dragons in Chinese folklore. It was a popular motif used to represent talented individuals who passed the civil service examinations and became officials. Here, the ordinary fish leaping about represent the competition for worldly success. See Duan, *Bishu shanzhuang qishier jing dingjingshi dianping*, 89.

93 See note 8.

亭臨曲渚. 巨石枕流. 湖水自長橋瀉
出. 至此折而南行. 亭左右. 岸石天成.
亘二里許. 蒼苔紫蘚. 豐草灌木. 極似
范寬圖畫.

隄柳汀沙翡翠茵. 清溪芳渚躍凡鱗.
數叢夾岸山花放. 獨坐臨流惜谷神.

RIPA'S TITLE AND COMMENT

"Roaring Water that Flows Down." A house for recreation.

Strepitosa acqua, che da sù viene giù. = Casino di recreazione.

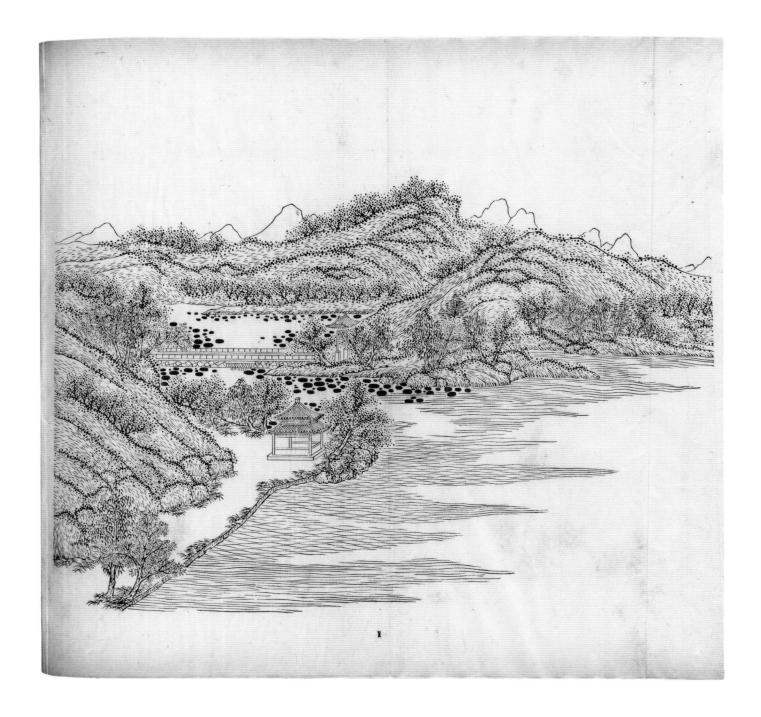

I

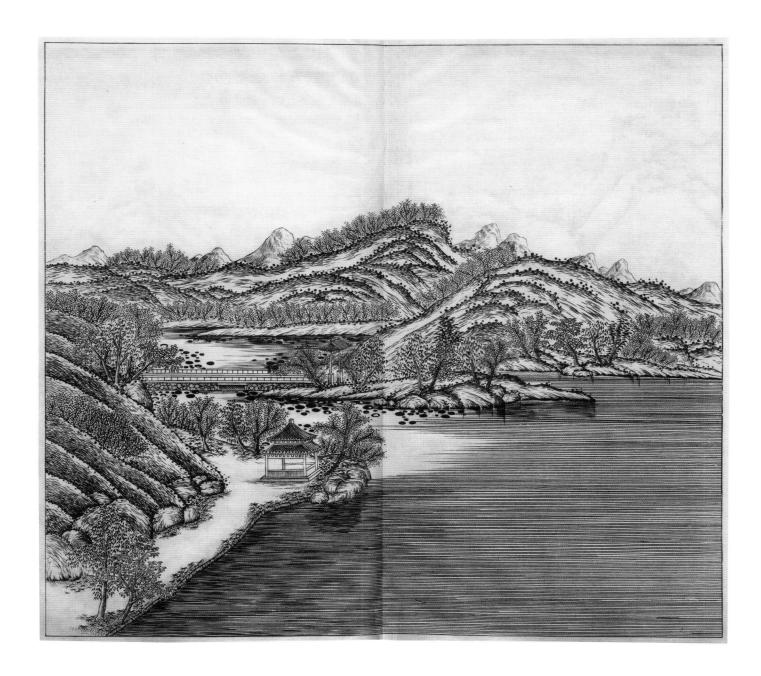

28. Shapes of Clouds and Figures in the Water

Yunrong shuitai 雲容水態

This five-bay pavilion stands before the towered gate in the mountainous area that marks the entrance to Pines and Clouds Ravine (Songyunxia 松雲峽).[94] *It faces the shore of Crescent Lake. When dense clouds roll out from the ravine, their ever-changing forms are mirrored in the water. The name of this View comes from a line by the Tang dynasty poet Du Mu 杜牧 (803–ca. 852).*[95] *Southern Mountains Piled with Snow (View 13) is shown in the upper right of the illustration.*

South of a gate is a building facing east. Proceeding up a slope and looking down from it reveals green trees like a field and blue-green peaks resembling a wall. The river flows abundantly as white clouds change shapes. One cannot tell which ones are the clouds and which are in the water. Crossing a long bridge, one imagines entering the world of Four Brilliances Mountain. A path divides the passing clouds in the water into groups north and south.[96]

> After rain passes, clouds easily disperse
> While water with flowing ripples endures.
> The common sort just stares contentedly.
> But to find the principle, consult the classics.

94 Qianlong later named the pavilion atop the gate "Boundless View" (Kuangguan 曠觀).

95 See Du Mu, "Late Autumn in Qi'an Commandery" (Qi'anjun wanqiu 齊安郡晚秋): "I can still appreciate shapes of clouds and figures in the water, and also feel free whistling my ambitions and singing from my heart" 雲容水態還堪賞; 嘯志歌懷亦自如.

96 Four Brilliances Mountain (Simingshan 四明山) is located along the border of Fenghua and Yuyao counties, near Ningbo, Zhejiang, and is considered the ninth cavern-heaven of religious Daoism. Ascending it takes the traveler into an enclosed landscape. Breaks in the peaks admit the light of the sun, moon, stars, and asterisms, hence the name. Because the mountain is often enshrouded in dense clouds, there is a route named "Path through the Clouds" (Yunjing 雲徑) leading to areas referred to as "South of the Clouds" (Yunnan 雲南) and "North of the Clouds" (Yunbei 雲北).

關口之南. 有室東向. 緣坡下望. 綠樹為田. 青峰
如堵. 川流溶溶. 白雲冶冶. 不知孰為雲. 孰為水也.
由長橋而渡. 疑入四明山中. 一逕分過雲南北.

雨過雲容易散. 波流水態長存. 悠然世俗惟念. 必
得經書考原.

RIPA'S TITLE AND COMMENT

"A Place Like Clouds and Water." Houses for recreation.

Luogo simile nubbi ed all'acqua. = Casini di recreazione.

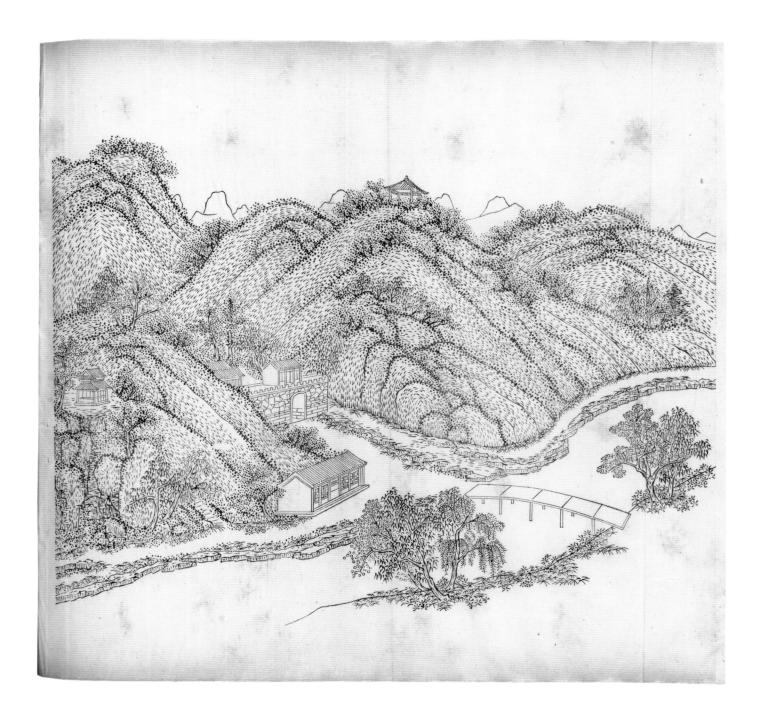

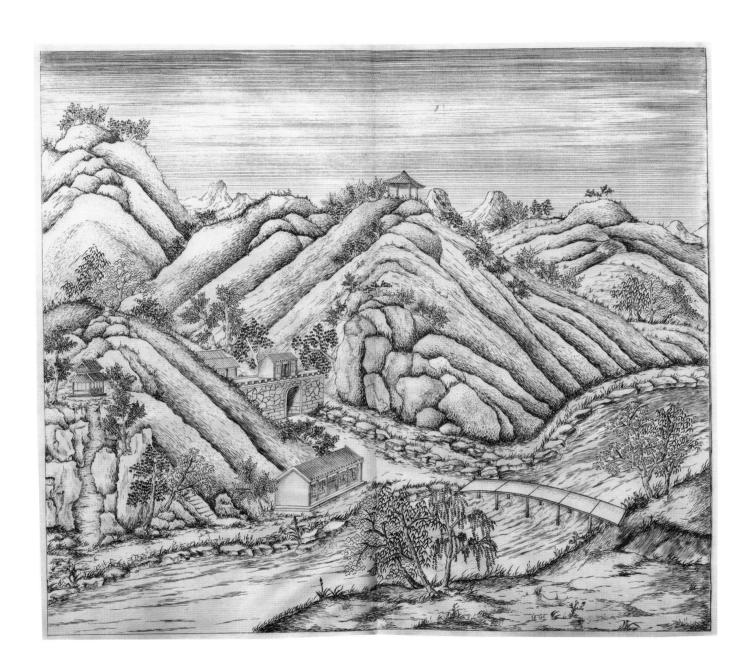

29. A Clear Spring Circling the Rocks

Chengquan raoshi 澄泉遶石

This was the name of a pavilion in front of a hill that faced a stream. It stood near the entrance to Pear Tree Vale (Lishuyu 梨樹峪) and was reached by a meandering path through the ravine. It is not shown in the illustration, which focuses on the stream. The pavilion in the upper left is probably Clouds and Peaks on All Sides (View 9) and in the lower right of the illustration is Pear Blossoms Accompanied by the Moon (View 14).

A pavilion overlooks a rocky pond to the south. Almost a mile to the west is the fountainhead of a spring, which issues forth through a crack in the rocks. An aqueduct was constructed out of giant bamboo to pipe its sonorous flow along the mountains. It makes a bend when it reaches here. After a rainfall, the stream rushes through the valley so at each critical point, a weir of rocks was built to hold back the silt. Therefore, the water in the pond is always so clear that reflections appear in it.

> I always yearn for lofty tranquility
> So here I constructed a humble abode.
> Through dense trees, a path was opened;
> These long mountains seem like the outskirts of town.
> The springwater winds through the old rocks;
> Pheasants and sparrows enjoy their new nests.
> On clear nights, the lotuses drip with pearls,
> And dew gathers on the tips of the trees.

亭南臨石池. 西二里許為泉源. 源自石罅出. 截架鳴箕.
依山引流. 曲折而至. 雨後谿壑奔注. 各作石堰以過泥
沙. 故池水常澄澈可鑒.

每存高靜意. 至此結衡茅. 樹密開行路. 山長疑近郊.
水泉繞舊石. 雉雀樂新巢. 晴夜荷珠滴. 露凝眾木梢.

RIPA'S TITLE AND COMMENT

"Clear Spring Water that Encircles the Rocks." Other dwellings where various ladies of the
emperor lived.

Acqua limpida del fonte, che circonda le pietre. = Altra abbitaz.ne, nella quale dimoravano
diverse donne dell'Imperadore.

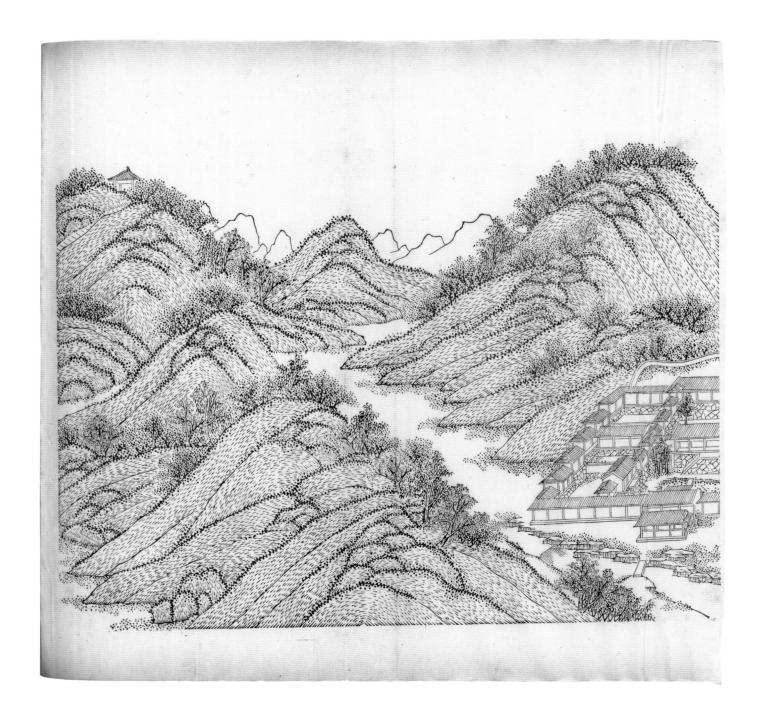

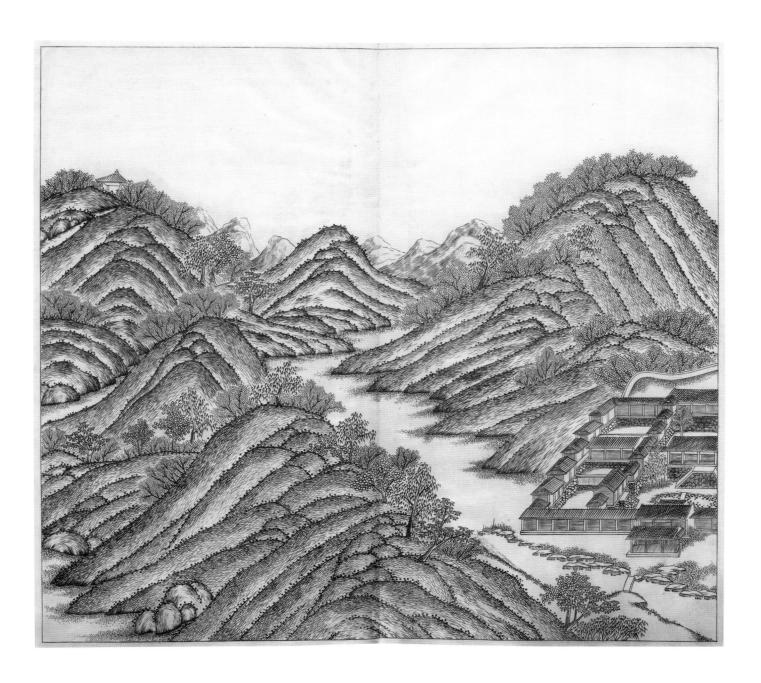

30. Clear Ripples with Layers of Greenery

Chengbo diecui 澄波疊翠

This three-bay, open pavilion stands on the southern bank of Clearwater Lake. In the illustration, it looks northward across the water at the groves of tall trees and the mountains in the distance, but it is actually located directly across from Untrammeled Thoughts by the Hao and Pu Rivers (View 17). The name derives from the reflection of the mountains in the lake.

In the rear of Wish-Fulfilling Island, a small pavilion stands by the lake. The lake water with its limpid ripples is clear down to the bottom. To the north are peaks upon peaks covered with greenery. They resemble clusters of clouds and billowing waves, as if a screen had been deliberately placed there. When passing by here in a small boat, one feels compelled to linger. It is just like the lines in Wei Yingwu's poem, "Green spring water mingles with the secluded remoteness; I so cherish it that I cannot leave."[97]

> Layers of greenery tower thousands of feet.
> Clear ripples display patterns in purple.
> Lake's mirror opens, reflections are arrayed
> And blend with the mist in the sunset glow.

97 The lines are from "An Excursion to Fragrant Mountain Spring at Dragon Gate" (You Longmen Xiangshanquan 遊龍門香山泉) by the Tang poet Wei Yingwu 韋應物 (739–ca. 789). But the *Complete Poems of the Tang Dynasty* (*Quan Tang shi* 全唐詩, 1707) version sponsored by Kangxi gives the character 更 (*geng,* increases) instead of 交 (*jiao,* mingles with), so that the first line would read "Green spring water increases the remoteness and seclusion." *Kangxi sanshiliu jing shi xuanzhu,* 107

如意洲之後. 小亭臨湖. 湖水清漣徹底.
北面層巒重掩. 雲簇濤湧. 特開屏障. 扁
舟過此. 輒為流連. 正如韋應物詩云. 碧
泉交幽絕. 賞愛未能去.

疊翠聳千仞. 澄波屬紫文. 鑑開倒影列.
反照共氤氳.

RIPA'S TITLE AND COMMENT

"Water Like the Color of the Bird *Tsui* [*cui* 翠]"[98] A house for recreation.

Acqua simile al color dell'ucello detto <u>Tsui</u>. = Casino di recreaz.^ne.

98 This refers to the attractive colors of the feathers of the kingfisher bird (*feicui* 翡翠), which varies from
blue green to emerald green.

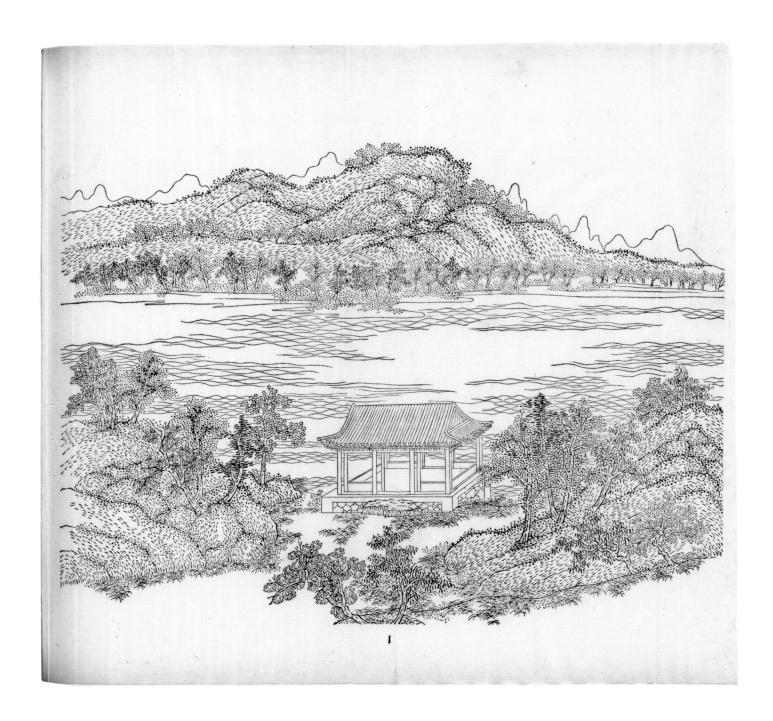

1

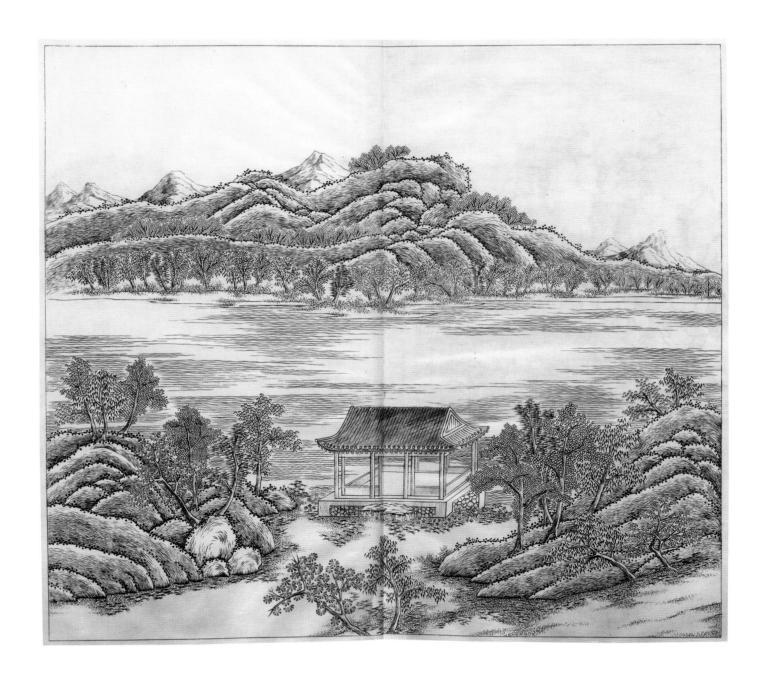

31. Observing the Fish from a Waterside Rock

Shiji guanyu 石磯觀魚

This three-bay open pavilion was built along the western bank of Inner Lake.

South of Sounds of a Spring Near and Far [View 25] one crosses the water on stepping stones to where there is a pavilion facing east. It abuts a mountain and faces the stream. The stream's water is clear down to the bottom. Long, thin fish swim head to tail and aquatic plants entwine their branches. Everything can be seen in detail. Beside the stream is a flat rock where one can sit down and fish.

> Evening songs of fishermen
> are heard by a waterside rock.
> Birds fly freely in the sky
> towing the clouds along.
> Long for a fish or make a net?—
> no need for me to ponder.[99]
> I have a long rod ready
> to cast and catch a fat one.

99 The statement "To stand by a deep chasm and long for a fish is not as good as returning home and making a net" 臨淵羨魚不如歸家而結網 first appears in the chapter "Discussion of Forests," in the Daoist compendium *Prince of Huainan* (*Huainanzi*: "Shuo lin" 淮南子: 說林, 139 BCE). Later, in "The Biography of Dong Zhongshu," in the *History of the Western Han Dynasty* (*Hanshu*: "Dong Zhongshu zhuan" 漢書: 董仲舒傳, 93 CE), the Confucian philosopher Dong Zhongshu 董仲舒 (179–104 BCE) was recorded as quoting this saying when criticizing the government for only desiring to maintain order instead of taking concrete action to reform its policies.

遠近泉聲而南. 渡石步. 有亭東向.
依山臨溪. 溪水清澈. 脩鱗銜尾.
荇藻交枝. 歷歷可數. 溪邊有平石.
可坐以垂釣.

唱晚漁歌傍石磯. 空中任鳥帶雲飛.
羨魚結網何須計. 備有長竿墜釣肥.

RIPA'S TITLE AND COMMENT

"Atop the Cliff Is a Fine View of the Fish." A house for recreation.

Sopra lo Scoglio è un bel vedere i pesci. = Casino di recreaz.^{ne}.

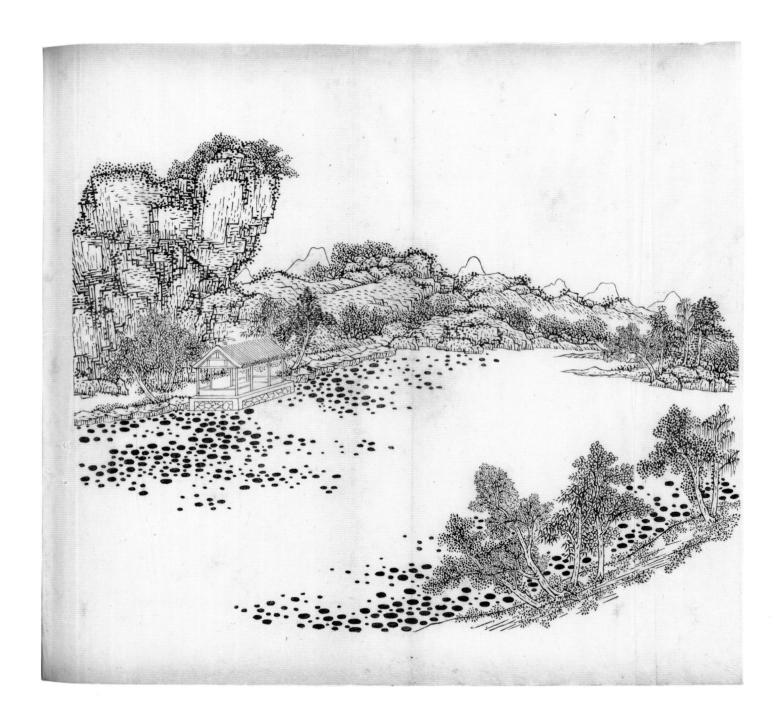

248

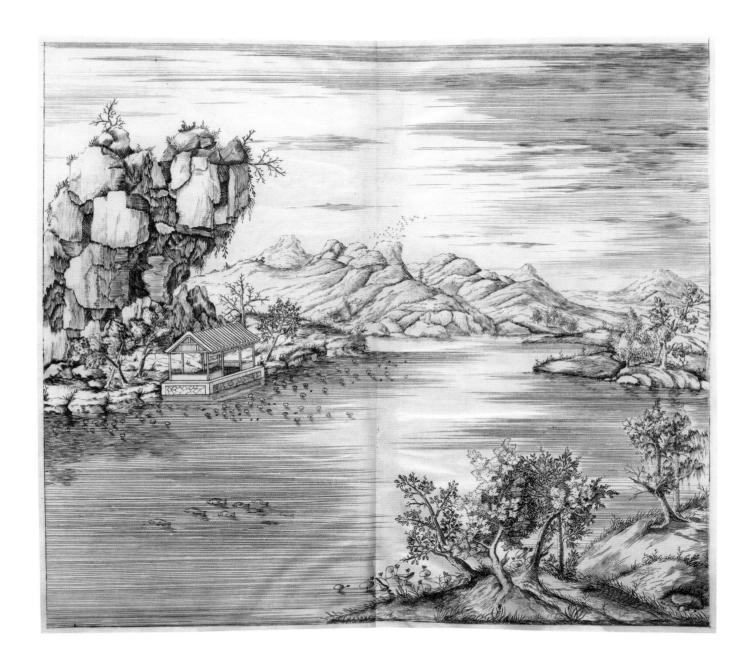

32. Clouds and Peaks in the Mirroring Water

Jingshui yuncen 鏡水雲岑

The lower group of buildings in the illustration form part of the larger complex that includes The Entire Sky Is Exuberant (View 18) and the Tower of the Supreme God. They are shown here looking from the north. The five-bay main hall stands directly in front of an artificial rockery.

The rear of the hall abuts a ridge and the other three sides face the lake. A gallery encloses it and follows the shape of the mountain downwards. In the bright ripples are shadows of the mountain haze as mists and clouds undergo transformations. There are no limits to this beautiful view, which makes one feel that there is never enough time to experience it.

Tiers of cliffs a thousand feet high
 are a towering mountain screen;
Layers of crystal clear water
 form depths in the blue-green lake.
Lion Path twists and turns,
 a pathway toward the north;
Pine branches bend and coil
 on the south side of the mountains.
My powers fade when deeply pondering
 for nature is hard to grasp.
I observe the heavenly bodies
 and scrutinize the earth below.
To grasp the highest principles,
 never seek techniques.
The classics, by themselves,
 contain all there is to know.

後楹依嶺. 三面臨湖. 廊廡周遮. 隨山高下.
波光嵐影. 變化烟雲. 佳景無邊. 令人應接
不暇.

層崖千尺危嶂. 涵渌幾重碧潭. 獅逕盤旋道
北. 松枝宛轉山南. 沉吟力盡難得. 懸象俯
察仰參. 至理莫求別技. 經書自有包函.

RIPA'S TITLE AND COMMENT

"Water Like a Mirror and Mountains Like Clouds." Another view of the temple with the idol that the emperor worshipped.

Acqua come speccio, e monte come nubbi. = Altra veduta del Tempio degl'Idolo, che l'Imp.ᵉ adorava.

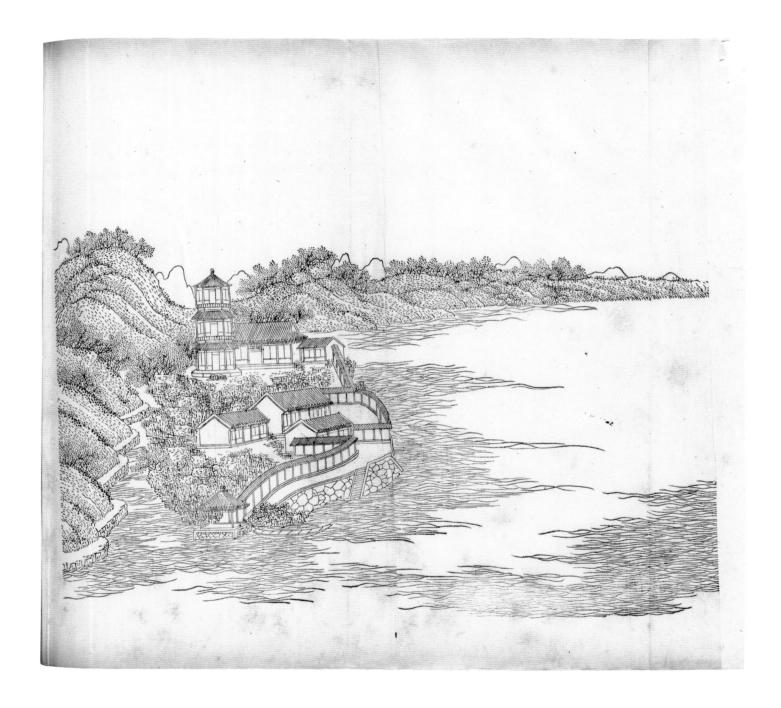

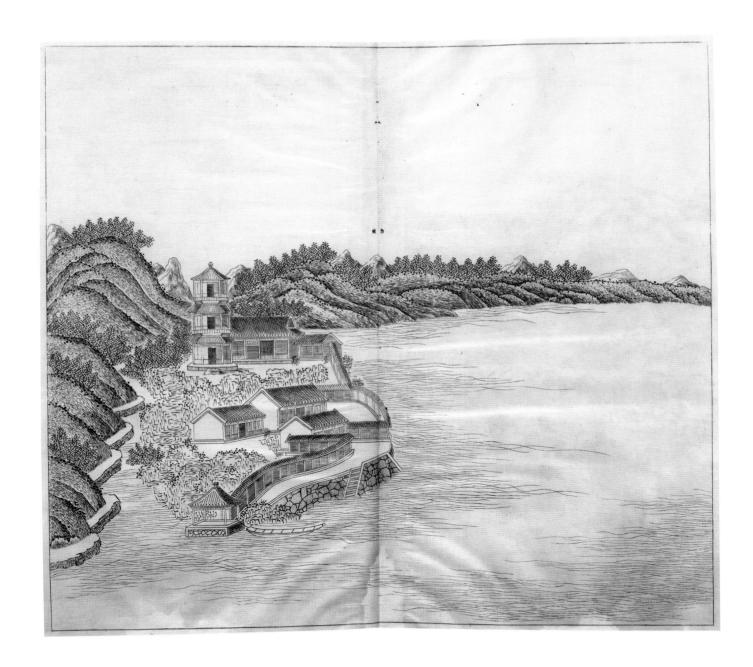

33. A Pair of Lakes Like Flanking Mirrors

Shuanghu jiajing 雙湖夾鏡

This View is composed of the two reflecting lakes on each side of Long Bridge, which was built atop rocks to serve as an embankment. It created the Inner Lake and controlled its flow into Wish-Fulfilling Lake to the east through a water gate underneath. The name of the View, which was inscribed by Kangxi on the arch at the northern end of the bridge, is based on a line from a poem by the Tang dynasty poet Li Bo 李白 (701–762).[100] The illustration looks north to include the arch and the planked bridge mentioned in Kangxi's description, placing Inner Lake on the left. It would appear to the right of Long Bridge if the viewer were looking in the opposite direction southward as in View 34. The five-bay pavilion to the right of the bridge is Knowing the Joy of Fish Jetty (Zhiyuji 知魚磯).[101] Beside it is a boathouse, partially shown here.

The springs in the mountains all flow forth from beneath a planked bridge, converging to form a lake on the right side of a stone bridge. Then, the water flows down under the stone bridge and is released to create a big lake. These two lakes are connected but divided by the long dike, just like the Inner and Outer Lakes at West Lake.[102]

> From separate streams among connected mountains
> a hundred springs gather
> To form flanking mirrors smoothly flowing
> through a dike drenched with blossoms.
> Had nature not made
> these rocky banks,
> How could man alone
> have crafted this scene?

100 For the origin of the name of this and View 34, see Li Bo, "On Ascending Xie Tiao's North Tower in Xuancheng in Autumn" (Qiu deng Xuancheng Xie Tiao Beilou 秋登宣城謝朓北樓): "The two rivers are flanking, clear mirrors; a pair of bridges are descending, colorful rainbows" 兩水夾明鏡; 雙橋落彩虹.

101 The name again alludes to the anecdote about Master Zhuang standing by the Hao River. See note 54. Qianlong rebuilt this complex in 1741 and included it as no. 33 of his additional thirty-six Views.

102 This description refers to a small planked bridge connecting Sounds of a Spring Near and Far (View 25) and Observing the Fish from a Waterside Rock (View 31). Looking southwest from the arch at the northern end of the stone bridge, the Inner Lake is on the right and Wish-Fulfilling Lake is on the left. At West Lake in Hangzhou, the Inner Lake is separated from the Outer Lake by a dike built by Bo Juyi when he served as magistrate.

山中諸泉. 從板橋流出. 滙為一湖. 在石橋之右. 復從
石橋下注. 放為大湖. 兩湖相連. 阻以長堤. 猶西湖之
裏外湖也.

連山隔水百泉齊. 夾鏡平流花雨隄. 非是天然石岸起.
何能人力作雕題.

RIPA'S TITLE AND COMMENT

"Two Lakes Like Two Mirrors." A house in which they store the service boats of the emperor
and his concubines.

Due laghi simili a due Specchi. = Casa della quale custodiscono le barche di servizio
dell'Imp.ᵉ, e sue Concubine.

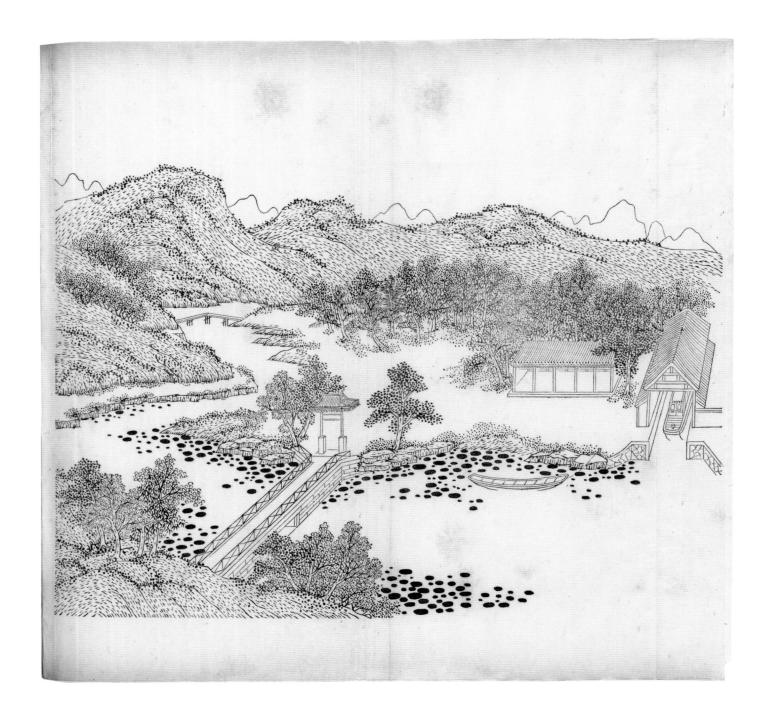

256

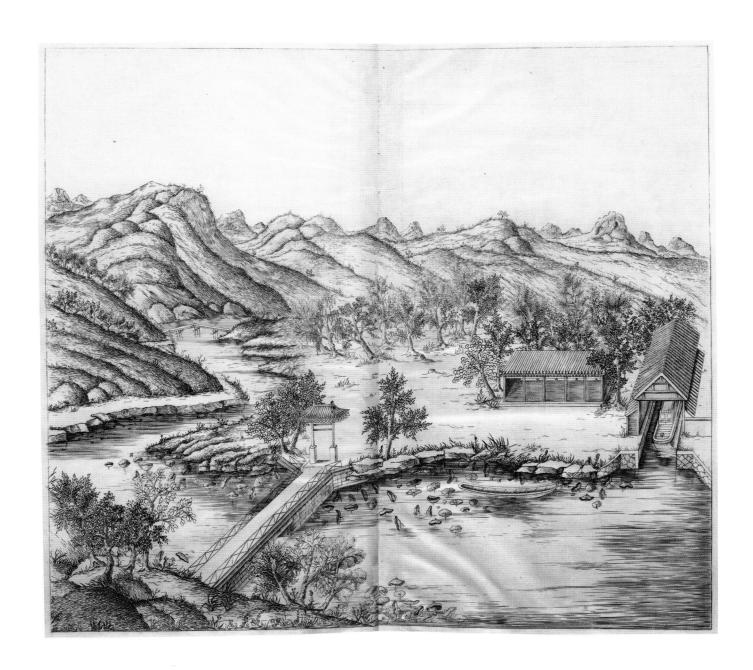

34. A Long Rainbow Sipping White Silk

Changhong yinlian 長虹飲練

This bridge forms part of the scene that includes View 33. The name, which refers to the bridge and the shimmering surface of the two flanking lakes, combines images from poems by Li Bo and the Southern Qi dynasty poet Xie Tiao 謝朓 (464–499).[103] It was inscribed on the arch at the southern end of Long Bridge, shown here in the illustration. The pavilion on the left is A Fragrant Islet by Flowing Waters (View 27).

The brilliant lakes are a clear blue. A bridge is lying down on the ripples. South of the bridge, myriad Aohan lotuses have been planted with white lotuses from the interior interspersed among them.[104] They form an intricate embroidery or a colorful mist, and their pure aromas are striking. Su Shunqin said in his poem about Rainbow Bridge that the scene was like a jade palace or the silvery world, but these are merely empty words.[105]

A long rainbow, a secluded path,
 an array of layered cliffs.
By shoreline willows and sounds of streams,
 moonlight shines on steps.
In this lovely scene, among a thousand trees,
 the rising sun appears.
Everywhere, birds are singing
 with eight tones in harmony.[106]

103 See Xie Tiao, "Ascending Triple Mountains in the Evening and Gazing Back Toward the Capital" (Wan deng Sanshan huanwang Jingyi 晚登三山還望京邑): "The remaining clouds thin out and form a gauze; the clear river is as placid as white silk" 餘霞散成綺; 澄江靜如練. Long Bridge also appears in View 27.

104 For the Aohan lotus (*aohan hehua* 敖漢荷花), see note 78. This variety represented the northern part of the Qing empire beyond the Great Wall, while the white lotus from the interior represented China to the south.

105 The Northern Song poet Su Shunqin 蘇舜欽 (1008–1048) wrote in praise of Rainbow Bridge (Chuihongqiao 垂虹橋) in modern Wujiang, Jiangsu, invoking the Buddhist trope of a silvery world and Daoist images of jade palaces where Transcendents reside. See his "Written on Viewing the Moon at Mid-Autumn at New Bridge in Songjiang to Harmonize with a Poem by Magistrate Liu" (Zhongqiu Songjiang Xinqiao duiyue he Liu Ling zhi zuo 中秋松江新橋對月和柳令之作).

106 The eight tones (bayin 八音) represent the variety of timbres produced by musical instruments based on the material of their construction. These are gourds, earth, skin, wood, stone, metal, silk, and bamboo.

湖光澄碧. 一橋臥波. 橋南種敖漢荷花萬枝.
間以內地白蓮. 錦錯霞變. 清芬襲人. 蘇舜欽
垂虹橋詩. 謂如玉宮銀界. 徒虛語耳.

長虹清徑羅層崖. 岸柳溪聲月照階. 淑景千
林晴日出. 禽鳴處處八音諧.

RIPA'S TITLE AND COMMENT

"A Rainbow that Sucks in the Water." A house for recreation.

Arco baleno che succhia l'acqua. = Casino di recreazione.

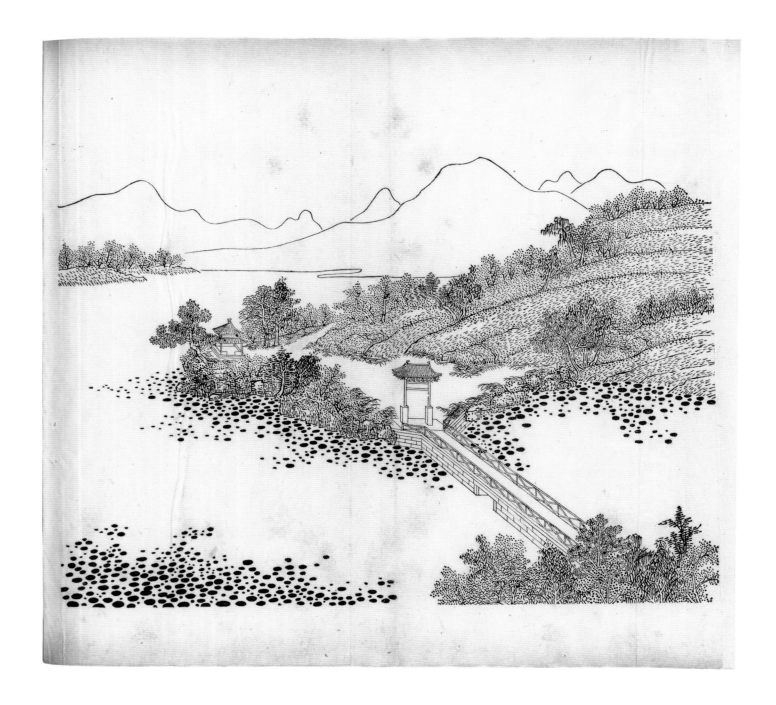

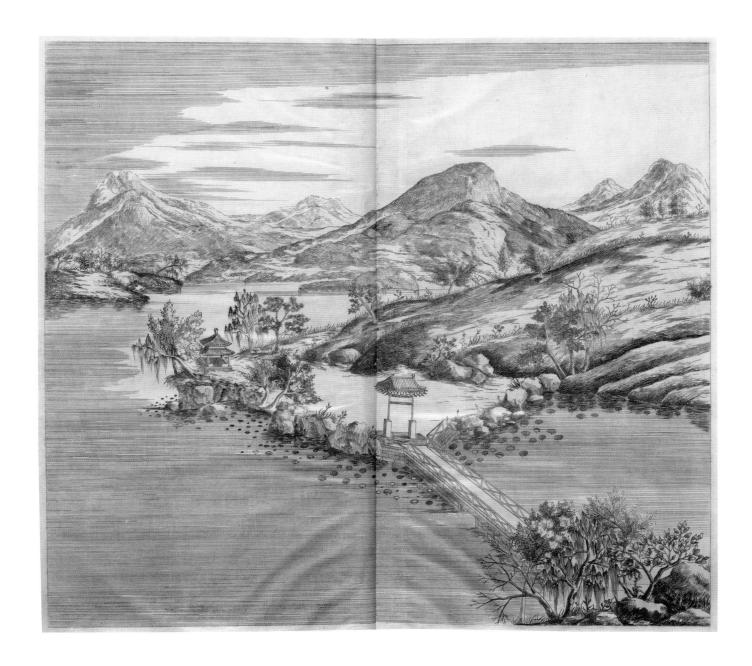

35. An Immense Field with Shady Groves

Futian congyue 甫田叢樾

This square pavilion stood along the northern bank of Clearwater Lake in the plains area next to a vegetable garden and a patch for growing melons. It provided a place where Kangxi could relax after observing the gardeners at work. The words "immense field" (futian 甫田) are from a poem in The Book of Songs.[107] The area was adjacent to flat grounds with old trees evoking the Mongolian grasslands. Outdoor entertainments and diplomatic receptions were held here on special occasions.[108]

North of the Pavilion for Floating Winecups[109] and west of the Melon Patch are grounds as flat as the palm of a hand, where plants abound and trees flourish. It is filled with deer, pheasants, and rabbits, all dwelling together. When the brisk autumn weather tightens bowstrings and strengthens arrows, a multitude of followers is assembled, and we encircle the animals on foot. It is indeed a choice hunting park.

> I stop and rest
> to enjoy the fields,
> Gazing into the distance
> and cherishing the people.
> The Shady Groves
> is a place worth admiring:
> The whole land shows signs
> of an abundant harvest.

107 See the poem "Immense Fields" in *The Book of Songs* (*Shijing*: "Futian" 詩經: 甫田): "Do not farm an immense field, for dogtail weeds will arrogantly sprout" 無田甫田, 維莠驕驕. The poem was traditionally interpreted as a caution to an ancient ruler not to sacrifice virtue to ambition. Kangxi often asserted that the Mountain Estate was a modest residence that did not displace any people. The areas for growing vegetables and melons were comparatively small in size, and the plains area with its shady groves, though the result of considerable landscaping, was more or less kept in a natural state during his time.

108 Later known as the Garden of Myriad Trees (Wanshuyuan 萬樹園), it was no. 20 of Qianlong's additional thirty-six Views.

109 The Pavilion for Floating Winecups (Liubeiting 流杯亭) alludes to Wang Xizhi's celebration at the Orchid Pavilion. It was part of View 15, which was originally located near a gate of the same name in the palace wall on the east. See notes 41 and 43.

流杯亭之北. 瓜圃之西. 平原
如掌. 豐草茂木. 麞麀稚兔. 交
物其間. 秋涼弓勁. 合烝徒. 行
步圍. 誠獵場選地.

留憇田間樂. 曠觀恤閭閻. 叢
林欣賞處. 遍地豫豐占.

RIPA'S TITLE AND COMMENT

"A Field with Many Beautiful Trees." A house for recreation with a flower garden.

Prato con bellissini e moltismi albori. = Casino di recreazione con un giardino di Fiori.

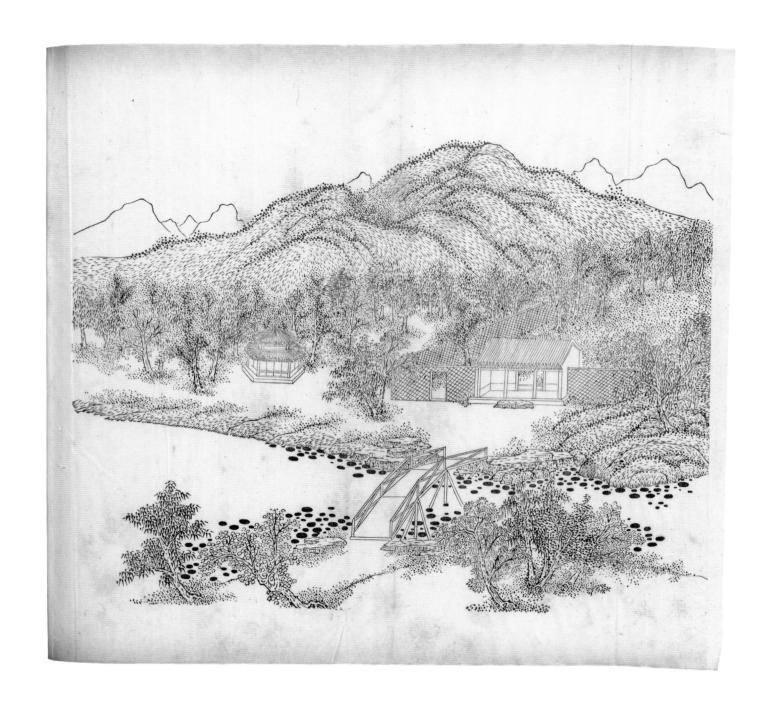

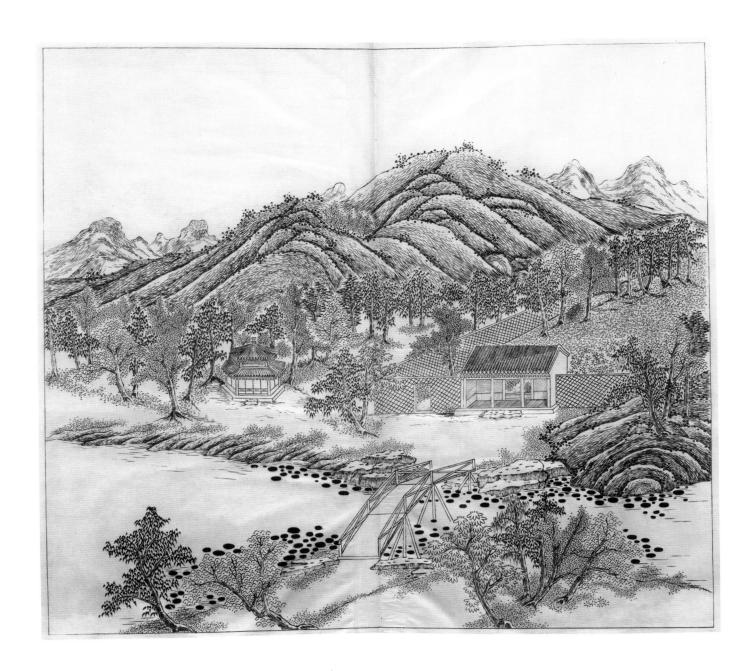

36. Clouds Remain as Water Flows On

Shuiliu yunzai 水流雲在

This ingenious pavilion is a square structure with three protruding alcoves and a double-tiered roof. It is located on the northern shore of Clearwater Lake near Long Bridge (Views 27, 33, and 34), at the bend where the water from the Rehe River from outside is joined by the waters from the ravines in the mountain section before flowing into the lake. The last of the Thirty-Six Views, it offers a thematic conclusion to the sequence as Kangxi poignantly reflects on his own mortality. The names of the court painter Shen Yu and the engravers Zhu Gui and Mei Yufeng appear in the lower left of the woodblock illustration.

The clouds emerge mindlessly from the mountain tops.[110] The water never ceases its endless flow.[111] Such is the inexhaustible treasury of natural creation.[112] Du Fu's poem says, "The water flows on, but my mind won't race against it; the clouds in it remain, and my intentions have slowed with them."[113] I feel the meaning of these words deeply.

> After the rain,
> the clouds and peaks are cleansed.
> The water flowing from afar,
> becomes still on its own.
> Flowers along the shore
> hasten my hair to thin.
> Little by little,
> the years are mounting up.

110 A line from Tao Qian's poem "Returning Home" (Guiqulai xi ci 歸去來兮辭, 405): "Clouds emerge mindlessly from the mountain tops; birds, when tired of flying, know to return home" 雲無心以出岫; 鳥倦飛而知還.

111 A paraphrase of a remark by Confucius in the chapter "Zihan" in *The Analects* (*Lunyu*: "Zihan" 論語: 子罕) when he stood beside a river: "It just flows away like this. It never ceases day or night" 逝者如斯夫. 不舍晝夜.

112 A line from Su Shi's "Rhapsody on the Red Cliff, I" (Qian Chibi fu 前赤壁賦, 1082): "This is the inexhaustible treasury of the creator of things" 是造物者之無盡藏也.

113 The lines are from the poem "Riverside Pavilion" (Jiangting 江亭) by the Tang dynasty poet and official Du Fu 杜甫 (712–770).

雲無心以出岫. 水不舍而長流. 造物
者之無盡藏也. 杜甫詩云. 水流心不
競. 雲在意俱遲. 斯言甚有體驗.

雨後雲峰澄. 水流遠自凝. 岸花催短
鬢. 高年寸寸增.

RIPA'S TITLE AND COMMENT

"Water that Runs and a Cloud that Stays Still." A house for recreation with another view of
the boathouse.

Acqua che corre, e nubbe che stà. = Casino di recreazione con un altra veduta della Casa delle
barche.

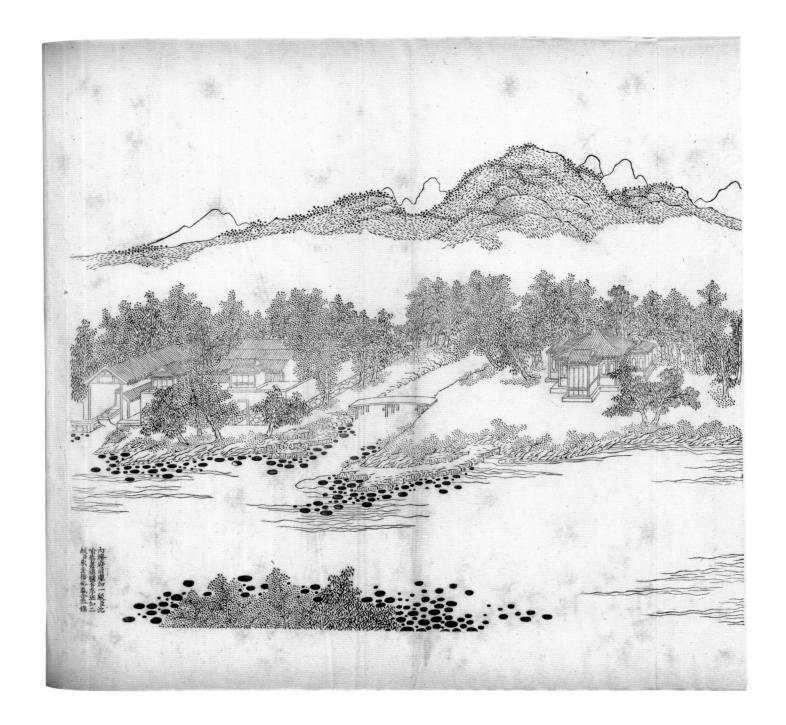

内務府司庫加一級臣沈
喻林書謹臧古庄班加二
級臣朱主梅恭繪臣金

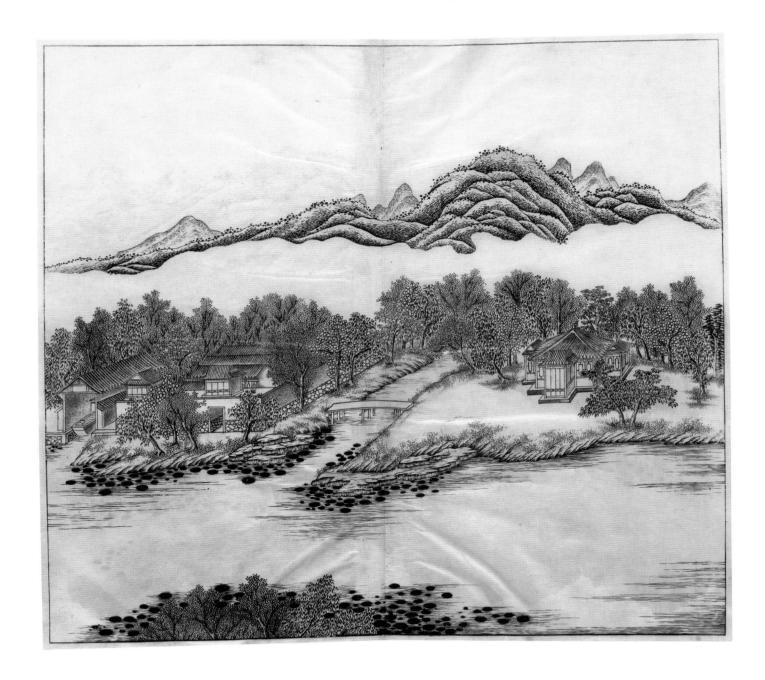

APPENDIX 1

Kuixu et al., "Postscript to *Imperial Poems on the Mountain Estate for Escaping the Heat*"

Yuzhi Bishu shanzhuang shi ba 御製避暑山莊詩跋

Translated by Stephen H. Whiteman

In the sixth month of the fifty-first year of the Kangxi era [July 1712], Your Majesty's servant Kuixu and others respectfully annotated the imperial poems on the Thirty-Six Views of the Mountain Estate for Escaping the Heat. We marvel at the profundity of Your Majesty's sage learning. Your Majesty holds the Classics close and, savoring the very essence of the Way, cherishes most the pure and refined. In composing poetry and songs, Your Majesty follows the "Airs" and "Odes," embracing the Hundred Schools of philosophy.[1] Your servants' learning is meager by comparison, our vision narrow and our understanding shallow, and we are therefore unable to adequately express our admiration for the exalted beauty of this work. Now, by the favor bestowed upon us through Your Majesty's edict, we append our names to the end of this work. At this, we are both joyous and ashamed, unable to contain our feelings.

The teachings and influence of our Imperial Sovereign reach far and wide. To the edges of the Heavenly vault, all lies within your domain, and even the most distant territories obey Your authority as though they were the suburbs of the capital. Serried peaks entwined with pure rivers extend northeast from Your Celestial Capital until they reach Rehe, where their forms harmonize to create a verdant, resplendent environment. In ancient times, it was said that the mountains and rivers of the Northwest are often magnificent and extraordinary, while those of the Southeast are secluded and intricate. This place truly possesses the beauty of both, as all of Nature's ingenious beauty is especially gathered here. Former dynasties

1 For the "Airs" and "Odes," see 147n20. The Hundred Schools (Baijia 百家) refers to many important schools of philosophy, including Confucianism, Daoism, and Mohism, that arose during the Spring and Autumn (771–ca. 476 BCE) and Warring States periods (ca. 475–221 BCE).

were unable to extend their prestige and virtue such a distance, so people rarely arrived here. Your Majesty regularly traversed this territory while on an imperial tour and immediately recognized it as extraordinary. Taking into consideration that no one had dwelt here for a very long time, Your Majesty had it cleared to create a detached palace without causing the people harm by damaging any fields and cottages. Furthermore, it is close to Your Celestial Capital, such that memorials from ministers sent forth in the morning arrive by nightfall, so that administering affairs of state is no different than in the palace.

Accordingly, the valley's mountains and plains have been surveyed and its overgrowth cleared. The designs of the buildings all follow the marvelous, natural contours of the cliffs and ravines. In opening up the forests and brooks nothing was removed or cut down. By avoiding clearing or excavating the land, the cost of construction was kept to a minimum as the landscape became a luxuriant tapestry. Among the innumerable beautiful vistas within the garden, those cited as particularly exceptional number thirty-six. Cool and refreshing, high in the mountains and without humidity, it is a place entirely suitable for passing the summer. Each year during midsummer, Your Majesty respectfully attends to Her Majesty the Empress Dowager during Her sojourn here. The springs are sweet and the soil fertile, such that after living here even for a short while, Your Sagacious Majesty is in excellent form and Your spirit revitalized. Your Majesty exhausts Himself with concern for all the people, and Your virtue is in harmony with Heaven. Because of this, Heaven created this divine precincts that has awaited Your Majesty's traveling here for relaxation.

Your Majesty's servants, unworthy of the honor of being counted among the ranks of Your attendants, have regularly enjoyed the privilege of being entertained here at imperial invitation. We have seen all these Views with our own eyes, and yet are unable to capture them in words. Upon reverently reading the *Imperial Poems*, every green grove and misty spring suddenly fills our hearts. This place's Views result from the natural life-force of Heaven and Earth and of the landscape; only Your Majesty's brush could transmit the essence of these Views into words. Your servants are greatly blessed to have been able to reverently read the "Imperial Record of the Mountain Estate for Escaping the Heat" and Your Majesty's collected poems. When You served Your Mother, it exemplified for us the sincerity of standing at a parent's gate and inquiring about her meals. When you rested on terraces and in pavilions, it revealed Your intention to dwell in simple, rustic abodes. When You observed watering and planting, You were concerned about the difficulties of farming. When You gazed over flowers and plants, You were examining the forces of *yang* and *yin*. When You enjoyed birds and fish, you thought about how all things are in accord. Through Your Majesty's verses, all readers are able to explore the magnificence of these Views. Even for those who have never visited here, it is as though they have seen it with their own eyes!

Thus, Your Majesty's veneration of Heaven, Your exhaustion for the sake of the people, and the auspicious omens reflecting the convergence of Heaven and Earth reveal that Your Majesty's empire, uniting All Under Heaven, will surely continue for ten thousand generations, eternal and without end.

Imperial Censor of the Left and Scholar of the Hanlin Academy Kuixu, Imperial Tutor Li Tingyi, Imperial Tutor Jiang Tingxi, Herald to the Crown Prince Zhang Tingyu, Secretary to the Crown Prince Chen Bangyan, Official Compiler Zhao Xiongzhao, and Hanlin Academician Wang Tubing, solemnly bowing and prostrating ourselves, respectfully submit this postscript.[2]

康熙五十一年六月. 臣揆敘等恭注御製避暑山莊三十六景詩. 仰見皇上. 聖學崇深. 含經味道. 純粹以精. 發為詩歌. 上繼雅頌. 囊括百家. 臣等學識弇陋. 管窺蠡測. 未能宣揚盛美. 茲蒙恩諭俾得附名簡末. 且喜且愧. 不容於心. 欽惟我皇上聲教覃敷. 極天所覆盡入版籍. 要荒之外率同畿甸. 自京師東北行. 羣峰迴合. 清流縈繞. 至熱河而形勢融結. 蔚然深秀. 古稱西北山川多雄奇. 東南多幽曲. 茲地實兼美焉. 蓋造化靈淑特鍾於此. 前代威德. 不能遠孚. 人跡罕至. 皇上時巡過此. 見而異之. 念此地舊無居人. 闢為離宮. 無侵民田廬之害. 又去京師至近. 章奏朝發夕至. 綜理萬幾與宮中無異. 乃相其岡原. 發其榛莽. 凡所營構. 皆因巖壑天然之妙. 開林滌澗. 不采不斷. 工費省約. 而綺縮繡錯. 煙景萬狀. 標其尤者凡三十有六. 清涼爽塏. 於夏為宜. 每至盛暑. 則奉皇太后駐蹕焉. 泉甘土沃. 居此逾時. 聖容豐裕. 精神益健. 蓋皇上憂勞萬民. 德合於天. 故天特開靈境以待皇上之遊息也. 臣等忝列侍從. 時賜讌遊. 諸景皆嘗目擊. 而莫能摹寫. 及伏讀御製詩. 則林泉蒼蔼 一一湧現於胷中. 蓋此地之景乃天地山川自然之氣所發著. 非皇上化工之筆. 莫能傳也. 而臣等尤有厚幸者. 伏讀御製避暑山莊記及諸詩. 奉慈闈則徵寢門問膳之誠. 憑臺榭則見茅茨不剪之意. 觀溉種則念稼穡之艱難. 覽花蒔則驗陰陽之氣候. 玩禽魚則思萬物之咸若. 凡讀者因詩以求諸景之勝. 豈獨未見者如親歷哉. 即皇上敬天勤民與覆載同流之氣象. 可以昭示天下萬世永永無極矣. 左都御史兼掌院學士臣揆敘. 侍講學士臣勵廷儀. 侍講臣蔣廷錫. 洗馬臣張廷玉. 中允臣陳邦彥. 脩撰臣趙熊詔. 庶吉士臣王圖炳. 謹拜手稽首恭跋.

2 Translated from Kangxi, *Yuzhi Bishu shanzhuang shi:* "Ba" 御製避暑山莊詩: 跋, 1a–4a. Although the authorship of the postscript is not recorded in the *Imperial Poems*, the *Imperially Sponsored Gazetteer of Rehe* identifies Zhang Tingyu as author. See *Qinding Rehe zhi* 108:11a. Following these names, the names of the four officials chiefly responsible for the production of the *Imperial Poems* are listed: General Work Supervisor in the Hall of Military Glory in Charge of the Translation Office, Grand Secretariat Academician Reader-in-Waiting, and Current Company Commander, Second Class Hesu 和蘇; General Work Supervisor in the Hall of Military Glory, Vice Director of the Office of Palace Accounts in the Imperial Household Department, and Concurrent Company Commander, Third Class Zhang Changzhu 張常住; General Work Supervisor in the Hall of Military Glory, Vice Director of the Office of Palace Accounts in the Imperial Household Department, and Concurrently Supplementary Company Commander, First Class Li Guoping 李國屏; and General Work Supervisor in the Hall of Military Glory and Courageous Guard Lieutenant, First Class Bashi 巴實.

APPENDIX 2

Matteo Ripa,
"Description of the Villa"

Translated by Bianca Maria Rinaldi

The Imperial Villa of Gehol [Jehol, Rehe] is situated in Tartary, and it is located about 150 Italian miles from Peking by winding routes on a plain completely surrounded by mountains from the base of which runs a river that one can usually cross on foot. But, during rainy weather or when the ice and snow melt, it overflows so much that it is frightening to look at. From this hill gently emerges a high and spacious hill at the base of which were constructed houses for the emperor's entourage as well as for the others coming from various provinces of China to sell their merchandise. This hill ends in a plateau where a wall begins that surrounds the Villa. From this plateau one descends to another, situated in a valley of the hill from which emerges a mountain crowned with various lovely hills with an abundance of water that gushes forth in the same place. Aided by art, this water circulates around the hills like rivers and then forms a beautiful, large lake very rich with good fish. In addition to this place that is so well situated that one can see from everywhere the vast sea of the mountains of Tartary, in this location of Gehol as well, one can see not only the plateau and its hills but the same mountain completely covered with trees, many of which are fruit trees, such as hazelnuts, cornelian cherries, pears, and apples. And, even though these trees are wild, these fruits are so very good to eat that they are brought to the table of the emperor. Now this plateau with the mountain and hills is the one that the Emperor Canghi [Kangxi] enclosed for himself, and it takes more than one hour on horseback to go around it. And, here he built in various distinct locations at a distance from one another various dwellings or compounds of houses that are more or less large according to the use decided by this emperor; that is: one for his residence; behind this, one for the seraglio of his concubines; one for his mother; some others for some of His Majesty's queens who are more distinguished; and others for the eunuchs. Here he also built a temple where many idolatrous priests dressed in yellow robes

officiate—they, however, are all eunuchs—and to which place the emperor goes with his ladies to offer sacrifices and worship the idols when he resides in Gehol. Also, one can see a number of small houses and lodges for amusement. These lodges, built in various locations, are all covered and are built in different shapes in good taste and with great skill; and, they are able to be closed off on each side by silk door-curtains so that it is not possible to see who is inside. They have various seats placed around in the middle of which, in some of these houses, is a table, and, in others, there is a bed all prepared. These houses and lodges are used by the emperor to amuse himself with his queens and concubines, since, when he spends time at the Villa, he has nothing to do with others besides his ladies and the eunuchs. With these ladies, he, in an open sedan chair borne on the shoulders of the eunuchs and they on foot, often enjoys himself here and there around the Villa. With them in many small boats, he goes fishing on the canals and lakes. With some of them who are more dear to him, he eats, but not at the same table, because he always eats by himself, seated on mats that are two palms in height. But, they are seated in his sight before him on the floor on cushions in the Tartar style, each having her own small table, and this is also the way it is when studying, etc.

Descrizione della Villa[1]

La Villa Imp.le di Gehol stà situata in Tartaria, e dista di Pekino p. vie ritorte un 150. miglia in circa d'Italia in una pianura tutta recinta da monti, dalla Falda, de quali corre un fiume, che p. ordinario si passa a piedi; ma nel tempo di piogia, o che si liquefanno i giacci, e le nevi, gonfia tanto, che in vederlo dà orrore. Da essa collina và dolcem.te ergendosi un'altra, e spaziosa collina, alla falda, della quale sono edifite le Case p. uso di que; che seguono l'Imp.e, e degli altri; che vi concorrono da varie Prov.e di Cina p. sparciare le loro mercanzie. Essa collina termina in un piano, nel quale comincia il muro, che recinge la Villa. Da questo piano si discende in un altro situato nella valle del colle, dal quale erge un monte coronato da varie deliziose colline con abbondanza d'acqua, che scaturisce nel med.o luogo, quale poi ajutata dall'arte, và circondato que' colli a guisa di Fiumi che poi ne forma un ben grande lago ricco assai di buoni pesci. Oltre il sito sì ben disposto, quello in che si vede da p. tutto il vasto mare di que' monti Tartari, eppure in questo sito di Gehol, si vede non sol il piano, e sue colline ma lo stesso monte tutto fatto di alberi, e molti di essi fruttiferi, cioè di nocchjole, corognali, pera, e mela, e questi benché silvestri, sono però tanto buoni a mangiare, che si portano alla tavola dello stisso Imp.e. Or questo piano col monte, e colline e qullo, che si rinserò quell'Imp.e *Canghi*, ch'è di circuito un'ora avanzata di camino a cavallo; e quivi eresse in varii loghi distinti, un dall'altro distante varie abbitaz.ni, o siano comprensorj di Case più o meno vasti, a proporzione dell'uso, al quale da esso Imp.e destinati furono, cioe uno p. sua abbitaz.ne, dietro a questo un'altro p. il serraglio delle sue concubine, uno p. sua Madre, alcuni altri p. alcune Regine della Sua M.tà più distinte, ed altri p. gl'Eunuchi. Vi eresse di più un Tempio, che è

1 This rare description of the Mountain Estate was handwritten by Matteo Ripa as a preface to a list of his titles and comments on the engravings of the Thirty-Six Views. It is preserved together with the version now in the Bibliotheca Nazionale di Napoli (I.G.75). The transcription is by Richard Strassberg and follows Ripa's abbreviations, spellings, and punctuation.

officiato da molti sacerdoti Idolatri vestiti di veste di giallo, sono però tutti Eunuchi, nel quale
và l'Imp.ᵉ colle sue donne a sacrificare, adorare gl'Idoli, mentre dimora in Gehol. Di più vi
si vedono varj Casini, e loggie di diporto. Queste loggie edificate in varj loghi sono tutte
coverte, tutte di diversa Figura edificate con buon gusto, e con gran polizia, e da potersi in
ogni lato con portieri di seta serrate in modo che non si possa vedere, chi stà dentro: hanno
intorno varii sedili, e nel loro mezzo, in alcuni vi è una mensa, ed in altri un letto tutto for-
nito, servano i detti Casini e loggie per andarvi l'Imp.ᵉ a doporto insieme colle sue Regine, e
concubine, giachi in tutto il tempo, che stà dentro la Villa, con altri non tratta, che colle sole
sue donne, ed Eunuchi, con esse donne egli andanno in sedia scoverto da Eunuchi portata sù
le spalle, ed esse a piedi, và a spasso divertendosi or quà, or là per la Villa. Con esse in più bar-
chette và per qui canali, e laghi facendo la pesca. Con alcune di esse a se piu care egli magia,
non gia però nella stessa mensa, mangiando sempre egli solo, seduto sopra un stato alto circa
due palini, ma avanti se a sua vista sedute nel pavimento sù d'un coscino alla Tartara, avendo
ognuna avanti di sé il proprio tavolino, e cosi quando si studia etc.

APPENDIX 3

Zhang Yushu 張玉書, "Record of Touring the Rehe Rear Garden at Imperial Invitation"

Hucong ciyou ji 扈從賜遊記

Translated by Stephen H. Whiteman

On the second day of the sixth month [July 19, 1708], the imperial entourage arrived by carriage at the Rehe Traveling Palace. On the eleventh day [July 28], I received an imperial edict commanding me to tour the rear park with senior Manchu officials and others. Entering at the main gate, we proceeded northeast, reaching a cliff. There was a three-bay hall, the name-tablet above the door read, "Pine Winds through Myriad Vales."[1] A couplet hung on columns by the entry reads: "The clouds roll up the color of a thousand peaks; The spring harmonizes with the sound of a myriad pipes."[2]

We climbed several tens of stone steps one set after another, then wound back around and descended. To the right, there was an eight-cornered pavilion from which one might fish.[3] Crossing a bridge, we walked along a long dike;[4] at this point, His Majesty stood in a pavilion,[5] and, turning to address me and the other officials, said, "The form and appearance of this dike is similar to that of a *lingzhi* fungus." Now, the long dike wound along in an

1 See View 6.

2 A reference to the chapter "Discussion on Equalizing Things" in the *Master Zhuang*, in which Zhuangzi describes the myriad sounds of the pipes of Heaven as an expression of the Way in nature.

3 Perhaps "Clear Jade Pavilion" (Qingbi ting 晴碧亭), shown as a four-sided pavilion at the base of the artificial cliff in the illustration of "Pine Winds through Myriad Vales," which also features the stone steps that Zhang describes descending.

4 See View 2, "A *Lingzhi* Path on an Embankment to the Clouds" (Zhijing yundi 芝逕雲隄).

5 It is not clear to which pavilion Zhang is referring, as there is no extant pavilion in "A *Lingzhi* Path on an Embankment to the Clouds," nor does one appear in any of the illustrations from the *Imperial Poems* that feature the embankment.

unbroken line. Halfway, one branch extended out to divide the lake into three small bays, each forming a glorious realm. It is, in truth, comparable to a *lingzhi*.

To its east is "A Colorful Painting of Cloudy Mountains";[6] to its west is the imperial princes' study.[7] We proceeded straight ahead for a *li* and more and came to the place where the emperor resides.[8] The name-tablet over the main gate read, "Clear Ripples with Layers of Greenery."[9] Beyond the gate, in the midst of the residence, stands the imperial bed. Gazing appreciatively over the broad and distant scene, a thousand cliffs and a myriad of valleys appeared within our sight.

Upon entering the gate, a short way to the west is "Inviting the Breeze Lodge";[10] a couplet flanking the door reads, "Clouds stir the trees along the stream so that they invade the curtains of the study; Breezes bring grotto springs to moisten pools of ink." Behind the lodge, there is a Buddhist hall, its name-board reading "Fragrant Waters and Beautiful Cliffs."[11] The door-couplet reads, "There are mountains and rivers stretching to the Northern Pole Star;[12] And a natural landscape to surpass that of West Lake." To the side there is a two-story hall whose name-board reads, "Moon Boat with Cloud Sails."[13] The door-couplet reads, "I suspect I have boarded a painted vessel and risen to Heaven; I want to raise a light sail to enter into the mirror." We wound around and arrived at the imperial throne. In front of the main hall[14] a variety of flowers were planted in rows containing a great number of exotic varieties. There were five hydrangea bushes, each grafted with blossoms of five colors, something I had never seen before.

6 Referring here generally to the complex on one of the three islands in View 2, "Sounds of the River in the Moonlight" (Yuese jiangsheng). "A Colorful Painting of Cloudy Mountains" today designates the northernmost gate of the complex.

7 The study was located on Surrounded by Greenery Island (Huanbidao), another one of the three islets in View 2.

8 A *li* is roughly equivalent to one-third of a mile.

9 In this, Zhang appears to be referring to the gate depicted in View 3, "Un-Summerly Clear and Cool" (Wushu qingliang 無暑清涼). In the *Imperial Poems*, "Clear Ripples with Layers of Greenery" is the name of View 30, which includes a small pavilion on the north shore of what is now Wish-Fulfilling Island.

10 See View 4.

11 See View 5.

12 In Chinese imperial ideology, the Northern Pole Star is both the heavenly correlative of the earthly emperor (and the imperial palace) and a locative metaphor for the Way. By describing the Mountain Estate as linked to the Northern Pole Star by its landscape of mountains and rivers, Zhang is supporting the emperor's view that Rehe is a ritually legitimate site from which to rule the empire, equivalent to the capital.

13 See View 26.

14 "Inviting the Breeze Lodge" (Yanxun shanguan 延薰山館); see View 4.

Opposite, there is a stage called "A Sheet of Cloud," and, at this time, music was performed. Various Manchu officials sat in the eastern gallery, and I accompanied the various officials of the Hanlin Academy, who were seated in the western gallery. Inside a small kiosk was placed a couch made of wood. We proceeded immediately to the banquet, during which His Majesty bestowed numerous dishes upon us, as well as bestowing a special gift of an imperial dish, potage of pheasant. When the midday banquet concluded, the group rose, expressed thanks for the emperor's favor, and went out. We thereupon boarded small boats and floated upon the lake. The broadest and most open part of the lake is similar to West Lake, yet its quiet seclusion and clear, clean beauty cannot be matched by West Lake.

On the bank were several towering trees, and an imperial attendant said that these were all saved by personal command of His Majesty. An embankment has been built along the trees, their dark and emerald greens shimmering back and forth, and their ancient trunks growing into even more gnarled shapes. Gazing into the distance from inside the boat, I cannot fully describe the glorious scenery. There are distant banks and winding currents that make the water feel supremely expansive; there are encircling cliffs and embracing rivers that create an ultimate sense of brilliant beauty. Ten thousand trees of concentrated green, vermillion towers like sunset's hue.

On the lake's eastern shore there is a sluice gate and the water of a hot spring enters from this spot.[15] Where we went ashore, there was a lotus pond. By the edge of the pond there is a hall for enjoying cool air.[16] To the right of the hall there is a pavilion, a place for floating goblets along a winding stream.[17] The name-board reads, "Water Clover Fragrance Bank," and the door-couplet reads, "The moon constantly flows on the pair of brooks; A thousand peaks naturally merge with the clouds." The sounds of springs from near and far[18] are drawn here along a watercourse dredged according to the twists and turns of the land.

Following the lake water around several bends, we arrived again at the boat landing where we had first climbed ashore. We crossed a bridge and went out along our original path. This is the magnificent scenery extending from the center of the park to the northeast section.

On the twenty-eighth day of the month [August 14], we again received an imperial command to tour the park, this time exploring the beauties of the northwest section. Proceeding north

15 Known as Rehe Spring; see View 19.

16 See View 23, "Fragrance Grows Purer in the Distance" (Xiangyuan yiqing 香遠益清).

17 This is the focus of View 15, "The Scent of Lotuses by a Winding Stream" (Qushui hexiang 曲水荷香), which now bears the name "Savoring a Pure View" (Hanchengjing 含澄景).

18 This phrase, "sounds of springs from near and far" (*yuanjin quansheng* 遠近泉聲), was also used for the name of View 25, where it denotes the sounds of a single spring that led into a waterfall. It may derive from a line in the poem, "Walking in the Evening in Maping" (Maping wanxing 麻平晚行), by Wang Bo 王勃 (ca. 649–676): "As I searched high and low for the road that defends the frontier, I heard the sounds of springs from near and far" 高低尋戍道; 遠近聽泉聲.

from the eastern side gate, we again passed "Pine Winds through Myriad Vales," and from the long embankment came to "Clear Ripples with Layers of Greenery." After a time, we set out from the main gate, going straight past "Moon Boat with Cloud Sails" and, walking underneath a covered passage, we reached "A Sheet of Cloud." Taking our seats again in the western gallery, we were given a banquet and watched entertainments, again receiving a special gift of a soup from the imperial table. When we finished eating, we rose.

His Majesty issued instructions that, as the lotus blossoms were in full bloom, we could all observe them together. We boarded boats and passed by the boathouse. When I looked into the distance, I saw a dividing embankment. The glimmering lake was a brilliant void that stretched without end. What is called "A Pair of Lakes Like Flanking Mirrors" can be seen from here.[19] The lotus in the western portion of the lake were especially burgeoning. Among them was one variety, the color of which was perfectly gorgeous. Its seeds were obtained from the Aohan Confederacy. Blossoms and leaves float together on the surface of the water, reflected upside down in the lake, forming the most novel and beautiful scene. The rest of them, whether closer or further away, grew in randomly distributed clumps, their delicate fragrance surrounding us. It was truly a grand sight.

We climbed ashore where the land was open and flat, with both cultivated fields and groves of trees. Crossing over a small bridge, we followed the winding base of the mountain. The mountain peaks were covered with dark green vines and ancient mosses, plants untold hundreds of years old. Eventually, we arrived at a gate set in an opening in the mountains, beyond which was known as Lion Valley.[20] The gate spans across a ridge, which was called West Ridge. Below the gate was a small viewing pavilion, its name-board reading, "Untrammeled Thoughts by the Hao and Pu Rivers."[21] There were two sets of couplets. One reads: "Through the window, the color of the trees joins with the purity of the mountains; Outside the door, the glistening mountain mist bears traces of the water's brilliance." The other reads: "In the still of the wilderness, the *qi*-enery of the mountains gathers; In the sparse forest, winds and dew endure." Sitting here to rest for a while, one truly feels that "this is another world, not the world of men."[22]

Behind this mountain are Hazelnut Glen and Pine Valley. We returned before having a chance to go there. Proceeding south, we came to the Temple of the Dragon King, while still

19 See View 33.

20 Presumably, the valley now known as Cloudy Pines Gorge (Songyunxia 松雲峽), which runs northwest from the valley floor to the Northwest Gate (Xibeimen 西北門).

21 The name later assigned to View 17, a pavilion on the north shore of the main lakes; here, the name is applied to another structure, perhaps View 28, "Shapes of Clouds and Figures in the Water" (Yunrong shuitai 雲容水態).

22 This line, commonly used in praise of a garden, comes from a poem by the Tang poet Li Bo 李白 (701–762), "A Reply to a Question about Living in the Mountains" (Shanzhong wenda 山中問答): *bieyou tiandi fei renjian* 別有天地非人間.

further south there is a winding path paved with stones with grasses growing here and there. During the spring, pear blossoms appear here in great profusion, so that it is extolled as a seasonal scenic spot.[23] We walked in the mountains for roughly ten-odd *li*. The slope of the trail rose and fell and twisted and turned. Sometimes the trail broke off, sometimes it continued. These unusual precincts were formed by Nature.

We returned to the long bridge and the stone jetty,[24] where we gained a fine vista of the route through the northwest section. We once again took a boat, headed to the western side gate and went ashore. We all expressed our gratitude for His Majesty's beneficence by the bank of the lake.

What are called the "Sixteen Views" are: "Clear Ripples with Layers of Greenery," which is the main gate to the imperial throne; "A *Lingzhi* Path on an Embankment to the Clouds," which is the long embankment; "A Long Rainbow Sipping White Silk," which is the long bridge; "Warm Currents and Balmy Ripples," which is the place where the warm spring enters;[25] "A Pair of Lakes Like Flanking Mirrors," which is the place where two lakes are separated by an embankment; "Pine Winds through Myriad Vales," which is the hall on the hill at the entrance to the park; "The Scent of Lotuses by a Winding Stream," which is the place for floating wine goblets; "Morning Mist by the Western Ridge," which is the pass at the mouth of West Ridge;[26] "Sunset at Hammer Peak," which is a distant view of that peak to the west of the park;[27] "A Fragrant Islet by Flowing Waters," which is a small pavilion next to the stone steps;[28] "Southern Mountains Piled with Snow," which is a range of peaks within the park;[29] "Golden Lotuses Reflecting the Sun," which is the several *mu*[30] of golden lotus on the western banks that were seen;[31] "Pear Blossoms Accompanied by the Moon," which is the place where

23 Likely referring to the area around View 14, "Pear Blossoms Accompanied by the Moon" (Lihua banyue 梨花伴月).

24 The "long bridge" refers to "A Long Rainbow Sipping White Silk" (Changhong yinlian 長虹飲練), the primary subject of View 34, which also appears in View 33, "A Pair of Lakes Like Flanking Mirrors" (Shuanghu jiajing 雙湖夾鏡). The "stone jetty" likely refers to the nearby pavilion of Observing the Fish from a Waterside Rock (Shiji guanyu 石磯觀魚), the subject of View 31.

25 Given the general correlation between the sites described in the main body of the text and those listed among the Sixteen Views, it is unclear whether Zhang is referring here to the site of Rehe Spring, which he described earlier in his account, or the location of View 19, "Warm Currents and Balmy Ripples" (Nuanliu xuanbo 暖溜暄波). The former is at the northeast corner of the main lake; the latter is a pavilion overlooking a branch of the Wulie River, which was diverted to enter the Mountain Estate through a sluice gate at the north end of the park.

26 See View 11.

27 See View 12.

28 See View 27. The pavilion can also be seen beyond the bridge near the left edge of View 34.

29 See View 13.

30 A *mu* is roughly equivalent to 0.16 of an acre.

31 See View 24.

pear blossoms form a scene of surpassing beauty in springtime; "Orioles Warbling in the Tall Trees," which is a place along the banks where many tall trees are;[32] "Observing the Fish from a Waterside Rock," where one can fish anywhere along a stone jetty;[33] and "An Immense Field with Shady Groves," which is a place of exceedingly luxuriant fields and trees.[34]

Among the mountains and forests of the emperor's realm, there are none so extraordinary and magnificent as these; among the gardens of the emperor's realm, there are none so grand and vast as these. From first to last, every detail of the design was executed according to our Sagacious Emperor's instructions. When it was not yet completed, none knew of its unsurpassable scenic beauty; now it is finished, and everyone maintains that not a thing could be improved upon. In its broad contours, the design follows what is natural in the place, and the construction proceeded without altering the landscape. It was designed to accord with the form of the land. Consideration was given to what was appropriate to the earth itself, and the places for human activities were situated within this. In governing All-Under-Heaven, there is no other Way than this.[35]

六月初二日駕至熱河行宮. 十一日有旨同滿大臣等遊觀後苑. 由正門入向東北行至山崖. 有殿三楹. 額曰萬壑松風. 聯曰雲卷千峯色泉和萬籟吟. 歷石磴數十層. 紆折而下. 右有八角亭可垂釣. 過橋循長隄行. 時上在亭中. 顧謂臣等. 曰此隄形勢有類靈芝. 蓋長隄綿互蜿蜒. 至中道別出一支. 分為三沱. 各踞勝境. 實與芝相類也. 其東則雲山卷畫. 西則皇子讀書之所. 直行里許. 至駐蹕之地. 正門額曰澄波疊翠門外居中設御榻. 眺覽曠遠. 千巖萬壑. 俱在指顧間. 入門少西為延薰山館. 聯曰雲移溪樹侵書幌風送巖泉潤墨池. 館後有佛堂. 額曰水芳巖秀. 聯云自有山川開北極天然風景勝西湖. 旁有樓. 額曰雲帆月舫. 聯云疑乘畫櫂來天上欲挂輕帆入鏡中. 轉至御座. 正殿前羣花列植. 極多異種. 繡球五本分五色. 目中所未見也. 對面有臺. 曰一片雲. 於是臺上設音樂. 滿諸臣坐於東廊. 臣偕翰林諸臣坐西廊. 小榭內設木榻. 即宴賜食數器. 又特賜御膳野雞羹一器. 及午宴罷. 羣起謝恩出. 遂登舟泛湖. 湖之極空曠處. 與西湖彷彿. 其清幽澄潔之勝. 則西湖不及也. 岸有喬木數株. 近侍云此皆奉上命所留. 隨樹築隄. 蒼翠交映. 而古幹更具屈蟠之勢. 舟中遙望. 勝概不可殫述. 有遠岸縈流. 極其浩淼者有巖迴川抱. 極其明秀者. 萬樹攢綠. 丹樓如霞. 謂之畫境可. 謂之詩境亦可. 湖東岸一閘. 溫泉水從此入. 登岸

32 See View 22.

33 See View 31.

34 See View 35.

35 Cf. Liu Zongyuan 柳宗元 (773–819), "The Biography of the Gardener Camel Guo" (Zhongshu Guo Tuotuo zhuan 種樹郭橐駝傳), in which Liu's hunchbacked gardener, Guo, cultivates trees by avoiding interfering with their natural tendencies as they grow. The story advocates an ideal mode of governing that balances action and non-action.

This translation excerpts the portion of Zhang's "Record" in which he recounts his visits to the Mountain Estate, then known as the Rehe Traveling Palace. A version of the full "Record," upon which this translation is based, is reproduced in *Zhongguo bianjiang shizhi jicheng* 中國邊疆史志集成 [A Collection of Historical Records of China's Frontier Regions], vol. 7, *Dongbei shizhi* 东北史志 [Historical Accounts of the Northeast] (Beijing: Quanguo tushuguan wenxian suowei fuzhi zhongxin, 2004), 3–6.

則有荷池. 池上有涼殿. 殿右有亭. 為曲水流觴之地. 額曰蘋香汋. 聯云雙澗常流月千峰自合雲. 遠近泉聲. 皆隨地勢曲折疏導而得之. 循湖水數折. 復至初乘舟處登岸. 渡橋由舊道而出. 此苑中東北一路勝概也. 至二十八日. 復奉命再遊. 則尋西北之勝. 從東披門北行. 仍經萬壑松風. 由長隄至澄波疊翠. 時從正門行. 直過雲帆月舫. 循廊下行至一片雲處. 仍坐西廊賜食觀樂. 復特賜御案羹湯. 食畢而起. 傳諭荷花盛開. 可同觀之. 登舟過藏舟塢. 對望隔一隄. 湖光空明無際. 所謂雙胡夾鏡者. 於此地見之. 湖西蓮甚盛. 內有一種色至鮮妍者. 從敖漢部落得其種. 花與葉俱浮水面. 倒影湖中最為奇麗. 其他或遠或近. 叢生散布. 清芬環匝. 真巨觀也. 登岸地勢平衍. 有田疇. 有林木. 過小橋數折. 沿山趾而行. 山巔蒼藤古蘚. 不知幾百年物. 比至關口. 關以外為獅子峪. 關踞嶺上. 是為西嶺. 關下一軒. 額曰濠濮間想. 有二聯. 一曰窗間樹色連山淨戶外嵐光帶水明. 一曰野靜山氣斂林疏風露長. 坐憩數刻. 真覺別有天地非人間也. 其山後榛子峪松樹峪. 不及往而返. 南行則為龍王廟. 又南則迤邐石徑. 雜以叢卉. 春月梨花甚繁. 稱一時之勝. 山行約十數里. 坡陀委折. 時斷時續. 異境天成. 回至長橋石磯. 而西北一路彷彿得一勝概矣. 復乘舟指西披門登岸. 偕於岸旁謝恩. 所謂十六景者. 一曰澄波疊翠. 則御座正門也. 一曰芝徑雲隄. 則長隄也. 一曰長虹飲練. 則長橋也. 一曰暖流暄波. 則溫泉所從入也. 一曰雙湖夾鏡. 則兩湖隔隄處也. 一曰萬壑松風. 則入門山崖之殿也. 一曰曲水荷香. 則流觴處也. 一曰西嶺晨霞. 則關口西嶺也. 一曰錘峰落照. 則遠望苑西一峰也. 一曰芳渚臨流. 即石磴旁之小亭也. 一曰南山積雪. 則苑內一帶山也. 一曰金蓮映日. 則西岸所見金蓮數畝是也. 一曰梨花伴月. 則春月梨花極盛處也. 一曰鶯轉喬木. 則隄畔喬木數株是也. 一曰石磯觀魚. 則石磯隨處可垂釣者也. 一曰甫田叢樾. 則田疇林木極茂處也. 宇內山林. 無此奇勝. 宇內亭園. 無此宏曠. 先後布置. 皆由聖心指點而成. 未成之時. 人不知其絕勝. 既成之後. 則皆以為不可易矣. 大抵順其自然. 行所無事. 因地之勢. 度土之宜. 而以人事區畫於其間. 經理天下. 無異道也.

BIBLIOGRAPHY

Albanese, Andreina. "Matteo Ripa e la carta geografica dell'Impero Cinese commissionata da Kangxi." In *Matteo Ripa e il Collegio dei Cinesi di Napoli (1682–1869),* edited by Michele Fatica, 49–70. Naples: Università degli Studi di Napoli "L'Orientale," 2006.

———. "La carta geographica di Matteo Ripa: Caratteristiche dell'esemplare della Biblioteca Universitaria di Bologna." In *La missione cattolica in Cina tra i secoli XVIII–XIX: Matteo Ripa e il Collegio dei Cinese,* edited by Michele Fatica and Francesco D'Arelli, 135–183. Naples: Istituto Universitario Orientale, 1999.

Bai Xinliang 白新良, ed. *Kangxi zhuan* 康熙传 [Biography of Kangxi]. Beijing: Xueyuan chubanshe, 1994.

Barrier, Janine, Monique Mosso, and Che Bing Chiu, eds. and trans. *Aux jardins de Cathay, l'imaginaire anglo-chinois en occident: William Chambers.* Besançon: Editions de l'Imprimeur, 2004.

Barfield, Thomas J. *The Perilous Frontier: Nomadic Empires and China.* New York: Basil Blackwell, 1989.

Barnhart, Richard M., Wen Fong, and Maxwell K. Hearn. *Mandate of Heaven: Emperors and Artists in China; Chinese Painting and Calligraphy from the Metropolitan Museum of Art.* Zurich: Museum Reitberg Zurich, 1996.

Bell, John. *A Journey from St. Petersburg to Pekin, 1719–1722.* Edited, with an introduction by J. L. Stevenson. Edinburgh: Edinburgh University Press, 1966.

Berliner, Nancy. "Gardens, Water, and Calligraphy: The Development and References of the Curving Waterway Garden Element." Unpublished conference paper, Harvard University, November 12, 2010.

Bouvet, Joachim. *Histoire de l'empereur de la Chine (Cang-Hy).* The Hague: M. Uytwerf, 1699.

Brockey, Liam Matthew. *Journey to the East: The Jesuit Mission to China, 1579–1724.* Cambridge, Mass.: Harvard University Press, 2007.

Bush, Susan. "Lung-mo, K'ai-ho, and Ch'i-fu: Some Implications of Wang Yuan-ch'i's Three Compositional Terms." *Oriental Art* 8, no. 3 (Autumn 1962): 120–127.

Cahill, James. *The Compelling Image: Nature and Style in Seventeenth-Century Chinese Painting.* Cambridge, Mass.: Harvard University Press, 1982.

———. "The Orthodox Movement in Early Ch'ing Painting." In *Artists and Traditions: Uses of the Past in Chinese Culture,* edited by Christian F. Murck, 169–181. Princeton, N.J.: The Art Museum, Princeton University, 1976.

———. "Yuan Chiang and His School." *Ars Orientalis* 5 (1963): 259–272, and 6 (1966): 191–212.

Campbell, Duncan. "Qi Biaojia's 'Footnotes to Allegory Mountain': Introduction and Translation." *Studies in the History of Gardens and Designed Landscapes* 19, nos. 3–4 (1999): 243–271.

Chang, Michael G. *A Court on Horseback: Imperial Touring and the Construction of Qing Rule, 1680–1785.* Cambridge, Mass.: Harvard University Asia Center, 2007.

Chen Baosen 陈宝森. *Chengde Bishu shanzhuang Waibamiao* 承德避暑山庄外八庙 [The Mountain Estate for Escaping the Heat and the Outer Eight Temples in Chengde]. Beijing: Zhongguo jianzhu gongye chubanshe, 1995.

Chen, Jack W. *The Poetics of Sovereignty: On Emperor Taizong of the Tang Dynasty.* Cambridge, Mass.: Harvard University Asia Center, 2010.

Chen Yuan 陳垣, ed. *Kangxi yu Luoma shijie guanxi wenshu yingyinben* 康熙與羅馬使節關係文書影印本 [Photographic Reproductions of Documents Concerning Relations between Kangxi and Envoys from Rome]. Beiping: Gugong bowuyuan, 1932.

Chen Zhi 陈植 and Zhang Gongchi 张公弛, eds. *Zhongguo lidai mingyuan ji xuanzhu* 中国历代名园集选注 [Annotated Anthology of Records of Famous Historical Gardens in China]. Hefei: Anhui kexue jishu chubanshe, 1983.

Chung, Anita. *Drawing Boundaries: Architectural Images in Qing China.* Honolulu: University of Hawai'i Press, 2004.

Clunas, Craig. *Elegant Debts: The Social Art of Wen Zhengming, 1470–1559.* London: Reaktion, 2004.

———. *Fruitful Sites: Garden Culture in Ming Dynasty China.* Durham, N.C.: Duke University Press, 1996.

Commentale, Christophe. "Les recueils de gravures sous la dynastie des Ch'ing: La série des eaux-fortes du *Pi-shu shan-chuang*; Analyse et comparaisons avec d'autres sources contemporaines, chinoises et occidentales." In *Echanges culturels et religieux entre la Chine et l'Occident*, edited by Edward J. Malatesta, Yves Raguin, and Adrianus C. Dudink, 81–113. San Francisco: The Ricci Institute for Chinese-Western Cultural History, 1995.

———. "Ripa, graveur aquafortiste et la tradition de la gravure sous les Qing." In *La conoscenza dell'Asia e dell'Africa in Italia nei secoli XVIII e XIX*, edited by Aldo Gallotta and Ugo Marazzi, 2:189–209. Naples: Istituto Universitario Orientale, 1985.

———, trans. *Matteo Ripa, peintre-graveur-missionaire à la Cour de Chine*. Taipei: Ouyu chubanshe/Victor Chen, 1983.

Conner, Patrick. *Oriental Architecture in the West*. London: Thames and Hudson, 1979.

———. "China and the Landscape Garden: Reports, Engravings, and Misconceptions." *Art History* 2, no. 4 (December 1979): 429–440.

Corsi, Elisabetta. "Late Baroque Painting in China Prior to the Arrival of Matteo Ripa: Giovanni Gherardini and the Perspective Painting Called 'Xianfa.'" In *La missione cattolica in Cina tra i secoli XVIII–XIX: Matteo Ripa e il Collegio dei Cinese*, edited by Michele Fatica and Francesco D'Arelli, 103–122. Naples: Istituto Universitario Orientale, 1999.

Crossley, Pamela Kyle. "The Conquest Elite of the Ch'ing Empire." In *The Cambridge History of China*, vol. 9, pt. 1, *The Ch'ing Dynasty to 1800*, edited by Willard J. Peterson, 310–359. Cambridge: Cambridge University Press, 2002.

———. *A Translucent Mirror: History and Identity in Qing Imperial Ideology*. Berkeley: University of California Press, 1999.

———. *The Manchus*. Oxford: Blackwell, 1997.

D'Arelli, Francesco. "The Chinese College in Eighteenth-Century Naples." *East and West* 58 (2008): 283–312.

Dennerline, Jerry. "The Shun-chih Reign." In *The Cambridge History of China*, vol. 9, pt. 1, *The Ch'ing Empire to 1800*, edited by Willard J. Peterson, 73–119. Cambridge: Cambridge University Press, 2002.

Denzel, Markus A. *Handbook of World Exchange Rates, 1590–1914*. London: Ashgate, 2010.

Di Fiore, Giacomo. "La posizione di Matteo Ripa sulla questione dei riti cinesi." In *La conoscenza dell'Asia e dell'Africa in Italia nei secoli XVIII e XIX*, edited by Aldo Gallotta and Ugo Marazzi, 3:381–432. Naples: Istituto Universitario Orientale, 1989.

———. *La legazione Mezzabarba in Cina (1720–1721)*. Naples: Istituto Universitario Orientale, 1989.

Dott, Brian R. *Identity Reflections: Pilgrimages to Mt. Tai in Late Imperial China*. Cambridge, Mass.: Harvard University Press, 2004.

Duan Zhongrong 段钟嵘, ed. *Bishu shanzhuang qishier jing dingjing-shi dianping* 避暑山庄七十二景定景诗点评 [Poems on the Seventy-Two Views of the Mountain Estate for Escaping the Heat with Commentary]. Huhehaote: Yuanfang chubanshe, 2003.

Edgren, Sören. *Chinese Rare Books in American Collections*. New York: China House Gallery, China Institute in America, 1984.

Elliott, Mark C. *The Manchu Way: The Eight Banners and Ethnic Identity in Late Imperial China*. Stanford: Stanford University Press, 2001.

———. "Manchu Widows and Ethnicity in Qing China." *Comparative Studies in Society and History* 41, no. 1 (1999): 33–71.

Elliott, Mark C., and Ning Chia. "The Qing Hunt at Mulan." In *New Qing Imperial History: The Making of Inner Asian Empire at Qing Chengde*, edited by James Millward et al., 66–83. London: Routledge, 2004.

Elliott, Mark C., and Scott Lowe, trans. "Preface to the 'Thirty-Six Views of Bishu shanzhuang': Record of the Mountain Villa to Escape the Heat." In *New Qing Imperial History: The Making of Inner Asian Empire at Qing Chengde*, edited by James Millward et al., 167–170. London: Routledge, 2004.

Elman, Benjamin. *From Philosophy to Philology: Intellectual and Social Aspects of Change in Late Imperial China*. Cambridge, Mass.: Council on East Asian Studies, Harvard University, 1984.

The Emperor of China's Palace at Pekin, and His Principal Gardens, as well in Tartary, as at Pekin, Gehol and the Adjacent Countries; with the Temples, Pleasure-Houses, Artificial Mountains, Rocks, Lakes, etc. as Disposed in Different Parts of Those Royal Gardens. London: Robert Sayer, Henry Overton, Thomas Bowles, and John Bowles and Son, 1753. Reprint, London: Whittle and Laurie, ca. 1829.

Fan Shuyuan 樊淑媛 and Duan Zhongrong 段钟嵘, eds. *Bishu shanzhuang yuzhi fengjingshi jianshang* 避暑山庄御制风景诗鉴赏 [An Appreciation of Imperial Landscape Poems on the Mountain Estate for Escaping the Heat]. Hailaer: Neimenggu wenhua chubanshe, 2000.

Fang Chao-ying. "Fu-lin." In *Eminent Chinese of the Ch'ing Period*, edited by Arthur W. Hummel, 255–259. Washington, D.C.: Government Printing Office, 1943.

———. "Hsüan-yeh." In *Eminent Chinese of the Ch'ing Period*, edited by Arthur W. Hummel, 327–331. Washington, D.C.: Government Printing Office, 1943.

Fatica, Michele. *Matteo Ripa e il Collegio dei Cinesi di Napoli (1682–1869)*. Naples: Università degli Studi di Napoli "L'Orientale," 2006.

———. *Sedi e Palazzi dell'Università degli Studi di Napoli "L'Orientale" (1729–2005)*. Naples: Università degli Studi di Napoli "L'Orientale," 2005.

Fatica, Michele, and Francesco D'Arelli, eds. *La missione cattolica in Cina tra i secoli XVIII–XIX: Matteo Ripa e il Collegio dei Cinese.* Naples: Istituto Universitario Orientale, 1999.

Ferguson, John C. 福開森. *Lidai zhulu huamu* 歷代著錄畫目 [A Catalog of Paintings from Different Dynasties with Notes]. Beijing: Renmin meishu chubanshe, 1993.

Finlay, John R. "'40 Views of the Yuanming yuan': Image and Ideology in a Qianlong Imperial Album of Poetry and Paintings." PhD diss., Yale University, 2011.

Flood, Finbarr Barry. *Objects of Translation: Material Culture and Medieval "Hindu-Muslim" Culture.* Princeton, N.J.: Princeton University Press, 2009.

Fong, Wen C. "The Orthodox School of Painting." In *Possessing the Past: Treasures from the National Palace Museum, Taipei,* edited by Wen C. Fong and James C. Y. Watt, 473–491. New York: Metropolitan Museum of Art, 1996.

Fontana, Michela. *Matteo Ricci: A Jesuit in the Ming Court.* Lanham, Md.: Rowman and Littlefield, 2011.

Forêt, Philippe. *Mapping Chengde: The Qing Landscape Enterprise.* Honolulu: University of Hawai'i Press, 2000.

Fuchs, Walter. "Der Kupferdruck in China vom 10. bis 19. Jarhundert." *Gutenberg Jarbuch* (1950): 67–87.

Gao Shiqi 高士奇. *Pengshan miji* 蓬山密記 [A Secret Account from Pengshan]. 1703. Reprinted in *Guxue huikan* 古學彙刊, vol. 4, *1445–1452.* Shanghai: Guocui xuebao she, 1912; Taipei: Lixing shuju, 1964.

Gates, M. Jean, and Fang Chao-ying. "Hsiao-chuang Wen Huang-hou." In *Eminent Chinese of the Ch'ing Period,* edited by Arthur W. Hummel, 300–301. Washington, D.C.: Government Printing Office, 1943.

Gray, Basil. "Lord Burlington and Father Ripa's Chinese Engravings." *The British Museum Quarterly* 22, nos. 1–3 (1960): 40–43.

Guan Xiaolian 关孝廉 and Qu Liusheng 屈六生, eds. *Kangxi chao manwen zhupi zouzhe quanyi.* 康熙朝满文朱批奏折全译 [Complete Translations of the Manchu Memorials with Imperial Comments during the Kangxi Reign]. Beijing: Zhongguo shehui kexue chubanshe, 1996.

Gugong bowuyuan 故宫博物院, ed. *Tianlu zhencang: Qinggong nei-fuben sanbainian* 天禄珍藏：清宫内府本三百年 [A Treasury of Heavenly Objects: Three Hundred Years of Imperial Household Department Editions from the Qing Court]. Beijing: Zijincheng chubanshe, 2007.

———. *Gugong bowuyuan cang Qingdai gongting huihua* 故宫博物院藏清代宫廷绘画 [Qing Dynasty Court Painting from the Collection of the Palace Museum, Beijing]. Beijing: Wenwu chubanshe, 1992.

Guoli gugong bowuyuan 國立故宮博物院, ed. *Gugong shuhua tulu* 故宮書畫圖錄 [Collection of Painting and Calligraphy in the Palace Museum, Taipei]. 27 vols. Taipei: Guoli gugong bowuyuan, 1989–2010.

———. *Yuanlin minghua tezhan tulu* 園林名畫特展圖錄 [Catalog of the Special Exhibition of Famous Paintings of Gardens]. Taipei: Guoli gugong bowuyuan, 1987.

———. *Midian zhulin, Shiqu baoji* 秘殿珠林, 石渠寶笈 [Forest of Pearls of the Secret Hall, Precious Works of the Stone Moat]. Taipei: Guoli gugong bowuyuan, 1971.

———. *Midian zhulin, Shiqu baoji xubian* 秘殿珠林, 石渠寶笈續編 [Forest of Pearls of the Secret Hall, Precious Works of the Stone Moat: Second Catalog]. Taipei: Guoli gugong bowuyuan, 1971.

———. *Midian zhulin, Shiqu baoji sanbian* 秘殿珠林, 石渠寶笈：三編 [Forest of Pearls of the Secret Hall, Precious Works of the Stone Moat: Third Catalog]. Taipei: Guoli gugong bowuyuan, 1969.

Guy, R. Kent. *The Emperor's Four Treasuries: Scholars and the State in the Late Ch'ien-lung Era.* Cambridge, Mass.: Harvard University Press, 1987.

Halbwachs, Maurice. "The Legendary Topography of the Gospels of the Holy Land." In *On Collective Memory,* edited by Lewis A. Coser, 193–235. Chicago: University of Chicago Press, 1992.

Hall, David L., and Roger T. Ames. *Thinking from the Han: Self, Truth, and Transcendence in Chinese and Western Culture.* Albany: State University of New York Press, 1998.

Han Qi 韩琦. "Cong Zhongxi wenxian kan Ma Guoxian zai gongting de huodong" 从中西文献看马国贤在宫廷的活动 [Matteo Ripa's Activities in the Palace as Seen in Chinese and Western Documents]. In *La missione cattolica in Cina tra i secoli XVIII–XIX: Matteo Ripa e il Collegio dei Cinese,* edited by Michele Fatica and Francesco D'Arelli, 71–82. Naples: Istituto Universitario Orientale, 1999.

Hammers, Roslyn. *Pictures of Tilling and Weaving: Art, Labor, and Technology in Song and Yuan China.* Hong Kong: Hong Kong University Press, 2011.

Harris, John. *Sir William Chambers, Knight of the Polar Star.* London: A. Zwimmer, 1970.

Harrist, Robert E. "Site Names and Their Meaning in the Garden of Solitary Enjoyment." *Journal of Garden History* 13 (1993): 199–212.

———. *Painting and Private Life in Eleventh-Century China: Mountain Villa by Li Gonglin.* Princeton, N.J.: Princeton University Press, 1998.

Hay, Jonathan. "The Kangxi Emperor's Brush-Traces: Calligraphy, Writing, and the Art of Imperial Authority." In *Body and Face in Chinese Visual Culture,* edited by Wu Hung and Katherine Tsiang Miao, 311–334. Cambridge, Mass.: Harvard University Press, 2004.

Hearn, Maxwell K., ed. *Landscapes Clear and Radiant: The Art of Wang Hui (1632–1717)*. New York: Metropolitan Museum of Art, 2008.

———. "The Kangxi Southern Tour: A Narrative Program by Wang Hui." PhD diss., Princeton University, 1990.

Ho, Wai-kam. "The Literary Concepts of 'Picture-Like' (*ju-hua*) and 'Picture-Idea' (*hua-i*) in the Relationship between Poetry and Painting." In *Words and Images: Chinese Poetry, Calligraphy, and Painting*, edited by Alfreda Murck and Wen Fong, 359–404. New York: The Metropolitan Museum of Art, 1991.

Honour, Hugh. *Chinoiserie: The Vision of Cathay*. London: J. Murray, 1961.

Hu, Philip. "Idealized Labor: Material and Social Manifestations of Riziculture and Sericulture in Imperial China." Unpublished conference paper, presented at Academia Sinica, October 25–27, 2002.

Huang Weiling 黄煒鈴. "Huatu liuyu renkan: You Wang Yuanqi de shitu yu huaye kan Qingchu gongting shanshuifeng de dianli" 畫圖留與人看：由王原祁的仕途與畫業看清初宮廷山水風的奠立 [Paintings to Remain for People to See: The Establishment of Landscape Painting Trends in the Early Qing Court from the Perspective of Wang Yuanqi's Official Career and Painting Oeuvre]. MA thesis, National Taiwan University, 2005.

Hucker, Charles O. *A Dictionary of Official Titles in Imperial China*. Stanford: Stanford University Press, 1985.

Hummel, Arthur W., ed. *Eminent Chinese of the Ch'ing Period (1644–1912)*. Washington, D.C.: Government Printing Office, 1943.

Ishida, Mikinosuke. "A Biographical Study of Giuseppe Castiglione (Lang Shih-ning), a Jesuit Painter in the Court of Peking under the Ch'ing Dynasty." *Memoires of the Research Department of the Tōyō Bunko* 19 (1960): 79–121.

Jacobson, Dawn. *Chinoiserie*. London: Phaidon, 1993.

Jami, Catherine. *The Emperor's New Mathematics: Western Learning and Imperial Authority During the Kangxi Reign (1662–1722)*. Oxford: Oxford University Press, 2011.

Jacques, David. "On the Supposed Chineseness of the English Landscape Garden." *Garden History* 18, no. 2 (Autumn 1990): 180–191.

Ji Cheng. *The Craft of Gardens*. Translated by Alison Hardie. New Haven: Yale University Press, 1988.

Kahn, Harold L. *Monarchy in the Emperor's Eyes: Image and Reality in the Ch'ien-lung Reign*. Cambridge, Mass.: Harvard University Press, 1971.

Kangxi emperor 康熙 (Qing Shengzu, Xuanye 清聖祖, 玄燁; Aisin Gioro hala i Hiowan Yei). *Han-i araha Alin-i tokso de halhūn be jailaha ši bithe* [Poems on the Mountain Estate for Escaping the Heat, Written by the Khan]. Edited by Kuixu 揆叙 et al.

Illustrations by Shen Yu 沈喻. 2 vols. Beijing: Neiwufu Wuyingdian, postscript 1712.

———. *Kangxi shixuan* 康熙詩選 [Selected Poems of Kangxi]. Edited by Bu Weiyi 卜維義 and Sun Piren 孫丕任. Shenyang: Chunfeng wenyi chubanshe, 1984.

———. *Yuzhi Bishu shanzhuang shi* 御製避暑山莊詩 [Imperial Poems on the Mountain Estate for Escaping the Heat]. Edited by Kuixu 揆叙 et al. Illustrations by Shen Yu 沈喻. 2 vols. Beijing: Neiwufu Wuyingdian, postscript 1712. Reprint, Kyoto: Nichiman bunka kyōkai, 1935.

———. *Yuzhi Bishu shanzhuang shi* 御製避暑山莊詩 [Imperial Poems on the Mountain Estate for Escaping the Heat]. Illustrations by Matteo Ripa. Beijing: Neiwufu Wuyingdian, 1714. Facsimile reprint reissued as *Tongban yuzhi Bishu shanzhuang sanshiliu jing shitu* 銅板御製避暑山莊三十六景詩圖 [Engraved Copperplate Edition of *Imperial Poems on Thirty-Six Views of the Mountain Estate for Escaping the Heat with Illustrations*]. Beijing: Xueyuan chubanshe, 2002.

Kangxi emperor 康熙, and the Qianlong emperor 乾隆 (Qing Gaozong, Hongli 清高宗, 弘曆; Aisin Gioro hala i Hung Li), *Yuzhi gonghe Bishu shanzhuang sanshiliujing shi* 御製恭和避暑山莊三十六景詩 [Imperial Poems in Response to Poems on the Thirty-Six Views of the Mountain Estate for Escaping the Heat]. Edited by Kuixu 揆叙, Eertai 鄂爾泰, et al. Illustrations by Shen Yu 沈喻. 2 vols. Beijing: Neiwufu Wuyingdian, 1741. Facsimile reprint of Wujin Taoshi Sheyuan 武進陶氏涉園, 1921 edition, reissued as *Yuzhi Bishu shanzhuang tuyong* 御製避暑山莊圖詠 [Imperial Poems and Illustrations of the Mountain Estate for Escaping the Heat]. Nanjing: Jiangsu guji chubanshe, 2003.

Kangxi qijuzhu 康熙起居注 [Court Diary of the Kangxi Reign]. Edited by Zhongguo diyi lishi dang'anguan. 3 vols. Beijing: Zhonghua shuju, 1984.

Kangxi sanshiliu jing shi xuanzhu 康熙三十六景诗选注 [Kangxi's Poems on the Thirty-Six Views of the Mountain Estate for Escaping the Heat with Commentary]. Edited by Chengde shizhuan Bishu shanzhuang shiwen yanjiu xiaozu. Chengde: Chengde shizhuan xuebao bianjibu, 1985.

Kelsall, Malcolm. "The Iconography of Stourhead." *Journal of the Warburg and Courtauld Institutes* 46 (1983): 133–143.

Kessler, Lawrence D. *K'ang-hsi and the Consolidation of Ch'ing Rule, 1661–1684*. Chicago: University of Chicago Press, 1976.

Lattimore, Owen. *Inner Asian Frontiers of China*. New York: American Geographical Society, 1940. Reprint, Hong Kong: Oxford University Press, 1988.

Lavely, William, and R. Bin Wong. "Revising the Malthusian Narrative: The Comparative Study of Population Dynamics in Late Imperial China." *The Journal of Asian Studies* 57, no. 3 (August 1998): 714–748.

Lee, Hui-shu. *Exquisite Moments: West Lake and Southern Song Art.* New York: China Institute Gallery, 2001.

Lejune, Philippe. *On Autobiography.* Minneapolis: University of Minnesota Press, 1989.

Li, Chu-Tsing. *A Thousand Peaks and Myriad Ravines: Chinese Paintings in the Charles A. Drenowatz Collection.* 2 vols. Artibus Asiae Supplementum 30. Anscona, Switzerland: Artibus Asiae, 1974.

Li Tiangang 李天纲. *Zhongguo liyi zhi zheng: lishi, wenxian he yiyi* 中国礼仪之争：历史，文献和意义 [The Chinese Rites Controversy: History, Documents, and Significance]. Shanghai: Shanghai guji chubanshe, 1998.

Li, Wai-yee. "Early Qing to 1723." In *The Cambridge History of Chinese Literature,* vol. 2, *From 1375,* edited by Kang-i Sun Chang, 152–244. Cambridge: Cambridge University Press, 2010.
———. "Gardens and Illusions from Late Ming to Early Qing." *Harvard Journal of Asiatic Studies* 72, no. 2 (2012): 295–336.

Li Xiaocong 李孝聪. "Ma Guoxian yu tongban Kangxi *Huangyu quanlan tu* de yinzhi jianlun zaoqi Zhongwen ditu zai Ouzhou de chuanbu yu yingxiang" 马国贤与铜版康熙《皇舆全览图》的印制兼论早期中文地图在欧洲的传布与影响 [Matteo Ripa and the Printing of Kangxi's Copper-Engraved *Complete Map of the Empire* with a Discussion of the Early Transmission and Influence of Maps of China in Europe]. In *La missione cattolica in Cina tra i secoli XVIII–XIX: Matteo Ripa e il Collegio dei Cinese,* edited by Michele Fatica and Francesco D'Arelli, 123–134. Naples: Istituto Universitario Orientale, 1999.

Li Yuandu 李元度. *Guochao xianzheng shilue* 國朝先正事略 [Historical Biographies of Eminent Men of the Qing Dynasty]. 4 vols. 1866. Reprint, Taipei: Wenhai chubanshe, 1967.

Liscomb, Kathlyn. "'The Eight Views of Beijing': Politics in Literati Art." *Artibus Asiae* 49, nos. 1–2 (1988): 127–152.

Liu, Cary. "Archive of Power: The Qing Dynasty Imperial Garden-Palace at Rehe." *Meishu shi yanjiu jikan* 美術史研究集刊 28 (2010): 43–66.

Liu, Heping. "'The Water Mill' and Northern Song Imperial Patronage of Art, Commerce, and Science." *The Art Bulletin* 84, no. 4 (2002): 566–595.

Liu, Yu. *Seeds of a Different Eden: Chinese Garden Ideas and a New English Aesthetic Ideal.* Columbia: University of South Carolina Press, 2008.

Liu I-ch'ing. *Shih-shuo Hsin-yü: A New Account of Tales of the World.* Translated by Richard B. Mather. Minneapolis: University of Minnesota Press, 1976.

Lo, Hui-chi. "Political Advancement and Religious Transcendence: The Yongzheng Emperor's (1678–1735) Deployment of Portraiture." PhD diss., Stanford University, 2009.

Loehr, George H. "L'artiste Jean-Denis Attiret et l'influence exercée par sa description des jardins impériaux." In *La mission française de Pékin aux XVIIᵉ et XVIIIᵉ siècles,* 69–83. Paris: Cathasia, 1976.
———. "The Sinicization of Missionary Artists and Their Work at the Manchu Court During the Eighteenth Century." *Cahiers d'histoire mondiale* 7, no. 3 (1963): 795–815.
———. "Missionary-Artists at the Manchu Court." *Transactions of the Oriental Ceramic Society* 34 (1962–1963): 51–67.

Lowe, Scott, trans. "Five Poems by the Qianlong Emperor." In *New Qing Imperial History: The Making of Inner Asian Empire at Qing Chengde,* edited by James Millward et al., 199–201. London: Routledge, 2004.

Lu, Andong. "Deciphering the Reclusive Landscape: A Study of Wen Zheng-Ming's 1533 *Album of the Garden of the Unsuccessful Politician.*" *Studies in the History of Gardens and Designed Landscapes* 31, no. 1 (2011): 40–59.

Lu Fusheng 卢辅圣. *Zhongguo shuhua quanshu* 中国书画全书 [Complete Catalog of Chinese Painting and Calligraphy]. 14 vols. Shanghai: Shanghai shuhua chubanshe, 1992.

Lui, Adam Yuen-chung. *The Han-lin Academy: Training Ground for the Ambitious, 1644–1850.* Hamden, Conn.: Archon Books, 1981.

Luo Hongbo 罗红波 and Lin Mian 林岷. "Zhongguo guanfang wenxian dui Ma Guoxian de jizai ji Zhongguo dui Ma Guoxian de yanjiu" 中国官方文献对马国贤的记载及中国对马国贤的研究 [Official Chinese Documents Recording Ma Guoxian [Matteo Ripa] and Research in China about Ma Guoxian]. In *La missione cattolica in Cina tra i secoli XVIII–XIX: Matteo Ripa e il Collegio dei Cinese,* edited by Michele Fatica and Francesco D'Arelli, 61–69. Naples: Istituto Universitario Orientale, 1999.

Ma Guoxian 马国贤 (Matteo Ripa). *Qingting shisan nian: Ma Guoxian zai Hua huiyilu* 清廷十三年：马国贤在华回忆录 [Memoirs of Father Ripa during Thirteen Years Residence at the Court of Peking in the Service of the Emperor of China]. Translated by Li Tiangang 李天纲. Shanghai: Shanghai guji chubanshe, 2004.

Ma, Ya-chen. "Picturing Suzhou: Visual Politics in the Making of Cityscapes in Eighteenth-Century China." PhD diss., Stanford University, 2006.

Maeda, Robert J. "*Chieh-hua*: Ruled-Line Painting in China." *Ars Orientalis* 10 (1975): 123–141.

Makeham, John. "The Confucian Role of Names in Traditional Chinese Gardens." *Studies in the History of Gardens and Designed Landscapes* 18, no. 3 (Autumn 1998): 187–210.

Malatesta, Edward J. "A Fatal Clash of Wills: The Condemnation of the Chinese Rites by the Papal Legate Carlo Tommaso Maillard de Tournon." In *The Chinese Rites Controversy: Its History and Meaning,* edited by David E. Mungello, 211–246. Nettetal: Steyler Verlag, 1994.

Meng Zhaoxin 孟昭信. *Kangxi dadi quanzhuan* 康熙大帝全傳 [A Complete Biography of the Great Emperor Kangxi]. Changchun: Jilin wenshi chubanshe, 1987.

Meng Zhaozhen 孟兆禎. *Bishu shanzhuang yuanlin yishu* 避暑山庄 园林艺术 [The Garden Artistry of the Mountain Estate for Escaping the Heat]. Beijing: Zijincheng chubanshe, 1985.

Meyer-Fong, Tobie S. *Building Culture in Early Qing Yangzhou.* Stanford: Stanford University Press, 2003.

McNulty, Kneeland. "Matteo Ripa's Thirty-Six Views of Jehol." *Artist's Proof* 8 (1968): 87–92.

Millward, James et al., eds. *New Qing Imperial History: The Making of Inner Asian Empire at Qing Chengde.* London: Routledge, 2004.

Minamiki, George. *The Chinese Rites Controversy from Its Beginning to Modern Times.* Chicago: Loyola University Press, 1985.

Munakata, Kiyohiko. "Mysterious Heavens and Chinese Classical Gardens." *RES* 1 (Spring 1988): 61–88.

Mungello, David E. *Western Queers in China: Flight to the Land of Oz.* London: Rowman and Littlefield, 2012.
———. "Reinterpreting the History of Christianity in China." *The Historical Journal* 55, no. 2 (2012): 533–552.
———. *The Great Encounter of China and the West.* Lanham, Md.: Rowman and Littlefield, 2005.

Mungello, David E., ed. *The Chinese Rites Controversy: Its History and Meaning.* Monumenta Serica Monograph Series 33. Nettetal, Germany: Steyler Verlag, 1994.

Murck, Alfreda. "The Meaning of the Eight Views of Hsiao-Hsiang: Poetry and Painting in Sung China." PhD diss., Princeton University, 1995.
———. "Eight Views of the Hsiao and Hsiang Rivers by Wang Hong." In *Images of the Mind,* edited by Wen C. Fong, 213–235. Princeton, N.J.: The Art Museum, Princeton University, 1984.

Nanshū meigaen 南宗名畫苑 [A Garden of Famous Paintings of the Southern School]. 25 vols. Tokyo: Shinbi Shoin, 1904–1916.

Ning Chia. "The Li-fan Yuan in the Early Ch'ing Dynasty." PhD diss., Johns Hopkins University, 1992.

Ortiz, Valérie Malenfer. *Dreaming the Southern Song Landscape: The Power of Illusion in Chinese Painting.* Leiden: Brill, 1999.

Owen, Stephen. "The Self's Perfect Mirror: Poetry as Autobiography." In *The Vitality of the Lyric Voice: Shih Poetry from the Late Han to the T'ang,* edited by Shuen-fu Lin and Stephen Owen, 71–102. Princeton, N.J.: Princeton University Press, 1986.

Oxnam, Robert B. *Ruling from Horseback: Manchu Politics During the Oboi Regency, 1661–1669.* Chicago: University of Chicago Press, 1975.

Pak Jiwŏn 朴趾源. *Yŏrha ilgi* 熱河日記 [Rehe Diary]. Translated into modern Korean by Yi Sangho. In *Kyŏrae kojŏn munhak sŏnchap* [Anthology of Pre-Modern Korean Literature], 3:551–552. Kyŏnggi-do: Pori, 2004.

Park, J. D. *Art by the Book: Painting Manuals and the Leisure Life in Late Ming China.* Seattle: University of Washington Press, 2012.

Pelliot, Paul. "La gravure sur cuivre en Chine au XVIIIᵉ siècle." *Byblis* 2 (1923): 103–108.
———. "Les conquêtes de l'empereur de Chine." *T'oung Pao* 20 (1921): 183–274.

Peiwen yunfu 佩文韻府 [A Treasury of Rhymes for Ornamenting Literature]. Originally published as *Yuding peiwen yunfu* 御定佩文韻府 [Imperially Sponsored Treasury of Rhymes for Ornamenting Literature]. Edited by Zhang Yushu 張玉書 et al., 202 *juan.* Beijing: Neiwufu Wuyingdian, 1711. Reprint, Shanghai: Shanghai shudian, 1983.

Peiwenzhai shuhua pu 佩文齋書畫譜 [Selected Texts on Calligraphy and Painting from the Studio for Ornamenting Literature]. Edited by Sun Yueban 孫岳頒 et al. 100 *juan.* 1708. Reprint, Shanghai: Shanghai guji chubanshe, 1991.

Perdue, Peter. *China Marches West: The Qing Conquest of Central Eurasia.* Cambridge, Mass.: Harvard University Press, 2005.

Peterson, Willard J., ed. *The Cambridge History of China,* vol. 9, pt. 1, *The Ch'ing Empire to 1800.* Cambridge: Cambridge University Press, 2002.

Qian Yong 錢泳. *Lüyuan conghua* 履園叢話 [Chats by Lüyuan]. 1825. Reprint, Beijing: Zhonghua shuju, 1979.

Qinding gujin tushu jicheng 欽定古今圖書集成 [Imperially Sponsored Encyclopedia of Books and Illustrations, Past and Present]. Edited by Jiang Tingxi 蔣廷錫, Chen Menglei 陳夢雷 et al. 10,000 *juan.* Beijing: Neiwufu Wuyingdian, 1726–1728. Reprint, Shanghai: Zhonghua shuju, 1934.

Qinding Rehe zhi 欽定熱河志 [Imperially Sponsored Gazetteer of Rehe]. Edited by Heshen 和珅 et al. Beijing: Neiwufu Wuyingdian, 1781. Reprint, Dalian: Youwenge / Liaohai shushe, 1934.

Qinding siku quanshu 欽定四庫全書 [Imperially Sponsored Complete Collection of the Four Libraries]. Edited by Ji Yun 紀昀 et al. 78,178 *juan.* Beijing: Neiwufu Wuyingdian, 1772–1781. Facsimile reprint issued as *Yingyin Wenyuange siku quanshu* [Photographic Reprint of the Wenyuange Edition of the *Complete Collection of the Four Libraries*]. 1,500 vols. Taipei: Shangwu yinshuguan, 1983–1986.

Qingshi gao 清史稿 [Draft History of the Qing Dynasty]. Edited by Zhao Erxun 趙爾巽 et al. 48 vols. 1928. Reprint, Beijing: Zhonghua shuju, 1976–1977.

Qing shilu 清實錄 [Veritable Records of the Qing Dynasty]. 60 vols. Beijing: Zhonghua shuju, 1985–1987.

Qingdai gongting banhua 清代宮廷版畫 [Court Printed Illustrations of the Qing Dynasty]. Edited by Yang Renkai 楊仁愷 et al. 40 vols. Hefei: Anhui meishu chubanshe, 2002.

Qingdai gongting huihua 清代宮廷繪畫 [Court Painting of the Qing Dynasty]. Edited by The Palace Museum. Beijing: Wenwu chubanshe, 1992.

Rawski, Evelyn S. *The Last Emperors: A Social History of Qing Imperial Institutions.* Berkeley: University of California Press, 1998.

Rawski, Evelyn S., and Jessica Rawson, eds. *China: The Three Emperors, 1662–1795.* London: Royal Academy of Arts, 2005.

Reed, Marcia, and Paola Demattè, eds. *China on Paper: European and Chinese Works from the Late Sixteenth to the Early Nineteenth Century.* Los Angeles: The Getty Research Institute, 2007.

Rinaldi, Bianca Maria. *The "Chinese Garden in Good Taste": Jesuits and Europe's Knowledge of Chinese Flora and Art of the Garden in the Seventeenth and Eighteenth Centuries.* Munich: Martin Meidenbauer Verlagsbuchhandlung, 2006.

Ripa, Matteo. *Giornale (1705–1724).* Edited by Michele Fatica. 2 vols. Naples: Istituto Universitario Orientale, 1991 and 1996.
———. *Memoirs of Father Ripa, during Thirteen Years Residence at the Court of Peking in the Service of the Emperor of China; With an Account of the Foundation of the College for the Education of Young Chinese at Naples.* Translated by Fortunato Prandi. London: J. Murray, 1844. Reprint, New York: Wiley and Putnam, 1846.
———. *Storia della fondazione della Congregazione e del Collegio de' Cinesi.* 3 vols. Naples: Manfredi, 1832. Reprint, Naples: Istituto Universitario Orientale, Collana Matteo Ripa, 1983.
———. "Letter to Father Alesandro Bussi in Rome, August 26, 1714." In Matteo Ripa, *Thirty-Six Views of Jehol*, by Matteo Ripa. MEXE+; #611030B. The Miriam and Ira D. Wallach Division of Art, Prints and Photographs, New York Public Library.

Rogers, Elizabeth Barlow, et al. *Romantic Gardens: Nature, Art, and Landscape Design.* New York: The Morgan Library and Museum, 2010.

Rosenzweig, Daphne Lange. "Court Painters of the K'ang-Hsi Period." PhD diss., Columbia University, 1978.

Schweizer, Anton, and Avinoam Shalem. "Translating Visions: A Japanese Lacquer Plaque of the Haram of Mecca in the L. A. Mayer Memorial Museum, Jerusalem." *Ars Orientalis* 39 (2010): 148–173.

Sekino, Tadashi 関野貞 and Takuichi Takeshima 竹島卓一. *Jehol: The Most Glorious and Monumental Relics in Manchoukuo.* 4 vols. Tokyo: The Zauho Press, 1934.

Shen Dingping 沈定平. "Ma Guoxian zai Zhongguo de huihua huodong jiqi yu Kangxi, Yongzheng huangdi de guanxi shulun" 马国贤在中国的绘画活动及其与康熙雍正皇帝的关系述论 [A Discussion of Matteo Ripa's Artistic Activities in China and His Relationships with the Kangxi and Yongzheng Emperors]. In *La missione cattolica in Cina tra i secoli XVIII–XIX: Matteo Ripa e il Collegio dei Cinese,* edited by Michele Fatica and Francesco D'Arelli, 83–102. Naples: Istituto Universitario Orientale, 1999.

Sirén, Osvald. *Chinese Painting: Leading Masters and Principles.* 9 vols. New York: Ronald Press, 1956.
———. *China and Gardens of Europe of the Eighteenth Century.* New York: Ronald Press, 1950. Reprint, Washington, D.C.: Dumbarton Oaks Research Library and Collection, 1990.

Spence, Jonathan D. "The K'ang-hsi Reign." In *The Cambridge History of China,* vol. 9, pt. 1, *The Ch'ing Empire to 1800,* edited by Willard J. Peterson, 120–182. Cambridge: Cambridge University Press, 2002.
———. *The Memory Palace of Matteo Ricci.* New York: Viking Penguin, 1984.
———. *Emperor of China: Self-Portrait of K'ang-Hsi.* New York: Alfred A. Knopf, 1974.
———. *Ts'ao Yin and the K'ang-hsi Emperor, Bondservant and Master.* New Haven: Yale University Press, 1966.

Spence, Jonathan D., and John E. Wills Jr., eds. *From Ming to Ch'ing: Conquest, Region, and Continuity in Seventeenth-Century China.* New Haven: Yale University Press, 1979.

Spence, Joseph (penname of Sir Harry Beaumont). *Observations, Anecdotes, and Characters of Books and Men: Collected from Conversation.* Edited by James M. Osborn. 2 vols. Oxford: Clarendon Press, 1966.

Standaert, Nicolas, ed. *Handbook of Christianity in China,* vol. 1, *635–1800.* Leiden: Brill, 2001.

Strassberg, Richard E. "Translating a Chinese Garden: Texts and Images from the Kangxi Emperor's *Imperial Poems on The Mountain Estate for Escaping the Summer Heat.*" In *Two Voices in One: Essays in Asian and Translation Studies,* edited by Laurence K. P. Wong et al., 7–22. Newcastle: Cambridge Scholars Publishing, 2014.
———. "Transmitting a Qing Imperial Garden" 一座清代御苑之传播. *Landscape* 风景园林 83 (June 2009): 93–103.
———. "War and Peace: Four Intercultural Landscapes." In *China on Paper: European and Chinese Works from the Late Sixteenth to the Early Nineteenth Century,* edited by Marcia Reed and Paola Demattè, 89–137. Los Angeles: The Getty Research Institute, 2007.
———. *Inscribed Landscapes: Travel Writing from Imperial China.* Berkeley: University of California Press, 1994.

Struve, Lynn A. *Voices from the Ming-Qing Cataclysm: China in Tigers' Jaws.* New Haven: Yale University Press, 1993.

Sturman, Peter, and Susan Tai, eds. *The Artful Recluse: Painting, Poetry, and Politics in Seventeenth-Century China.* Santa Barbara: Santa Barbara Museum of Art, 2012.

Sullivan, Michael. *The Meeting of Eastern and Western Art from the Sixteenth Century to the Present Day.* London: Thames and Hudson, 1973.

Sze, Mai-mai, trans. and ed. *The Mustard Seed Manual of Painting.* Princeton, N.J.: Princeton University Press, 1956.

Temple, William. *Miscellanea, the Second Part; In Four Essays.* London: Simpson, 1690.
———. "Upon the Gardens of Epicurus: Or, Of Gardens, in the Year 1685." In *The Genius of the Place: The English Landscape Garden 1620–1820,* edited by John Dixon Hunt and Peter Willis, 96–99. Cambridge, Mass.: The MIT Press, 2000.

Thomas, Antoine. *Histoire de la Mission de Pékin.* 2 vols. Paris: Louis-Michaud, 1923.

Torbert, Preston M. *The Ch'ing Imperial Household Department: A Study of Its Organization and Principal Functions, 1662–1796.* Cambridge, Mass.: Council on East Asian Studies, Harvard University, 1977.

Tsien, Tsuen-hsuin. "Technical Aspects of Chinese Printing." In *Chinese Rare Books in American Collections,* by Sören Edgren, 16–25. New York: China House Gallery, China Institute in America, 1984.

Vinograd, Richard. "Brightness and Shadows: The Politics of Painting at the Ming Court." In *Power and Glory: Court Arts of China's Ming Dynasty,* edited by He Li, Michael Knight, and Richard E. Vinograd et al., 183–201. San Francisco: Asian Art Museum / Chong-Moon Lee Center for Asian Art and Culture, 2008.

Vissière, Isabelle, and Jean-Louis Vissière, eds., *Lettres édifiantes et curieuses jésuites de Chine, 1702–1776.* Paris: Éditions Desjonquères, 2001.

Von Erdberg, Eleanor. *Chinese Influence on European Garden Structures.* Edited by Bremer W. Pond. Cambridge, Mass.: Harvard University Press, 1936.

Von Spree, Clarissa, ed. *The Printed Image in China from the Eighth to the Twenty-First Centuries.* London: The British Museum Press, 2010.

Wakeman Jr., Frederic E. *The Great Enterprise: The Manchu Reconstruction of Imperial Order in Seventeenth-Century China.* 2 vols. Berkeley: University of California Press, 1985.

Wang, Eugene Y. "The Rhetoric of Book Illustrations." In *Treasures of the Yenching: Seventy-Fifth Anniversary of the Harvard-Yenching Library,* edited by Patrick Hanan, 181–217. Cambridge, Mass.: Harvard-Yenching Library, 2003.
———. "Tope and Topos: The Leifeng Pagoda and the Discourse of the Demonic." In *Writing and Materiality in China: Essays in Honor of Patrick Hanan,* edited by Judith T. Zeitlin and Lydia H. Liu, 488–552. Cambridge, Mass.: Harvard University Asia Center, 2003.

———. "Perceptions of Change, Changes in Perception—West Lake as Contested Site/Sight in the Wake of the 1911 Revolution." *Modern Chinese Language and Culture* 12, no. 2 (Fall 2000): 73–122.

Wang Juyuan 汪菊渊. "Bishu shanzhuang fazhanshi ji qi yuanlin yishu" 避暑山庄发展史及其园林艺术 [A History of the Development of the Mountain Estate for Escaping the Heat and Its Garden Artistry]. In *Bishu shanzhuang luncong* 避暑山庄论丛 [Collected Essays on the Mountain Estate for Escaping the Heat], edited by Bishu shanzhuang yanjiu hui, 465–494. Beijing: Zijincheng chubanshe, 1986.

Wang Qi 王圻 and Wang Siyi 王思義, eds. *Sancai tuhui* 三才圖會 [Collected Illustrations of the Three Realms]. 108 *juan.* Nanjing, 1609. Reprint, Taipei: Chengwen chubanshe, 1970.

Wang Qianjin 汪前進 et al., eds. *Qingting sanda shice quantu ji* 清廷三大实测全图集 [Three Maps Based on Surveys from the Qing Dynasty Court]. 3 vols. Beijing: Waiwen chubanshe, 2007.

Wang, Robin. *Yinyang: The Way of Heaven and Earth in Chinese Thought and Culture.* Cambridge: Cambridge University Press, 2012.

Wang, Shen. "Wang Yuanqi and the Orthodoxy of Self-Reflection in Early Qing Landscape Painting." PhD diss., University of Pennsylvania, 2010.

Wang Xianqian 王先謙. *Donghualu* 東華錄 [Records from the Eastern Flower Gate]. 124 vols. Shanghai: Guangbaisongzhai, 1884.

Wells, Matthew V. *To Die and Not Decay: Autobiography and the Pursuit of Immortality in Early China.* Ann Arbor, Mich.: Association for Asian Studies, 2009.

Wen Zhengming 文徵明 and Kate Kirby. *An Old Chinese Garden: A Three-fold Masterpiece of Poetry, Painting, and Calligraphy.* Translated by Mo Zung Chung. Shanghai: Chung Hwa, 1923.

Weng Lianxi 翁连溪. *Qingdai neifu keshu tulu* 清代内府刻书图录 [Illustrated Catalog of Qing Dynasty Imperial Printing]. Beijing: Beijing chubanshe, 2004.

West, Stephen H. "Body and Imagination in Urban Gardens of Song and Yuan." In *Gardens and Imagination: Cultural History and Agency,* edited by Michel Conan, 40–64. Washington, D.C.: Dumbarton Oaks Research Library and Collection, 2008.
———. "Spectacle, Ritual, and Social Relations: The Son of Heaven, Citizens, and Created Space in Imperial Gardens in the Northern Song." In *Baroque Garden Cultures: Emulation, Sublimation, Subversion,* edited by Michel Conan, 291–321. Washington, D.C.: Dumbarton Oaks Research Library and Collection, 2008.

Whiteman, Stephen H. "From Upper Camp to Mountain Estate: Recovering Historical Narratives in Qing Imperial

Landscapes." *Studies in the History of Gardens and Designed Landscapes* 33, no. 4 (December 2013): 249–279.

———. "Kangxi's Auspicious Empire: Rhetorics of Geographic Integration in the Early Qing." In *Chinese History in Geographical Perspective*, edited by Du Yongtao and Jeffrey Kyong-McClain, 34–54. Lanham, Md.: Lexington Books, 2013.

———. "Creating the Kangxi Landscape: Bishu Shanzhuang and the Mediation of Qing Imperial Identity." PhD diss., Stanford University, 2011.

Whitfield, Roderick, and Wen C. Fong. *In Pursuit of Antiquity: Chinese Paintings of the Ming and Ch'ing Dynasties from the Collection of Mr. and Mrs. Earl Morse*. Princeton, N.J.: The Art Museum, Princeton University, 1969.

Widmer, Ellen. "Between Worlds: Huang Zhouxing's Imaginary Garden." In *Trauma and Transcendence in Early Qing Literature*, edited by Wilt Idema et al., 349–281. Cambridge, Mass.: Harvard University Press, 2006.

Wilkinson, Endymion. *Chinese History: A Manual, Revised and Enlarged*. Cambridge, Mass.: Harvard University Asia Center, 2000.

Wu, Pei-yi. *The Confucian's Progress: Autobiographical Writings in Traditional China*. Princeton, N.J.: Princeton University Press, 1980.

Wu, Silas H. L. *Passage to Power: K'ang-hsi and His Heir Apparent (1661–1722)*. Cambridge, Mass.: Harvard University Press, 1979.

Xiaopeng 小朋. *Lengyan kan shanzhuang* 冷眼看山莊 [An Unbiased View of the Mountain Estate]. Harbin: Heilongjiang meishu chubanshe, 2000.

Xiaotian 啸天. *Chengde mingsheng* 承德名勝 [Famous Places in Chengde]. Hailaer: Neimenggu wenhua chubanshe, 2004.

Xiao Tong, ed. *Wen xuan, or, Selections of Refined Literature*. Translated, with annotations and introduction by David R. Knechtges. 3 vols. Princeton, N.J.: Princeton University Press, 1986–1992.

Xihu shijing 西湖十景 [Ten Views of West Lake]. Shanghai: Shanghai renmin chubanshe, 1979.

Yang, Boda 杨伯达. "Leng Mei ji qi 'Bishu shanzhuang tu'" 冷枚及其《避暑山庄图》 [Leng Mei and His *View of Bishu shanzhuang*]. *Gugong bowuyuan yuankan* 故宫博物院院刊 1 (1979): 51–61.

Yang Xiaoshan. *Metamorphosis of the Private Sphere: Gardens and Objects in Tang-Song Poetry*. Cambridge, Mass.: Harvard University Asia Center, 2003.

Yuen-chung Lui, Adam. *The Han-lin Academy: Training Ground for the Ambitious, 1644–1850*. Hamden, Conn.: Archon Books, 1981.

Yu Jianhua 俞剑华. *Zhongguo meishujia renming cidian* 中国美术家人名词典 [Biographical Dictionary of Chinese Artists]. Shanghai: Shanghai renmin meishu chubanshe, 2004.

Yu Minzhong 于敏中 et al., eds. *Rixia jiuwen kao* 日下舊聞考 [Historical Information about the Capital with Additional Research]. 4 vols. Beijing: Beijing guji chubanshe, 1981.

Zarrow, Peter, trans. "The Imperial Word in Stone." In *New Qing Imperial History: The Making of Inner Asian Empire at Qing Chengde,* edited by James Millward et al., 146–163. London: Routledge, 2004.

Zhang Yushu 張玉書. "Hucong ciyou ji" 扈從賜遊記 [Record of Touring the Rehe Rear Garden at Imperial Invitation]. In *Dongbei shizhi* 东北史志: 1 [Historical Records of the Northeast: 1], in *Zhongguo bianjiang shizhi jicheng* 中國邊疆史志集成 [A Collection of Historical Records of China's Frontier Regions], 7:3–6. Beijing: Quanguo tushuguan wenxian suowei fuzhi zhongxin, 2004.

Zhao Houjun 赵厚均 and Yang Jiansheng 杨鉴生, eds. *Zhongguo lidai yuanlin tuwen jingxuan* 中国历代园林图文精选 [Selected Literature and Images of Historical Gardens in China]. 4 vols. Shanghai: Tongji daxue chubanshe, 2005.

Zhongguo gudai banhua congkan erbian 中国古代版画丛刊二遍 [Second Collection of Ancient Chinese Woodblock Printing]. Shanghai: Shanghai guji chubanshe, 1994.

Zhou Weiquan 周维权. *Zhongguo gudian yuanlin shi* 中国古典园林史 [A History of the Classical Chinese Garden]. Beijing: Qinghua daxue chubanshe, 1999.

Zhu Chengru 朱诚如, ed. *Qingshi tudian: Qingchao tongshi tulu, di 3–4 ce: Kangxi chao* 清史图典: 清朝通史图录，第三、四册：康熙朝 [Qing History Illustrated: A Comprehensive Pictorial History of the Qing Dynasty, vols. 3–4, The Kangxi Reign]. Beijing: Zijincheng chubanshe, 2002.

Zou, Hui. *A Jesuit Garden in Beijing and Early Modern Chinese Culture*. West Lafayette, Ind.: Purdue University Press, 2011.

———. "*Jing* (景): A Phenomenological Reflection on Chinese Landscape and *Qing* (情)." *Journal of Chinese Philosophy* 35, no. 2 (2008): 353–368.

CONTRIBUTORS

RICHARD E. STRASSBERG received his PhD in East Asian studies from Princeton University in 1975. Since 1978, he has been teaching in the Department of Asian Languages and Cultures at the University of California, Los Angeles, where he is Professor of Chinese. He specializes in traditional Chinese literature, with a particular interest in landscape and garden culture. Among his books are *Inscribed Landscapes: Travel Writing from Imperial China; A Chinese Bestiary: Strange Creatures from the* Guideways Through Mountains and Streams; and *Wandering Spirits: Chen Shiyuan's Encyclopedia of Dreams*, all published by University of California Press. He has served as an adjunct curator at the Pacific Asia Museum and was a senior fellow at Dumbarton Oaks. He is currently a member of the advisory committee for the Liu Fang Yuan Garden at the Huntington Library, Art Collections, and Botanical Gardens.

STEPHEN H. WHITEMAN is Lecturer in Asian Art at The University of Sydney. A past curator of the New York Chinese Scholar's Garden, he has taught garden and art history at the University of Pennsylvania, the University of Colorado, and Middlebury College. He received his doctorate in art history from Stanford University in 2011 and has been the recipient of fellowships from Dumbarton Oaks, the Graham Foundation for Advanced Study in the Fine Arts, the Chiang Ching-kuo Foundation, and, most recently, the Center for Advanced Study in the Visual Arts at the National Gallery of Art. His essays on garden history and historiography have been published in *Ars Orientalis, Studies in the History of Gardens and Designed Landscapes*, and the anthology *Chinese History in Geographic Perspective.*

EX HORTO
DUMBARTON OAKS TEXTS IN GARDEN AND LANDSCAPE STUDIES
DUMBARTON OAKS RESEARCH LIBRARY AND COLLECTION, WASHINGTON, D.C.

Ex horto is devoted to classic works on the philosophy, art, and techniques of landscape design. Augmented with contemporary scholarly commentary, the series offers historical texts from numerous languages and reintroduces valuable works long out of print. The volumes cover a broad geographical and temporal range, from ancient Chinese poetry to twentieth-century German treatises, and constitute a library of historical sources that have defined the core of the field. By making these works newly available, the series provides unprecedented access to the foundational literature of garden and landscape studies.

Further information on Garden and Landscape Studies publications can be found at www.doaks.org/publications.

Garden Culture of the Twentieth Century
 Leberecht Migge, author; and David H. Haney, editor and translator

Travel Report: An Apprenticeship in the Earl of Derby's Kitchen Gardens and Greenhouses at Knowsley, England
 Hans Jancke, author; Joachim Wolschke-Bulmahn, editor; and Mic Hale, translator

Letters of a Dead Man
 Prince Hermann von Pückler-Muskau, author; and Linda B. Parshall, editor and translator

Thirty-Six Views: The Kangxi Emperor's Mountain Estate in Poetry and Prints
避暑山莊三十六景詩圖
 Poems by the Kangxi Emperor, with illustrations by Shen Yu and Matteo Ripa;
 Richard E. Strassberg and Stephen H. Whiteman, translators and authors